PICASSO: Fifty Years of his Art.

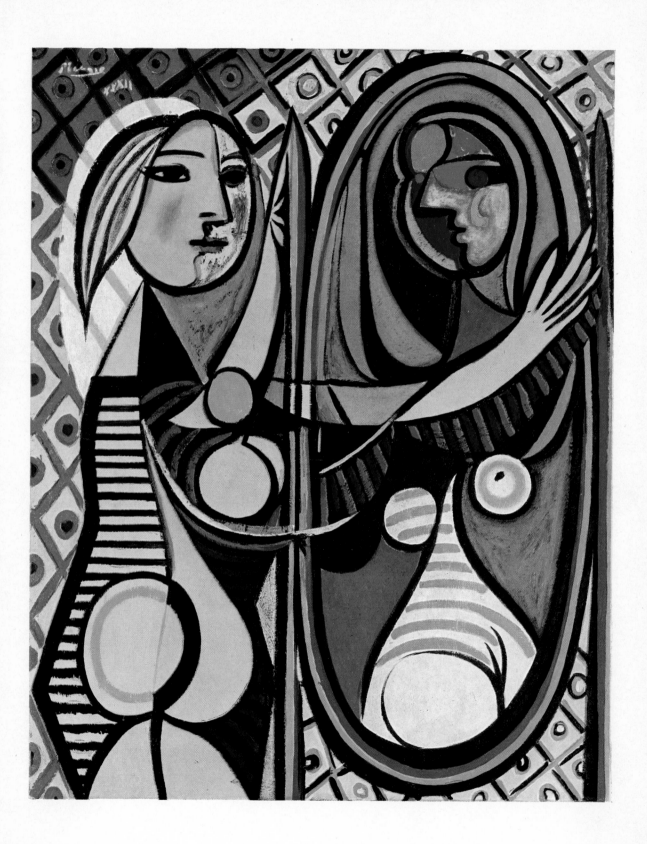

PICASSO

Fifty Years of his Art

by Alfred H. Barr, Jr.

The Museum of Modern Art, New York

Distributed by Simon and Schuster, New York

Contents

for my wife

Margaret Scolari-Fitzmaurice

advisor and invaluable assistant in the Picasso campaigns of 1931, 1932, 1936, 1939.

Preface and Acknowledgment

In 1939 the Museum of Modern Art organized, in collaboration with the Art Institute of Chicago, the comprehensive exhibition *Picasso: Forty Years of his Art.* The catalog of that exhibition has been the point of departure for the present book which includes a new and greatly amplified text, some 110 new plates, enlarged lists and appendices and, moreover, surveys both the earliest and latest periods of Picasso's art thereby adding a decade to the forty years represented in the 1939 publication.

The writer is indebted to so many scholars, artists, art dealers, collectors, photographers, publishers, colleagues and friends who have helped make this book that by oversight some names may be omitted from the list of those he wishes to thank.

Everyone who writes at any length about Picasso must be grateful to M. Christian Zervos, the zealous publisher of *Cahiers d'Art* and the great *Catalogue* of Picasso's works, two more volumes of which were produced during the war despite many difficulties. The writer is also obliged to M. Henry Kahnweiler whose scrupulous records and sense of history put students of Picasso greatly in his debt.

Mr. and Mrs. Joan Junyer have been most kind in translating and forwarding a questionnaire to a friend of Picasso's youth, Sr. Carles Junyer, who has taken great pains to reply in detail. In securing information from Picasso, his friend and secretary M. Jaime Sabartés, M. Georges Hugnet, M. Paul Rosenberg, Mme Jeanne Bucher and especially Lt. Commander James S. Plaut have all been helpful. Picasso himself has left many questions unanswered.

The following have most kindly provided information and photographs: Miss Harriet Dyer Adams, Mr. Philip R. Adams, Mr. George Amberg, Dr. Albert C. Barnes, M. André Breton, Mrs. Meric Callery, Mr. Robert Capa, M. Louis Carré, Mrs. Mimi Catlin, Mr. Walter P. Chrysler, Jr., Mr. Philip W. Claflin, Mr. Henry Clifford, Mr. Frank Crowninshield, Prof. Frederick B. Deknatel, Mme Gladys Delmas, Mr. John Ferren, Mr. Henry Sayles Francis, Miss Philippa Gerry, Mr. Xavier Gonzales, Mr. Jean Goriany, Mr. John Groth, Miss Peggy Guggenheim, Mr. Jorge Guillen, Prof. Edith F. Helman, Miss Elise Van Hook, Mr. Sidney Janis, Miss Una E. Johnson, Mr. T. Catesby Jones, Mr. Edgar Kaufmann, Jr., Mr. Georges Keller, Mr. Lincoln Kirstein, Sr. Juan Larrea, Miss Janice Loeb, M. Pierre Loeb, Prof. José Lopez-Rey, Mr. Wright Ludington, Mlle Dora Maar, Mr. Paul Magriel, Mrs. Marjorie D. Mathias, Mr. Pierre Matisse, Miss Agnes Mongan, Mrs. Barbara Morgan, Miss Hannah B. Muller, Prof. Dorothy Nicole Nepper, Mrs. Nancy Newhall, Mrs. W. W. Norton, Mr. Klaus G. Perls, Mr. Daniel Catton Rich, Miss Gigi Richter, Mr. Andrew C. Ritchie, Mr. Carl O. Schniewind, Mr. and Mrs. Jerome Seckler, Mr. José Luis Sert, M. Henri Seyrig, Miss Virginia Shull, Mrs. Dorothy Simmons, Mrs. George Palen Snow, Mr. and Mrs. J. K. Thannhauser, Mr. Virgil Thomson, Mr. Curt Valentin, Mr. Carl Zigrosser.

Most of the photographs of works of art are by Soichi Sunami and Marc Vaux; some are used by courtesy of the Galerie Simon (now Galarie Louise Léiris), Galarie Pierre, Paul Rosenberg Gallery, Cahiers d'Art, Life, Minotaure, Time, Vogue, and others, to whom credit is given beneath the reproduction.

For their critical reading of the text and many valuable suggestions, the author thanks Mr. James Johnson Sweeney, Mr. James Thrall Soby and Miss Margaret Miller; for reading proof, Miss Dorothy C. Miller, Mrs. Faith Rugo, Miss Margaret Scolari and, for designing the typography of the cover and introductory pages, Mr. Carlus Dyer. Mr. William S. Lieberman has given invaluable help in research, criticism and many other ways. The book has been seen through the press in the face of difficult wartime and reconversion conditions by Miss Frances Pernas under the general supervision of Mr. Monroe Wheeler.

Thanks are also offered to the owners, private and public, for the privilege of reproducing works of art in their possession.

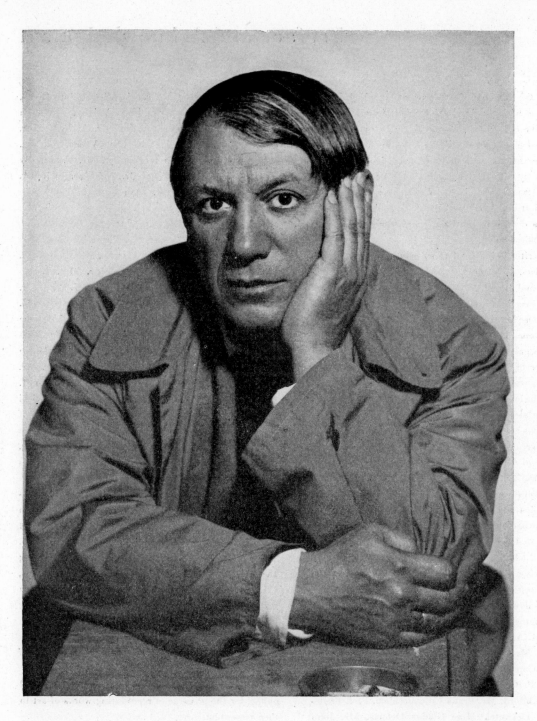

Picasso, 1935. Photograph by Man Ray

Introduction

Why another book on Picasso?

Probably no painter in history has been so much written about—attacked and defended, explained and obscured, slandered and honored by so many writers with so many words— at least during his lifetime. The list of books and articles about Picasso at the back of this volume omits hundreds of routine reviews and journalistic notices, yet it records over 550 items and includes 46 monographs alone.

There have been biographical essays on Picasso full of memoirs, anecdotes, speculations, facts and legends; there have been forewords to volumes of reproductions usually with little direct relation between the preface and the plates; interpretative and critical studies, some foolish, some brilliant, but almost all of them—and quite properly—involved with proposing a thesis or proving a theory about Picasso.

The author believes that this more modest and somewhat more comprehensive study is needed. This book neither argues an interpretation nor draws any general conclusions. But it does attempt a balanced, condensed survey of Picasso's art: first, by means of reproductions; second, by a running commentary which is closely integrated page by page with the illustrations and supported by notes; lastly, by a series of appendices which include chronologies, lists and reprints of Picasso's own statements.

The plates reproduce work in most of the media and techniques Picasso has used: paintings in oil, gouache, watercolor, sometimes varied with sand or sawdust; drawings in ink, pencil, pastel, crayon; etchings of various kinds,

woodcuts, lithographs; sculpture in plaster and wood, cast in bronze; compositions of paper and cloth pasted, pinned or sewn; constructions of wrought iron, wood, paper or sheet metal; photographs; designs for theatre costumes, curtains and settings. All these are arranged in chronological order, not in obeisance to mere historical sequence but because such an order reveals most objectively the progressions, the broad changes, the alternations and sudden mutations of Picasso's art.

Whoever finds such a chronological arrangement routine, may also be put off by an obvious preoccupation with the dating of pictures. Dates have no interest in themselves, except for the pedant. But to understand the growth of so rapid and manifold a production as Picasso's, dates, even precise dates, are almost essential. For nearly two decades now, Picasso, half in mockery no doubt, has obligingly dated most of his work by year, month and day. But occasionally he cannot remember even the year of a work done thirty or forty years ago—and between 1905 and 1915 the sequence of changes in his art often constitutes milestones, even monuments, along the highroad of Western art. Many facts, therefore, about Picasso and his production are yet to be established and meanwhile much of this book must be considered tentative or at least preliminary.

The text which follows is servant to the pictures. Fact and criticism in it are perhaps less important than the frequent reference to works that are earlier or later than the one under immediate discussion. This weaving forward and back, this continual retrospect and prophecy, may help reveal the complex but, in

9

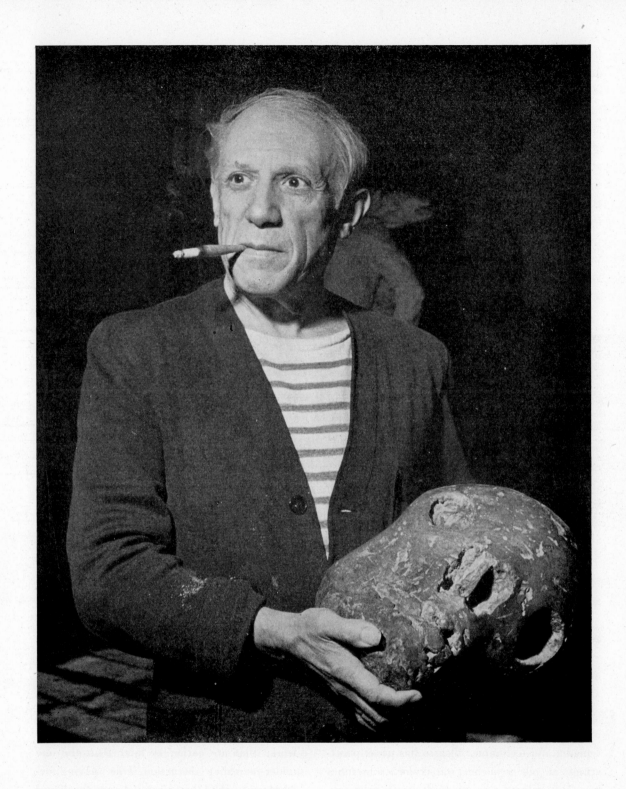

PICASSO, 1944. Photograph by Robert Capa, courtesy *Life*

10

the end, recognizable counterpoint in Picasso's development. Picasso has sometimes spoken of his belief that his art does not change in any fundamental sense. The recurrence of forms and motifs years after they first appear might offer superficial confirmation of Picasso's sense of immutability. More significant are the recurring supersessions and conflicts: sculptural, three-dimensional forms versus flat pictorial forms; the monochrome versus maximum intensity and variety of color; overt prettiness versus grotesque ugliness; emotional nullity versus convulsive passion; realism versus abstraction.

Two sections of the text are, however, not entirely ancillary to the plates. The account of Picasso's early years in Spain is a little longer and more detailed than later biographical paragraphs partly because much of the information has been published only in rather inaccurate Spanish narratives and partly because Picasso's adolescence anticipates certain patterns of his maturity: the humanitarian, even sentimental, strain in his art, for instance, and his close association with writers, especially poets, which began in Barcelona, recurred in Madrid, and continues down to this day in Paris.

The writer has never been in Barcelona or Madrid; nor in Paris since 1939, so that his accounts of Picasso's first and latest five years as an artist should perhaps have been shorter rather than longer than the story of the intervening four decades. However, if the obscurity of Picasso's early years invites some special attention his recent rôle demands it.

It is true that his recent renown does not depend upon his art alone. Picasso's life in Nazi-occupied Paris took on, apparently without the artist's intention, a symbolic character which had little directly to do with what he was painting. And his political stand after the

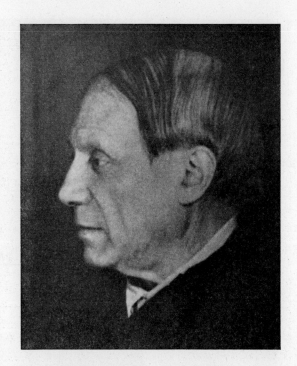

PICASSO, 1944. Photograph, courtesy *Vogue*

Liberation was in no way specifically reflected in his art. Neither the Nazis nor the Communists officially approve Picasso's painting. Quite the contrary. Yet under the Nazis and after his profession of Communism he kept on painting the way he had before, without regard to political theories about art. Responsible only to himself, he works out of his own inner compulsion. Take it or leave it, he says in effect, I can and will paint in no other way. In a world in which social pressures—democratic, collectivist, bourgeois—tend to restrict the freedom of the exceptional individual, Picasso's art assumes a significance far beyond its artistic importance.

Picasso's anarchic individualism is magnificent, even heroic. Yet, in the light of history, it may seem to have been a limitation. When the *Luftwaffe* bombed a Spanish town in 1937 Picasso painted *Guernica* in proclamation of

11

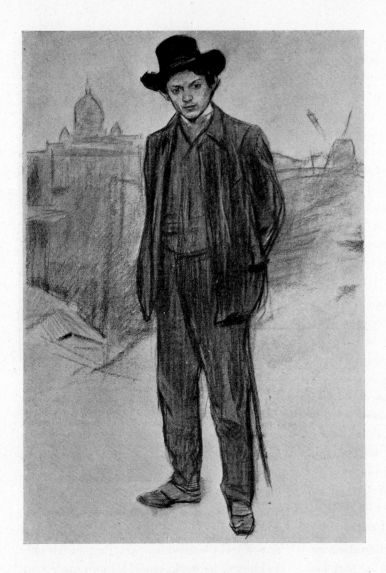

PICASSO. Drawing by Ramón Casas published in *Pèl & Ploma*, Barcelona, 1901 (bibl. 478)

horror and rage, not against the Germans, not specifically against fascism, but, as he said, against "brutality and darkness." *Guernica* was damned and praised as propaganda. We see now that it was not so much propaganda as prophecy.

Like all great prophecy the language of *Guernica* was allegorical. Those who ask Picasso to "humanize" his art, to speak simply and clearly the language of everyman, ask too little. Posters and newspaper cartoons, not *Guernica*, would answer their purpose more effectively. If they feel compelled to ask anything of Picasso it should be not clarity but once again the tragic courage of the prophet.

Now when humanity may be forging its own doom on a scale which dwarfs the puny bombs of Guernica, Picasso might be moved to paint an apocalypse. If not, if this should be too much, and he should continue to paint jugs and candles, landscapes and figures, we would still have excellent works of art to admire and the integrity of a great artist—and a great individual—to respect.

12

PICASSO: Fifty Years of his Art

Key

The text and illustrations are arranged chronologically except where layout or the nature of the illustrations requires minor departures from strict sequence.

Notes to the text begin on page 251.

"bibl." refers to the numbered bibliography, page 286.

IN THE CAPTIONS:

Oil paintings are on canvas unless otherwise noted.

Height precedes width in giving dimensions.

"(dated)" following a date means that the date appears on the front or back of the picture.
When two dates are given, the first is preferred by the author.

G. refers to the *catalogue raisonné* of Picasso's prints by Bernhard Geiser (bibl. 179).

K. following a date means that the date has been given or confirmed by D. H. Kahnweiler.

P. following a date means that it has been confirmed by Picasso.

Z. refers to *Pablo Picasso* by Christian Zervos, Vols. I and II, cataloging work from 1895 to 1917 (bibl. 524).

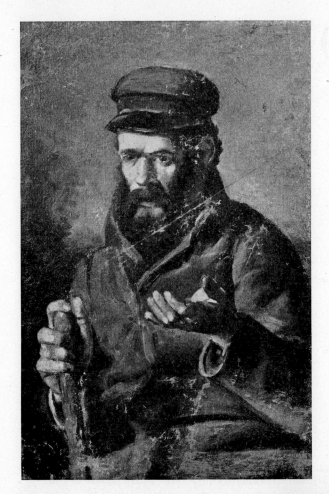

SPAIN: 1881-1900

Pablo Ruiz Picasso was born on October 25, 1881 in Malaga on the Mediterranean coast of Spain. His father, José Ruiz Blasco, came from northern Spain with Basque blood in his ancestry. His mother, Maria Picasso, was a Malagueña. The name Picasso is Italian, possibly Genoese, in origin but the artist believes that it was originally Spanish and spelt Picazo.† As is customary in Spain, Picasso was at liberty to use both his father's and his mother's family names. He was known at first as Pablo Ruiz, but about the time of his first exhibition in Barcelona in 1897 he added his mother's name to his signature: P. Ruiz Picasso. About 1901 he dropped his father's name entirely—Picasso is a much more unusual and distinguished name than Ruiz.*

José Ruiz was an art teacher in Malaga when Picasso was born. In 1891 the family moved to nearby Corunna and then, when the boy was fifteen, to Barcelona where his father became professor in the Academy of Fine Arts.‡

Picasso, from a very early age, showed exceptional talent. He began to draw as a child, receiving encouragement and highly competent, academic instruction from his father, Don José. At Corunna, while he was still a boy of fourteen studying at the School of Fine Arts, he painted some vigorous studies of beggars, such as the Man in a Cap. Though their idiom is 19th century they are as Spanish in their sombre realism as a Zurbaran or early Velasquez.

above: Man in a Cap. Corunna, 1895 (Z). Oil, 28¾ x 19¾ inches. Owned by the artist.

Roses. Barcelona, 1898 (Z). Oil, 14¼ x 16¾ inches. Bignou Gallery, New York.

14

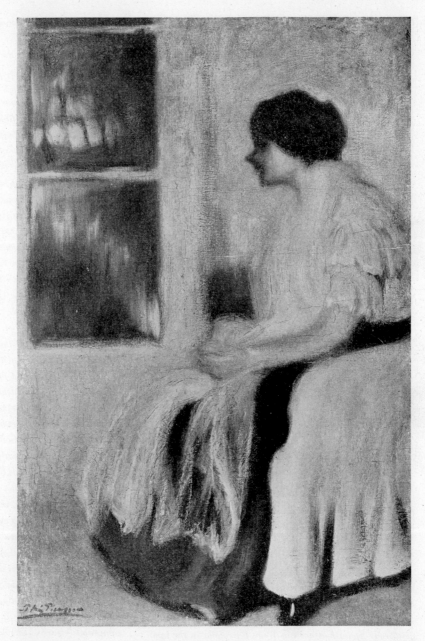

THE ARTIST'S SISTER. Barcelona, 1899 (P). Oil, 59 x 39½ inches. Owned by the artist.

BARCELONA: 1896-1900

In 1896, shortly after his family had settled in Barcelona, Picasso passed the entrance tests for the Academy, taking only one day for an examination so difficult that a whole month was ordinarily allowed for its completion. A few *months later he repeated this prodigious academic achievement at Madrid.* There, in the capital, the youth spent some time among the masterpieces of the Prado but the sterile atmosphere of the Royal Academy of San Fernando*

15

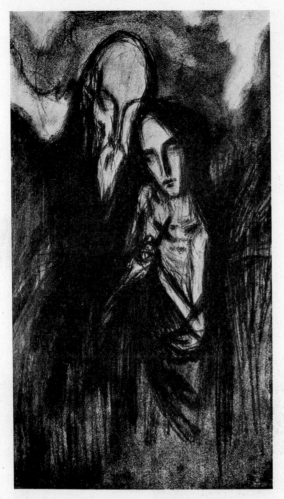

OLD MAN WITH A SICK GIRL. Barcelona, 1898 (Z). Conté
crayon, 18½ x 12⅜ inches. Repro. from Zervos, bibl.
524.

so bored him that he returned to Barcelona before the end of
the year.

Less conservative than Madrid and less affected by the
disastrous Spanish-American War, Barcelona in the late
90's was culturally the most progressive city in Spain. The
ancient capital of Catalonia and a great modern seaport, its
artists and intellectuals were open to contemporary currents
from England, Scandinavia, Germany, Italy and, above
all, from Paris.* Naturalism and symbolism, realism, both
satirical and humanitarian, impressionism, fin de siècle
estheticism, philosophical anarchism and Catalan nation-
alism, all had their supporters among the painters and
writers who met and argued and learned from each other

at the center of Barcelona's artistic life, the café Quatre
Gats (Four Cats).

Picasso often went to the Quatre Gats. There, among the
younger generation, he found the painters Sebastián
Junyer, the vigorous, very talented Isidre Nonell, Joaquín
Sunyer, Carles Casagemas, shortly to go with him to Paris,
the collector Carles Junyer, the sculptor Manolo, the
brothers Fernández de Soto, the architect Reventos, and the
poet Jaime Sabartés, today, a half-century later, Picasso's
secretary. Picasso was the Benjamin of the group.†

Among the older and better established men whom Pi-
casso knew at the famous café were the philosopher and
critic Eugenio d'Ors, thirty years later to write a brilliant
study of Picasso (bibl. 329); the painter-playwright Santi-
ago Rusiñol, an "intimist" and symbolist; Miguel Utrillo,
the pioneer authority on El Greco (two of whose paintings
Rusiñol had bought as early as 1894); and Ramón Casas,
the central figure of the Quatre Gats, at least so far as
painters were concerned.

Ramón Casas was a clever, prolific artist in the line of
Steinlen and Toulouse-Lautrec, and the publisher of im-
portant art magazines‡ which he and Utrillo edited. Casas
encouraged Picasso and passed on to him the influence of
the great French draughtsmen of the end of the century long
before the young artist saw their work in Paris. And
Utrillo, the critic and art historian, may well have fostered
his interest in Catalan Gothic and Romanesque art, as well
as in El Greco. Gothic sculpture or El Greco possibly stand
behind such a drawing as the Old Man with a Sick Girl.

In 1897 Picasso, then a youth of 16, exhibited some
paintings in Barcelona, including such works as the Man
with a Cap (p. 14). The exhibition was noticed in the
press but without marked enthusiasm.§ However, at Ma-
drid, about the turn of the century, in one of the National
Exhibitions Picasso won a prize.‖ Shortly before 1900 he
and Mateo Fernández de Soto, occasionally a sculptor, set
themselves up in a studio, where, lacking furniture, they
painted the walls like a theatre setting representing a
sumptuously furnished salon.¶

Picasso's canvases of the later nineties vary from the
modestly painted still life, Roses, to the large portrait, The
Artist's Sister (pages 14, 15), which shows a considerable
mastery of soft sweeping forms not far removed from the late
style of Renoir, though the tone is more silvery. For the
most part he made pastels and oil studies of the bull ring,
the cabaret and the life of Barcelona, bohemian or prole-
tarian. He is also said to have tried his hand at ceramics
during a visit to Majorca. Some essays in fresco painting

16

apparently came somewhat later, perhaps in 1901 or 1902 after he had been in Paris. All traces of these experiments seem to have disappeared.*

During these years Picasso drew incessantly, cramming notebooks with rapid sketches, some satirical or wicked in character, others sentimental or religious—such as the crayon drawing opposite. By 1899, when Casas was filling his new and successful magazine Pèl & Ploma with his own illustrations, Picasso had already accomplished work which makes the handsome drawings of the older draughtsman seem conventional. In Picasso's girls there was often more Lautrec and less Gibson; yet on the whole his early drawings were not particularly distinguished. The sketchbook page below, with its bohemian "types," music hall profile à la Yvette Guilbert, and its Daumier-like group of drunkards, was probably done in Paris late in 1900 but it differs little from many similar notes made earlier in Barcelona or a little later in Madrid.

Picasso's illustrations were first published not by Casas'

Pèl & Ploma but by Joventut† an important catalanista weekly which unlike the francophile Pèl & Ploma turned more toward England and Germany. Its early issues which began in 1900 reproduce Beardsley, Burne-Jones and Böcklin, but no Steinlen. During the summer of 1900 two drawings, signed P. Ruiz Picasso, appear as illustrations to poems by Joan Oliva Bridgman entitled The Call of the Virgins and To be or not to be. The drawing for the first is "fleshly," for the second, transcendental. Both are feeble by comparison with some of his unpublished sketches. It was only in December that Pèl & Ploma followed suit by publishing Picasso's caricature of Rusiñol.‡

In 1899 Nonell returned from Paris but others of Picasso's friends were leaving to study in the French capital and were writing him letters urging him to join them; and during 1900 Pèl & Ploma published excited reports of the Paris Exposition and its art. Finally, in the fall of that year, Picasso persuaded his parents to let him go after he had promised to return for Christmas.

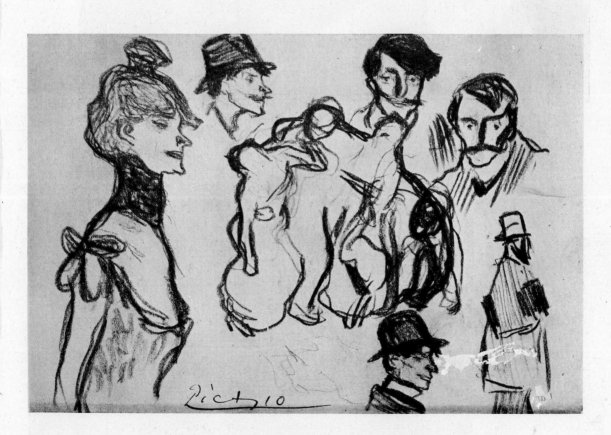

HEADS AND FIGURES (*Scène de bar*). Paris, 1900. Conté crayon, 5⅛ x 8¼ inches. Collection Ivan L. Best.

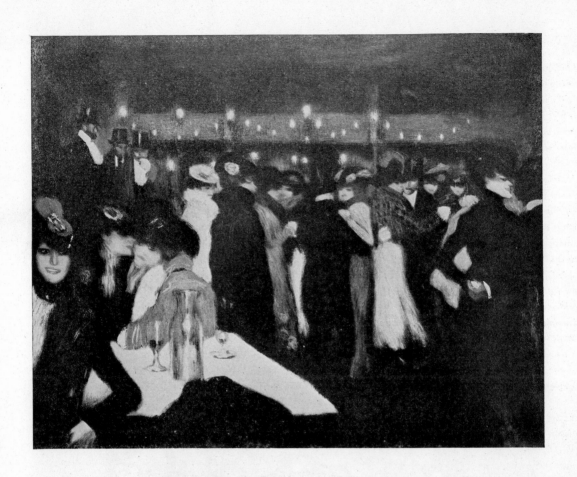

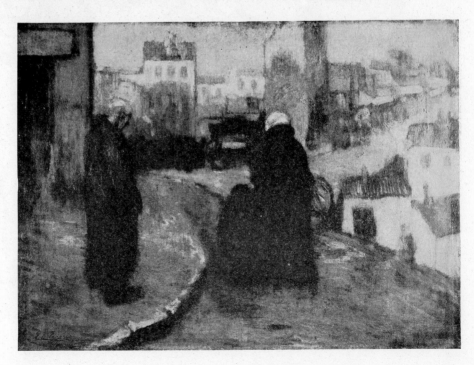

PARIS—SPAIN—PARIS: fall 1900, spring 1901

Picasso arrived in Paris late in October 1900 within a few days of his 19th birthday. It was the year of the World's Fair and Paris was full of foreigners, among them Picasso's Barcelona friends Manolo, Canals and Sunyer. Another Spaniard, Pedro Mañach, introduced him to the dealer Berthe Weill who bought three bullfight sketches done in Spain, the first canvases he sold in Paris.† Picasso lived with Manolo on Montmartre, argued at bohemian cafés and drew or painted scenes à la Steinlen like* Paris Street *(opposite) and the sultry* Moulin de la Galette, *the most important work of this first visit to Paris.*

Picasso returned to Spain for the Christmas holidays, visited Malaga, his birthplace, and then spent from January to May 1901 in Madrid. There the "young Andalusian who spoke Castillian with a Barcelona accent" came to know some of the writers of the group of '98 of whom Pio Baroja is the best known.‡ Picasso drew their portraits (and his own), contributed to their magazine, sketched Madrid bohemia, and painted some Steinlenesque canvases of women and café scenes some of which he sold. With the writer Soler he helped start a short-lived review Arte Joven§ *of which he was art editor. But Paris attracted him irresistibly and after a short stay in Barcelona he arrived a second time in the French capital to stay until the end of the year. About the time Picasso left Barcelona, Utrillo published in the June issue of* Pèl & Ploma *what was possibly the first article on his work. It was illustrated with several of his drawings and prefaced by a lively portrait of the young artist by Ramón Casas (p. 12 and bibl. 478).*

In Paris Picasso studied the work of the vanguard, Gauguin, van Gogh, Toulouse-Lautrec, Vuillard, Denis and the older men Carrière, Degas, Renoir and the Impressionists. During his early years in Paris he went often to the Louvre to study the old masters and also the rooms of Egyptian and ancient Mediterranean art which may have encouraged some of the archaisms which appear rather casually in his work of this and the next year or so.‖

Throughout much of 1901 he painted lustily with the rich palette and impressionist brushwork of On the Upper Deck *(p. 20); and then, characteristically, he reversed his style in a series of flat, decorative figure pieces such as the* Harlequin *(p. 21). He even tried his hand at a poster in the manner of Chéret (p. 20). In June 1901 Mañach arranged with Vollard to give Picasso his first Paris exhibition, mostly of work done in Spain. The show was not a success; Picasso was criticized as an imitator of Lautrec, Steinlen, van Gogh. But he won the interest of one important critic, Gustave Coquiot, and the friendship of the young poet Max*

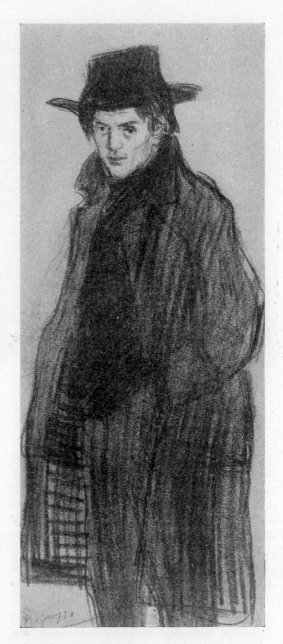

SELF PORTRAIT. Madrid, 1901? (1900 Z). Conté crayon, 13½ x 6 inches. Private collection.

opposite:

above: LE MOULIN DE LA GALETTE. Paris, autumn 1900 (Z). Oil, 35¼ x 45¾ inches. Collection J. Thannhauser. According to the owner, Picasso said that this was his first painting done in Paris.

below: PARIS STREET. Paris, autumn 1900. Oil, 18½ x 26 inches. Collection Miss Harriet Levy.

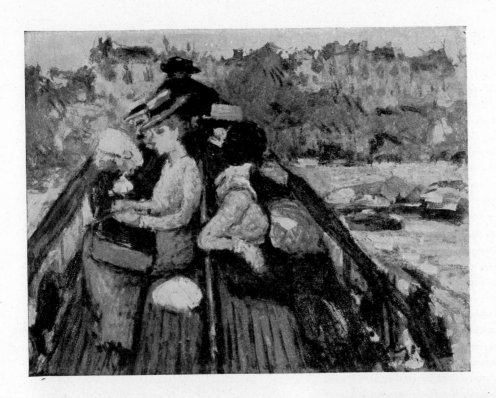

Jacob who was introduced to him by Mañach. Jacob was for years afterwards one of Picasso's most intimate and loyal friends. At this time, however, Picasso spoke no French and most of the "bande Picasso" were young Spaniards like himself. Besides those already mentioned there were Julio Gonzalez who was later to teach Picasso to work in wrought iron; Pablo Gargallo, also a master of wrought metal, whose famous head of Picasso is in the Barcelona museum; Zuloaga, for years a far better known painter than Picasso; and Paco Durio, a friend and enthusiastic admirer of Gauguin whose influence Picasso also felt during this period.

The year following his arrival in Paris was for Picasso a period of exploration. He learned by imitating many masters, sometimes with little discrimination but often with skill. If his art lacked a consistent direction he could, in October 1901 at the age of twenty, look back upon a body of work remarkable for its variety, facility and intelligence.

above: ON THE UPPER DECK. Paris, 1901. Oil, 19⅛ x 25¼ inches. Art Institute of Chicago, Mr. and Mrs. L. L. Coburn Collection.

"JARDIN PARIS": design for a poster. Paris, 1901-02. Watercolor, 25⅛ x 19¼ inches. Collection Walter P. Chrysler, Jr.

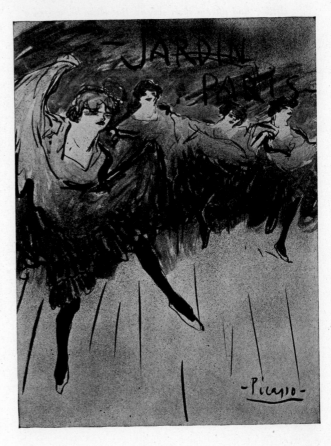

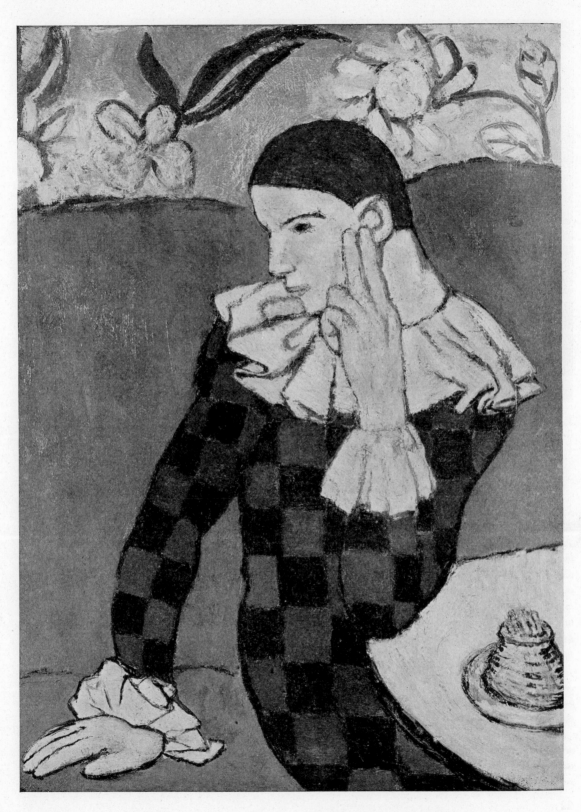

HARLEQUIN. Paris, 1901 (Z). Oil, 31½ x 23¾ inches. Collection Mr. and Mrs. Henry Clifford.

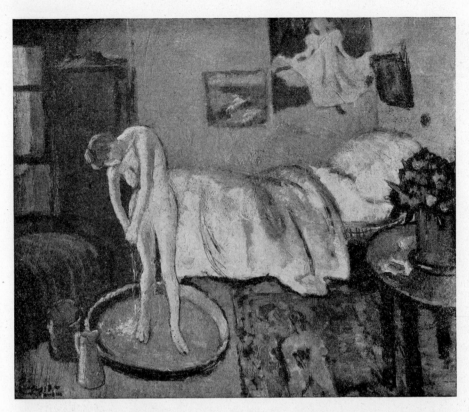

THE BLUE ROOM. Paris, 1901. Oil, 20 x 24½ inches. Phillips Memorial Gallery, Washington. Represents Picasso's studio at 130ter, Boulevard Clichy, in 1901. The poster on the wall is by Toulouse-Lautrec. (Compare Picasso's own design for a poster, p. 20.) Exhibited with fourteen other works by Picasso at the Galerie Berthe Weill, April, 1902.

THE BLUE PERIOD: late 1901 to early 1904

Toward the end of 1901 Picasso began to use a pervasive blue tone in his paintings which soon became almost monochrome. Just why Picasso came to use so much blue over so long a period has never been convincingly explained. Many of Cézanne's late paintings were saturated with blue; Matisse had painted several large figure studies in blue just before the turn of the century though these were probably not known to Picasso; and Carrière, whose work Picasso did admire, used a gloomy monochrome, though it was grey not blue. Some Catalan critics insist upon the influence of Isidre Nonell, whose dejected figures do at times closely resemble Picasso's, but Nonell was in Barcelona during 1901 at the very time Picasso's blue period was maturing in Paris.† Whatever its source—and it was probably from within Picasso himself—the lugubrious tone was in harmony with the murky and sometimes heavy-handed pathos of his subject matter—poverty-stricken mothers, wan harlots with femme fatale masks and blind beggars.*

During the Blue Period Picasso abandoned the varied landscapes, street scenes, dance halls, and flower pieces in order to concentrate almost exclusively on the human figure which he placed, usually alone and still, against a simple almost abstract background. Before the end of 1901, as a last renunciation, he had even given up the rich surfaces which had lingered on in the early blue paintings, such as The Blue Room *(above) and the* Mother and Child *(p. 25).*

The Self Portrait *opposite was painted early in the winter of 1901 before he returned to Barcelona for the holidays. The artist shows us frankly the face of a man who has known cold and hunger and disappointment—Picasso recalls his room without a lamp, his meals of rotten sausages, even his burning a pile of his own drawings to keep warm. But there is in this self portrait no self pity and none of the sentimentality which so often appears in other blue pictures.*

22

SELF PORTRAIT. Paris, 1901 (Z). Oil, 31⅞ x 23⅝ inches. Owned by the artist.

MOTHER AND CHILD. Paris, 1901 (Z). Oil, 44¼ x 38½ inches. Collection Maurice Wertheim.

opposite: WOMAN WITH FOLDED ARMS. Paris, 1901 (Z). Oil, 31⅞ x 23 inches. Collection Mr. and Mrs. Chauncey McCormick.

25

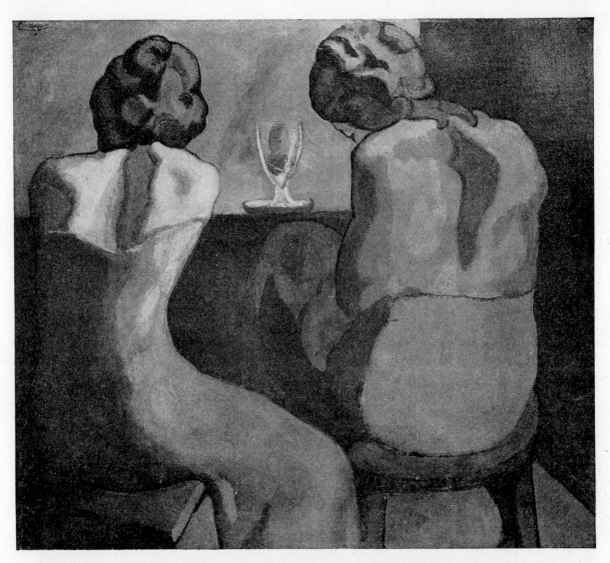

TWO WOMEN AT A BAR. Barcelona, 1902 (Z). Oil, 31½ x 36 inches. Collection Walter P. Chrysler, Jr. Formerly collection Gertrude Stein.

opposite: LA VIE. Barcelona, 1903 (Z). Oil, 77⅜ x 50⅞ inches. Cleveland Museum of Art.

 Picasso stayed in Barcelona during most of 1902, painting dejected figure pieces, like the Two Women at a Bar *(above), in blue monochrome except when an occasional portrait commission required more varied color. While he was in Spain, Mañach arranged exhibitions of his work at Berthe Weill's, where* The Blue Room *(p. 22) was shown, and at Vollard's, but with little success.*

 Picasso returned to Paris in the fall. There he lived with great difficulty even after Max Jacob, only a little less penniless, took him into his small hotel room where Picasso painted at night and slept by day while Jacob was out at work. Jacob lost his job early in 1903 and Picasso was forced to go back once more to Barcelona where he remained over a year.

 The most ambitious work of the Blue Period is La Vie *(opposite) painted during Picasso's last year in Barcelona. It is a very large canvas with something of the salon "machine" about it, a "problem" picture, awkward but with a serious statuesque dignity. Obviously allegory is intended.*

26

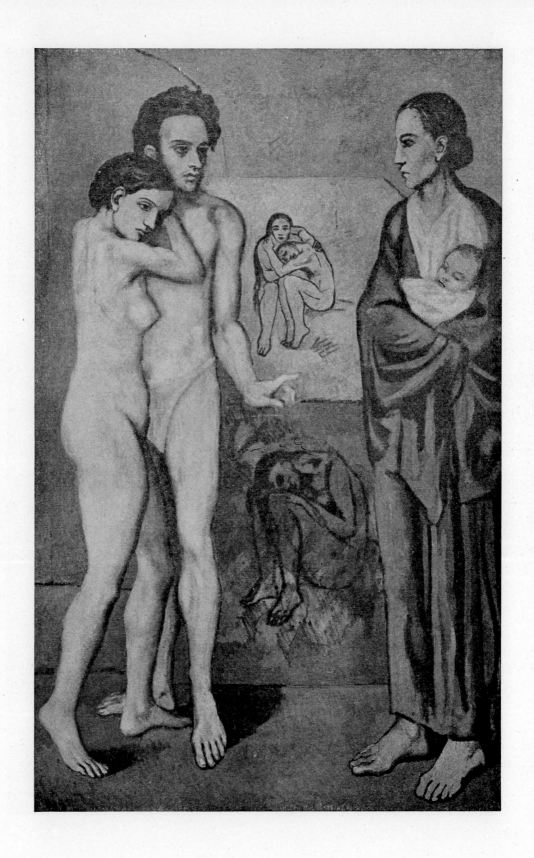

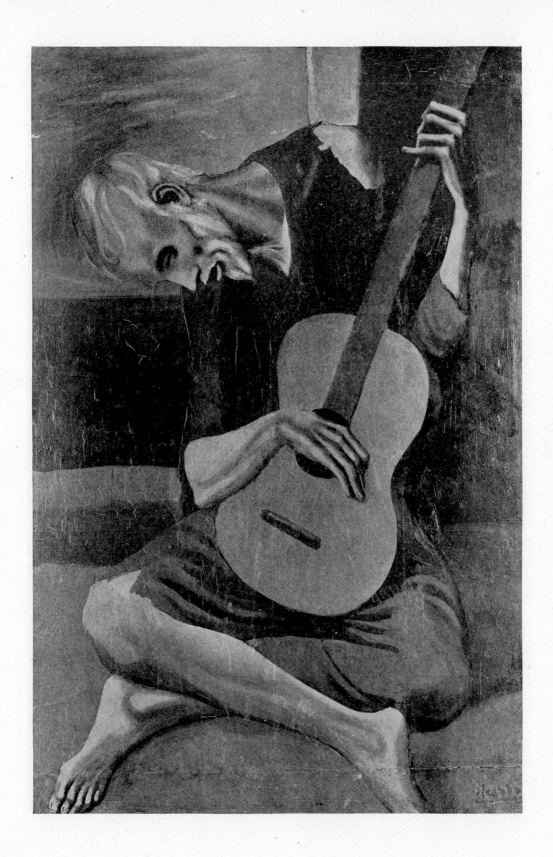

opposite: THE OLD GUITARIST. Barcelona, 1903 (Z). Oil on wood, 47¾ x 32½ inches. Art Institute of Chicago, Helen Birch Bartlett Memorial Collection.

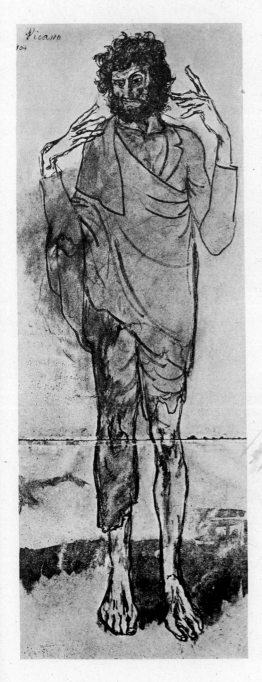

"MANNERISM": late 1903-1904

*Throughout Picasso's career he has again and again used figure styles which seem closely related to Mannerist painting of the late 16th century. The elongations, the insistent pathos, the cramped postures or affected gestures of the Old Guitarist (opposite), the drawings on this page, The Frugal Repast (p. 31) were possibly influenced by the great Spanish mannerists Morales and El Greco. Picasso had known El Greco's art probably as long before as 1896 (p. 16). The gesture of the child in the drawing above and such paintings as the Madonna with a Garland (bibl. 524, I, plate 101) suggest that Picasso also had a special interest in Gothic sculpture after his return to Paris early in 1904.**

above: MOTHER AND CHILD. Paris, 1904 (dated). Black crayon, 13½ x 10½ inches. Fogg Museum of Art, Cambridge, Massachusetts, Paul J. Sachs Collection. The drawing is a preliminary study for the painting *Family of Acrobats* in the Göteborg Art Museum, Sweden, repro. Zervos, bibl. 524, vol. I, pl. 131.

left: THE MADMAN. Paris, 1904 (Z). Watercolor, 33½ x 13¾ inches. Collection L. Plandiura.

Picasso
1904

WOMAN WITH A HELMET OF HAIR. Paris, 1904 (dated). Gouache, 16½ x 12 inches. Collection Mr. and Mrs. Walter S. Brewster.

right: WOMAN WITH A CROW. Paris, 1904 (dated). Gouache and pastel, 25½ x 19½ inches. Toledo Museum of Art, Toledo, Ohio. Picasso saw the crow at the restaurant *Lapin à Gill* where it was the pet of Margot, the daughter of Fredé the proprietor, and now the wife of Pierre MacOrlan.*

PARIS: 1904

In the spring of 1904 Picasso left Barcelona to settle permanently in Paris. He moved into a dilapidated tenement on Montmartre nicknamed the bateau-lavoir—the floating laundry—and lived there until 1909. Fernande Olivier has given us the most detailed account of these years in her picturesque, helter-skelter memoirs Picasso et ses amis. She first met him in 1904 while he was at work on the large etching The Frugal Repast. She describes him as "small, dark, thickset, unquiet, disquieting, with sombre eyes, deepset, piercing, strange, almost motionless. Awkward gestures, the hands of a woman, badly dressed, careless. A thick lock of hair, black and glossy cut across his intelligent obstinate forehead. Half bohemian, half workman in his clothes, his long hair brushing the collar of his tired coat."*

The bateau-lavoir on the rue Ravignon was an ark of talent. Friends of Picasso, the poets Reverdy and Salmon, the painters Van Dongen and, later, Juan Gris, and many others of lesser fame lived there among poverty-stricken clerks, laundresses and actors (pages 32, 33). Besides these neighbors and his faithful Spanish friends and Max Jacob who lived nearby, Picasso's circle soon widened to include the French writers Raynal, Vildrac, Jarry, Duhamel and Apollinaire. Guillaume Apollinaire, whom Picasso met in 1905, took his place beside Jacob among Picasso's intimates. Later he was to be one of the principal champions of cubism.

Vollard still bought occasionally from Picasso but often he had to depend on emergency sales to petty dealers and junkmen such as Soulier and Sagot—yet he no longer starved. Fernande Olivier tells how he worked and lived in bohemian poverty—and extravagance: how he painted at night; sat with poets at the café Closerie des Lilas and with painters at the restaurant Lapin à Gill; carried a Browning automatic; smoked hashish for a brief period with the mathematician Princet; went occasionally to prizefights and very often to the circus where he got to know the acrobats and their families back stage. They provided him with the subject matter of much of his work of 1905.

THE FRUGAL REPAST. Paris, 1904. Etching on zinc, 18⅜ x 14⅞ inches; 2nd state before steel-facing (G. 2, IIa). Collection Alfred Stieglitz. This proof was bought from Picabia and exhibited at Mr. Stieglitz' gallery "291" in 1915.

31

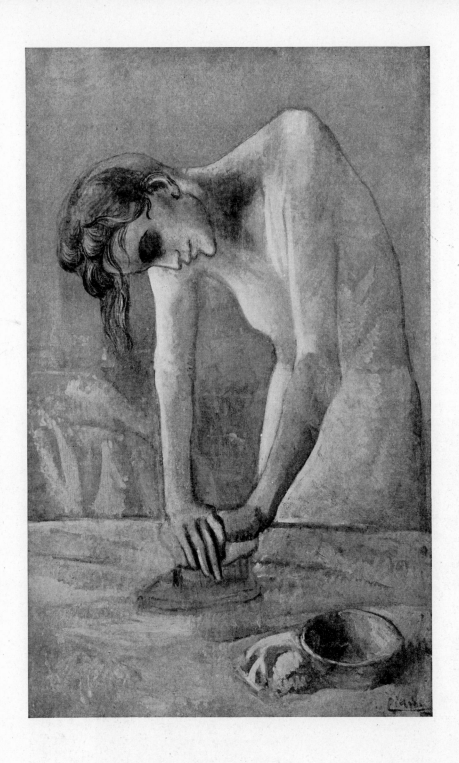

WOMAN IRONING. Paris, 1904 (Z). Oil, 46⅛ x 29⅛ inches. Collection J. Thannhauser.

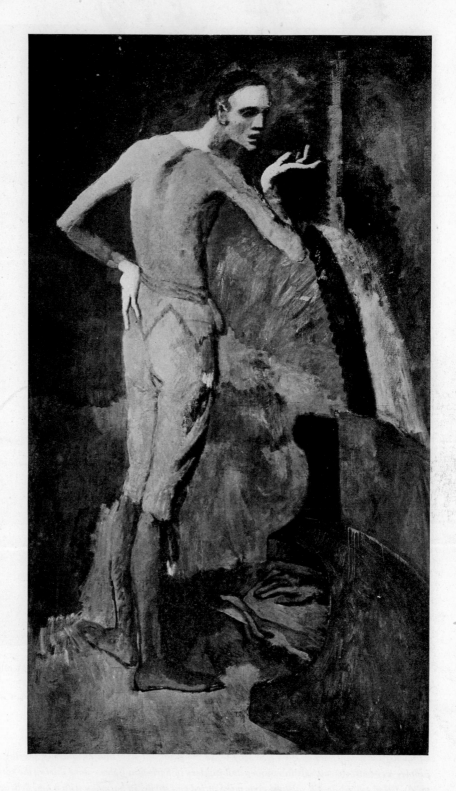

THE ACTOR. Paris, winter 1904-05 (K). Oil, 77¼ x 45⅛ inches. Collection Mrs. Byron Foy.

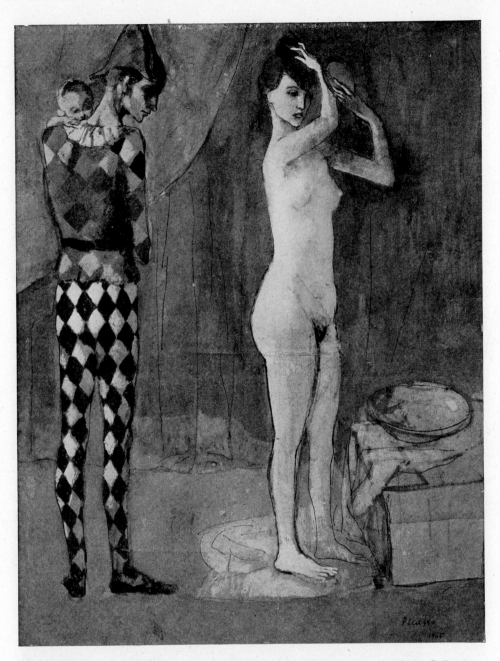

THE HARLEQUIN'S FAMILY. Paris, 1905 (dated). Gouache, 23 x 17¼ inches. Lewisohn Collection.

opposite: TWO ACROBATS WITH A DOG. Paris, 1905 (dated). Gouache, 41½ x 29½ inches. Collection Wright Ludington.

THE CIRCUS PERIOD: 1905

Gradually the mannerism of 1904 gave way to the more natural style and melancholy sweetness of the long series of circus people—acrobats, clowns, saltimbanques and jugglers in harlequin tights—done during the early months of 1905 (pages 34 to 36). Color, too, while still subdued grew more varied and subtle, in harmony with a new delicacy of drawing and sentiment.

34

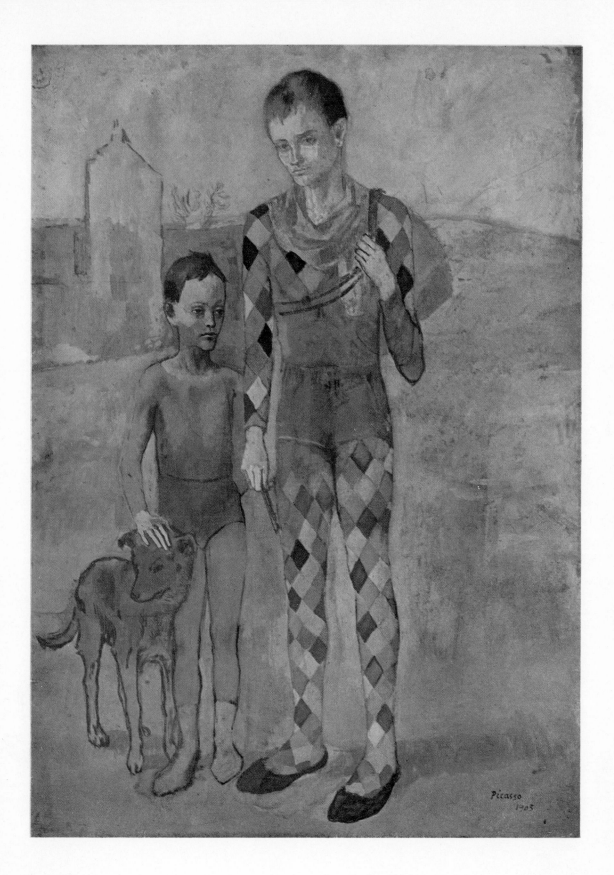

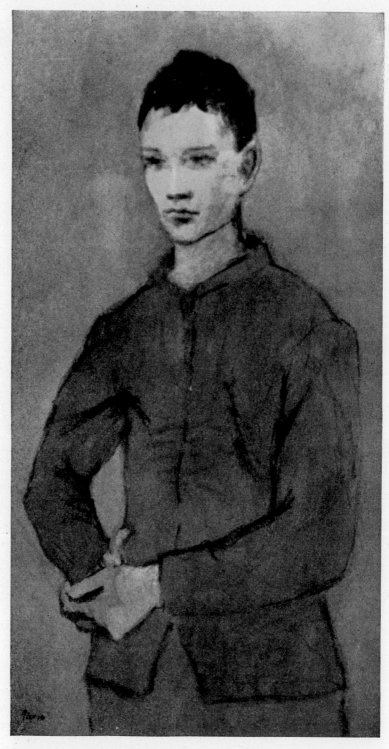

BLUE BOY. Paris, 1905 (Z). Gouache, 40 x 22½ inches. Collection Edward
M. M. Warburg.

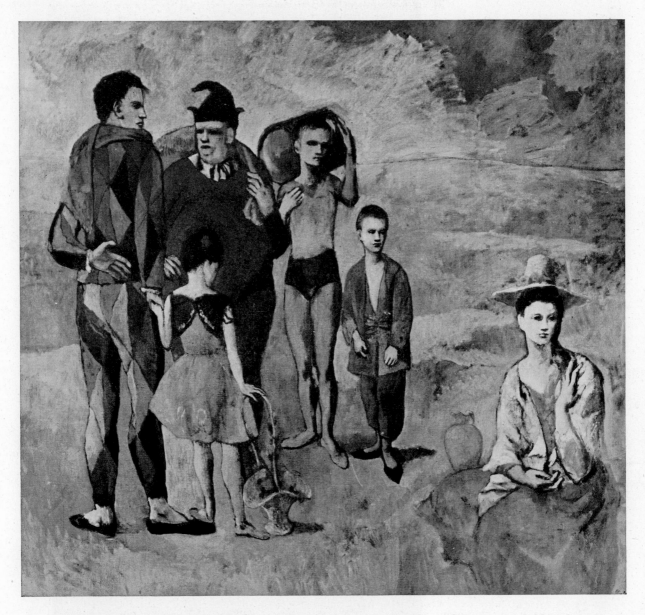

FAMILY OF SALTIMBANQUES. Paris, 1905 (Z). Oil, 84 x 90⅜ inches. Art Institute of Chicago, extended loan from the Chester Dale Collection.

Every few years throughout his career Picasso has had the conviction and energy to concentrate in one large canvas the motives and problems of a whole period of his work. Such "masterpieces" are not always as completely successful as smaller, less ambitious works. But for those who esteem courage above perfection they constitute important evidence of Picasso's stature.

In the Family of Saltimbanques, the largest painting of his first decade as an artist, Picasso assembles a number of the circus characters who appear in scores of drawings, prints and lesser paintings of 1905. If we compare it with La Vie, the big, awkward allegory of the Blue Period (p. 27), we find the Family of Saltimbanques entirely without drama or sermon.

The figures are almost unrelated psychologically and Picasso's romantic sentiment for circus people is restrained. Reticent, too, the muffled color, the subtle drawing and the sensitive placing of the figures.

It is not surprising that the haunting poetry of such a painting should have moved the poet Rainer Maria Rilke who knew Picasso and like him was held by the mystery of the saltimbanques.* For years the canvas hung in the collection of Hertha von Koenig in Munich. During the summer of 1915 Rilke lived in her house "beside the great Picasso" which inspired the fifth of his Duino Elegies. The poem—translated by J. B. Leishman and Stephen Spender† begins—

> But tell me, who are they, these acrobats, even a little
> more fleeting than we ourselves,—so urgently, ever since childhood,
> wrung by an (oh, for the sake of whom?)
> never-contented will? That keeps on wringing them,
> bending them, slinging them, swinging them,
> throwing them and catching them back. . . .

During the course of 1905 Picasso's mood changed. Early in the year the gloom and obvious tension of his work of 1902 to 1904 had yielded to the half-light of the Circus Period. A trip to Holland in the summer of 1905 seems to have increased his interest in material weight and substance. He disliked Holland, but one or two paintings such as the Dutch Girl have about them a sensual solidity which served as a transition to the more classic style of the following twelve months.

The increasing relaxation and calm of Picasso's art throughout 1905 may have been a reflection of his improving circumstances. He started to have a moderate success. Not only was he surrounded by brilliant and sympathetic friends but he began to interest discerning collectors such as the Americans, Leo and Gertrude Stein and, a little later perhaps, the Russian merchant Sergei Shchukine, who was to become by far his greatest patron from this period until the outbreak of war in 1914.‡

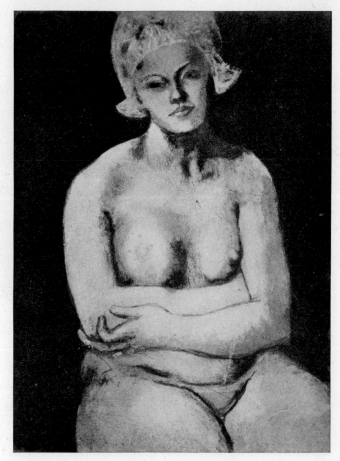

DUTCH GIRL. Schooredam, summer, 1905. Oil. Collection Stang. Repro. from Zervos, bibl. 524.

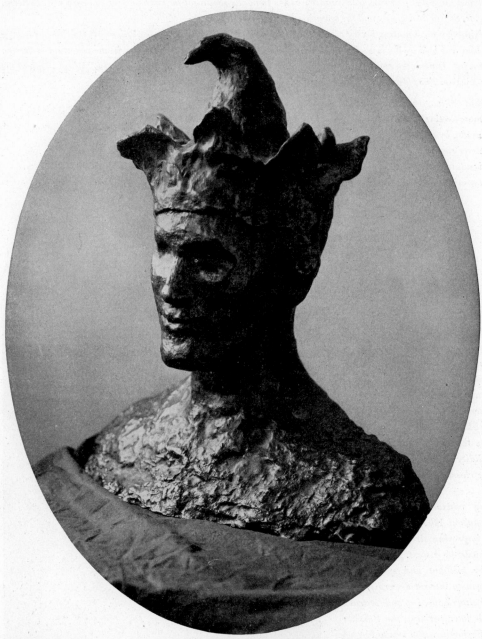

JESTER. 1905 (Z). Bronze, 16¼ inches high. Phillips Memorial Gallery, Washington.

SCULPTURE

In 1905 the dealer Ambroise Vollard cast a series of bronzes by Picasso, some of them modeled with rough rich surfaces in the manner of Rodin. This Head of a Jester is related to the paintings of actors and clowns of the same year; compare for instance the cap of the fat clown in the Family of Saltimbanques. *After this period, with a few isolated exceptions, Picasso was not to take up sculpture seriously again for more than twenty years.**

PRINTS

In 1905 Picasso made a series of some sixteen drypoints and etchings which epitomize his work of that year. Only a few of each were printed by Delâtre and signed by the artist. Late in 1913 the plates were acquired by Vollard, who steel-faced and reprinted them, together with The Frugal Repast *of 1904, in an edition of 250 copies.* They are by far the best known and most widely distributed of Picasso's prints.*

The earlier prints in the sequence parallel the paintings and drawings of circus people on and off stage. The Salomé *comes late in the series. It is classically elegant in drawing, and the legendary subject matter is properly more timeless and remote in treatment than the circus pictures—yet Salomé is acrobatic rather than seductive and Herod is first cousin to the fat clown or "understander" who appears in the* Family of Saltimbanques *and other compositions of the period.*

SALOMÉ. 1905. Drypoint, 15⅞ x 13¾ inches; proof before steel-facing (G. 17a). Private collection. Inscribed to Monsieur Delâtre, the original publisher of this series of prints.

THE FIRST "CLASSIC" PERIOD: mid-1905 to mid-1906

As 1905 passed Picasso gradually left behind him his nostalgic, introspective mood and emaciated figures. During the second half of the year his work began to assume a classic breadth and repose. Such paintings as the Woman with a Fan (opposite) reveal the new style, more objective in feeling, more studied in pose, broadly and more solidly modeled, simpler in color.

Picasso's youthful classicism is informal, fresh, unacademic. He was influenced somewhat by Puvis de Chavannes and the idyllic figure compositions of Gauguin though it is possible that during his visits to the Louvre he had studied Greek sculpture and painting.

Years later, during the twenties, when Picasso again tried his hand at the classic style, his references to the ancients were sophisticated. Perhaps by then he knew too much so that the results were less classic than neo-classic

AT THE CIRCUS. 1905. Drypoint, 8⅝ x 5½ inches (G. 11b). Museum of Modern Art, New York, gift of Mrs. John D. Rockefeller, Jr.

Picasso did not at first entirely abandon the circus as a subject but in this etching, as in the Salomé, the intimate, offstage life of the acrobats and their families is forgotten. In the classic, impersonal grace of these nymphs riding bareback there is no smell of the tanbark.

opposite: WOMAN WITH A FAN. Paris, 1905 (dated). Oil, 39½ x 32 inches. Collection Mr. and Mrs. William Averell Harriman.

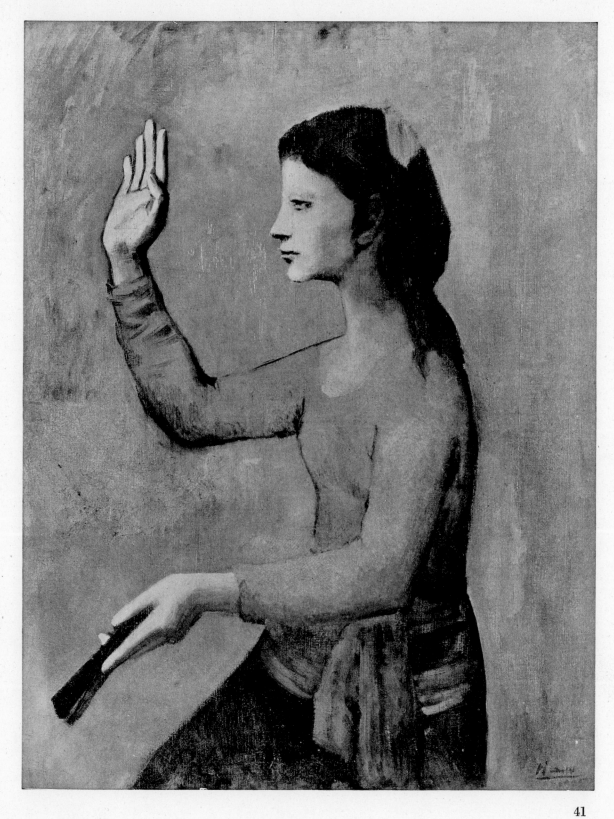

41

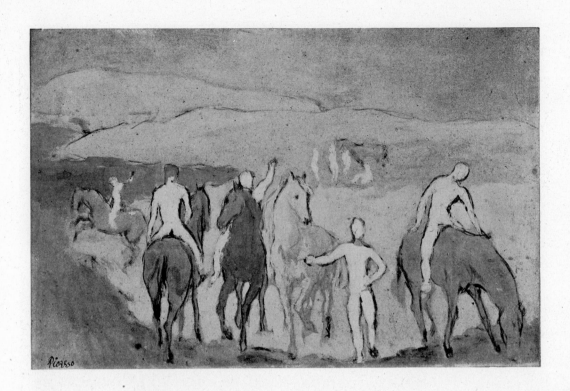

During this brief moment in his youth he was able to hold in delicate, intuitive balance the human and the ideal, the personal and the traditional. Such compositions as The Watering Place or its full scale detail, the Boy Leading a Horse, or La Toilette (p. 44) have an unpretentious, natural nobility of order and gesture which makes the official guardians of the "Greek" tradition such as Ingres and Puvis de Chavannes seem vulgar or pallid.

above: THE WATERING PLACE. Paris, 1905 (Z). Gouache, 14⅞ x 23 inches. Lent anonymously to the Worcester Art Museum. A study presumably for a large scale composition. Compare the drawing, left, and the large painting opposite.

left: YOUTH ON HORSEBACK. Paris, 1905. Charcoal, 18⅜ x 12 inches. Collection John W. Warrington. Study for a composition of men and horses of which the gouache above is the most complete version. (Compare Zervos, bibl. 524, I, pl. 118.)

opposite: BOY LEADING A HORSE. Paris, 1905 (Z). Oil, 86½ x 51¼ inches. Collection William S. Paley, on extended loan to the Museum of Modern Art, New York. A similar group occurs in the foreground of *The Watering Place.*

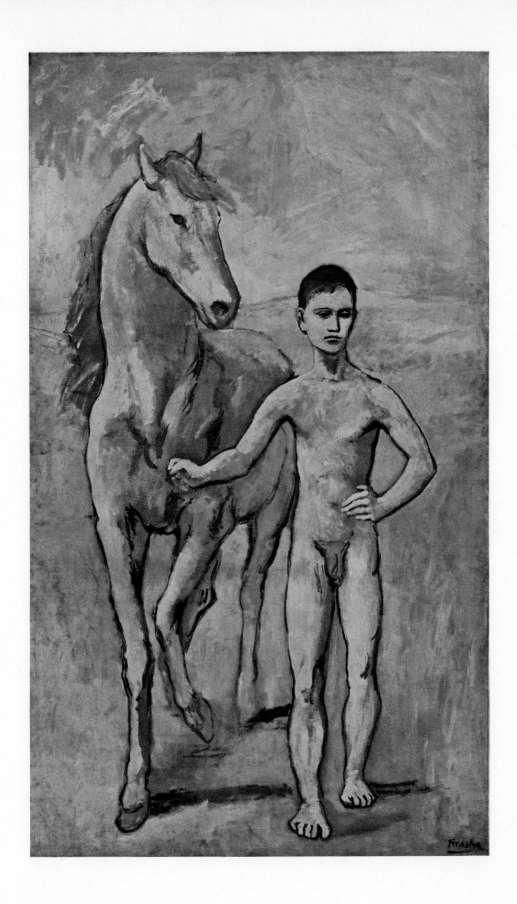

*During the classic period which extends roughly from the latter part of 1905 through the summer visit to Gosol in 1906 Picasso must also have been aware of strong new currents in French painting, of the rising interest in Cézanne among the younger artists, and the expressionist freedom of line and color developed by the fauves painters such as Matisse. But his own art except for a certain increased boldness in drawing seems to have been little affected at first (unless we accept the customary but improbable 1905 dating of so radically advanced a work as the Composition, p. 49). Picasso was still somewhat isolated as an artist: he never exhibited at the Salon des Indépendants or the Salon d'Automne as the fauves had just done; his friends were mostly little known Spaniards or French poets or foreign collectors, though he recalls that he met Matisse in 1905.**

The vigorous drawing and heavy contours, the calculated structure—compact and pyramidal like a Raphael Holy Family—make La Coiffure *remarkable among Picasso's paintings of the winter of 1905-06.†*

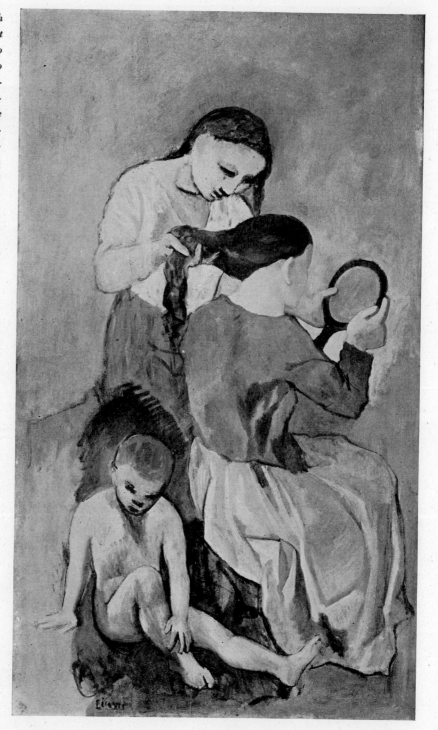

La Coiffure. 1905-06? (Paris, 1905, P.) Oil, 68⅞ x 39¼ inches. Museum of Modern Art, New York, given anonymously.

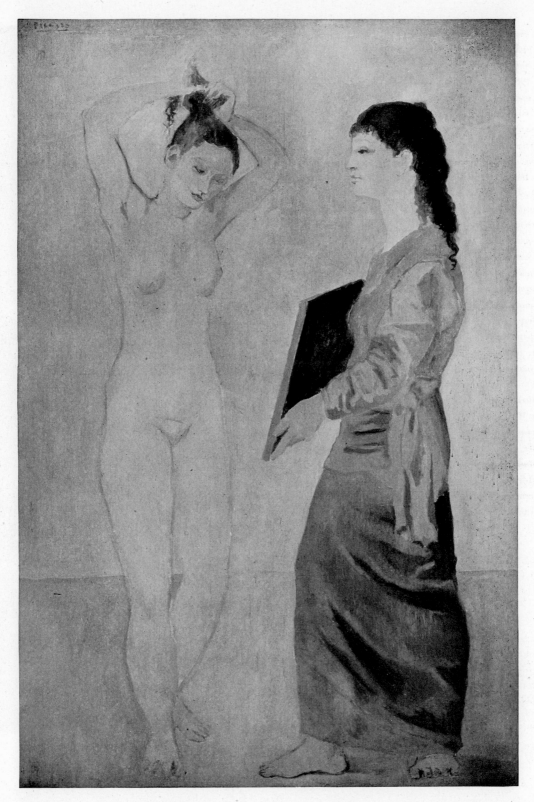

FERNANDE OLIVIER. Gosol, summer 1906 (K). Oil, 39⅜ x 31⅞ inches. Private collection.

GOSOL: summer 1906

*During the summer of 1906 Picasso spent several months at Gosol in the Andorra Valley of the Spanish Pyrenees. There his early classic style came to a culmination in such works as La Toilette and the portrait of Fernande Olivier whose statuesque beauty may well have confirmed the tranquillity of his art at this time.**

The serenity and easy pose of the figures in La Toilette seem directly inspired by Greek art of the classic period. Such gracious demi-goddesses posing against an abstract background are far removed from the stiff, fragile, "Gothic" naturalism of The Harlequin's Family *in which a woman makes her toilet in a circus tent while her husband holds their baby (p. 34).*

Along with his new classic forms Picasso began to use pinks and tans, occasionally contrasted with ochres, olives or pale blues, but often with such a reddish monochromatic effect that the latter part of 1905 and much of 1906 have been called his "Rose Period." At Gosol the terra cotta monochrome became almost as pervasive as the blue of the Blue Period. Even late in 1906 the Two Nudes *(p.52) is painted entirely in a strong reddish tone.*

45

opposite: WOMAN WITH LOAVES. Gosol, summer 1906 (P). The late "1905" beneath the signature is an error. Oil, 39 x 27½ inches. Philadelphia Museum of Art.

PEASANTS FROM ANDORRA. Gosol, summer 1906. Ink, 22⅞ x 13½ inches. Art Institute of Chicago, gift of Robert Allerton.

These two works, done at Gosol probably late in the summer of 1906, *are among the first to show a new character which was gradually to assume great importance in Picasso's art during the revolutionary winter of 1906-07. The gentle, rather soft style of the* Woman with a Fan *(p. 41), or* La Toilette *begins in these pictures to take on a certain severity. The contours are firmer, the modeling more definite and sculptural, especially in the* Woman with Loaves. *The faces look somewhat like finely drawn masks and even the pose of the figures, particularly in the* Peasants from Andorra *is stiffer, a little awkward. The artist seems to be passing, in terms of sculpture, from a seductive, Praxitelean style toward an archaic austerity which was to grow more marked in such works as the* Gertrude Stein, *the* Self Portrait *and the* Two Nudes *(pages 50, 51, 52) all completed within six months after his return from Gosol, and to culminate toward mid-1907 in* Les Demoiselles d'Avignon *(opp. p. 54).*

The archaistic and sculptural character of much of Picasso's work of this period, the artist says, was influenced by ancient Iberian sculpture with which the artist became acquainted as early, probably, as the spring of 1906 (pages 50-51).

In sketching the story of Picasso's development in the crucial years of 1905-07 it would be convenient to keep to the sequence of pictures just outlined and thereby lead with reasonable logic to the Demoiselles d'Avignon. *But Picasso's art is not subject to logical evolution. Sometimes it grows through a series, step by step; at other times it changes suddenly, as if by mutation, rather than gradual evolution. For months or even years he may seem obsessed by a single problem, or idea or color. Or he may paint in two or more radically different styles during the same period, even on the same canvas or sheet of paper.*

So, during 1905-07 he concentrated on painting figures, singly or in pairs side by side, in a style which changes, grows more sculptural, more archaistically rigid and isolated. Yet occasionally during this time, he tried his hand at a more complex, architectonic composition such as La Coiffure *(p. 43) or the* Composition *(p. 49).*

46

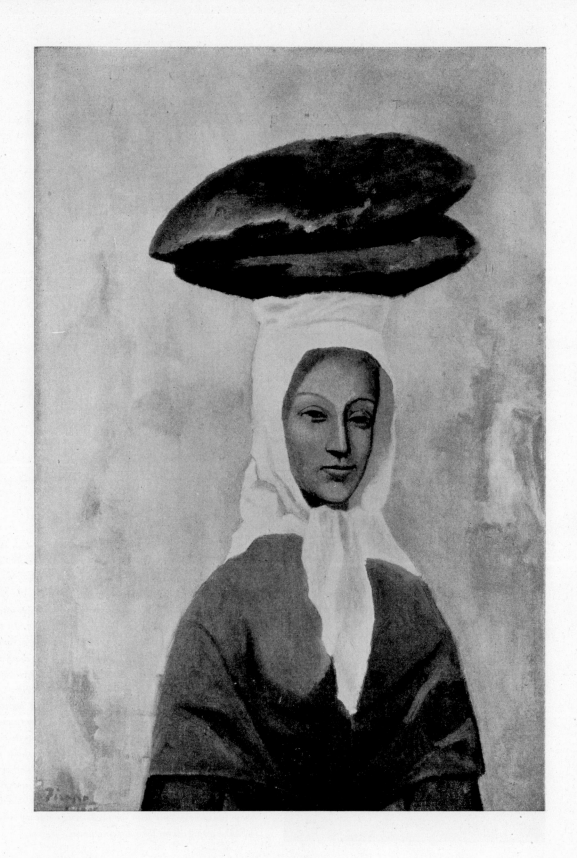

INFLUENCE OF EL GRECO

Altogether exceptional in Picasso's work of this period is the Composition *(opposite). Here there is nothing sculptural, nothing static. The drawing is free, cursive, lively— one of the few early paintings in which Picasso both portrays and expresses movement. And the distortions of the figures are far more violent than in any previous work of Picasso, or for that matter of Matisse, at that time leader of the vanguard fauves. The immensely tall, tiny-headed man, the bulging exaggerations of his forearms and far leg, the pinched-in, elongated waist of the girl, the plastic interplay of figures and drapery, all seem more or less inspired, not by Iberian sculpture but by the pictorial and highly sophisticated mannerisms of El Greco.*

Since 1904 Picasso had shown little if any interest in El Greco but in 1906 on his way to Gosol, he passed through Barcelona where in that very year the first Spanish monograph on El Greco was published by Picasso's old friend Miguel Utrillo. Back in Paris Picasso may also have seen one of two illustrated magazine articles on El Greco published during the fall. Utrillo's book and both French magazines reproduced El Greco's* St. Joseph with the Child Jesus *which bears a remarkable resemblance to Picasso's* Composition *of the peasant with the little girl, though in the El Greco the flowers are borne by angels and there are no cattle.† (The El Greco is reproduced on p. 255.)*

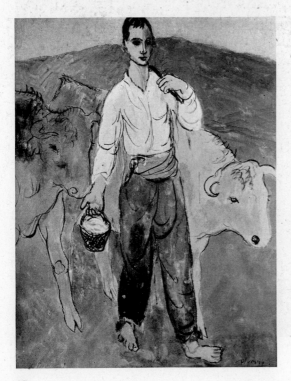

Somewhat similar in style and probably Spanish in subject is the preliminary drawing for the figures in the Composition. *The drawing (above) suggests that Picasso originally had in mind, or actually saw, a blind flower seller, his eyelids closed, his mouth open singing or calling his wares while a little girl leads him and offers a bouquet. In the* Composition *itself he turns the two figures into a rather improbable flower-carrying peasant and his daughter hurrying along beside two cattle. A youth with two cattle first appears in a gouache (left) done at Gosol in 1906.*

The Composition *is particularly important because more than any previous Picasso it looks forward to Cubism both in its free deformation of natural forms and its flickering angular planes which tend to spread throughout the whole canvas thereby creating an all-over unity of design in a way doubtless suggested by El Greco and, probably, Cézanne.‡ The* Demoiselles d'Avignon *will later combine these plastic elements with the archaizing tendency which we take up again on the following pages.*

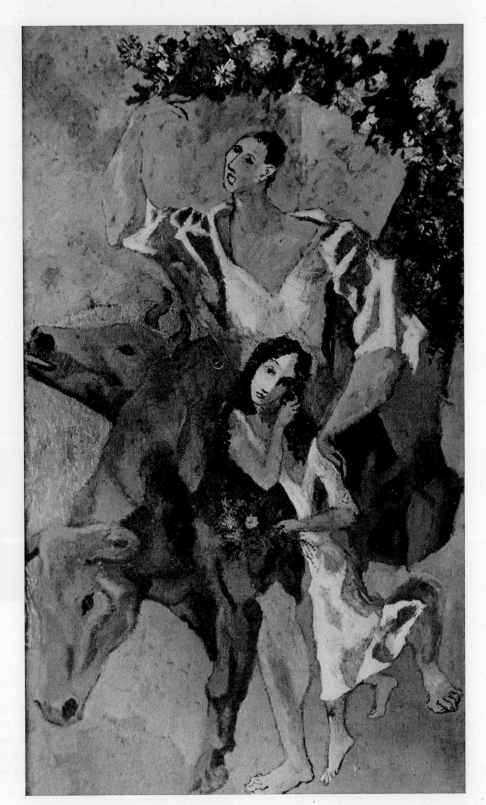

COMPOSITION (PEASANTS
AND OXEN). Paris, 1906?
(1905—Z). Oil, 86⅜ x 51
inches. Barnes Founda-
tion, Merion, Pennsyl-
vania.

opposite:

PEASANTS. 1906? (Paris,
1905—Z). Ink and water-
color. Repro. from Zervos,
bibl. 524.

BOY WITH CATTLE. Gosol
Z, 1906. Gouache, 23½ x
18½ inches. Columbus
Gallery of Fine Arts, Co-
lumbus, Ohio.

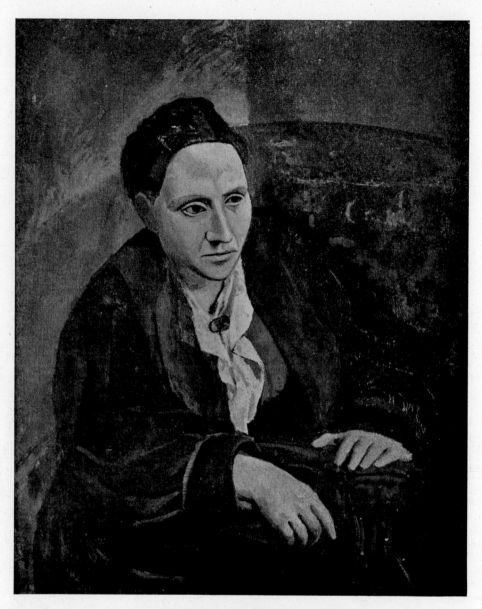

GERTRUDE STEIN. Paris, 1906 (Z). Oil. Collection Miss Gertrude Stein.

THE "IBERIAN" INFLUENCE

Gertrude Stein tells how she sat eighty times for her portrait during the winter of 1906 only to have the dissatisfied artist wipe out the face just before he left for Gosol early in the summer. In the fall when he returned to Paris he painted in a new face without consulting his model again. The new face differing in style from the figure and hands seems mask-like, with a long straight nose and severely drawn mouth, eyes, and eyebrows—features which had begun to appear in Gosol pictures such as the* Peasants from Andorra *and the* Woman with Loaves *(pages 46, 47) and which reach their ultimate exaggeration in the left-hand figures of* Les Demoiselles d'Avignon.

50

SELF PORTRAIT. Paris, 1906 (dated). Oil, 36 x 28 inches. Philadelphia Museum of Art, A. E. Gallatin Collection.

Picasso has stated to Zervos* that in painting Les Demoiselles he had drawn inspiration from Iberian sculpture, the ancient, pre-Roman sculpture of Spain which had been much discussed and publicized by archeologists during the previous years. In the spring of 1906 important new discoveries were published and put on view at the Louvre. This event may well have stimulated Picasso's interest which grew until by the spring of 1907 Iberian sculpture had become one of the prime influences on his art, a fact well confirmed by James Johnson Sweeney (bibl. 463).

The Self Portrait,† above, shows the "Iberian" style at a somewhat later and better assimilated stage than in the Gertrude Stein.

51

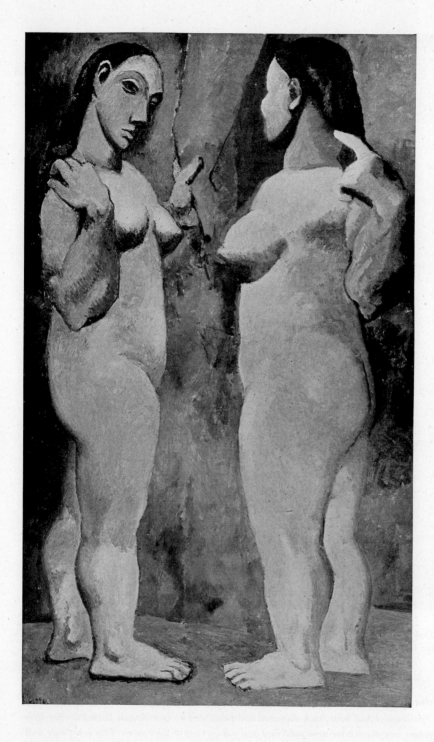

TWO NUDES. Paris, 1906 (Z). Oil, 59¾ x 36⅝ inches. Rosenberg and Helft Ltd., London.

Though the face of the left-hand nude is again archaic in style the squat figures were probably suggested by late Iberian sculpture of 400 to 200 B.C., which, as in some other provincial Greek traditions, grew heavy and stiff (bibl. 463, fig. 11).

Picasso was shortly to abandon such sculptural modeling for a flatter, more abstract style. He revived it again in 1908 (pages 62, 63), in 1920 (p. 116), 1927 (p. 150), and 1937 (p. 199).

52

RETROSPECT

On October 25, 1906 Picasso was twenty-five years old. During the previous five years he had produced over two hundred paintings and many hundreds of drawings, an output in quantity and quality such as few painters accomplish in a lifetime. But the Blue Period with its belated fin-de-siècle desperation, the wistful acrobats and tranquil classic figures of 1905 and 1906, all this cumulative achievement was, so far as the main highway of modern painting was concerned, a personal and private bypath.

But during the winter of 1906-07 Picasso changed the direction of his art and in so doing helped change to a remarkable extent the character of modern art as a whole. Cubism, the name subsequently given to this new direction, was not Picasso's single-handed invention; it was in fact something of a collaborative venture to which Braque among others contributed importantly; it was nourished, too, in various ways by Cézanne, Henri Rousseau, Seurat, Iberian and African Negro sculpture, the critic Apollinaire, the dealer Kahnweiler, as well as by popular talk of time-space mathematics and metaphysics and the general tendency toward esoteric formalism in art with its concomitant rejection of the values of imitation and representation. Yet, above all, it was the quality and power of Picasso's art that made cubism the characteristic movement in the art of the first quarter of our century.

THE AUTUMN SALON OF 1905: LES FAUVES; CÉZANNE

In 1905, a year before, while Picasso was emerging from his soliloquy with harlequins, two events of great historic importance occurred at the Autumn Salon. The most conspicuous of these was the first exhibition of a group of young painters whom a critic humorously called les fauves, the wild beasts. Vlaminck, Friesz, Derain were among them; Matisse was their leader and Rouault exhibited with them. The fauves seemed revolutionary because they had set free the bright pure colors of Signac and the Neo-Impressionists and had gone beyond Gauguin and van Gogh in their use of distorted outlines and bold flat patterns. Back of these violent innovations lay the idea that painting should be primarily an expression of pure esthetic experience and that the enjoyment of line and form and color was a sufficient end in itself. The representation of natural forms therefore seemed less important than before, though some resemblance to nature as a point of departure was still taken for granted. This emphatic declaration of art's independence of nature was an important factor in the background of cubism. In their departures from nature the fauves looked to exotic and primitive arts for sanction and inspiration; they were the "discoverers" of African Negro sculpture, the most important of several non-European traditions which were to interest Picasso in the course of his career.

Probably in the autumn of 1906* Picasso met Matisse and, perhaps a little later, Derain and Vlaminck, all of whom took part in a second fauve demonstration at the Autumn Salon of that year. Matisse was then the central figure among the most advanced younger painters. Possibly Picasso had felt Matisse's liberating influence in his drawing but his own rather restrained and archaistic style of late 1906 had little in common with the riotous color and swinging arabesques of the fauves. In any case he did not enter Matisse's cage of "wild beasts." Rather, there seems to have been from the first a certain rivalry between them.* During 1906 Matisse began work on his great canvas the Joie de Vivre, a composition of nudes in a landscape, which, since its exhibition in 1907, has generally been considered the masterpiece of the fauve movement. Picasso may well have considered Matisse's ambitious undertaking a challenge to be answered by some signal effort of his own.

The other significant event at the Autumn Salon of 1905 was a special gallery of ten paintings by Cézanne whose importance had been obscured in the eyes of the young avant-garde by the more easily digestible innovations of Gauguin and van Gogh or by the Neo-Impressionists' plausible science. Ten more Cézannes were shown in 1906, the year he died, and fifty-six at a memorial exhibition in 1907. For four or five years, from about the end of 1906 on, the profound and difficult art of Cézanne exerted an important influence upon Picasso.

PICASSO'S ART: 1905-06

Not explicitly affected by these events, Picasso's own art prior to the end of 1906 had passed, on the plane of sentiment, from the near-bathos of the Blue Period through the gentle melancholy of the saltimbanques and the ingratiating detachment of the "classic" figures to the comparatively impersonal masks of the Gertrude Stein and Self Portrait; and in figure style this change had been paralleled since mid-1905 by a generally increasing sculptural solidity of form. The Two Nudes, illustrated on page 52, painted very late in 1906, is the logical conclusion of these two tendencies. Influenced probably by the heavy proportions of certain late Iberian sculptures, these massive figures seem an emphatic expression of Picasso's denial both of sentiment and of traditional or conventional beauty; positively the Two Nudes is an assertion of his growing interest in objective esthetic problems, in this case the creation of volumes and masses and their composition within the painted space of the picture. It is instructive to turn back to earlier two-figure compositions, the Harlequin's Family (p. 34) and, later, La Toilette (p. 44). The Two Nudes is the end of the series.

In apparent conflict with the general direction of Picasso's art are a few pictures, notably the Composition (p. 49), which show him working on the purely pictorial (non-sculptural) problem of organizing the forms of nature into an all-over design of angular planes resembling somewhat the paintings of El Greco or the late style of Cézanne.

This conflict was soon, though briefly, to be resolved.

LES DEMOISELLES D'AVIGNON: 1907

The resolution and culmination of Picasso's labors of 1906 is concentrated in one extraordinary picture, Les Demoiselles d'Avignon, which was painted for the most part in the spring of 1907 after months of development and revision. Zervos reproduces no less than 17 composition sketches for this canvas.* Of the three studies reproduced on page 56 the earliest suggests that the composition of Les Demoiselles was inspired by Cézanne's late bather pictures in which the figures and background are fused in a kind of relief without much indication either of deep space in the

scene or of weight in the forms.† As the painting developed it is also possible that memories of El Greco's compact figure compositions and the angular highlights of his draperies, rocks and clouds may have confirmed the suggestions drawn from Cézanne.‡

Each of the five figures in the final composition was the subject of considerable study, beginning in several cases in 1906 and continuing in "postscripts" long after the painting was finished. Although their bodies are fairly similar in style the heads of the two right-hand figures differ so much from the others that they will be considered separately.

What happened to Picasso's figure style in the months between the Two Nudes of late 1906 (p. 52) and the painting of Les Demoiselles may be summarized by comparing the left-hand figures in the two canvases—figures which are quite clearly related in pose and gesture.§

Obviously the painter has lost interest in the squat forms, the sculpturesque modeling and the naturalistic curves of the earlier nude. The later figure is drawn mostly with straight lines which form angular overlapping planes and there is scarcely any modeling so that the figure seems flat, almost weightless. The faces of the two figures differ less than their bodies. The mask-like character of the earlier face (p. 52) is carried further in the "demoiselle's" head and the eye is drawn in full view although the face is in profile.

This primitive or archaic convention seems more startling when applied to the noses of the central two figures of the Demoiselles which are drawn in profile upon frontal faces, a device which later became a commonplace of cubism. The faces of the central two "demoiselles" may be compared with that of the transitional Self Portrait (p. 51) in which the stylized features of Iberian sculpture are not yet so exaggerated.

The right half or, more precisely, two-fifths of Les Demoiselles d'Avignon differs in character from the rest of the picture. The light browns, pinks and terra cottas at the left are related to the colors of late 1906, the so-called Rose Period. But, toward the right, grey and then blue predominate with accents of green and orange. The planes too are smaller and sharper and much more active.

The most radical difference between the left and right sides of the painting lies in the heads of the two figures a

opposite: LES DEMOISELLES D'AVIGNON. Paris, 1907. Oil, 96 x 92 inches. The Museum of Modern Art, New York, acquired through the Lillie P. Bliss Bequest.

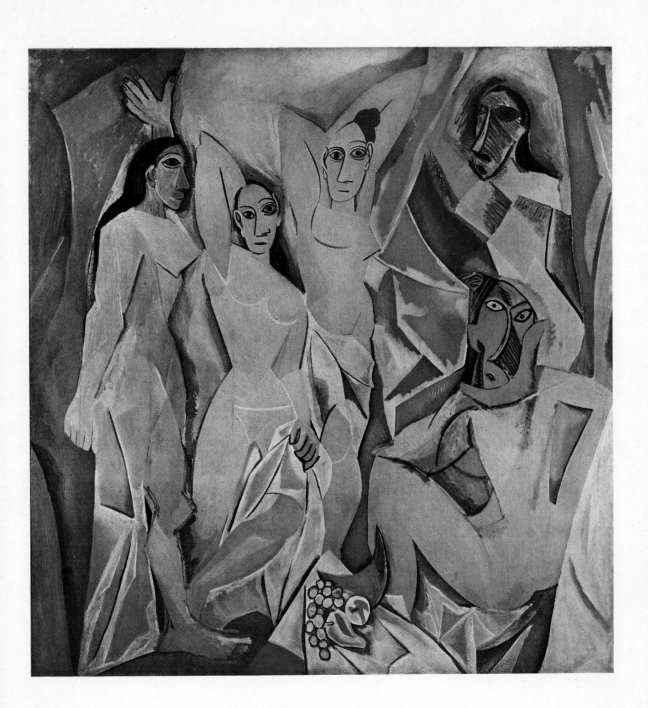

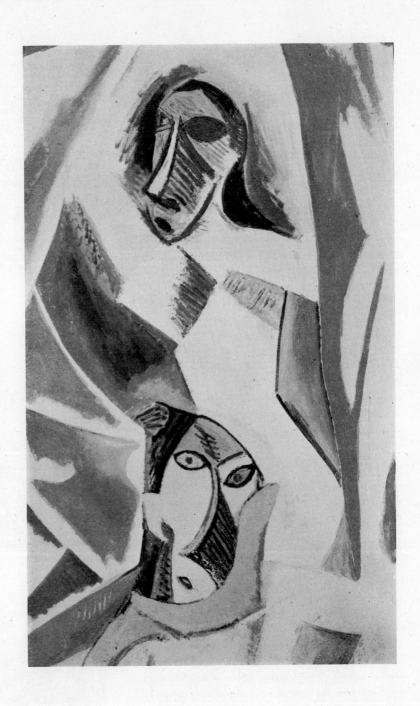

Detail of LES DEMOISELLES D'AVIGNON.

the right. The upper head is no longer flat but foreshortened, with a flat-ridged nose, a sharp chin, a small oval mouth and deleted ears, all characteristic of certain African Negro masks of the French Congo* more than of Iberian sculptures. In the face below the tentative three-dimensional foreshortening of the upper and doubtless earlier head gives way to a flattened mask in which eyes, nose, mouth and ear are distorted or even dislocated. The hand and arm which support this lower head are even more violently distorted. Like their forms, the coloring and hatched shading of these two faces seem inspired in a general way by the masks of the Congo or Ivory Coast, more than by any other source.

Traditionally Les Demoiselles d'Avignon *was indeed supposed to have been influenced by African Negro sculpture but Picasso has since denied this, affirming that although he was much interested in Iberian sculpture he had no knowledge of Negro art while he was at work on Les Demoiselles.* Only later in 1907, he states, did he discover Negro sculpture.*

Quite recently however Picasso has assured us that the two right-hand figures of Les Demoiselles *were completed some time after the rest of the composition.† It seems possible therefore that Picasso's memory is incomplete and that he may well have painted or repainted the astonishing heads of these figures after his discovery of African sculpture, just as only a year before, stimulated by Iberian sculpture, he had repainted the head of Gertrude Stein's portrait months after he had completed the rest of the picture.‡*

Whatever may have been their inspiration, these two heads for sheer expressionist violence and barbaric intensity surpass the most vehement inventions of the fauves. *Indeed the shocking strangeness of the lower mask anticipates the "surrealist" faces in Picasso's paintings of twenty or thirty years later (pages 148, 191).*

IMPORTANCE OF *LES DEMOISELLES D'AVIGNON*

Yet in spite of the interest of these heads and the fame of the vividly painted fruit in the foreground, Les Demoiselles d'Avignon *is more important as a whole than for its remarkable details. Although it was only once publicly exhibited in Europe, and was very rarely reproduced, the picture was seen by other artists in Picasso's studio§ where its early date, originality, size and power gave it a legendary reputation which persisted after it had passed into the collection of Jacques Doucet about 1920.*

Les Demoiselles d'Avignon *may be called the first cubist picture, for the breaking up of natural forms, whether figures, still life or drapery, into a semi-abstract all-over design of tilting shifting planes compressed into a shallow space is already cubism; cubism in a rudimentary stage, it is true, but closer to the developed early cubism of 1909 than are most of the intervening "Negro" works.* Les Demoiselles *is a transitional picture, a laboratory or, better, a battlefield of trial and experiment; but it is also a work of formidable, dynamic power unsurpassed in European art of its time. Together with Matisse's* Joie de Vivre‖ *of the same year it marks the beginning of a new period in the history of modern art.*

56

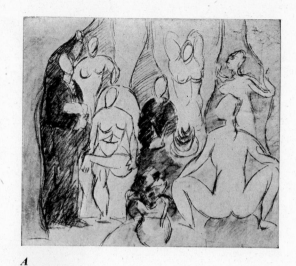

A

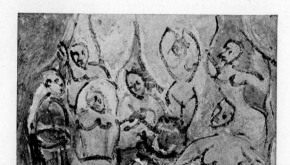

B

C

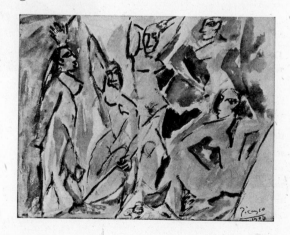

THE COMPOSITION OF *LES DEMOISELLES D'AVIGNON*

To judge from his work it was at Gosol in the summer of 1906 that Picasso first began to plan a large composition of nudes; but none of these early attempts so closely anticipate* Les Demoiselles d'Avignon *as do certain bather groups of Cézanne which in drawing as well as arrangement inspired the earliest composition studies such as the one reproduced opposite (A).*

Picasso explained, in 1939, that the central figure of the early study is a sailor seated and surrounded by nude women, food and flowers. Entering this gay company from the left is a man with a skull in his hand. Picasso originally conceived the picture as a kind of memento mori allegory or charade though probably with no very fervid moral intent. Only the three figures at the right and the melons were retained in the final version.

Though its relation to actuality is remote this study recalls the origin of the painting's rather romantically troubadour title, "Les Demoiselles d'Avignon," which was invented years later by a friend of Picasso's in ironic reference to a cabaret or maison publique *on the Carrer d'Avinyó (Avignon Street) in Barcelona.†*

In a later study (B) the sailor has given place to another nude. The figures are shorter in proportion, the format wider.

In the latest, perhaps final, study (C) with only five instead of seven figures, the man entering at the left in the earlier studies has been changed into a female figure pulling back the curtain. In the painting itself this figure loses her squat proportions in harmony with other figures and the taller narrower format of the big canvas. All implications of a moralistic contrast between virtue (the man with the skull) and vice (the man surrounded by food and women) have been eliminated in favor of a purely formal figure composition, which as it develops becomes more and more dehumanized and abstract.

opposite:

A. Composition study for LES DEMOISELLES D'AVIGNON. 1907 (dated on back). Charcoal and pastel, 18⅞ x 25 inches. Owned by the artist.

B. Composition study for LES DEMOISELLES D'AVIGNON. Paris, 1907. Oil on wood, 7⅜ x 9⅜ inches. Owned by the artist.

C. Composition study for LES DEMOISELLES D'AVIGNON. 1907 (dated). Watercolor, 6¾ x 8¾ inches. Philadelphia Museum of Art, A. E. Gallatin Collection.

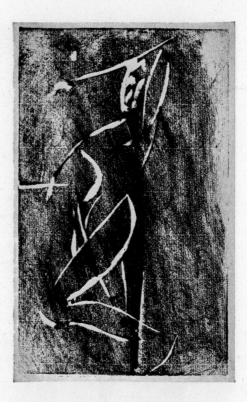

FIGURE TURNED TO THE LEFT. 1907. Woodcut, 8 9/16 x 5⅜ inches (G. 218). Collection Jean Goriany. Geiser states that there is but one proof, yet this is clearly a second proof differing from the one he reproduces and describes as unique. Related to the left central figure of LES DEMOISELLES D'AVIGNON (opp. p. 54). In printing the woodcut the figure was naturally reversed.

POSTSCRIPTS FOR *LES DEMOISELLES*

Such was the concentrated effort spent by Picasso upon each of the figures of Les Demoiselles d'Avignon *that he was not satisfied until he had reworked them, singly or by twos and threes, in pictures painted as much as a year after the great canvas was completed. For instance the figure in the very rare woodcut reproduced above is closely related to the second "demoiselle" from the left.‡ It is one of some dozen variations.*

Years later in 1937, during the months after Picasso had finished the Guernica mural, the momentum of his excitement carried him into a series of variations and postscripts comparable to those which followed in the wake of Les Demoiselles d'Avignon.

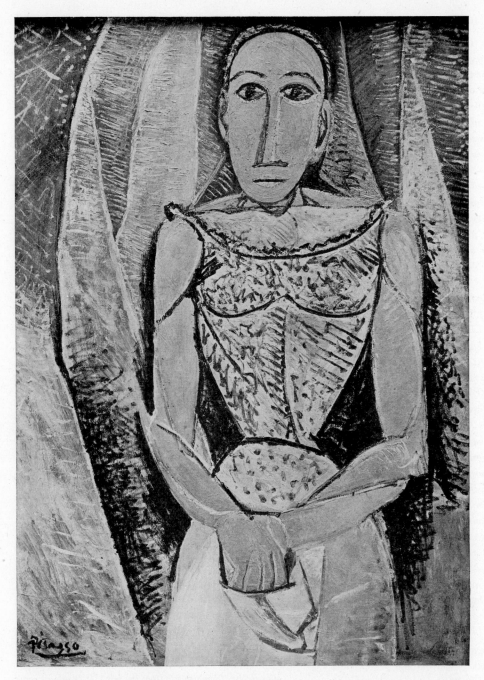

WOMAN IN YELLOW (LE CORSAGE JAUNE). Paris, 1907 (P), summer (Z). Oil, 51¼ x 37⅞ inches.
Collection Mr. and Mrs. Joseph Pulitzer, Jr.

"NEGRO" INFLUENCE

The discovery and appreciation of African Negro sculpture among the artists of Paris in the early 1900's is still a somewhat confused story. It seems probable that as early as 1904 Vlaminck began to take an interest in this hitherto neg-lected art. Shortly afterwards he introduced Derain to his new enthusiasm, and before long Derain and his fellow fauve Matisse began to form collections. Vlaminck's admiration lay more in the romantic and exotic values of the*

masks and fetishes but Derain and Matisse found in them unhackneyed esthetic values involving the bold distortion and structural reorganization of natural forms.

It is strange that Picasso who had met Matisse by 1906 should have been unaware of Negro art until the middle of 1907 when, as he says, he discovered it for himself almost accidentally while leaving the galleries of historic sculpture in the Trocadéro.* However the discovery, he affirms, was a "revelation" to him and he began immediately to make use of it. Whatever general stimulation the fauves had got from African art there is little specific trace of it in their painting. But several of Picasso's works of 1907-08 incorporate African forms and possibly colors to such an extent that the title "Negro Period" has hitherto been applied to his art of this time including Les Demoiselles d'Avignon. Actually Iberian sculpture continued to interest him and often its forms were fused (and by critics confused) with those of the Congo and the Guinea Coast.

For instance the Woman in Yellow (opposite) has long been considered one of the important paintings of Picasso's Negro period but it now seems clear that this hieratically impressive figure is related to Iberian bronzes even more closely than are the three earlier figures of Les Demoiselles d'Avignon which it resembles in style. As Sweeney has pointed out, the face and pose are remarkably similar to an archaic votive figure from Despeñaperros (repro. bibl. 463, fig. 14). The ochre color and striated patterns however may have been suggested by Negro art. More African in form is the Head (right) which may have been inspired by the almond-shaped masks of the Ivory Coast or French Congo.

In style, if not actually in time, both the pictures here reproduced seem to fall somewhere between the earlier figures of Les Demoiselles and the barbaric masks of the later figures at the right of that canvas. Zervos dates the Woman in Yellow in the summer of 1907.

HENRI ROUSSEAU AND PICASSO

In the Autumn Salon of 1905, along with the fauves and the ten Cézannes, were exhibited three paintings by Henri Rousseau, including a huge jungle picture. Rousseau had had a modest reputation in the 1890's but it was the Picasso-Apollinaire group which from about 1906 on spread his fame, both as a naive character and as an artist. In 1908 Picasso bought a large portrait of a woman by Rousseau from Soulier, the junk dealer, for a few francs† and thereupon honored the douanier with a banquet, possibly the most celebrated in the history of French art.‡ Among Picasso's guests were the writers Apollinaire, Jacob, Sal-

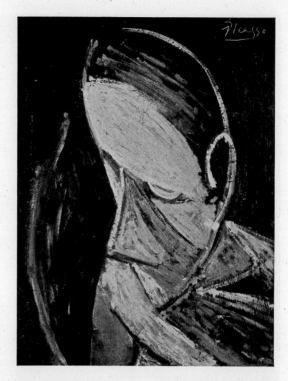

HEAD (FEMME AU NEZ EN QUART DE BRIE). 1907 (Z); dated on stretcher October, 1905, but the style is obviously of two years later. Oil, 13⅞ x 10¾ inches. Collection E. L. T. Mesens.

mon, Warnod and Raynal, the painters Braque and Marie Laurencin, the collectors Leo and Gertrude Stein.

Rousseau's influence on Picasso during these years is not explicit except perhaps in some landscapes done at La Rue des Bois in the summer of 1908. Rousseau's intuitive mastery of formal essentials; the directness of his pictorial imagination which led him to abstract and invent (even when he supposed himself to be painting realistically); the resulting revelation that out of a living Parisian might come paintings of primitive clarity and naive conviction: these factors may have confirmed Picasso in the direction his own art was taking at the time. Thirty years later Rousseau's influence was possibly more direct (pp. 212, 216).

Rousseau once remarked to Picasso: "We are the two greatest painters of our epoch, you in the Egyptian style, I in the modern style." Perhaps he had in mind Picasso's Demoiselles d'Avignon or his Woman in Yellow which however is scarcely more "Egyptian" than the rigidly frontal figure by Rousseau that Picasso bought from Soulier.

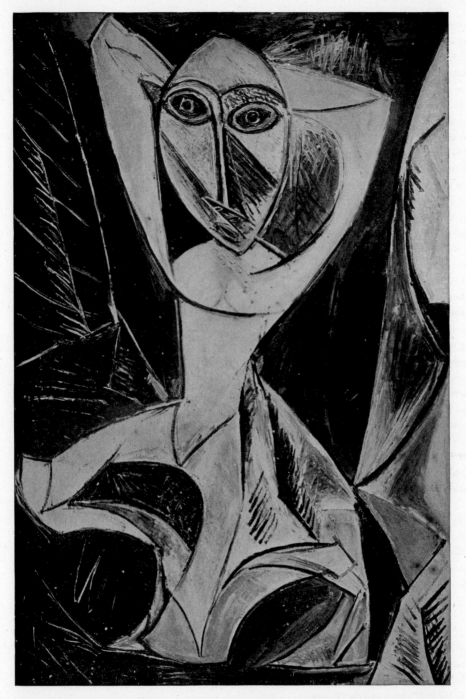

DANCER. Paris, 1907 (P), summer (Z). Oil, 59 x 39¼ inches. Collection Walter P. Chrysler, Jr.

The Dancer is of the same bizarre family as the later "demoiselles." The oval mask, pointed at forehead and chin, seems African and the bow-legged stance was apparently inspired by the metal-covered grave figures of the Gabun in French Congo. The angular interplay of figure, background and silk curtain are reminiscent of* Les Demoiselles *but the color is no longer the blue and tan of Cézanne. Instead the ochres, browns and blacks suggest an African origin, with earth green added.*

The Dancer, recklessly distorted, dramatic in movement and decorative in color is the masterpiece of a brief barbaric phase

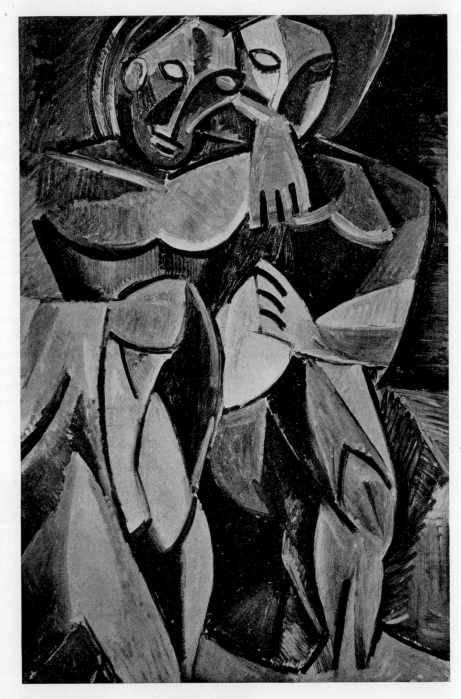

FRIENDSHIP. Paris, spring 1908 (K). Oil, 59¾ x 39¾ inches. Museum of Modern Western Art, Moscow.

of the Negro period. It was followed shortly by sombre studies in form, sculptural and monochromatic, which were to lead during 1908 into the first period of Cubism. Friendship already seems more three dimensional than the Dancer.

By the end of 1907 Picasso had passed through the barbaric phase of his "Negro" period. Though there are traces of both Negro and Iberian sculpture in many works of 1908, Picasso no longer depends explicitly on either. It would be better to call the paintings of this period "proto-cubist" rather than "Negro" as has been customary.

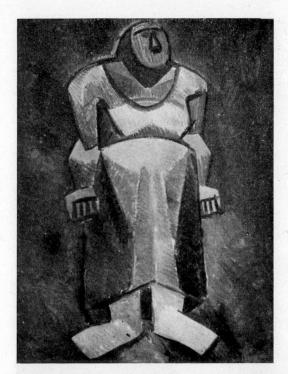

PEASANT WOMAN. La Rue des Bois, autumn 1908 (Z). Oil, 32¼ x 25⅝ inches. Museum of Modern Western Art, Moscow.

SCULPTURAL MONOCHROME

During the greater part of 1908 the sculptural grows stronger than the pictorial, and decorative color gives way to an all-over brownish red, perhaps as a reaction against the excess of bright color and flat pattern which had characterized the art of Matisse and the fauves as well as Picasso's own painting during much of 1907.*

Once before, in 1906, these conflicting interests had produced on the one hand, the sculptural, monochromatic Two Nudes *(p. 52) and, on the other, the pictorial, Grecoesque* Composition *(p. 49). The conflict was resolved, almost by sheer force, in* Les Demoiselles d'Avignon *only to reappear again a year later in the active, all-over design of* Friendship *(previous page) which was succeeded by the ponderous, static, sculptural forms of the* Peasant Woman *(left) and* Head *(opposite). A dozen years later in the early 1920's a similar contrast appears again, and to a dramatically exaggerated degree, in the monochromatic giantesses (p. 116) as against such flat, decorative figure paintings as the* Three Musicians *(pages 122, 123).*

The Landscape with Figures *like many other works of 1908 is a translation of natural forms into blocks of angular planes. The formal symmetry of this composition, the relation of figures to landscape is obviously classic in tra-*

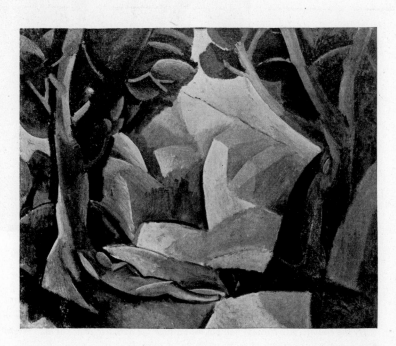

LANDSCAPE WITH FIGURES. Paris, 1908, autumn (K) or summer (Z). Oil, 23⅝ x 28¾ inches. Owned by the artist.

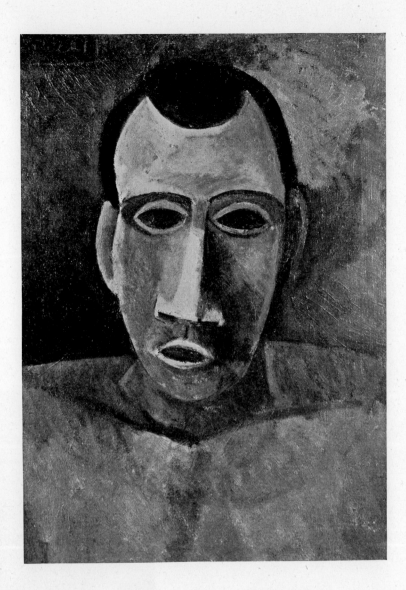

HEAD. 1908, summer (K) or autumn (Z). Oil, 24½ x 17 inches. Collection Walter P. Chrysler, Jr.

dition—Poussin, perhaps, reduced to rudimentary essentials with Cézanne's guidance. However the form, color and technique are so simple that they suggest a kind of tinted low relief rather than the complex, subtle color-plane method of Cézanne. Perhaps it was not Cézanne's art that influenced this picture so much as his famous maxim written to Emile Bernard and published just the year before: "You must see in nature the cylinder, the sphere, the cone." The Landscape with Figures is the most rudimentary form of cubism, and one of the earliest.

In fact the word cubism was inspired by some very similar landscapes painted about the same time by Georges Braque near Estaque in a more pious discipleship of Cézanne. They had been rejected at the Autumn Salon of 1908 where, the story goes, Matisse, surprised at the new style of his former disciple, made remarks about "les petits cubes." The critic Louis Vauxcelles first repeated Matisse's word "cubes" in his review of Braque's rejected pictures when they were shown at Kahnweiler's in November. Gradually the words "cubism" and "cubist" gained currency* and were officially adopted for the movement by Guillaume Apollinaire in 1911. It was through Apollinaire that Braque had met Picasso in 1907. During 1908 they became fast friends, and later worked so closely that at times their paintings are indistinguishable. Together they created cubism and were its greatest masters.

63

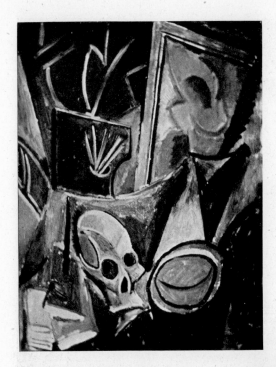

COMPOSITION WITH A SKULL. Paris, autumn 1907 (Z). Oil, 45¼ x 34⅝ inches. Museum of Modern Western Art, Moscow.

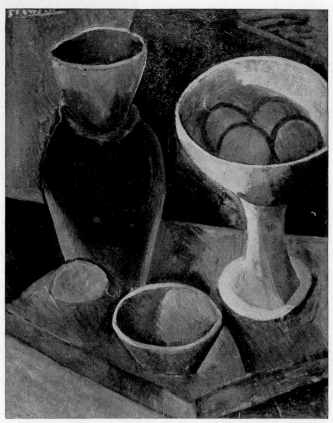

BOWLS AND JUG. Paris, summer 1908 (K and Z). Oil, 32 x 25½ inches. Philadelphia Museum of Art, A. E. Gallatin Collection.

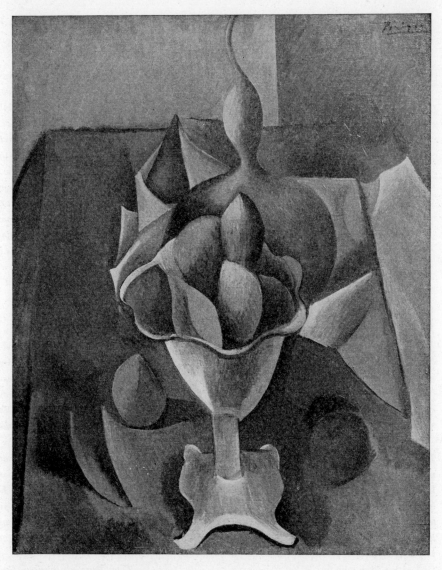

FRUIT DISH. Spring 1909 (K); Paris, winter 1908 (Z). Oil, 29¼ x 24 inches. Museum of Modern Art, New York, acquired through the Lillie P. Bliss Bequest.

The progress of Picasso's art during the proto-cubist period may be summarized in these three still lifes. The Composition *done late in 1907 is contemporary with the* Dancer *(p. 60) and shares its flat angular patterns and varied color. In* Bowls and Jug *of mid 1908 the pendulum swings to a powerful, sculpturesque rendering of forms in relief, simply and soberly painted in reddish brown (similar to the* Peasant Woman, *p. 62 and the* Head, *p. 63). But by winter of 1908-09 the artist has resumed his progress toward cubism, a progress already well advanced in the* Demoiselles d'Avignon *but retarded or reconsidered during much of 1908. The* Fruit Dish, *painted in greenish and ochre-grey tones, is more complex in form than the* Bowls and Jug *of six months before: perspective, foreshortening and modeling are abbreviated so that suggestions of space and weight are diminished. There is much of Cézanne in the crumpled napkin and the placing of the objects—and the tilted table top of his late still-life style is recalled and exaggerated.*

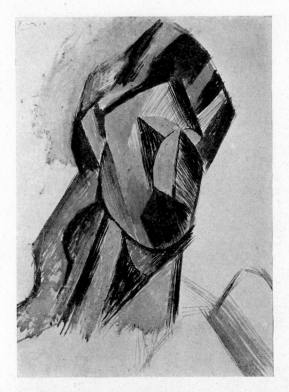

HEAD. Paris, spring 1909 (Z). Gouache, 24 x 18 inches. Museum of Modern Art, New York, gift of Mrs. Saidie A. May.

This drastically simplified head of early 1909 is blocked in with large planes of light and dark much in the style of the Landscape with Figures (p. 62). The bold elision which includes the far side of the nose and cheek in one plane extending to the right beyond the receding curve of the brow is the beginning of the kind of dislocation which appears in a clearer and more developed form in the far cheek of the Girl with a Mandolin (p. 70).

There is something tentative and awkward about many of the figure paintings of early 1909. In the Woman with a Book* the deformations of head and figure are more advanced than in the gouache above but they lack style and conviction, especially in the rather amorphous drawing of the torso. Actually the lower right-hand figure of the Demoiselles d'Avignon painted two years before is more radically distorted, the Friendship of a year before more abstract in general effect (p. 61). The two years from his completion of the Demoiselles d'Avignon late in the spring of 1907 to his departure for Horta de Ebro early in the summer of 1909 were for Picasso a time of exploration in which there was much trial and perhaps some error.

At Horta Picasso's style seemed suddenly to crystallize, literally and visually as well as metaphorically (see p. 68). The new style, or better, method has been called "analytical cubism." Analytical cubism developed for several years and then changed gradually into "synthetic" cubism, the watershed between the two occurring about 1912. Like most terms applied to the visual arts, "analytical" is not very exact yet it does describe in a general way the cubist process of taking apart or breaking down the forms of nature. "Analytical" also conveys something of the spirit of investigation and dissection of form carried on by Picasso and Braque almost as if their studios were laboratories. Not that their analyses were scientific or mathematical. In spite of its "geometrical" style and certain analogies to space-time physics, cubism, like all painting worthy of the name of art, was a matter primarily of sensibility, not science. Some conversations with their bohemian friend, the actuary Princet,† who lived in the same tenement house as Picasso, possibly encouraged their geometrizing but Princet's talk probably influenced Apollinaire's criticism of cubism more than it affected cubism itself.

Though Picasso calls analogies between mathematics and cubism nonsense, nevertheless they have often been drawn or implied and may be briefly summarized. First there is the mensurational character of most cubist drawing, the precise definition of distances or dimensions which Picasso put into words when he remarked to Kahnweiler "In a painting of Raphael's you can't measure the exact distance from the tip of the nose to the mouth. I want to paint pictures in which this would be possible." (Bibl. 240, p. 20.)

Then there are obvious formal resemblances between plane geometrical figures—rectangles, or segments of circles and spirals—and some of the shapes in cubist pictures (pages 72, 80, 92, 105). Both cubism and the artistic value of such shapes have often been rather speciously defended by reference to a passage in Plato's Philebus in which Socrates praises the intrinsic beauty of geometrical figures.‡

Forms which approximate those of solid geometry appear in Picasso's analytical cubism (pages 68, 70, 86 above). Although Cézanne's exhortation to perceive geometrical solids beneath the confusion of natural appearances influenced the cubists, it is curious that the Master of Aix cites the cylinder, sphere, and cone but not the prism

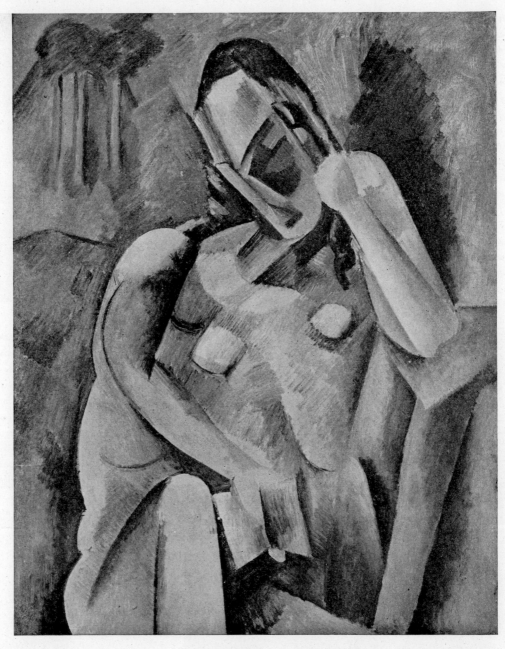

WOMAN WITH A BOOK. Paris, early summer 1909 (Z). Oil, 36¼ x 28½ inches. Collection Walter P. Chrysler, Jr.

with its edges and angles, or the cube from which cubism derives its name.

Reports of Picasso's dependence upon some system of geometrical design such as "dynamic symmetry," or root rectangles, or the "golden section" are scarcely proven by the internal evidence of his work though a sketch-book of drawings of 1915 shows that he did play with ruler and compass in certain cubist compositions of that period.*

Post-Euclidean geometry in the form of popular explanations of the time-space continuum and the fourth dimen-

sion may have encouraged Picasso. Logical explanations of cubism often involve the idea of simultaneity of point of view to account for the "impossible" combination of several profiles and sections of a single face or figure in the same picture (pages 72, 132). A cubist head, which in this way suggests the fusion of temporal and spatial factors, might indeed serve as a crude illustration of relativity. However, the analysis of time, that is, of movement, in painting was much more elaborately developed by the Futurists. Apollinaire, who as early as 1913 invoked the fourth dimension in his book on cubism, uses the term in a metaphorical rather than a mathematical sense (bibl. 20, p. 15-17).

*Joachim Weyl has suggested that cubism has more in common with early 17th century geometry culminating in Descartes. In Cartesian space "all points are the possible locations for an observer" rather than the single point of observation customary in post-medieval-pre-cubist painting.**

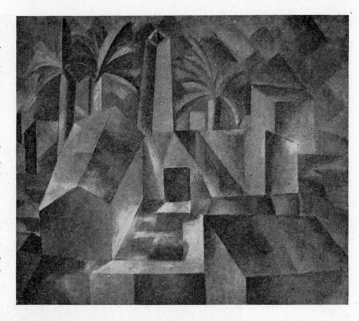

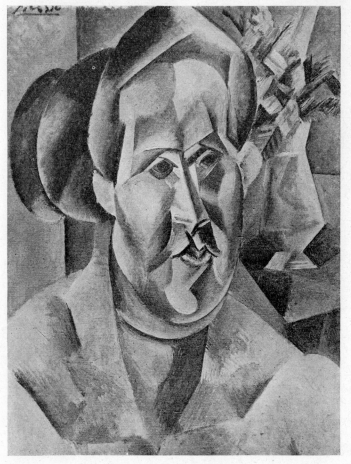

Though they were the most radical, the cubists were not the first painter analysts. The Impressionists thirty years before had made a haphazard analysis of the visual world in terms of light and color until they turned the solids and volumes of reality into evanescent, impalpable veils of pigment. Seurat's subsequent analysis of color and form was more scientific and systematic. Cézanne, passing through impressionism, tried to recover a sense of volume by analyzing appearances so that he could paint the essential, constructive planes of color. In analytical cubism Picasso and Braque abandoned color and began, almost where Cézanne had left off, to analyze, to disintegrate the forms of nature in order to create out of the fragments a new form.

above: FACTORY AT HORTA. Horta de Ebro, summer 1909 (Z). Oil, 20⅞ x 23⅝ inches. Museum of Modern Western Art, Moscow.

FERNANDE. Horta de Ebro, summer 1909. Oil, 24¼ x 16¾ inches. Museum of Modern Art, New York, extended loan from Henry Church.

HORTA DE EBRO: summer 1909

The half-dozen landscapes Picasso painted at Horta still owe much to Cézanne though Cézanne never geometrized so resolutely throughout the picture as Picasso does in the Factory. At the same time, it is possible that the blocky landscape, or rather buildings, of Horta affected even Picasso's figure painting by renewing his interest in geometric forms which for a time had lapsed somewhat in such paintings as the Woman with a Book (p. 67).*

In any case there is a much more consistent "geometrizing" in the Fernande, one of the earliest of a long series of heads and figures painted at Horta. The curved surfaces of head and shoulders are broken into sharply defined dark and light planes. Especially on the face these planes become sharp-edged facets like those of a crystal or cut diamond. By reducing the table, vase and flowers to angular shapes he brings the background into stylistic harmony with the head. The effect is at this stage less radical than the bolder deformations of the Head (p. 66) or Woman with a Book, but there is in the Fernande a new sense of style, of assured method.

If there is still something sculptural about the Fernande there is much that is painterly about the bronze Woman's

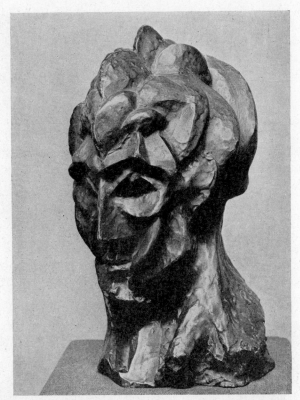

Head *done a little later. It shows in three dimensions how Picasso breaks up the surface into sharp ridges without, at this stage of cubism, losing the fundamental shape of the natural form of the head.*

But in the Portrait of Braque, painted toward the end of the year, not only the surface is broken into facets but the facets themselves begin to slip so that the sense of solid sculptural form so clearly preserved in the Fernande seems on the point of disintegration. For the first time the integrity, the unity, of the object is seriously threatened. The really radical character of cubism begins to appear.

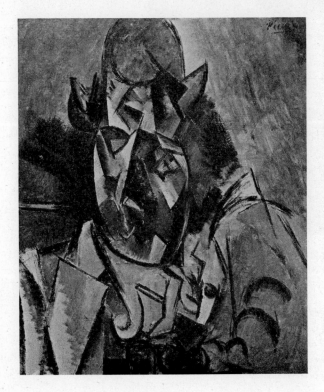

above: WOMAN'S HEAD. 1909. Bronze, 16¼ inches high. Museum of Modern Art, New York.

PORTRAIT OF BRAQUE. Paris, late 1909 (K). Oil, 24¼ x 19¾ inches. Collection Edward A. Bragaline.

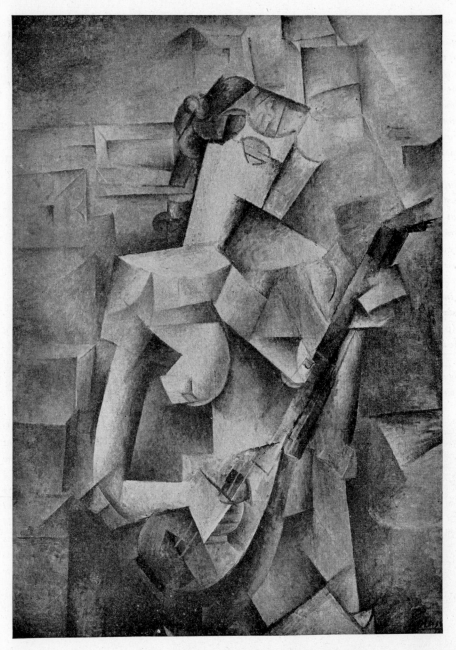

GIRL WITH A MANDOLIN (Fanny Tellier*). 1910 (dated); Paris, late (Z) but seems early 1910 in style. Oil, 39½ x 29 inches. Collection Roland Penrose.

In the Girl with a Mandolin *early cubism is summarized and mature cubism announced. Sculptural roundness is still suggested in the modeling of neck, breast and arms, and even by cast shadows, but all natural forms are reduced to semigeometrical shapes which are then often broken, dislocated or, as in the head, flattened out into rectangles or circle segments. This flattening is applied not only to some of the details but also to the whole space so that the figure seems reduced to a fragmented low relief against a background of flat or block-shaped rectangles.*

70

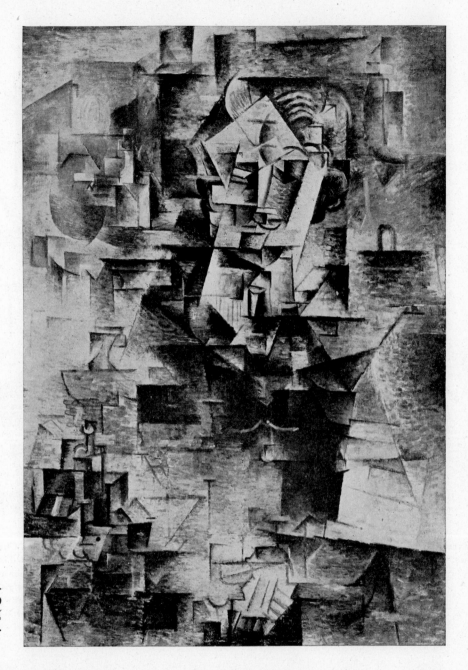

PORTRAIT OF KAHN-
WEILER. Autumn 1910
(K). Oil, 39¼ x 28¼
inches. Collection Mrs.
Charles B. Goodspeed.

The Girl with a Mandolin, though transitional in style, is one of the masterpieces of cubism, a work which aroused intense controversy when it was first exhibited but which now, paradoxically, seems to exert a gentle charm in spite of its radical deformations. Picasso painted a number of cubist portraits during 1910—Vollard, Wilhelm Uhde, the German critic, who paid him with a little Corot figure painting, and his dealer Henry Kahnweiler, one of the staunch champions and the soundest historian of cubism.†*

In the Kahnweiler portrait, done in the fall of 1910, Picasso used a more methodical and complex system of disintegration than in the Braque portrait or the Girl with a Mandolin. There is also a subtle equilibrium between the planes which seem suspended in front of the canvas and those which recede behind it.

71

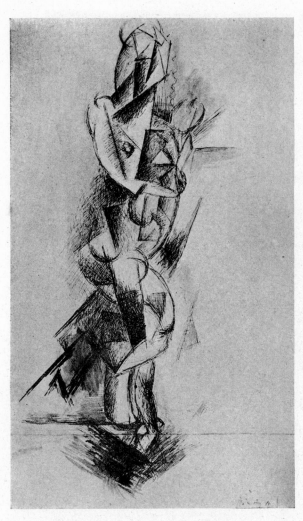

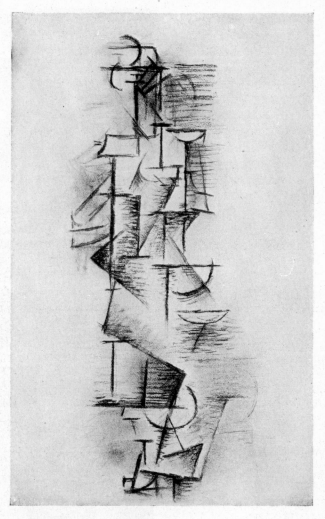

FEMALE NUDE. Spring 1910 (Z). Ink and water color, 29⅛ x 18⅜ inches. Collection Pierre Loeb. Repro. from Zervos, bibl. 524.

NUDE. Paris, spring 1910 (Z). Charcoal, 19 x 12¼ inches. Collection Alfred Stieglitz. Included in a retrospective exhibition of 83 Picasso drawings and etchings at Mr. Stieglitz' gallery "291," April 1911, the first one-man Picasso show in America (see list of exhibitions of Picasso's work, page 278) and probably the first time Picasso was exhibited in any way in this country.

The gradual patient analytical modulations which began with the Horta landscapes and the Fernande in mid-1909 Picasso carried forward during 1910 to such a degree of abstraction that the original object is scarcely recognizable or even identifiable unless one is familiar with the preceding evolutionary series. The earlier drawing of a nude at the left is perhaps one step beyond the Girl with a Mandolin, two steps beyond the Braque, three beyond the Fernande. The figure is still fairly legible, its lines reduced to straight edges and simple curves. There is still a suggestion of the third dimension, achieved by vestigial modeling in the round.

The right-hand drawing was done somewhat later, in the spring of 1910. In it all lines are straight or segments of circles. And many of the straight lines, unlike those in the earlier drawing, are schematically vertical or horizontal. There is little

trace of modeling—volumes are flattened into planes—but some of the planes are graded in tone so that they seem to tilt a little forward or back. And some of the planes defined by an angle are open on the opposite side so that they merge into others—a device derived from Cézanne and called passage. Other overlapping planes seem transparent.

In terms of the subject the effect might be compared to a geometrized anatomical chart in which transparent cross sections of the body are superimposed on the silhouette. Indeed Apollinaire, the chief defender of cubism, wrote in 1913 of Picasso's "assassinating" anatomy "with the science and technique of a great surgeon." (Bibl. 20, p. 37.)

Picasso spent the summer of 1910 with Derain at the little Catalan coastal village of Cadaqués. There, in canvases many of which he left unfinished, he brought cubism nearer than ever to an art of abstract design. The tall painting, Nude, at the right, carries further the direction indicated by the two drawings opposite. In the Nude there is little sense of a continuous volume or contour or silhouette. The form is no longer enclosed but is broken and open. There is a subtle balance of teetering horizontals cut by repeated diagonals; a play of light and dark tones of grey and tan hatched in with oblong brush strokes; a slight lifting, overlapping and subsiding of planes, like shingles lying upon rippling water.

A year after it was made the drawing (p. 72, right) was shown in New York where it was nicknamed the "fire-escape." It does in fact suggest a construction or perhaps more accurately, plan, elevations, and sections of one structure combined in the same drawing. Writing a dozen years later Jean Cocteau uses a second structural analogy to illumine analytical cubism. He likens the original subject matter—a woman or a bottle—to a scaffolding. Picasso, the cubist, removes this superficial scaffolding of apparent reality in order to reveal the essential though quite different structure beneath (bibl. 106, p. 227).

The patch with the realistic eye in the 1913 etching (p. 89) serves to confirm Cocteau's simile. But the synthetic cubist drawing of a seated man (p. 94) suggests that from 1910 on cubist structure is itself a scaffolding built around the natural form which in this unique example is actually though faintly indicated. Thus Picasso's own work seems to confirm both "skeleton" and "scaffolding" similes for cubism.

NUDE (Z). Cadaqués, summer 1910 (Z). Oil, 73⅝ x 24 inches. Collection Mrs. Meric Callery.

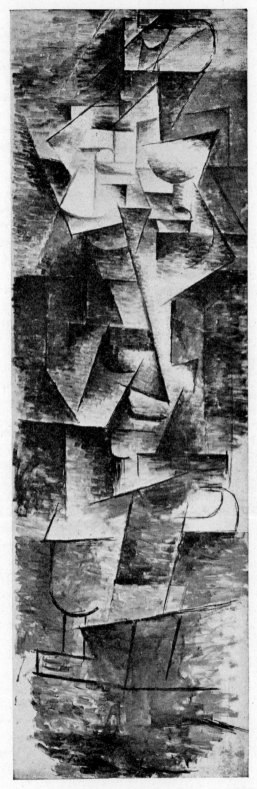

PICASSO AND CUBIST THEORY

Probably few styles or methods in art have provoked more elaborate theories and analogies than has cubism. Cubist works have been likened to structural steel, broken mirrors, Gothic architecture, post-Euclidean geometry, and the drawings of sufferers from dementia praecox and schizophrenia; it has been praised—and used—as an academic discipline and damned for its chaotic license; dynamic symmetry and the fourth dimension have been involved to help explain it; it has been called both a return to classic traditions and a consequence of reckless revolution; a supreme assertion of the independence and purity of art and a hoax produced by the collusion of painters and writers.

Such explanations and analogies may have a certain value as metaphor. Sometimes Picasso seems amused by them, sometimes he is exasperated, as when he said, in 1923: "Mathematics, trigonometry, chemistry, psychoanalysis, music, and whatnot, have been related to cubism to give it an easier interpretation. All this has been pure literature, not to say nonsense, which brought bad results, blinding people with theories" (p. 271).

Elsewhere Picasso has made clear that cubism was not for him a program or a movement (p. 273). He dislikes the terms "research" and "evolution" applied to his art and rejects the theory that cubism is a "transitional" style (pages 270-71). He insists that cubism does not differ from other schools of painting and shrugs his shoulders over its unintelligibility (p. 270): it is not his fault if we do not understand cubism. He himself does not understand English but "why should I blame anybody but myself if I cannot understand what I know nothing about" (p. 271).

Picasso suggests here that cubism is a language. But it is not a language for the ordinary communication of ideas or information or the ordinary human emotions. Rather it is a language peculiar to art—"an art," as Picasso puts it, "dealing primarily with forms" (p. 271).

INFLUENCE ON PRACTICAL DESIGN

The purely formal language of analytical cubism at this stage is simple; yet its laconic phrases were strong enough, intense enough to influence, perhaps even to generate the style of the visual arts in the Western world during the ensuing twenty years. Picasso, of course, had no interest in the arts of practical design but Piet Mondrian, who came to Paris in 1910, within ten years transformed Picasso's analytical cubism into a method of design in asymmetric rectangles which influenced architects, typographers and others during the 1920's and to some extent ever*

since (bibl. 313, pp. 140-158). Yet, looking back over the achievements of the thousands of artists and designers who have been affected by analytical cubism—painters, sculptors, architects and the rest—it is hard to find any work superior in quality to the series of canvases and drawings produced by Picasso and Braque during 1910, '11 and '12.

VESTIGES OF REALITY

Some of the painters who followed, Malevich and Mondrian for instance, were more abstract. They carried cubism to the logical goal of absolute purity by an art which dealt exclusively with forms. But this purification, however courageous, was also an impoverishment. For although cubism seemed to Picasso in 1923 to be primarily an art of form, it was secondarily an art of representation. It was never purely abstract. Always there were vestiges of "nature," whether a landscape, a figure or a still life. And these vestiges however slight remained essentially important for they revealed the point of departure, the degree of transformation undergone by the original image; they supplied the tense cord which anchored the picture to common reality yet gave the measure of its daring distance. In this sense a cubist picture is not only a design but a precisely controlled and far-fetched metaphor.

In spite of several fairly clear vestiges of reality the Accordionist, opposite, was for years thought to be a landscape by one of its former owners, perhaps because Picasso had written "Céret" on the back of the canvas. Yet if one is only slightly familiar with the vocabulary of cubism at this stage one can make out the general outlines of a seated figure facing front, the head tilted, the hair parted in the middle, the semicircles of the shoulders, the angle of arm and elbow leading (just below the center) to fingers and keys and, farther down below at the left and right the spiral volutes of the chair arms. But even by the expert many of the lines and shapes cannot be precisely identified. The puzzle can never be entirely solved. The mysterious tension between the painted image and "reality" remains.

Picasso of course was well aware that such paintings as the Accordionist are baffling at first, seem in fact to be an offense against common sense, that is, against common experience and prejudice. For this he has never apologized though he used to repeat a remark of his old friend Manolo who was living at Céret where Picasso and Braque spent the summer of 1911 during which the Accordionist was painted: "What would you say, Picasso, if your parents were to come to fetch you in the station at Barcelona and found you with such a fright?" (Bibl. 240, p. 29.)

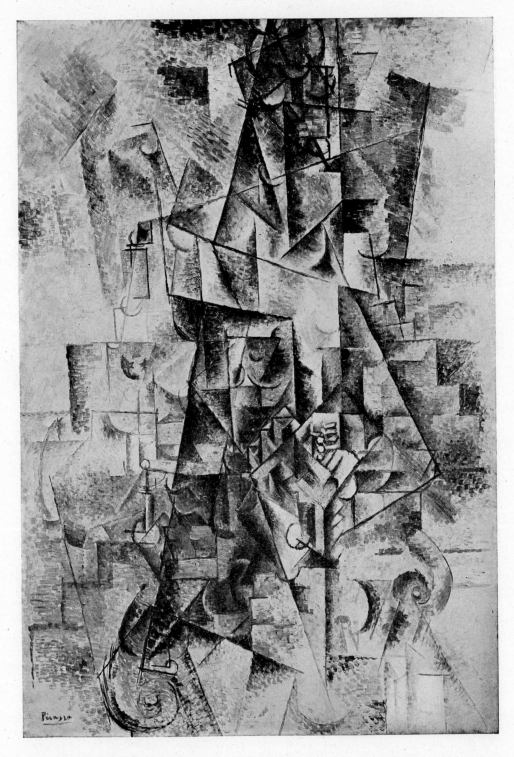

ACCORDIONIST. Céret, summer 1911 (K). Oil, 51¼ x 35⅛ inches. Museum of Non-Objective Paintings, New York.

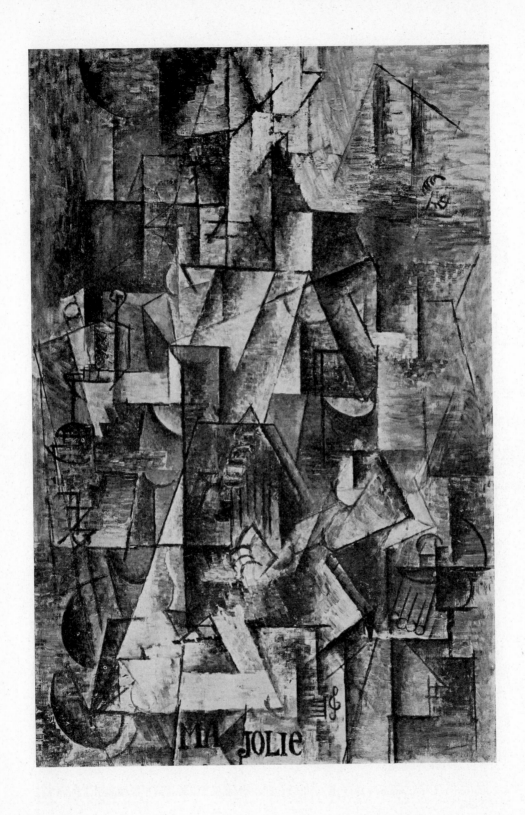

"MA JOLIE." (WOMAN WITH A GUITAR) Paris, 1911-12 (early 1911-Z). Oil, 39⅜ x 25¾ inches. Museum of Modern Art, New York.

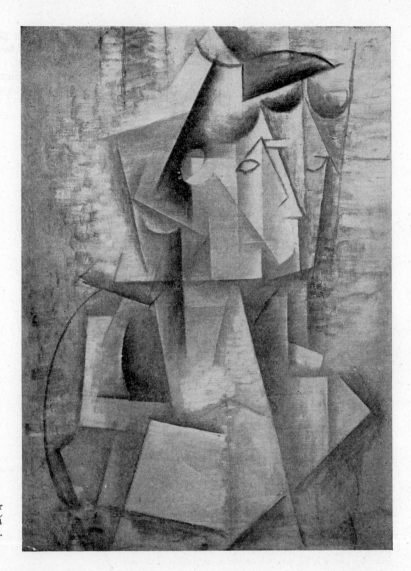

L'ARLÉSIENNE. Sorgues, summer 1912 (K); spring 1911 (Z). Oil, 28¾ x 21¼ inches. Collection Walter P. Chrysler, Jr.

In his paintings of 1912, Picasso generally used somewhat larger, flatter and less broken forms than during the three previous years. The Arlésienne is exceptionally pure in style, its sparse, clean-edged, transparent planes adumbrating the figure with confidence and clarity. Here in the combined profile and full face may clearly be seen "simultaneity"—showing two views of an object at the same time, that is, in the same picture. Simultaneity was first used by Picasso in the heads of the Demoiselles d'Avignon—profile nose on full face—and appears again and again throughout his cubist and post-cubist work, down to the "double face" portraits of today.

The sobriety and structural strength of "Ma Jolie" (opposite) and the tendency to integrate the entire area of the canvas into the design, characterize Picasso's best paintings of 1911 and 1912. Letters—often titles of newspapers or, perhaps, as in "Ma Jolie," the name of a popular song—begin to appear fairly frequently in the otherwise highly abstract compositions of this period.

Since the green and terra cotta tones had faded from his palette at Horta during 1909, Picasso had used almost no positive color in the tan or dun grey of his cubist canvases. This is still true of the Arlésienne which, according to Kahnweiler, was painted at Sorgues in the mountains of south central France where Picasso spent his summer vacation in 1912. However, other canvases done at Sorgues reveal a tentative return to color which within two or three years was to overwhelm the ascetic monochrome of "high" cubism.

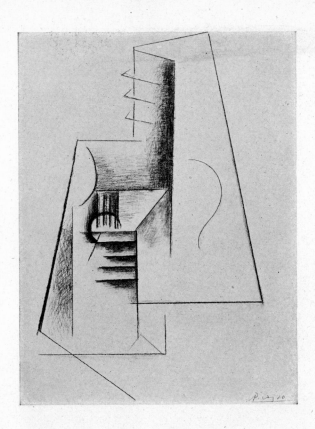

GUITAR. 1912 (P); 1911-12 (Z). Charcoal, 24⅜ x 18⅜ inches. Collection Richard Rosenwald.

below: STILL LIFE. 1912. Drypoint, 19⅝ x 12⅛ inches (G. 33b). Buchholz Gallery, New York.

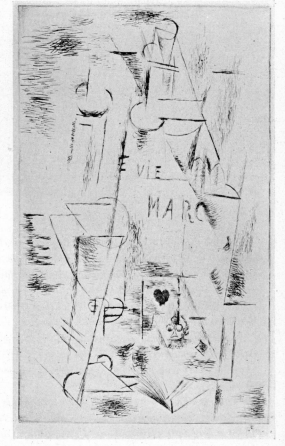

The drawing of a guitar (above) is a lucid and elegant example of the final classic stage of analytical cubism. The curving lines of the guitar are abruptly straightened (cubism is primarily rectilinear in style), but two curves are left as vestiges; three parallel check marks at the top indicate the frets; left center is the sound hole and a suggestion of the vertical strings.

TROMPE L'OEIL AND COLLAGE

The restless Picasso and the inventive Braque were not long satisfied with such austerity. Having almost completely abstracted painting from "reality" (or vice versa) they had begun as early as 1910—Braque taking the lead—to introduce facsimiles of reality into their pictures by carefully painting in head-line size letters or imitation wood grain or nails that looked real. Finally they brought in "reality" itself by pasting odds and ends of paper or other flat surfaces into their compositions. These fragments served not only as accents of color or light or form but as magic accents of common reality in a painting otherwise highly unrealistic in style.

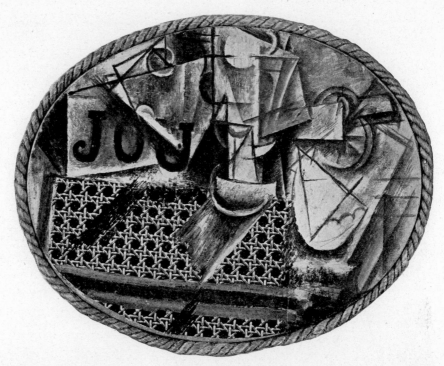

STILL LIFE WITH CHAIR CANING. Paris, winter 1911-12 (Z). Oil and pasted oilcloth simulating chair caning, oval 10⅝ x 13¾ inches. Owned by the artist who suggests that this may be dated 1911 and is his first collage.

ANALYTICAL CUBISM ENRICHED—OR ADULTERATED

In the same winter that Picasso drew the guitar with such fastidious purity of style, he painted—and pasted—the reck-lessly adulterated Still Life with Chair Caning. *The goblet and the sliced lemon are "analyzed" into fragments but the letters J O U of* Journal *are left, black, bold and intact and the pipestem (over the U) seems to stick right out of the picture. Far more radical is the section of chair caning which is neither real nor painted but is actually a piece of oilcoth facsimile pasted on the canvas and then partly painted over. Here then, in one picture, Picasso juggles reality and abstraction in two media and at four different levels or ratios. If we stop to think which is the most "real" we find ourselves moving from esthetic to meta-physical speculation. For here what seems most real is most false and what seems most remote from everyday reality is per-haps the most real since it is least an imitation.*

Yet however disparate these two media and several kinds or degrees of realism may appear they are held together, if not entirely harmonized, by various means, physical, optical, psychological. First, in space: laterally they are compressed within the oval; in depth they are virtually on the same plane. The optical or apparent depth is slight; some of the forms seeming to spring in front of the canvas or picture plane, others to recede a little behind it, as if it were a plaque sculptured partly in low relief, partly in intaglio. Apparent space is thus precisely controlled and compressed though traditional laws of pictorial perspective are ignored. The oilcloth with its sharp-focused, facsimile detail and its surface apparently so rough yet actually so smooth, is partly absorbed into both the painted surface and the painted forms by letting both overlap it. Similarly the eye-fooling pipestem disappears into an abstract cubist passage; and the word Journal *which starts out so securely as painted letters on painted paper begins to slip off into space by the time it reaches the U, is partly eclipsed by the pipestem, and dies obscurely in the shadow of the cubist goblet.*

Through psychological associations the painting also gains a certain unity, for the objects in it are all closely associated in actuality: the newspaper, the lemon, the wine glass, the facsimile chair caning (whether thought of as seat or wall covering) are the natural ingredients of a café still life.

79

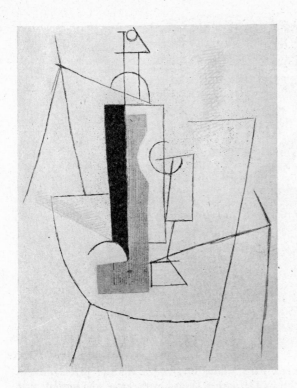

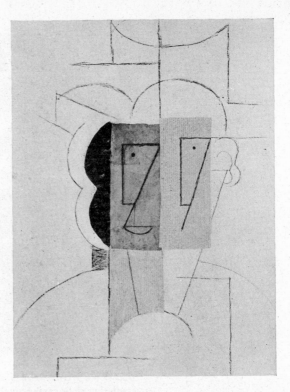

above: STILL LIFE. Paris, winter 1912-13 (Z). Pasted paper and charcoal, 24¼ x 18½ inches. Collection Alfred Stieglitz. First exhibited in America at Gallery "291," 1915.

right: MAN WITH A HAT. Paris, early 1913 (K). Pasted paper, charcoal, ink, 24½ x 18¼ inches. Museum of Modern Art, New York.

opposite: STILL LIFE. 1913?; Paris late 1912 (Z). Oil and pasted paper. Collection Mr. and Mrs. Walter C. Arensberg.

COLLAGE

Analytical cubism from 1909 to 1911 was revolutionary in its disregard of natural appearances so that the sudden introduction of trompe l'oeil *details such as wood graining after all surface realism had been abandoned was paradoxical. And this was soon capped in 1912 and '13 by paper pasting or collage which destroyed for the first time in hundreds of years that traditional technical integrity of the medium which had been sacrosanct since the Gothic artists gave up adding gilded plaster halos to painted saints. Eye-fooling illusionism was disconcerting in a style which had been notable for its extreme, abstract austerity; papier collé added insolence to paradox.*

Through collage the cubists not only broke the traditional integrity of the medium, they undermined the virtuosity, the academic dignity of painting. "Look" said Picasso and Braque arrogantly "we can make works of art out of the contents of waste baskets."

In these two classic collages paper is used in conjunction with charcoal drawing.† On the following two pages pasted paper is combined with oil painting (as oilcloth and oil painting were used together in the earlier Still Life with Chair Caning, p. 79).

80

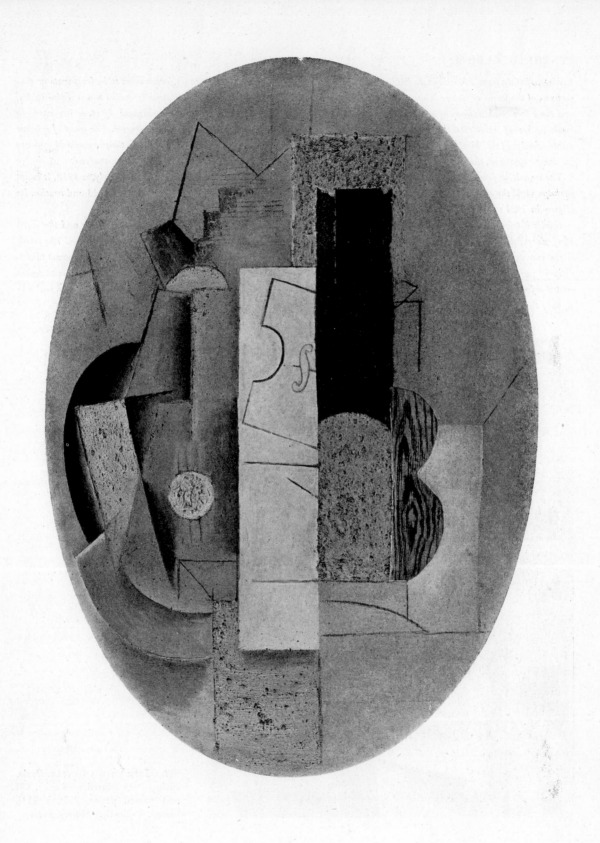

SYNTHETIC CUBISM

Cubist painting from 1909 through 1911 is with good reason called analytical, since its forms seem to be fragments or dissections of the forms of nature. But these three paintings (pages 81, 82, 83), with their arbitrarily varied textures and colors, and their free combinations of quasi-geometrical shapes, are so remote in character from the original object, so invented, so made up out of whole cloth (or whole paper!) that they have lost almost all their analytical character. For want of a better name, cubism of this kind has been called synthetic. *A succinct illustration of the difference between the two methods appears in one composition, the collage* Guitar and Wine Glass *on page 84. The guitar is synthetic, the glass analytic.*

The transition from analytic to synthetic cubism is gradual. Although synthetic elements appear as early as 1910, it is not perhaps until the end of 1912 that they begin to predominate. Synthetic cubism begins, then, about 1912-13 and reaches its climax in 1921 with the Three Musicians *(pages 122, 123).*

Cubist interest in textures increases during 1912-14 in such complex arrangements as the still life below and the Card Player *composition opposite in which a variety of actual and simulated surfaces is combined in one composition. The result is not merely a surface enrichment but an emphasis upon the sensuous tactile reality of the surface itself in contrast to traditional painting which through more or less realistic methods took the eye and mind past the surface of the canvas to represented objects, such as figures or landscapes. So, while cubism destroyed the reality or integrity of the object more than had any style of the past, by the same token it emphasized the reality of the painting itself.*

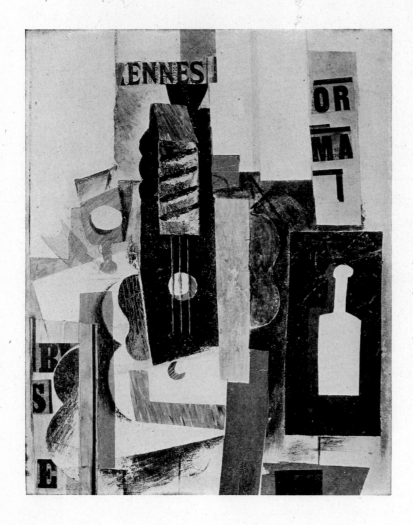

STILL LIFE WITH A GUITAR. Paris, spring 1913 (dated on back). Oil and pasted paper, 25⅝ x 21⅛ inches. Collection Sidney Janis.

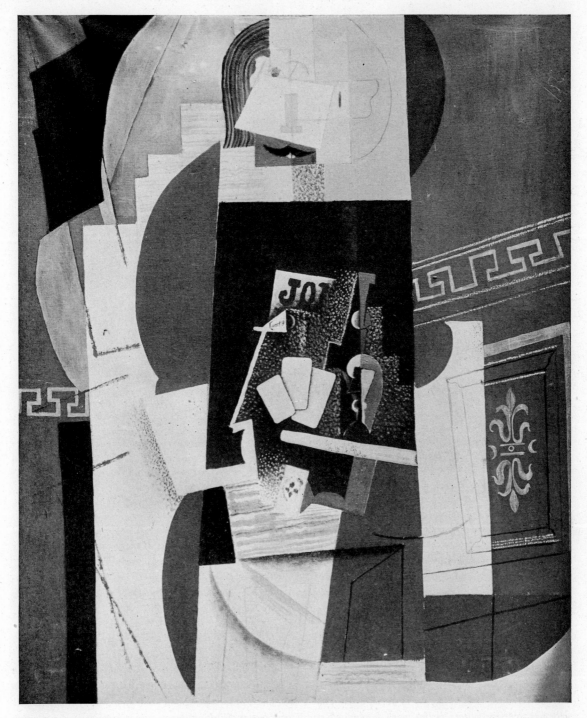

CARD PLAYER. Paris, winter 1913-14 (Z). Oil, 42½ x 35¼ inches. Museum of Modern Art, New York, acquired through the Lillie P. Bliss Bequest.

Though no pasted paper is used, parts of the Card Player give the effect of collage. The varied color is still restrained and the confetti-like stippling still sparsely used by comparison with the "rococo" canvases painted a few months later in the summer of 1914 (pages 90, 91).

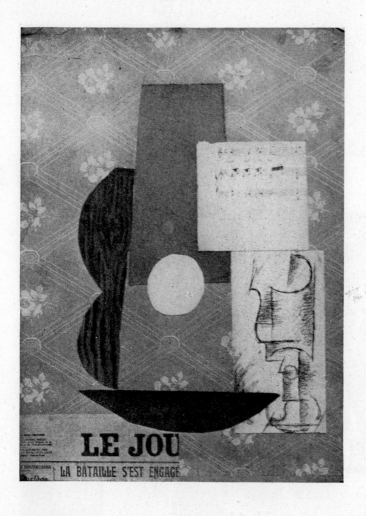

GUITAR AND WINE GLASS. Paris, 1913 (K) or winter 1912-13 (Z). Pasted paper and charcoal, 24½ x 18½ inches.

In the development of synthetic cubism, the part played by collage is very important: collage strengthened the awareness of the picture surface while at the same time it increased the range, variety and remoteness of the pictorial metaphor. (By pictorial metaphor is meant, as before, the relation between the picture and the object or scene represented.)

The collage Guitar and Wine Glass *reproduced above combines the symbols or metaphors of four still-life objects—a newspaper and sheet music represented by actual paper fragments; a guitar, by four pieces of paper, one of which is wood-grained; and a glass, by a charcoal drawing, analytical in style and probably somewhat earlier in date.*

ICONOGRAPHY OF CUBISM

The cubists, traditionally, are supposed to have had little interest in subject m atter whether objectively or symbolically, yet their preference for a rather repetitive range of subjects may be significant. Besides occasional vacation landscapes Picasso and his colleagues painted figures of poets, writers, musicians, pierrots, harlequins and women; or still-life compositions with ever-recurring guitars, violins, wine, brandy, ale and liqueur bottles, drinking glasses, pipes, cigarettes, dice, playing cards, and words or word fragments referring to newspapers, music, or drinks. These subjects, both people and things, consistently fall within the range of the artistic and bohemian life and form an iconography of the studio and café. Whether they represent simply the artist's environment or whether they symbolize in a more positive though doubtless unconscious way his isolation from ordinary society is a debatable question. *

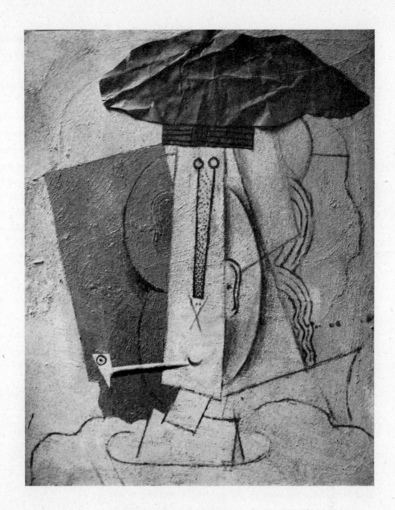

STUDENT WITH A PIPE. Paris, 1914
(K) or winter 1913 (Z). Oil and
pasted paper, 28¾ x 23¼ inches.
Collection Miss Gertrude Stein.

below: STILL LIFE WITH A CALLING
CARD. Paris, 1914 (K). Pasted paper
and crayon, 5½ x 8¼ inches. Collec-
tion Mrs. Charles B. Goodspeed.

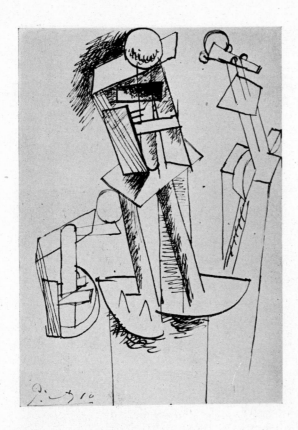

and rectangular planes surmounted by a sphere. The form remotely suggests a human figure but it is so abstract and geometrical in character that it clearly anticipates by several years the work of the Russian and German constructivists. Picasso himself never made an actual construction in so abstract a style as that of Tatlin, the pioneer Russian constructivist, who used to visit his studio in the period before the war of 1914.†

During the next two years Picasso put together several more paper guitars and in 1913 a still-life relief of cut-out boards glued to a square plank (bibl. 524, II, nos. 575, 773, 779). But these, too, were much more painterlike in conception than the prophetic Study for a Construction.

STUDY FOR A CONSTRUCTION. Paris, spring 1912 (Z). Ink, 6¾ x 4⅞ inches. Museum of Modern Art, New York.

below: GUITAR. Paris, 1912 (Z). Construction in colored papers, 13 x 6¾ inches. Owned by the artist. Repro. from Zervos, bibl. 524.

CUBIST CONSTRUCTIONS

The latent structural or architectonic character of cubism had been apparent even in the analytical period—as the analogies to fire-escapes or scaffolding have already suggested. In 1912, thanks perhaps to the catalyzing effect of collage, Picasso began to explore three-dimensional structure at the very time cubist painting itself was growing more two dimensional.

However it was not to sculpture in the traditional sense of the term that Picasso turned.* The guitar shown at the right is not a modeled or chiseled mass but a thing of colored paper cut and folded and glued together into a three-dimensional construction to be hung from a nail. In style it resembles the flat papiers collés of the period such as the Guitar and Wine Glass (p. 84). With paper, scissors and glue and Picasso's ingenuity it is easy to see how the three-dimensional structure grew out of the two-dimensional collage.

The little drawing for a construction above, also of 1912, is possibly of greater importance in the history of recent art, for it is a rendering, in perspective with shades and cast shadows, of a construction built up of cylinders

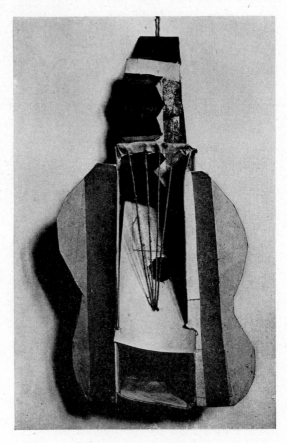

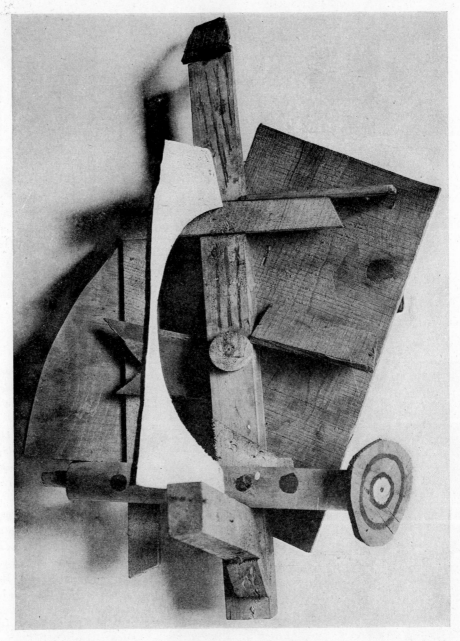

MANDOLIN. Paris, 1914 (Z). Wood construction, 23⅝ inches high. Owned by the artist. Repro. from Zervos, bibl. 524.

In 1914, however, he built the Mandolin, *a vigorously three-dimensional construction which comes near fulfilling the promise of the little drawings of 1912. Mandolin is neither sculpture nor painting, nor architecture. Technically it is carpentry; esthetically it is a composition in space division, without a frame, without a base, with little sense of weight but enriched by color and the texture of the rough sawn wood. Picasso's strong sense of material surfaces kept him from working in the more abstract and characteristic materials of glass or plastic so beloved by the later constructivists—nor did he anticipate their interest in technical perfection: his joinery is childish but his iconoclastic ideas, taste and courage triumph.*

CUBISM AS SURREALISM

The new forms and new techniques invented by the cubists produced endless esthetic speculation and debate. Popularly, cubism was often considered a hoax or a form of delusion or madness. Among those who liked it or were persuaded by the personalities of Picasso, Braque, and the others, cubism was looked on primarily as an art of form with perhaps some metaphysical or mathematical implications. Collage, too, was easily absorbed into an esthetic of pattern and texture, just as the paper guitars led to an art of pure construction. Yet the purists deplored the persistent connection, however vestigial, which Picasso maintained between his art and its subject matter; or, they ignored it or considered it arrested progress toward a purely abstract art.

For the initiates, pure cubism gradually became a familiar method or vocabulary. They got so used to it that they tended to forget the fantastic and grotesque character of its systematic distortion and destruction of "reality"

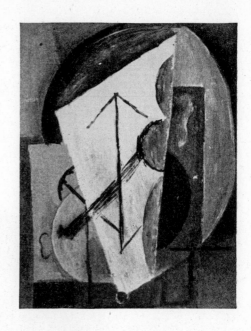

which seemed crazy to the public, schizophrenic or demented to the bewildered psychiatrist. A dozen years later the surrealists were to acclaim the "madness" of cubism enthusiastically.*

The painting above is owned by an abstract painter who called it Composition, *preferring to look at it as an organization of shapes and colors without reference to subject. Picasso, however, when shown a photograph of it called it* Head.†

The collage, at the left, is greatly admired by the surrealists and is in fact owned by a surrealist artist. It too is titled Head‡ *but as a head it is so fantastically far-fetched that it easily meets the surrealist esthetic of the marvelous— though scarcely more than the* Head *above.*

Both these "heads" are austere in their madness. In the etching Female Nude, *opposite page, the figure as a whole is as cubist, as remote from reality as the head above;*

above: HEAD (P). 1913 (K); Paris, winter 1912-13 (Z). Oil on panel, 9¼ x 7¼ inches. Collection George L. K. Morris.

left: HEAD: 1914 (K). Pasted paper and charcoal, 17⅛ x 13⅛ inches. Collection Roland Penrose.

*but on the cubist head of this cubist nude is a white patch
and on the patch lightly drawn is a perfectly normal eye.*

*If this paradox is perhaps too witty and restrained for
surrealist taste, the drawings which Picasso did at Avignon
the following summer are wildly, grotesquely outrageous.
The drawing reproduced below is the same classic subject
as Titian's Venus with a Lute Player. The lady, reclin-
ing toward the left, rests her head on her right hand. In her
left she holds a glass. Her musician, barefooted, wearing a
striped jersey and playing a guitar, is seated at a tabouret.
Her face is like a pinched triangle, his like an elaborate
keyhole adorned by Ainu hair. The right arms of both seem
as stiff, narrow and straight-edged as lathing; the left arms
are as boneless and flexible as a ribbon. Though there is
cubism in the handling of planes, the discipline and geomet-
rical sobriety of cubism is flaunted. Such drawings are
scarcely surpassed in extravagance by Picasso a dozen
years later in his so-called surrealist period, or by Miro.*

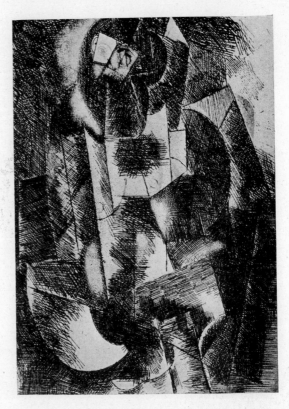

FEMALE NUDE. 1913-14. Etching with drypoint; 6¼ x
4⅝ inches, 6th state after steel-facing (G. 35, VI b);
for Max Jacob: *Le siège de Jérusalem*, Paris, Kahn-
weiler, January 1914 (see p. 276). Museum of Modern
Art, New York, gift of Frank Crowninshield.

NUDE WITH A GUITAR PLAYER. Avignon, 1914. Pencil. Owned by the artist. Repro. from Georges,
bibl. 185.

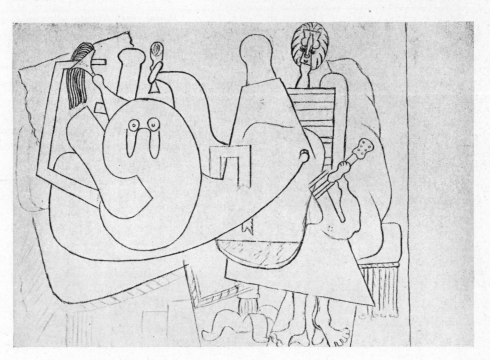

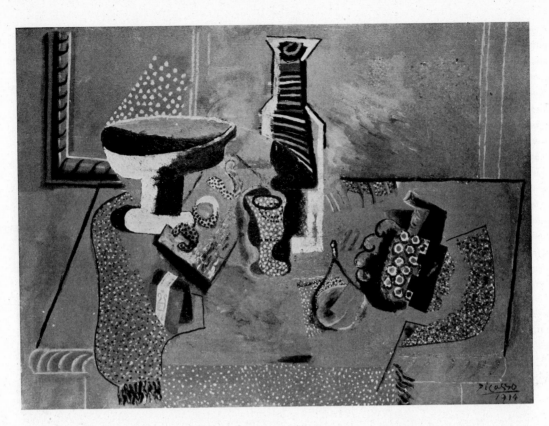

"ROCOCO" CUBISM

During 1914 Picasso continued to enrich and expand cubism—or to adulterate it—depending on one's point of view. Already by 1912 Delaunay had brought brilliant color into cubism. Picasso and Braque, however, kept to their modulations of grey and tan through most of 1913 with only occasional and tentative deviations. When they did use color it seems to have been inspired by the wall papers in their own papiers collés and by Seurat's neo-impressionism more than by the example of the lesser cubists.

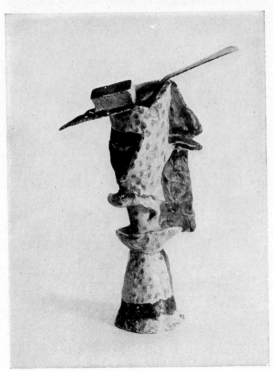

above: GREEN STILL LIFE. Avignon, summer (Z) 1914 (dated). Oil on canvas, 23½ x 31¼ inches. Museum of Modern Art, New York, Lillie P. Bliss Bequest.

left: GLASS OF ABSINTHE. Paris, 1914 (K). Painted bronze, 8¾ inches high. Philadelphia Museum of Art, A. E. Gallatin Collection. Six casts were made for Kahnweiler, each one differently painted.

At Avignon in the summer of 1914 Picasso gave full play to his revived interest in bright color just as at the same time he let his pencil run wild in such drawings as Nude with a Guitar Player, p. 89. In the Green Still Life (opposite) accents of white, olive, vermilion, ultramarine and black are dashed against a background of brilliant green. The bisected bottle is striped with violet, yellow, and orange, and here and there are patches of confetti-like dots which Picasso adapted from the neo-impressionist technique of Seurat. Seurat in the 1880's had painted his entire canvas "scientifically" with dots of pure tones of the six primary colors. Picasso was interested neither in Seurat's science nor his painstaking "pointillism," but he found that patches of brilliant dots in contrasting colors gave him one more means of adding variety to his textures and vibration to his color.

The still life Vive la France, begun at Avignon, is richer still, almost to the point of surfeit. A profusion of brightly colored objects embellished with dots and letters play against a flowered wall paper. Even more than in the Green Still Life forms seem soft both in surface and in contour. There are no large motives, no bold rhythms. Rococo scale, rococo gaiety, rococo curves, rococo virtuosity for the moment overwhelmed the most austere tradition in modern painting.

An epitome of rococo cubism is the little painted bronze Glass of Absinthe. Dotted like the glasses in the two Avignon still-life paintings and surmounted by its spoon and lump of sugar it is a minor but daring tour de force. It is also probably the only piece of sculpture (as distinguished from constructions) produced by Picasso during the many years between 1910 and 1925.

VIVE LA FRANCE. Avignon, summer 1914—Paris, 1915 (dated on back). Oil, $21\frac{3}{8}$ x $25\frac{3}{4}$ inches. Collection Sidney Janis.

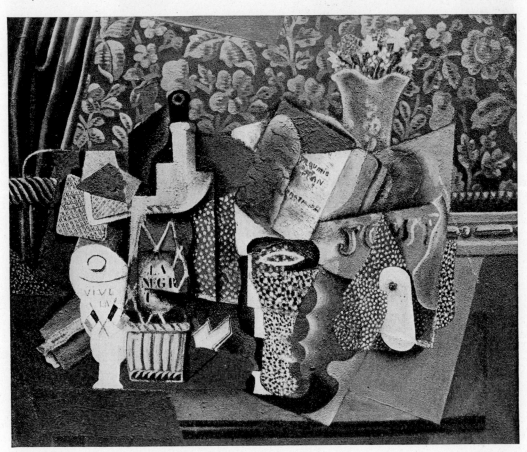

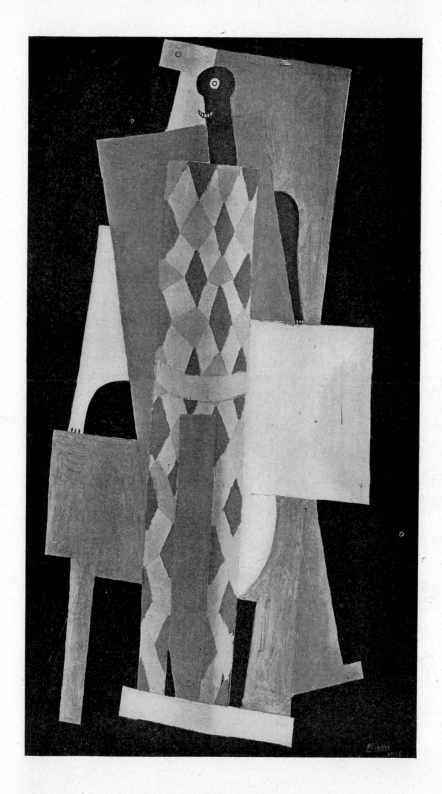

HARLEQUIN. Paris, 1915 (dated). Oil, 71¼ x 41⅜ inches. Private collection.

During the winter of 1914-15 Picasso abandoned his rococo cubism. He still used pointillist dots to enliven certain passages, but returned to predominantly straight lines and used larger and fewer forms, mostly flat rectangles tilting slightly to left or right to form opposing diagonals. His best paintings of 1915 and 1916 are impressive in size, bold in their color and abstract simplicity. The canvases reproduced here are six or seven feet high. They initiated what might be called the classic period of synthetic cubism, which lasts for about a decade and includes such notable canvases as the Violinist of 1918 (p. 105), the Dog and Cock (opposite p. 120), and Three Musicians, (pages 122, 123) of 1921 and the great still lifes of 1924 to 1926. Analytic cubism had had its classic phase from 1910 to 1912, patient, modest, gradual, a little dry and drab, but informed by an unsurpassed ascetic intensity. Then came the experimental period of 1912 to 1914 with its lumber still life, its sand and sawdust textures, confetti shadows, bronze absinthe glasses, wall-paper guitars and painted speculations on the nature of visual reality. Picasso's cubism from 1915 to 1925, though it had its sober moments, was not austere; and while it grew and changed as any living tradition should, it was never tentative or experimental. Instead his synthetic cubist style grew in confidence and magnificence. At its worst it was merely decorative, at its best, majestic.

But it did not hold the field alone, for the years 1915-16 saw the beginning of a different current in Picasso's art more radical than any since 1907.

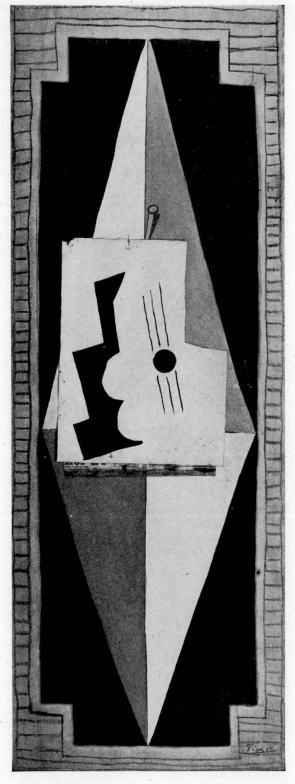

GUITAR. Paris, winter 1916-17 (Z). Oil, charcoal and pinned paper, 85 x 31 inches. Collection A. Conger Goodyear.

REALISTIC PENCIL PORTRAITS; "BACK TO INGRES"; 1914-1915

In August 1915 Picasso drew the portrait of Ambroise Vollard with an exquisite and precise realism. The idiosyncracies of his hands and ears, the cut of his suit are described with painstaking care. Even the textures of his beard and hands, and the color values of flesh and coat are conscientiously differentiated.

*Since 1906 Picasso had scarcely concerned himself at all with "realism" in the popular or ordinary sense of the word. Sometimes his style had been less abstract as in 1908 (pages 62-64) and 1914 (pages 90, 91). Sometimes he had approached realism obliquely as in the papiers collés and occasionally he had flirted with it in the trompe l'oeil textures of 1912 or the eye in the etching of 1913 for Le siège de Jérusalem (p. 89). Another and lesser known etching done in 1914 presents some apples in a fairly objective style (bibl. 179, no. 38); and the tentatively penciled Seated Man (p. 261) is a whole year earlier than the Vollard. More significant perhaps is the drawing reproduced below where behind a cubist structure hides a pale pencil outline of a seated man—a work interesting both in its relation to Picasso's cubism of 1915 and to the drawing opposite.**

These intimations, however, scarcely prepared his contemporaries for the shock of such works as the Vollard portrait and the suite of drawings and paintings of friends and theatre people and, later, the neo-classic figures, which for a decade were to compete with his cubist paintings. Conservatives, and a few of the extreme avant-garde, looked on Picasso's apostasy with approval. Among the cubists naturally there was astonishment and some consternation, though a few years later many of them took the same road. Looking back, what seems most surprising is not that Picasso should suddenly have reversed his

SEATED MAN WITH ARMS CROSSED. Paris, 1915 (Z). Pencil, 8 x 5⅛ inches. Owned by the artist. Repro. from Zervos, bibl. 524.

Tracing of the light outline beneath the cubist drawing at the left. Compare the Seated Man, Avignon, summer, 1914, page 261.

94

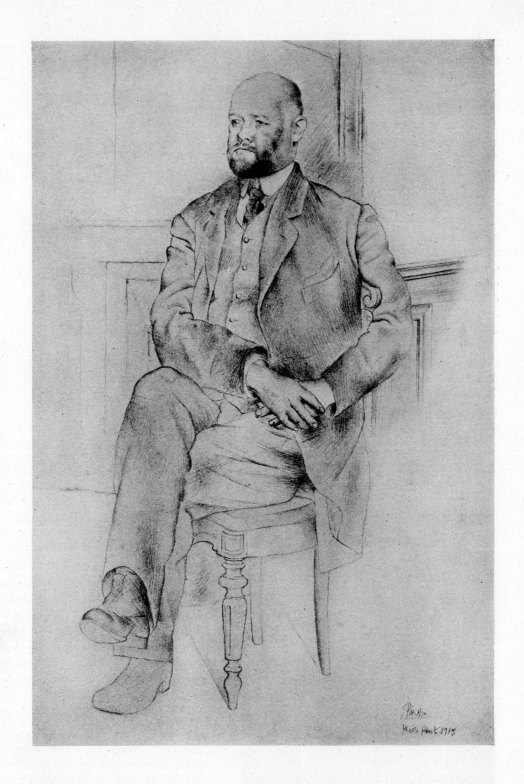

Portrait of Ambroise Vollard. Paris, August 1915 (dated). Pencil. Repro. from Zervos, bibl. 524.

direction, but that he should have continued his cubist style with such energy and power.

The *Vollard* drawing was done earlier than the highly abstract cubist *Guitar* on page 93, and much of 1916 Picasso gave to cubist paintings in the manner of the *Harlequin* (p. 92) though he drew several nudes and characters from the Italian Comedy in his new style which was soon associated with the name of Ingres, whose art Picasso greatly admired.*

The influence of Ingres may well be present in such drawings as the *Vollard* portrait; it appears too in some of the distortions and contour elisions of his in figure paintings and drawings of the succeeding decade. Picasso's interest in the ballet and his trip to Rome in 1917 also doubtless contributed to the formation of what is often called his "Classic Period" which begins about 1915 and ends, except for graphic art, about 1925. What might be called Picasso's "neo-classic" style, however, with its direct, conscious and often mannered references to Greco-Roman forms and subjects, does not begin until about 1920.

Besides *Vollard*, Picasso drew the portrait of his friend *Max Jacob* in the same meticulous style (bibl. 80, p. 51). That was 1915, the year that Jacob was baptized a Roman Catholic, Picasso acting as his godfather.† A year later

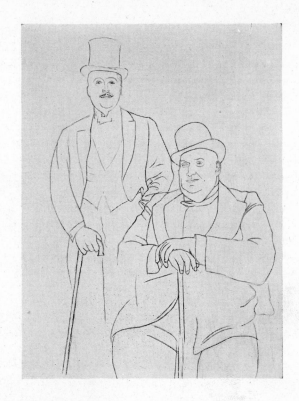

Guillaume Apollinaire received quite another kind of baptism. Though not a French citizen he had volunteered for service in the French Army and had been wounded in the head on the Western Front. He sat for Picasso in uniform, his bandage showing beneath his cap.

Picasso was a foreigner and did not have to fight but others of his friends besides Apollinaire were in the French Army, Braque, Derain, Salmon, Cocteau among them. His faithful dealer, Henry Kahnweiler, was of German birth and had to close his gallery, yielding his rôle for the duration to generous Léonce Rosenberg. From the time Picasso came back from Avignon in August 1914 Paris had been a frightened and comparatively joyless capital yet Picasso stayed there throughout 1915 and 1916, moving in the latter year from Montparnasse to suburban Montrouge. Only in 1917 did he leave Paris.

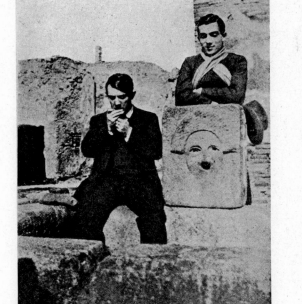

above: DIAGHILEV AND SELISBURG. Rome or Florence, spring 1917. Pencil, 24⅞ x 18⅞ inches. Owned by the artist. Selisburg was the lawyer of Otto Kahn, the American patron of the Russian Ballet.

left: Picasso and Massine at Pompeii, spring 1917.

96

THE RUSSIAN BALLET, ITALY, 1917

Although some of his cubist figures have theatrical names and costumes, Picasso had shown little active interest in the theatre since 1905, and even then he had been concerned with the marginal theatre—circuses and traveling shows of popular comedy, and only as a painter not a participant.

When Picasso turned again to the theatre in 1917 it was not to paint dejected and impoverished saltimbanques but to take part himself as a designer for the most megalopolitan and elegant of spectacles—the Russian Ballet.

Diaghilev, the great Russian impresario, had held his company together with difficulty during the War, principally by touring North and South America. The Ballet left the United States early in 1917, arriving in Rome in February. From Spain came Diaghilev himself, and from Paris, Jean Cocteau, the acrobatic writer, bringing with him Picasso to work on the settings for the ballet Parade. *Cocteau with some difficulty had persuaded Picasso to leave Paris. Picasso hated traveling, especially in foreign countries, and besides, as Cocteau put it, "the cubist code forbade any other journey than that on the Nord-Sud subway between the Place des Abbesses and the Boulevard Raspail."**

In Rome Picasso met not only Diaghilev but also Strawinsky, at work on the music for Feu d'artifice, *and Massine, the young dancer and choreographer. He drew their portraits in rapid slashing sketches or more deliberately as in the Ingres-like double portrait of Diaghilev and Selisburg. "We did* Parade," *Cocteau writes, "in a Roman cellar in which the troupe rehearsed . . . We walked in the moonlight with the dancers, and we visited Naples and Pompeii."**

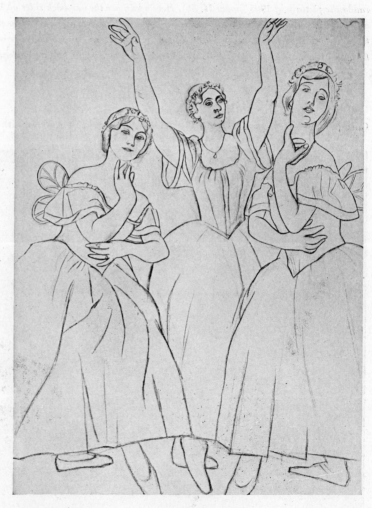

THREE BALLERINAS. 1917? Pencil and crayon, 23⅛ x 17⅜ inches. Owned by the artist. The costumes are those of *Les Sylphides* which was included in both the 1917 and 1919 seasons of the *Ballets Russes*. Picasso states that the drawing was done in Paris from a photograph.†

PARADE: 1917

Parade* *was an* avant-garde *demonstration of considerable importance for it combined the revolutionary theatrical ideas of Cocteau, the music of the most advanced composer of France, Erik Satie,† the painting of Picasso and, rather subordinately, the choreography of Massine and the dancing of Diaghilev's Russian Ballet.*

Cocteau, who had been associated with Diaghilev for some years, had proposed the ballet to Satie in 1915. During the winter of 1916-17 Cocteau interested Picasso in designing the decor. Plans for Parade *were completed in Rome during February and Picasso worked on the settings at Montrouge during the spring. The first performance was given in Paris in May.*

Cocteau could scarcely have invented a piece better calculated to overcome Picasso's left-bank prejudices against the fashionable and luxurious ballet. Parade, called by Cocteau a "ballet réaliste," was an ironic sophisticated burlesque of the popular music hall or vaudeville with which Picasso was thoroughly familiar. There were only four dancers: a Chinese conjurer (danced by Massine), a little American girl and two acrobats. In addition there were three managers added apparently at Picasso's suggestion. Satie's unassuming music "like an inspired village band" was to be accompanied by noises, a dynamo, a siren, a telegraph key, an airplane propeller, a typewriter—"ear deceivers" Cocteau called them, employed with the same object as the "eye deceiving" newspapers, facsimile wood graining and moldings which the cubist painters had used.

Picasso painted the curtain himself with the help of assistants. It was the largest and most complete figure composition he had so far achieved and was perhaps his first painting in his new style. At first glance, it carries us back to the circus and vaudeville pictures of 1905 (pages 34, 36). Here again are the bareback rider on her horse, the acrobat's ball, the harlequins and guitarists. But the style is cruder and more mannered, a skillful parody of popular scene painting. The colors are mostly heavy reds and greens and there is none of the sentimental melancholy and nervous refinement of the early work—Pegasus backstage is a mare suckling her foal, her wings held on by a strap, and the harlequins are smiling and well fed.

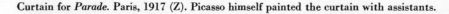

Curtain for *Parade*. Paris, 1917 (Z). Picasso himself painted the curtain with assistants.

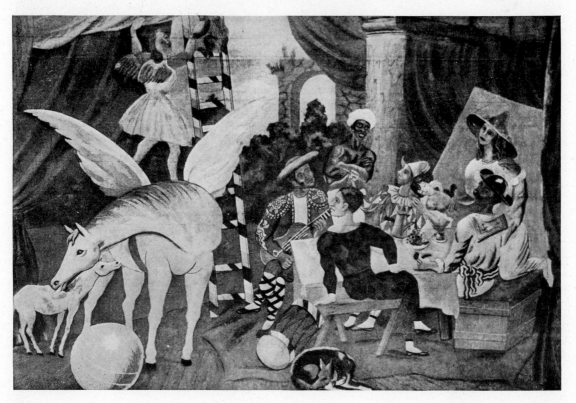

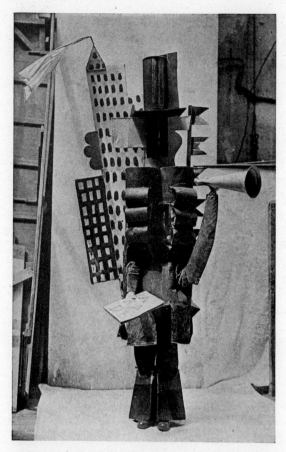

THE MANAGER FROM NEW YORK. Costume designed by Picasso for *Parade*, 1917. About 10 feet high. Repro. from Zervos, bibl. 524.

*Leon Bakst, the great Russian scene designer of the ballet's previous decade, found Picasso's curtain "passéiste" and the audience which expected to be shocked by the famous cubist painter must have been soothed when they saw the curtain and heard the sombre organ tones of Satie's overture. When the curtain rose they knew they had been misled. Stamping across the stage comes the French manager, a figure ten feet tall and completely covered except for his legs by a cubist construction. He introduces the Chinese conjurer dressed in the most famous of Picasso's costumes—vermilion, yellow, black and white in stripes, rays and spirals. After his performance the New York manager stalks on the scene, his stamping dance like "an organized accident . . . with the strictness of a fugue." He wears cowboy boots and cubist skyscrapers, and bellows in his megaphone the virtues of his protegée, the little American girl who, in Cocteau's words, "rides a bicycle, quivers like movies, imitates Charlie Chaplin . . . dances a rag-time . . . buys a Kodak."**

The curtain and costumes—with the important exception of the managers—were not in the least cubist yet the esthetics of Parade *was strongly under cubist domination. The gigantic cubist managers like moving sections of scenery were intended by Picasso to dwarf and flatten out the dancers, turning them into unreal puppets. Thus cubist reality—the agglomeration of pipes, hats, split faces, architecture and angular dissections which made up the inhuman managers—triumphed over the traditional reality of the characters, human in shape and scale. Similarly the cacophony of pounding footsteps, whistles, typewriters, et cetera, was supposed by Cocteau to take the foreground against Satie's subtle and modest music.*

Guillaume Apollinaire wrote some program notes for the ballet under the title "Parade" et l'esprit nouveau. He discovered in the fusion of scenic and choreographic arts achieved in Parade *a kind of "sur-réalisme" in which he saw the beginnings of the New Spirit. Cocteau preferred the word realism—the heightened realism of art which is more real than actuality. Yet the incongruous mixture of real and unreal in* Parade, *its making the commonplace*

CHINESE CONJURER'S COSTUME (LE CHINOIS). Rome?, 1917. Gouache, 10¾ x 7⅜ inches. Collection Mrs. Yvon Helft and Mr. Jacques Helft. Costume design for the ballet *Parade*. Massine wore this costume in the original production. The spirals represent the smoke in one of the conjurer's tricks; the rays of the rising sun symbolize the Orient.†

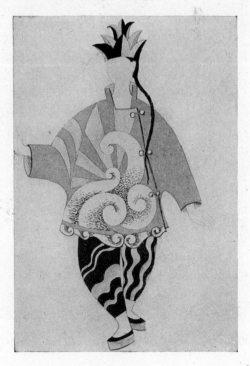

marvelous, its strategy of shock, anticipate surrealism—a word said to have been invented by Apollinaire who, apparently, published it for the first time in this ballet program.

Picasso's impact on the ballet was considerable but no less than the ballet's influence on him. As an artist his concern with the natural and esthetic beauty of the human body had died out during 1906. After years of cubism it had begun to revive in a few figure drawings of 1916. Beyond a doubt the ballet and its dancers greatly stimulated this interest which flourished in many drawings and paintings from 1917 to 1925. During the earlier part of this period he made many pictures of characters from the Commedia dell' arte. Some were precise period costume studies for the ballet Pulcinella of 1920, others were informal and casual. Below are a drawing and a watercolor of Pierrot and Harlequin. Identical in size and subject and done in the same period they show how Picasso played back and forth between his new "classic" or "realistic" style and cubism.

Among the minor dancers in the Ballets Russes was Olga Koklova whom Picasso met in Rome and married within a year, Apollinaire, Cocteau and Max Jacob serving as witnesses. Picasso painted and drew many portraits of her. The one reproduced at the left, probably done in Spain during the summer of 1917, shows her wearing a mantilla. It is one of the earliest paintings in Picasso's new style, with carefully modeled and well characterized features which are less idealized than in her later and more famous portraits.

After a summer at Biarritz Picasso moved from Montrouge to a large apartment in the rue la Boétie. Paul Rosenberg became his principal dealer.

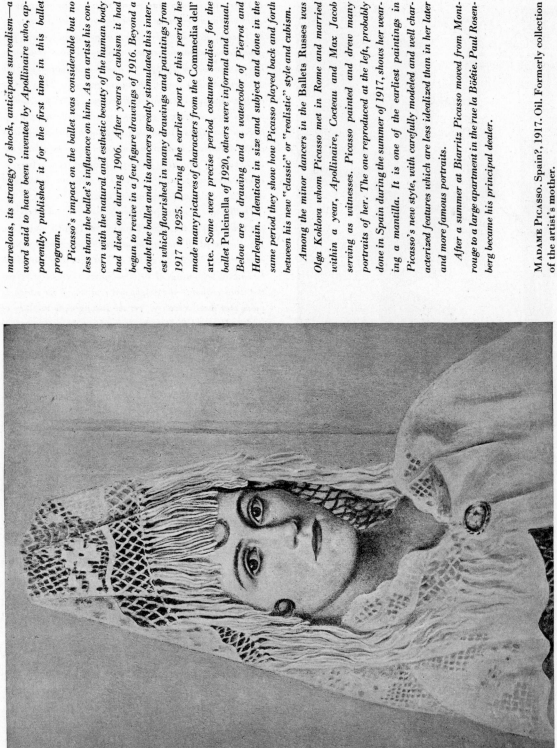

MADAME PICASSO. Spain?, 1917. Oil. Formerly collection of the artist's mother.

PIERROT AND HARLEQUIN. 1919. Gouache, 10⅛ x 7¾ inches. Collection Mrs. Charles B. Goodspeed. Possibly related to the ballet *Pulcinella.*

PIERROT AND HARLEQUIN. 1918 (dated). Pencil, 10¼ x 7½ inches. Collection Mrs. Charles B. Goodspeed. Said to be a costume study for the ballet *Pulcinella*, produced in 1920 (see p. 275); the drawing, however, is dated 1918.

101

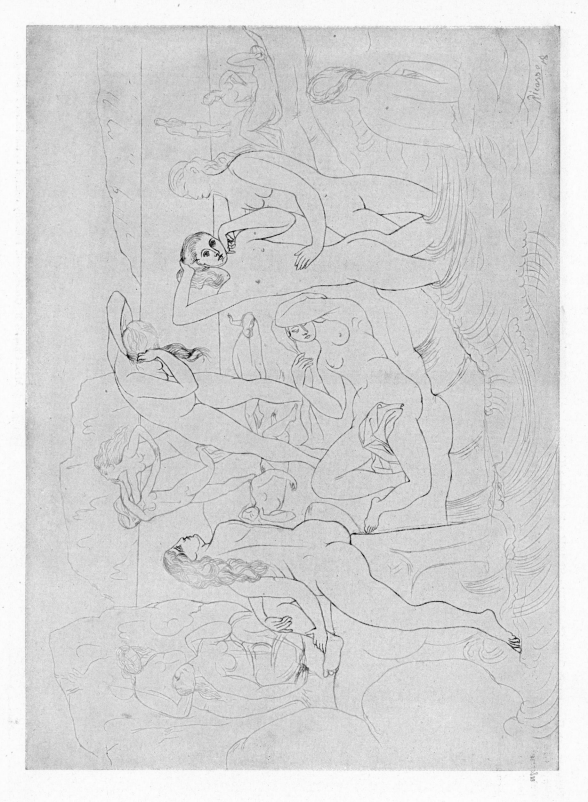

102

The Bathers, one of Picasso's most elaborate figure compositions, combines fifteen figures with extraordinary grace and subtlety. The distortions and elegant simplifications in the outlines, the twisting of limbs or torsos to reveal an unforeshortened silhouette, may have been inspired by Ingres, but they appear in many periods, for instance, in mannerist drawing of the 16th century, in Pollaiuolo and Botticelli and in Greek vase painting. Yet there is nothing obviously derivative about such a drawing. Picasso combines a certain sense of individuality in the figures with a purity of style in which there is as yet no suggestion of neo-classic formula.

In the Fisherman there is greater realism of detail but the drawing is far more mannered, with distortions which suggest El Greco though more subtly than do the figures in the Composition of 1906 (p. 49). The fisherman is clearly derived almost line for line from the peasant carrying a basket of flowers in that early painting. (The reproductions of the Bathers and the Fisherman were treated with asphaltum during the engraving process, making the line coarser and darker than in the originals which are so exquisitely delicate that they would almost have disappeared in an ordinary half-tone.)

above: BATHERS. 1918 (dated). Pencil, 9⅛ x 12¼ inches. Fogg Museum of Art, Cambridge, Massachusetts, Paul J. Sachs Collection.

right: FISHERMAN. Biarritz?, 1918 (dated). Pencil, 13¾ x 10 inches. Private collection.

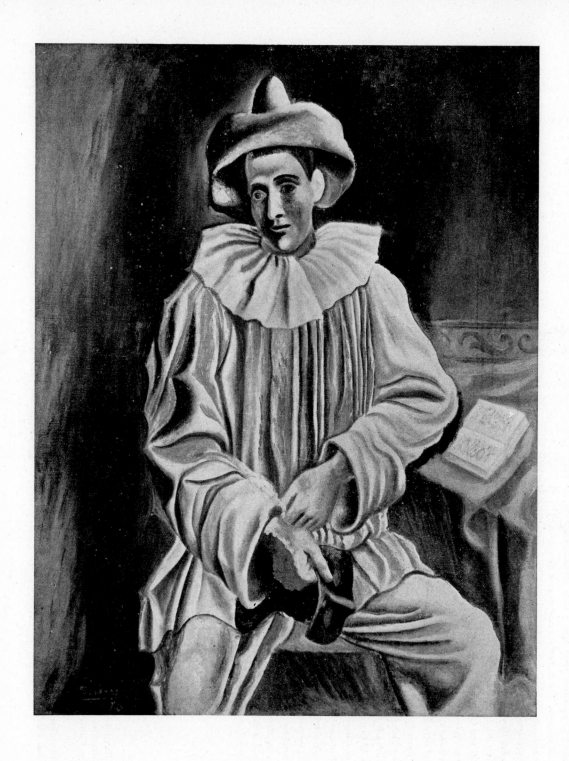

PIERROT SEATED. 1918 (dated). Oil, 36½ x 28¾ inches. Lewisohn Collection.

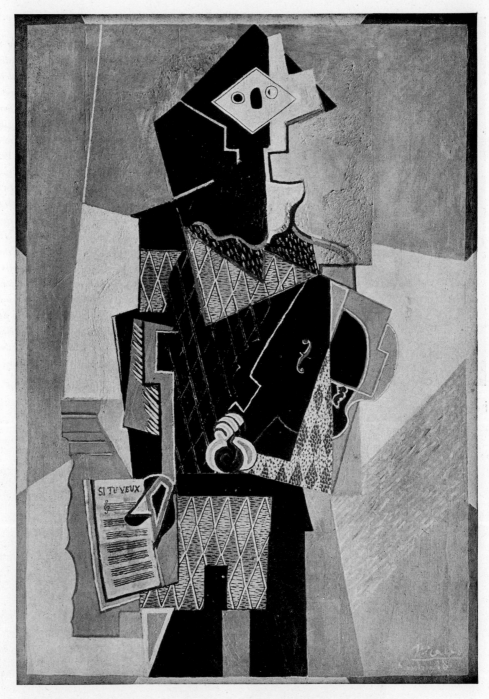

THE VIOLINIST ("SI TU VEUX"). 1918 (dated). Oil, 56 x 39½ inches. Private collection.

The parallel course of Picasso's cubist and "realistic" styles is illustrated again by this harlequin violinist and the pierrot opposite.

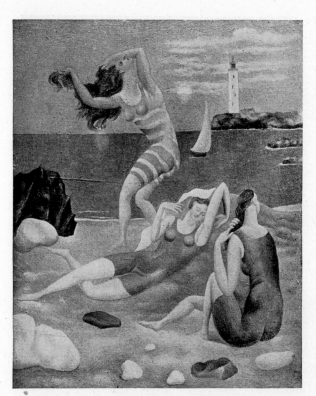

MANNERISM: Fat and Lean

The Mannerists of the 16th century in Italy, and their followers elsewhere, in escaping classic canons, whether of antiquity or the High Renaissance, developed two kinds of figure style, the one extremely elongated and elegant, the other ponderous and bulky; and often their figures were forced into compact, cramped compositions.

Picasso had recalled both styles from 1904 to 1906 (pages 30-33, 52). And now from 1918 to 1925 both stylistic extremes appear again. There was a suggestion of mannerism in the drawing of Bathers *(p. 102). In the painting* Beach Scene *the figures are very similar but their manneristic elegance and torsion are still more exaggerated.*

Quite the opposite kind of mannerism appears in the Sleeping Peasants *of 1919, one of the earliest and most memorable of Picasso's compositions in the "colossal" style. The figures are ingeniously forced into a kind of oblong, free-standing relief. The drawing, especially the head and upper part of the woman's figure, is directly inspired by the late style of Ingres, so well demonstrated in his* Bain turque. *Picasso is less sensual than Ingres and more powerful, particularly in the construction of the composition.*

BEACH SCENE. 1918. Oil. Owned by the artist.

SLEEPING PEASANTS. 1919. Colored ink or crayon, 12¼ x 18⅞ inches.

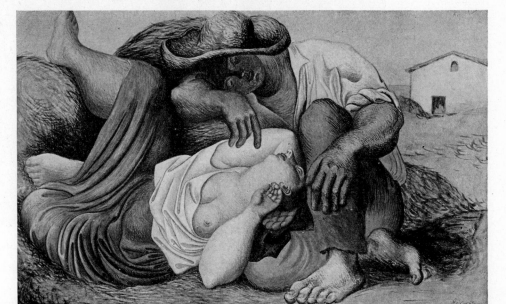

106

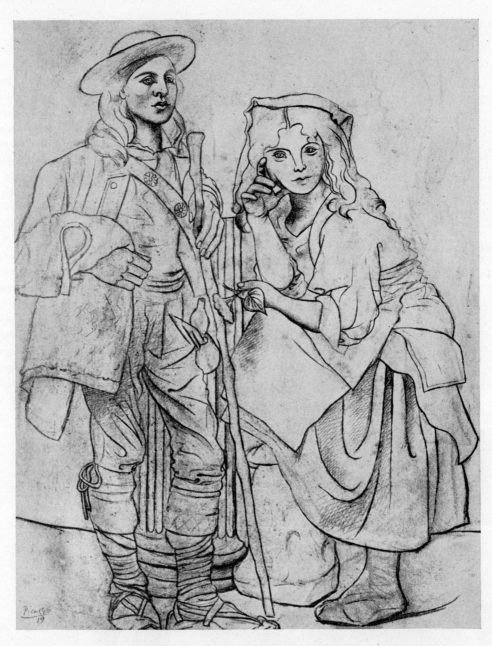

TWO PEASANTS. 1919 (dated). Pencil, 18½ x 23½ inches. Collection Wright Ludington.

This drawing of peasants represents the naturalistic mean between the two extremes of mannerism illustrated opposite. The figures are in their natural proportions and the details are fairly exact. The arms of the girl, the hooked lines indicating the folds in the man's trousers, even the placing of the two figures suggest a coarse, vigorous translation of Ingres' portrait drawings. Yet it is Picasso's own strong sense of style which pulls the drawing together, gives it strength, precision and unity.

107

Sketch for the setting of *Le Tricorne*. London or Paris, 1919. Ink, 5 x 7½ inches. Wadsworth Atheneum, Hartford, Connecticut. Lifar Collection.

BALLET: 1919-1921

There was no ballet season in Paris during 1918 but two years after Parade (*Rome and Paris, 1917*) *Picasso once more became directly involved with the Ballets Russes. For Diaghilev he designed* Le Tricorne (*London, 1919*), *Pulcinella (*Paris, 1920*) and Cuadro Flamenco (*Paris, 1921*).

Tricorne *and* Cuadro Flamenco *were both Spanish in theme so that Picasso's costumes and settings were variants of traditional folk dress. The curtain for* Tricorne, *much drier and more literal than in the sketch below, presents a rather conventional view into the bull ring. However the setting, following the drawing (left) was possibly Picasso's most successful theatrical design with its able use of height and recession—the bridge seen through the great arch—and its effectively simple color of salmon and pale ochre against a starry blue sky. There is perhaps a trace of cubism in the interplay of the angles and in the evident desire to fill the whole scene with construction*

For Cuadro Flamenco, *a suite of Andalusian dances, Picasso designed a backdrop representing a provincial theatre with a small stage flanked by boxes, all in heavy red, black and gold. One of the boxes, painted by Picasso himself, is reproduced opposite. (A list, with details of ballets for which Picasso made designs is given on p. 275.)*

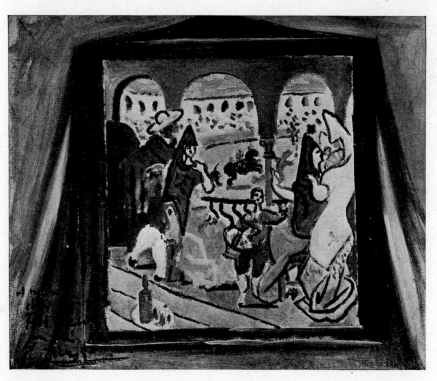

Study for the curtain of the ballet, *Le Tricorne*, 2nd version. 1919. Oil, 14¾ x 18 inches. Private collection. Inscribed: "A mon cher Paul Rosenbergs on ami Picasso."

108

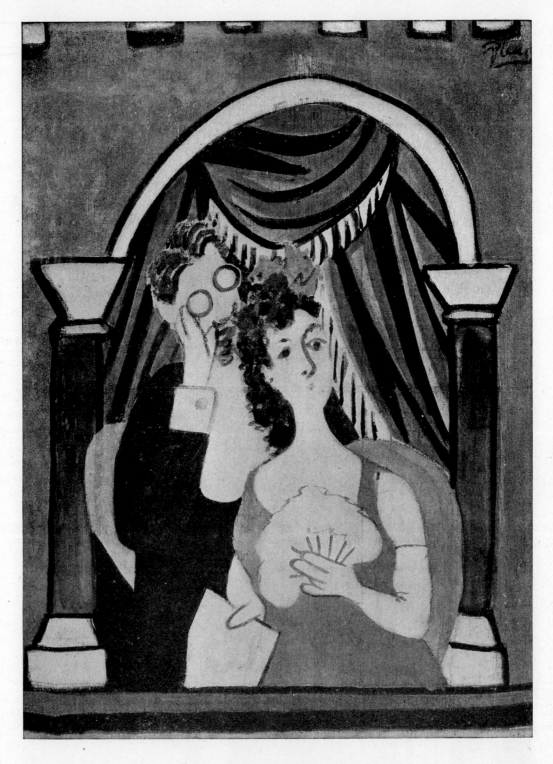

THE THEATRE BOX. 1921. Oil, 76½ x 58⅜ inches. Rosenberg and Helft, Ltd., London. Picasso himself painted this section cut from the scenery of *Cuadro Flamenco* (see p. 275).

(see p. 275)

Since his adolescence, even during the period of analytical cubism, Picasso had painted characters from the Italian comedy which in France survived principally in circus and carnival costumes. From 1915 on he multiplied his pierrots and harlequins until in 1919-20 Diaghilev commissioned him to do the designs for Pulcinella. Picasso made many careful studies bringing to life the traditional costumes of the Commedia dell' arte while Strawinsky was editing and scoring Pergolesi's music for the ballet. There were however more than the usual misunderstandings and delays so that in the end Picasso's costumes were hastily put together and his setting reduced from the elaborate interior of an 18th century theatre to a simple blue, grey, and white street perspective which looks down across the bay of Naples to Vesuvius in the distance. The bright moon and its light accent the cubist angles of house fronts and conventionalized water surrounded by a band of stars (below).

Picasso had met Strawinsky in Rome in 1917 and there heard his music for the first time, though Petrouschka had been produced in Paris in 1911 and the Sacre du Printemps in 1913.* They became friends, the musician and the painter, who in their development as artists show certain remarkable analogies although they actually collaborated only on Pulcinella. Picasso designed the cover for Strawinsky's Ragtime—for once the banjo supersedes the guitar!—and drew his portrait three or four times. The most elaborate is the seated figure (opposite) done nine days after the opening night of Pulcinella. The Strawinsky portrait is very different in style from the patient literal likeness of Vollard (p. 95). The line is curiously modest without inflection or accent, as prosaic and casual as the sack suit which it describes. Here is none of the consummate linear elegance of Ingres' early drawings to which these

Picasso portraits have so often been compared. Yet the distortions in the foreshortening of hands, face and eyeglasses and the guileless character of the line are effective and have been widely imitated.

Picasso has made dozens of similar portrait drawings of musicians, artists, picture dealers, collectors and writers. Many have been reproduced in ballet programs or as the frontispieces of books. Taken together they form an unrivalled portrait gallery of personalities in the literary and artistic world of modern Paris.

above: TWO MUSICIANS. 1918-19. Cover design, 11⅜ x 9¼ inches, for Strawinsky's Ragtime, Paris, Editions de la Sirène, 1919. Courtesy New York Public Library.

left: Design for the setting of Pulcinella. 1920. Watercolor.

110

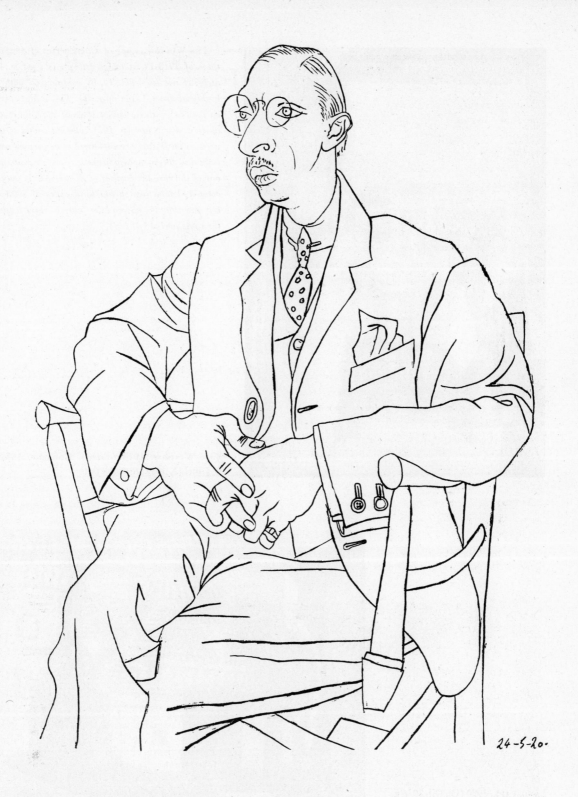

24-5-20.

Portrait of Igor Strawinsky. Paris, May 24, 1920 (dated). Pencil or crayon.

The Window *is one of a long series of compositions of 1918-19 in which cubism is used moderately, if not superficially, by comparison with the highly abstract* Table *opposite. The* Table *carries on the flat synthetic cubist style of the* Violinist *of about a year before (p. 105). The horizontal stripes used in the* Table *are combined with various wavy lines and dots to make a bright, decorative pattern in one of the rare landscapes of the period. It may be compared with two earlier landscapes of 1908 (p. 62) and 1909 (p. 68) and the "classic" landscape of the same period (p. 119).*

THE WINDOW. 1919 (dated). Gouache, 13¾ x 9¾ inches. Private collection.

LANDSCAPE. 1920 (P). Oil, 20½ x 27½ inches. Owned by the artist.

THE TABLE. 1919-20. Oil, 51 x 29⅝ inches. Smith College Museum of Art,
Northampton, Massachusetts.

The three drawings on this and the opposite page, all done in or about 1920, give some idea of the variety and virtuosity of Picasso's figure drawing.

The emaciated Beggar, tall as a Greco prophet, is stabbed, hooked and blotted in with a staccato pen. The figure study, below, is almost Michel-angelesque in its forced, sculpturesque modeling and ponderous torsion.

Far removed from both is the delicate, continuous outline of the Centaur and Woman. As in the three works of a year or so before shown on pages 106-107, the pendulum of Picasso's figure style continues to swing from mannerist elongation to mannerist gigantism passing through a kind of natural or classic norm (pages 107 and 115).

BEGGAR. 1919-21? (P). (Formerly dated 1901-04?) Ink and pencil, 12¼ x 4⅝ inches. Collection Walter P. Chrysler, Jr.

FIGURE STUDY, BACK. 1920-21 (P). (Formerly dated 1906.) Charcoal, 24½ x 18½ inches. Collection Walter P. Chrysler, Jr.

"NEO-CLASSIC"

The ballet and theatre, portraits and beach scenes, an occasional fisherman or peasant provided Picasso with most of his figure subjects during the four years before 1920. But about that year he began to take an interest in the style, the sentiment, the characters, the mythology of Greek and Roman antiquity—an interest far more explicit and prolonged than his brief, youthful, classic period of 1905-06 which had little directly to do with the Antique.

Picasso's neo-classicism was, of course, a part of a broad, complex reaction against the excesses and violent originalities of prewar movements such as cubism, expressionism and primitivism. By 1920 cries of back to Poussin! back to Ingres! back to Seurat! rang through Paris; back to Bach! Racine! Thomas Aquinas! back to the Greeks and Romans! back to discipline and order, clarity and humanity. Benda's angry Belphégor, Matisse's "Nice" Period, Ozenfant's attempts to reform and purify cubism, the apotheosis of Satie, Strawinsky's Pulcinella, so remote from his Sacre du Printemps of only seven years before, Cocteau's Antigone (for which Picasso also designed décors), all were incidents, serious or fashionable, of a general movement in which Picasso was an important, though half-time participant.

During his Italian trip in 1917 he visited Pompeii and doubtless the museums of classical art in Naples and Rome, though what he saw there seems to have affected his art very little, at least for two or three years thereafter. The Centaur and Woman is among the first of hundreds of line drawings and etchings of classical subjects—Greek subjects—made by Picasso during the past twenty-five years. These include the illustrations for Ovid's Metamorphoses *(p. 159), Aristophanes'* Lysistrata *(p. 192), and Suarès'* Hélène chez Archimède *(unpublished).*

CENTAUR AND WOMAN. September 12, 1920 (dated). Pencil, 7⅞ x 10½ inches. Collection Gilbert Seldes. Inscribed: "*12-9-20 Pour le ménage Seldes son ami Picasso.*" Gilbert Seldes, the American writer, later translated into English the *Lysistrata* of Aristophanes for which Picasso made illustrations (p. 277).

Two Seated Women. 1920 (dated). Oil, 76¾ x 64¼ inches. Collection Walter P. Chrysler, Jr.

THE RAPE. 1920 (dated). Tempera on wood, 9⅜ x 12⅞ inches. Collection Philip L. Goodwin.

Many of Picasso's neo-classic compositions of the early twenties employ the ponderous figure style forecast in the Sleeping Peasants of 1919 (p. 106). One of the earliest and most impressive of a series of colossal nudes is the Two Seated Women shown opposite. Here, as in the Two Nudes and the figure drawing (pages 52,46) of 1906, sculpturesque modeling is forced to an extreme of light and shade. The brooding melancholy of these giantesses is exceptional in a figure style as remarkable for its lack of sentiment as for its bulk.

In the same period Picasso painted a series of tempera panels of classic subjects, miniature tableaux of warriors or goddesses, composed and painted with something of the confident charm of Roman or Pompeian fresco decorations.

FOUR CLASSIC FIGURES. 1921 (dated). Tempera on wood, 4 x 6 inches. Private collection.

117

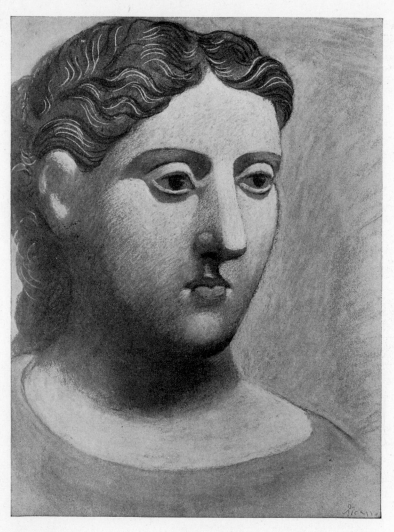

CLASSIC HEAD. September, 1921 (dated). Pastel, 25¼ x 19¼ inches. Private collection.

This colossal head suggests more than do earlier works the direct influence of sculpture of the late or provincial Hellenistic styles in which eyes and nose are modeled with an increasingly rigid and stylized formula.

The landscape, opposite, is designed in the same spirit as the classic figures, with natural forms reduced to simple, strongly modeled essentials.

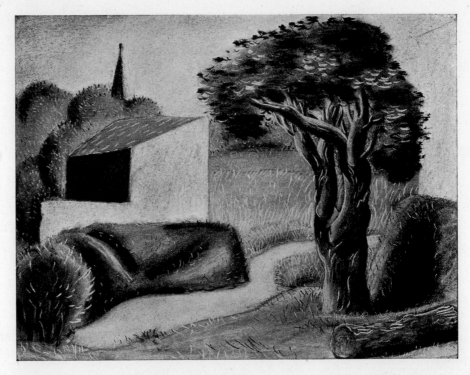

LANDSCAPE. 1921 (dated). Pastel, 19½ x 25¼ inches. Collection Walter P. Chrysler, Jr.

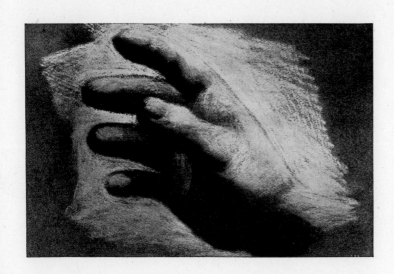

HAND. January 20, 1921 (dated). Pastel, 8¼ x 12⅝ inches. Collection Walter P. Chrysler, Jr.

Picasso's greatest cubist paintings of the early 1920's are the two versions of the Three Musicians, *reproduced on pages 122 and 123. Very close in style and period to the* Three Musicians, *though more brilliant in color, is the* Dog and Cock *reproduced opposite.* The dog which lurks like a shadow beneath the table in the vide version of the* Three Musicians *has here become the principal character, his silhouette bristling with white sawtooth fringes of hair, his violet tongue yearning toward the sprawling, scarlet-combed fowl. Both the cock and the dog reveal Picasso's power vividly to transform and intensify natural images, without sacrificing their identity.*

Like the narrow version of the Three Musicians, *the* Dog and Cock *seems compressed, too narrow for decorative comfort. But obviously Picasso was concerned more with visual dynamics than with visual repose in a composition so full of discordant angles and sharp color contrasts.*

Throughout 1921 Picasso continued to make his classic line drawings. In Women by the Sea *there is something of the ballet, something of Ingres—and behind Ingres stands Raphael.*

opposite: Dog and Cock. 1921. Oil, 61 x 30¼ inches. The Museum of Modern Art, New York, Mrs. Simon Guggenheim Fund.

Women by the Sea. April 29, 1921 (dated). Pencil, 9⅛ x 13 inches. Collection Mrs. Charles J. Liebman.

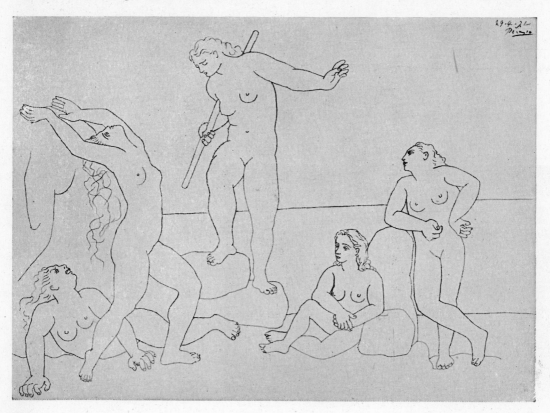

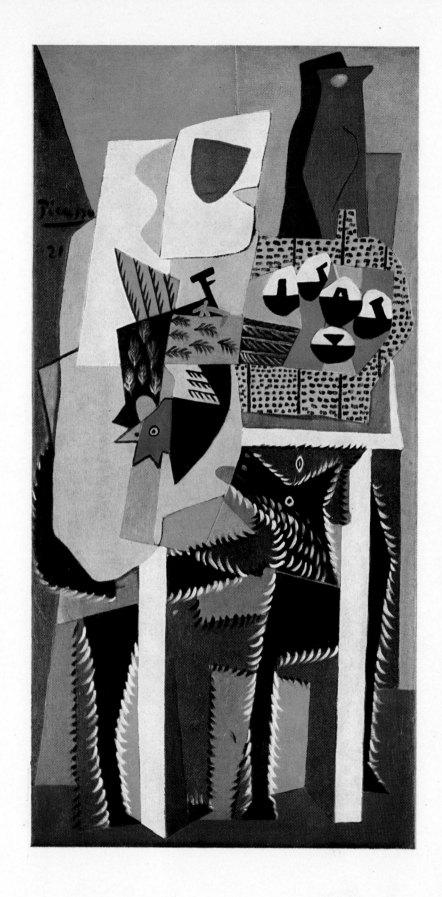

The rectangle and straight line dominated Picasso's cubist style until about 1922. Exceptions are the two paintings on this page, though they can scarcely be called cubist. Rather, they are a kind of linear calligraphy superimposed on two or three flat areas of color which are curved in the figure, rectangular in the still life.

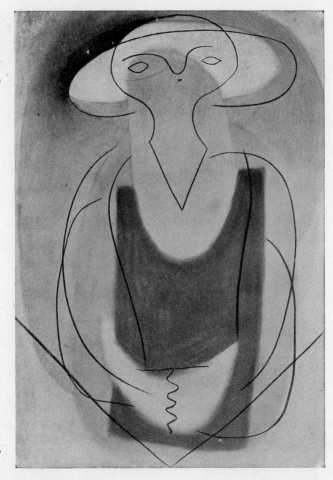

GIRL IN A YELLOW HAT. April 16, 1921 (dated). Pastel, 41¼ x 29½ inches. Collection Walter P. Chrysler, Jr.

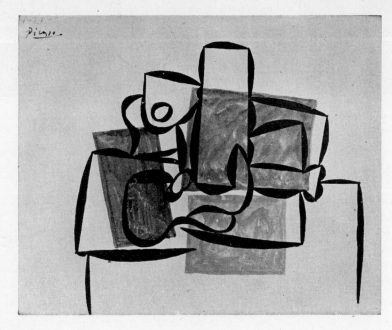

STILL LIFE. January 8, 1921 (dated). Gouache, 8¼ x 10¼ inches. Collection Walter P. Chrysler, Jr.

121

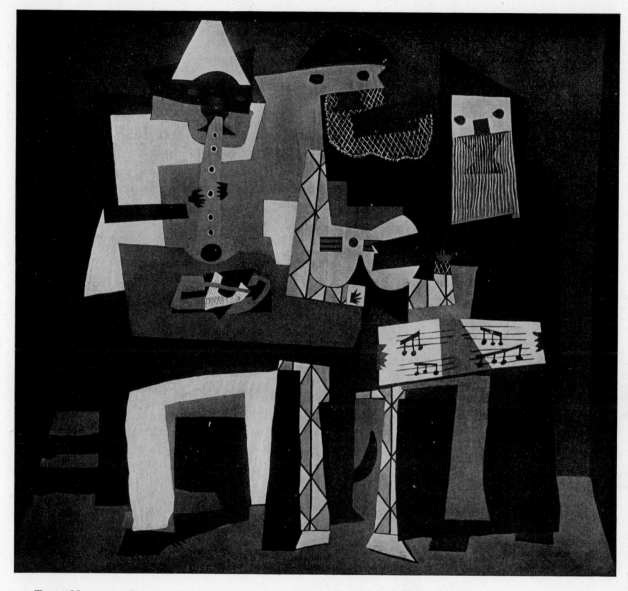

THREE MUSICIANS. Fontainebleau, summer 1921 (dated). Oil, 80¼ x 88½ inches. Private collection, on extended loan to the Museum of Modern Art, New York.

During 1921 Picasso once again gave his best energies to cubism. In fact at Fontainebleau in the summer of that year he painted two great compositions, both of them generally called the Three Musicians, *which are perhaps the high point of synthetic cubism, at least in its rectilinear phase. In both paintings three over life-size figures are seated at a table: a pierrot, a harlequin and a monk.*

*In this, the more spaciously composed version, a dog lies on the floor beneath the table. The color is rich and decorative, yet the effect is sombre; the subject is gay but the strange masks and the hieratic array of the trio give the composition a solemn, even a sinister, majesty.**

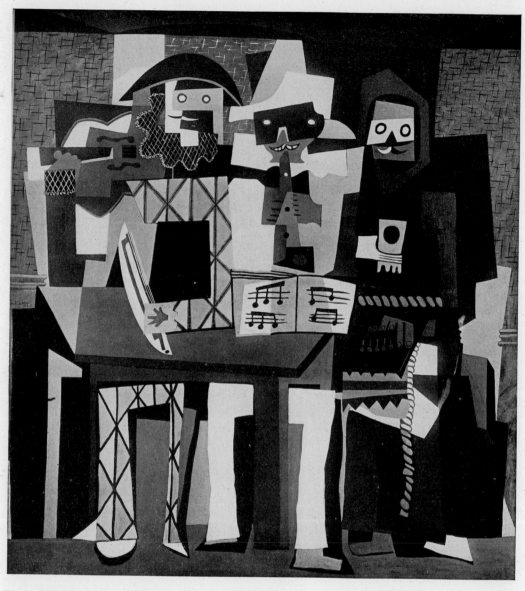

THREE MUSICIANS. Fontainebleau, summer 1921 (dated). Oil, 80 x 74 inches. Philadelphia Museum of Art, A. E. Gallatin Collection.

This other version is more complex in pattern, gayer in color. Lacking the space at the sides and the sense of depth given by the perspective lines of the floor it seems a little cramped by comparison, but gains perhaps in concentration.

There is nothing particularly new about these two great paintings. Their style descends from the cubist harlequins of the previous six years; their composition is remarkably similar to the large Three Banjo Players *exhibited in 1918 by the Polish cubist, Henri Hayden;* and even the most bizarre motive, the arm of the pierrot at the left of the wider version, may be found in a more extreme form in Picasso's own drawing done at Avignon in 1914 (p. 89). The Three Musicians are, rather, the authoritative and magnificent summing up of a style and a period.*

123

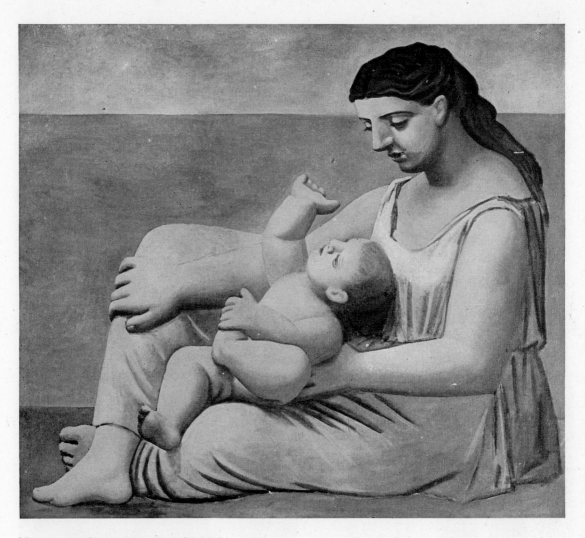

MOTHER AND CHILD. 1921. Oil, 55⅞ x 63¾ inches.

During 1921 and much of 1922 Picasso maintained the monumental character of his classic style whether in five-foot canvases like the Mother and Child or in little panels such as the Standing Nude (opposite). Usually these stone or terra cotta-colored figures are placed against a generalized background of drapery, sea, or sky which supports their effect of impassive, immutable permanence.

Though it would be hard to imagine a more impersonal monument to maternity than this Mother and Child, it may be recalled that Picasso's son was born a year or so before. He became, year by year, the model and inspiration for a long series of portraits, often, significantly, in the costumes of pierrot or harlequin.

STANDING NUDE. 1922 (dated). Oil on wood, 7½ x 5½ inches.
Wadsworth Atheneum, Hartford, Connecticut.

HEAD OF A MAN. 1922? Pastel, 25⅝ x 19¾
inches. Collection Mrs. Charles H. Russell.

125

For the most part Picasso's giantesses seem not only motionless but immovable; but when they run they shake the earth— especially when they are magnified to the size of a theatre curtain. This happened to The Race, the small panel reproduced in color, opposite. In 1924 it was enlarged for the curtain of the Diaghilev ballet Le Train Bleu and provided a ponderous preview to that spectacle of agile seaside athletics.

The Guitar, shown below, is a typical painting of the end of the period when straight lines were still dominating curves in Picasso's cubist paintings.

opposite: THE RACE. 1922. Tempera on wood, 12⅞ x 16¼ inches. Owned by the artist. This design was subsequently used for the curtain of the ballet *Le Train Bleu* produced in 1924 (see p. 275).

GUITAR. 1922 (dated). Oil, 32⅛ x 45⅞ inches. Collection Paul Willert.

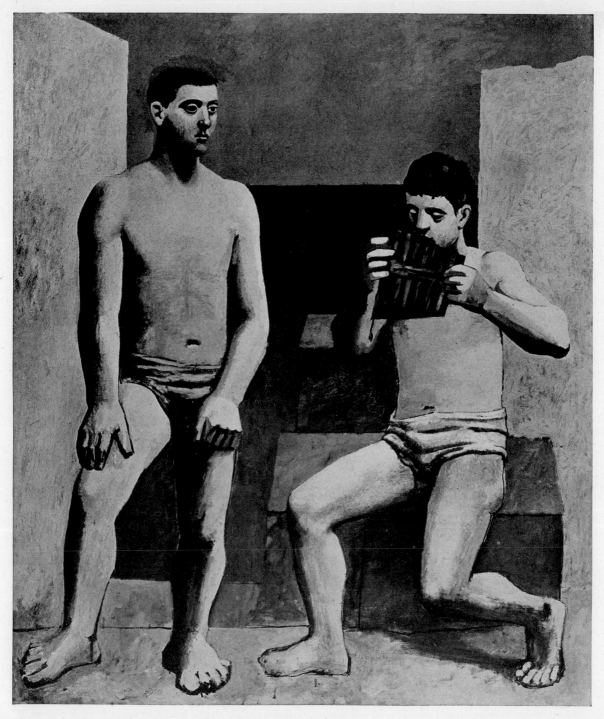

THE PIPES OF PAN. 1923. Oil, 80½ x 68⅝ inches. Owned by the artist.

Strongly modeled figures against opaque blues make The Pipes of Pan *one of the capital works of Picasso's classic period. It is also one of those most esteemed by the painter himself.**

THE SIGH. 1923 (dated). Oil and charcoal, 23¾ x 19¾ inches. Collection James Thrall Soby.

By 1923 Picasso had virtually abandoned his colossal classic nudes for a style more in keeping with the grace and elegance of traditional neo-classicism. Defying the chronic modern prejudice against prettiness and sentiment he made a series of sweet figures of women in classic draperies, mothers dandling babies, a pair of ineffable lovers, harlequins. Among these are The Sigh, which seems inspired by the ballet, and the Woman in White, which demonstrates Picasso's ability to breathe new life and charm into so exhausted a style as the neo-classic. The Woman in White is one of the most serene and least mannered paintings of the period.

128

WOMAN IN WHITE. 1923. Oil, 39 x 31½ inches. Museum of Modern Art, New York, Lillie P. Bliss Collection.

By the Sea. 1923 (dated). Oil on wood, 32 x 39½ inches. Collection Walter P. Chrysler, Jr.

The grotesque foreshortening of the running figure in the background of By the Sea suggests the snapshots of reclining picnickers whose feet are comically magnified by the camera.* But Picasso's "bather" is running, is in motion; her foot is on the shore while her head is already a hundred yards out at sea, so that the abrupt foreshortening seems the result of action in time more than the static optical distortion of the camera lens.

As a cubist, Picasso had broken up a figure or face and shown different aspects of it simultaneously in one picture, super-imposing or juxtaposing profile and full face. In By the Sea the figure keeps its continuity of form and outline; it is not broken up; rather it is stretched so that near and far, now and five seconds from now, are simultaneously represented. Thus time and space are fused in a two-dimensioned picture with vivid, though rudimentary, four-dimensional implications.

By the Sea with its reckless foreshortening is said to have been intended as a burlesque of the long tradition of solemn "bather" compositions by Cézanne, Renoir, Matisse, Friesz and others, of which a relevant example is the Matisse Women by the Sea, formerly in the Essen Museum.† That Picasso himself should be one of the most prolific producers of beach scenes in a dozen styles makes this interpretation all the more plausible.

THE END OF NEO-CLASSIC PAINTING

So far as paintings are concerned, the refined and colorless elegance of the Three Graces brings to a close Picasso's neo-classic period which had begun with such powerfully imposing paintings as the Two Seated Women of 1920.

130

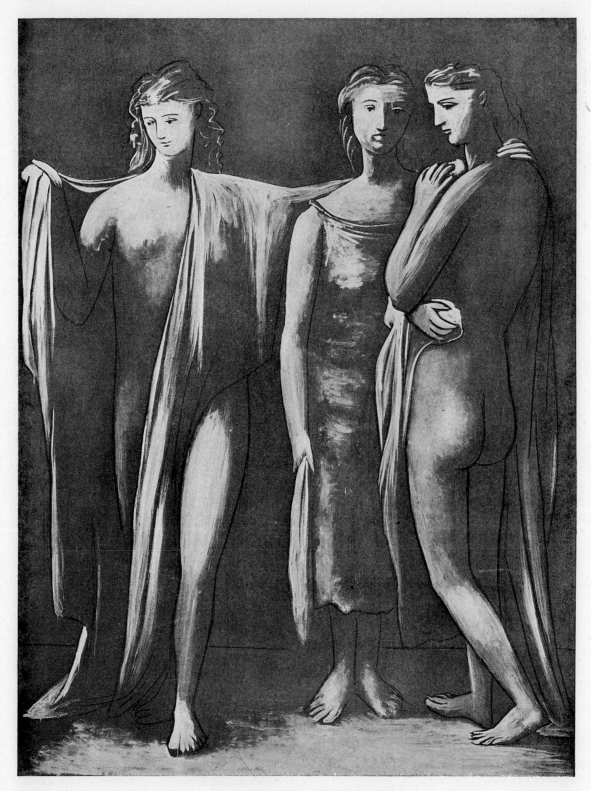

THREE GRACES. 1924. Oil and charcoal, 78⅞ x 59 inches. Owned by the artist.

WOMAN. 1922-23. Etching on zinc. 4½ x 3 inches; 2nd state (G. 99). Weyhe Gallery, New York. Published in the first fifty-six copies of *Picasso, Oeuvre, 1920-26* by Christian Zervos (bibl. 527).

CURVILINEAR CUBISM

During the year 1923, Picasso's cubism grew more and more curvilinear. This had happened once before in 1914 at Avignon (pages 89, 91). Occasionally thereafter he had composed isolated cubist or semi-abstract pictures in curves, The Girl in a Yellow Hat, for instance (p. 121). But from 1923 on the curved line dominates in Picasso's painting though not without frequent and sometimes almost complete reversion to the straight line and angle—in 1928 for example (pages 152 and 157), 1938 (p. 220) and in certain pictures of the past five years (p. 230).

The departure from the straight line and angular plane has led critics to consider Picasso's cubism at an end by 1922. Certain purists even propose 1914 as the date of cubism's demise. But cubism depends fundamentally not upon the character of the shapes—straight edged or curved —but upon the combination of other factors such as the flattening of volumes and spaces, the overlapping, inter penetrating and transparency of planes, simultaneity of points of view, disintegration and recombination, and, generally, independence of nature in color, form, space and texture—without, however, abandoning all reference to nature.

Nevertheless, whether strictly cubist or not, Picasso's preoccupation with the curved line and shapes in semi-abstract pictures was shortly to become of great stylistic importance.

Setting for the ballet *Mercure*. Paris, 1924 (or 1923) repro. from Stein, bibl. 458.

MUSICAL INSTRUMENTS. 1923 (dated). Oil, 38 x 51 inches. Collection Mrs. Patrick C. Hill.

A few of Picasso's pictures of this period take on the character of fine calligraphy, a wandering line like that in the two musicians he drew for Strawinsky's Ragtime *(p. 110), or a rapid sweeping stroke like that of* Girl in a Yellow Hat *(p. 121). In both pictures the curved line does not clearly define or bind a shape. In the etching (opposite page) curved lines create curved shapes which are further emphasized by a difference in tone. Similarly in the "movable scenery" which Picasso designed for the ballet* Mercure *are flat curved shapes radically different in character from the insistent angles of the "moving scenery" of the managers' costumes in* Parade *seven years before (p. 99, above).*

This etching and the Mercure designs are early examples of what is now called by architects and designers the "free form"— a form generated neither by compass and ruler nor by the direct imitation of natural forms but rather by the freely curving movement of the hand which creates half-accidental shapes like those of lakes and clouds or like certain organic forms such as a liver or an amoeba. Hans Arp has expressed this form the most thoroughly—and indeed "Arp shape" has gained some currency as a phrase—but Picasso's drawings of 1914 (p. 89) anticipate Arp by years and such works of the early 1920's as the Mercure scenery and Musical Instruments *(above) establish the free form more simply and positively than Arp had up to that time.*

Musical Instruments *is one of the small group of curvilinear cubist still lifes of rich pigment and strong but rather somber color.*

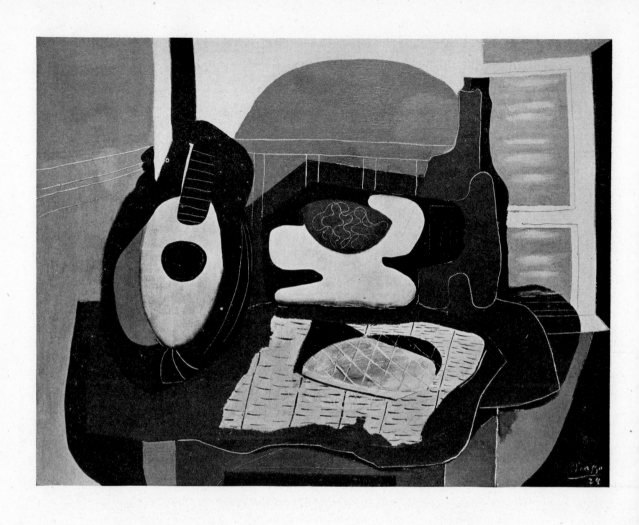

STILL LIFE WITH A CAKE. May 16, 1924 (dated on back). Oil, 38½ x 51½ inches. Museum of Modern Art, New York, acquired through the Lillie P. Bliss Bequest.

134

From 1924 to 1926 Picasso produced a series of large and magnificently colored still-life compositions. All are more or less in the cubist tradition, though often the shapes of objects are preserved without radical deformation or dissection. Still Life with a Cake comes early in the series. Its subtle, restrained color and curvilinear forms relate it to the Musical Instruments of the previous year.

The Red Tablecloth, most famous of the series, is sumptuous in color but without the over-richness of some of the compositions of the following year. Sometimes in these still lifes a single object seems to be informed by a peculiar intensity: for instance, the enigmatic shape beneath the black bust or the reticulated loaf in the picture opposite. Yet on the whole the series is objective and formal in spirit, untroubled by psychological or esthetic experiment.

THE RED TABLECLOTH. December 1924 (dated). Oil, 38¾ x 51⅜ inches. Collection Miss Micheline Rosenberg.

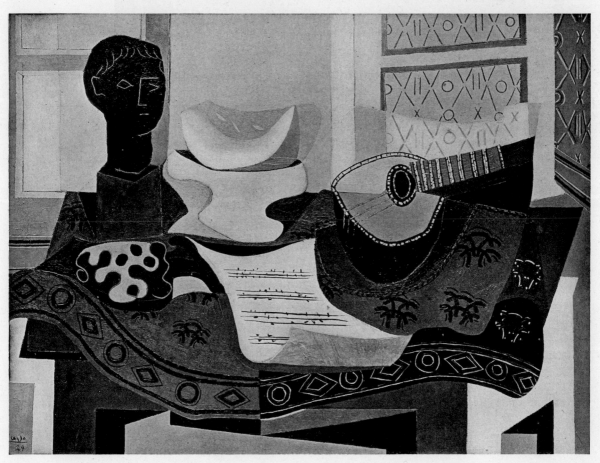

135

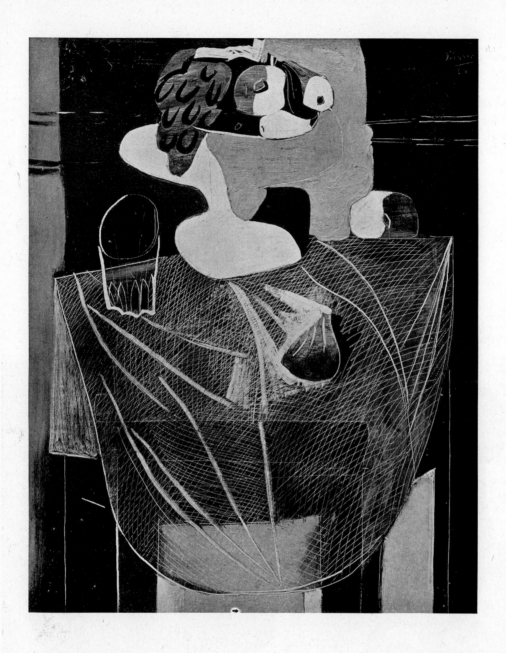

THE FISH NET. Juan les Pins, summer 1925 (dated). Oil, 39¾ x 32⅜ inches. Collection Miss Micheline Rosenberg.

The fishnet itself is achieved by scoring the dark surface of the table so that the lighter surface beneath is revealed.

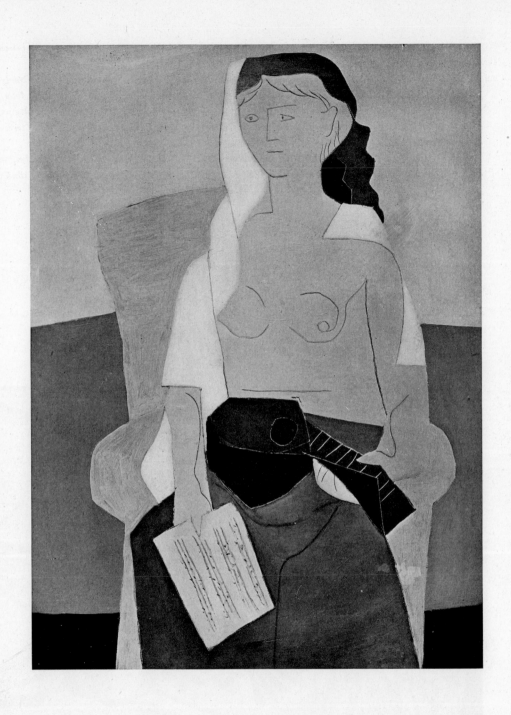

GIRL WITH A MANDOLIN. 1925 (dated). Oil, 51⅜ x 38⅝ inches. Collection Lt. Alexandre Paul Rosenberg.

Though not large the Ram's Head *is remarkable for its concentrated, bristling energy, and the rather sinister character of the dead animal's visage surmounting the miscellany of marine fauna.*

In The Studio *Picasso returns to the right angle and straight line in the most compactly and intricately organized of the group. The fragments of sculpture—arms and head—reappear in a very different rôle twelve years later in the* Guernica *(p. 200). The architecture in the background which seems to imply a view through a window is actually part of the still life since it was based upon a toy theatre belonging to Picasso's son.* Picasso has translated it into cubist terms not unlike those he used for the* Pulcinella *setting five years before.*

Both The Studio *and the* Ram's Head *are extremely rich in color, in form and even in texture. The great still-life series continues throughout the rest of 1925 and into 1926, even after the* Three Dancers, *a painting very similar in color but so radically different in spirit that it marks the beginning of a new period in Picasso's work.*

RAM'S HEAD. Juan les Pins, summer 1925 (dated). Oil, 32⅛ x 39½ inches. Private collection.

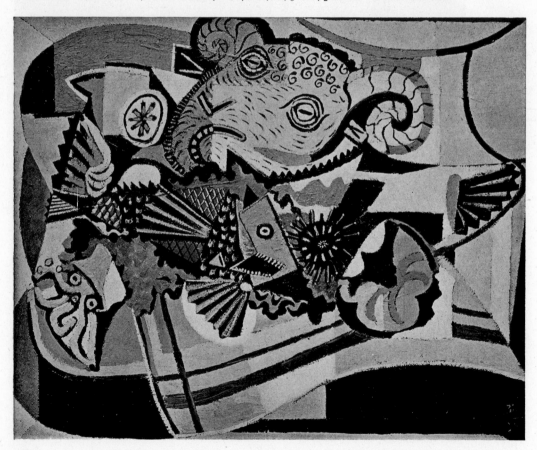

138

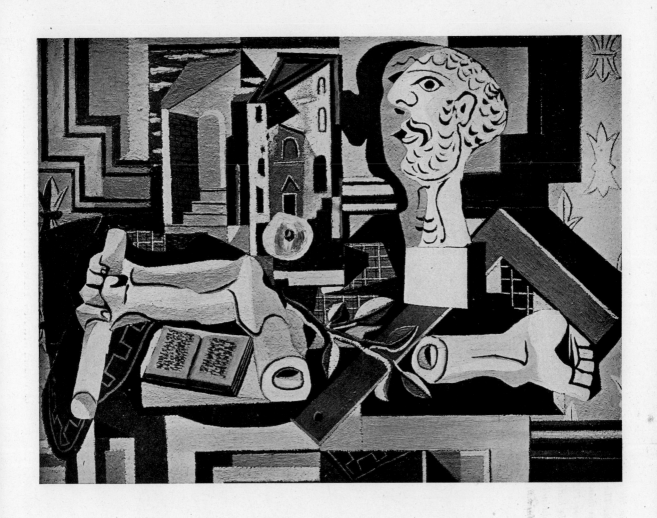

The Studio. Juan les Pins, summer 1925. Oil, 38⅝ x 51⅝ inches. Private collection.

Although Picasso no longer used his "classic" figure style in his paintings after 1924 he maintained it in his line drawings and prints. The series of ballet drawings done in 1925 is more fluent and spontaneous than the comparatively calculated drawings of similar subjects made before 1920 (pages 97, 101). Picasso was in Monte Carlo early in 1925 during the ballet season* but after these drawings his interest in the ballet seems to have dwindled, giving way to a much more personal and radical interpretation of the human figure.

140

THREE DANCERS RESTING. 1925 (dated). Ink, 13¾ x 9⅞ inches. Collection Miss Micheline Rosenberg.

left: FOUR BALLET DANCERS. 1925 (dated). Ink, 13½ x 10 inches. Museum of Modern Art, New York, gift of Mrs. John D. Rockefeller, Jr.

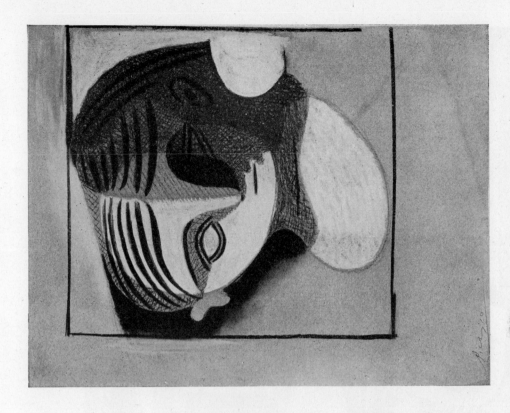

HEAD. 1926. Charcoal and white chalk. 25 x 19 inches. Collection Walter P. Chrysler, Jr. Study for a head in *L'Atelier de la modiste*, 1926.

left: READING (LA LECTURE). 1926. Lithograph, 13 x 9⅞ inches (G. 242). Museum of Modern Art, New York, gift of Mrs. John D. Rockefeller, Jr.

The lithograph, doubtless of Picasso's son, is much more circumstantial than the rather abstract Head at the right, but in both Picasso makes his linear design play behind light and shadow.

In the Head dark and light make a more positive pattern. The cubist device of combining full face and profile is here partly rationalized by turning the shaded half of the face into a profile as if it were a cast shadow, though in the reverse direction.

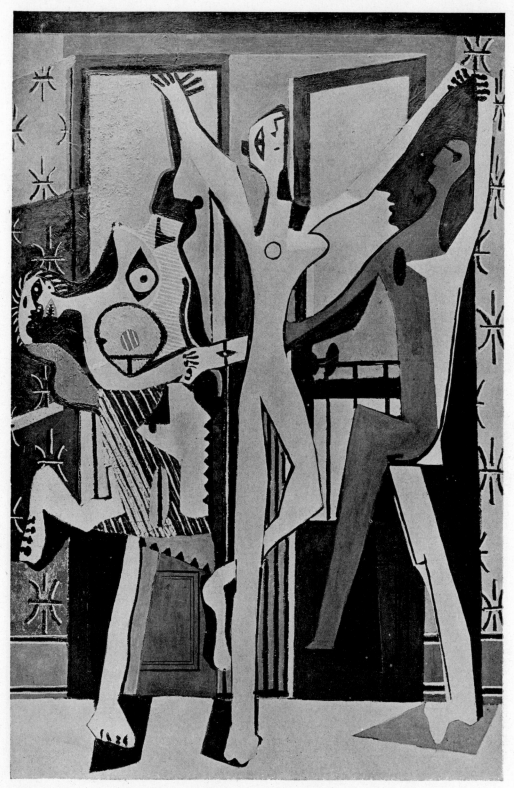

THREE DANCERS. 1925, Oil, 84⅝ x 56¼ inches. Owned by the artist.

"CONVULSIVE" AND "DISQUIETING"

The Three Dancers, *painted only a year later than the* Three Graces *(p. 131), comes as a sudden and surprising interruption to the series of monumental still-life compositions and flat linear figures like the* Girl with a Mandolin *(p. 137). Instead of static, mildly cubist decoration, the* Three Dancers *confronts us with a vision striking in its physical and emotional violence. Seen objectively as representations of nature, cubist paintings such as the* Three Musicians *of 1921 are grotesque enough (pages 122, 123)—but their distortions are comparatively objective and formal whereas the frightful, grinning mask and convulsive action of the left-hand figure of the* Three Dancers *cannot be resolved into an exercise in esthetic relationships, magnificent as the canvas is from a purely formal point of view. The metamorphic* Three Dancers *is in fact a turning point in Picasso's art almost as radical as was the proto-cubist* Demoiselles d'Avignon *(opp. p. 54). The convulsive left-hand dancer foreshadows new periods of his art in which psychologically disturbing energies reinforce or, depending on one's point of view, adulterate his ever changing achievements in the realm of form.*

This new and disturbing spirit in Picasso's work shows itself again, though very differently, in the large collage Guitar. *The strings are real strings but the guitar itself is a rectangle of coarse sack cloth pierced by nails, their points out. This guitar differs not only from the decorative instruments in the still lifes of the previous few years but also from the superficially similar pasted or constructed cubist guitars of 1912-14. The aggressive nails go beyond the cubist esthetics of "texture": they are psychologically, almost physically, disquieting.*

"Convulsive" and "disquieting" were favorite adjectives of praise among the surrealists whose leader, André Breton, had published his first Manifesto of Surrealism *in 1924. A year earlier Picasso had twice etched Breton's portrait.*

GUITAR. 1926 (P). Sackcloth with string, pasted paper, oil paint, and cloth pierced by two-inch nails, points out; 51¼ x 38¼ inches. Owned by the artist.

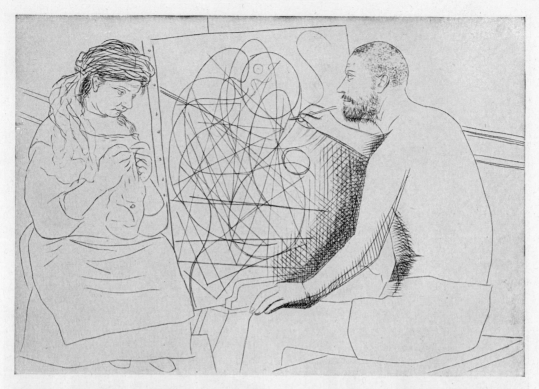

PAINTER WITH A MODEL KNITTING. 1927. Etching, 7⅝ x 11⅜ inches (G. 126). Illustration for Balzac: *Le Chef-d'oeuvre inconnu*, Paris, Vollard, 1931 (see page 277). Museum of Modern Art, New York, gift of Henry Church.

opposite: INK DRAWING. 1926. Subsequently reproduced by wood engraving in Balzac: *Le Chef-d'oeuvre inconnu*, see p. 277.

During 1926 Picasso filled a sketch book with ink drawings unlike any he had made before. They are constellations of dots connected by lines or, better, lines with dots where the lines cross or end. A few vaguely suggest figures or musical instruments, others seem abstract. Some are small and simple, arranged three or four to a sheet; some like the one opposite grew and spread over the page. All seem done absentmindedly or automatically as if they were doodles.

Later, sixteen of the pages were reproduced by woodcut as a "kind of introduction" to a special edition of Balzac's Le Chef-d'oeuvre inconnu, published in 1931 by Vollard. In this volume, one of the most remarkable illustrated books of our time, Vollard printed woodcuts of many other Picasso drawings both cubist and classic.

Picasso also made a dozen etchings especially for Le Chef-d'oeuvre inconnu. The one above comes nearest illustrating Balzac's story of the mad old painter who spent ten years upon the picture of a woman, little by little covering it over with scrawlings and daubings until what seemed to him a masterpiece was to others meaningless.

Curiously, Balzac's tale begins in the year 1612 before a house on the rue des Grands-Augustins, the very street where Picasso was to take a 17th century hôtel for a studio in 1938.

145

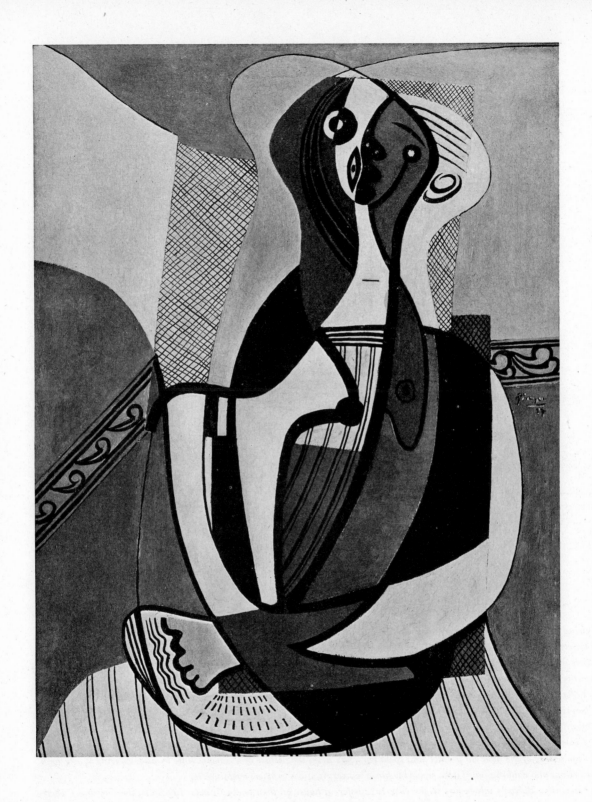

SEATED WOMAN. 1926-27 (dated on back). Oil, 51½ x 38½ inches. Museum of Modern Art, New York.

146

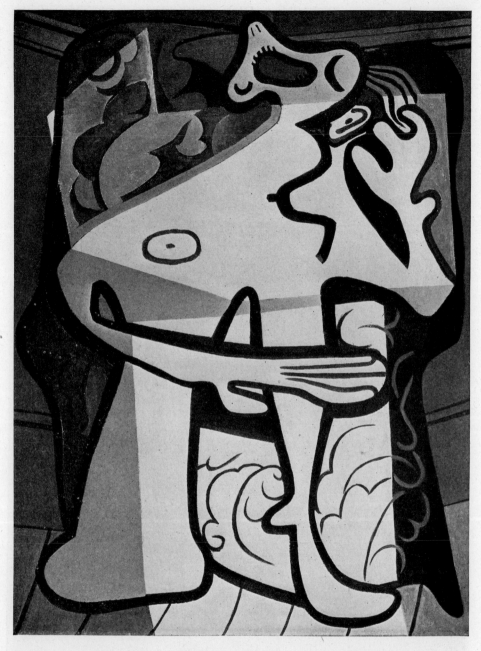

WOMAN IN AN ARMCHAIR. January 1927 (dated on back). Oil, 51⅜ x 38¼. Owned by the artist.

These two paintings of seated women carry into fluid arabesques the deformations announced in the left hand figure of the Three Dancers (p. 142) but without the kinetic effect of the Three Dancers.

In subject the Woman in an Armchair anticipates the long series of sleeping women which preoccupied Picasso in 1932; in conception it is one of the earliest of Picasso's grotesque post-cubist metamorphoses. It is also remarkable for its suggestion of a spotlight falling on the figure, comparable to the effect of light in the lithograph of the previous year (p. 141): in both the beam makes a field of light and dark against which Picasso weaves his linear design.

147

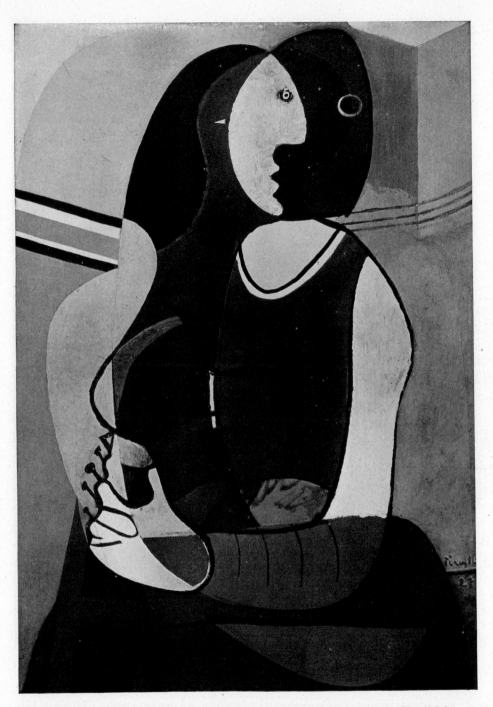

SEATED WOMAN. 1927 (dated). Oil on wood, 51⅛ x 38¼ inches. Collection James Thrall Soby.

The complex arabesque of curves of the Seated Woman (p. 146) is simplified in this version of the same subject.

Picasso's power of inventing masks is here remarkably demonstrated: a great curving band sweeps upward to terminate in the frightening white profile which is then both intersected and magically extended by the black, axe-bladed, disc-eyed shadow.

This is one of the most awe-inspiring of all Picasso's figure paintings.

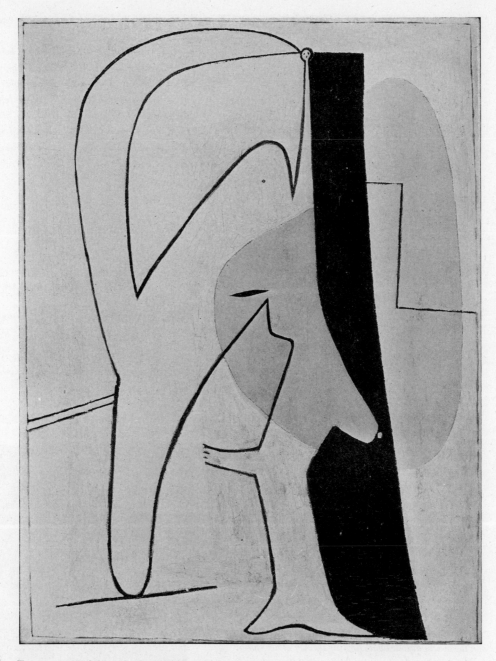

FIGURE. 1927. Oil on plywood, 51⅛ x 38⅛ inches. Owned by the artist.

In 1927 Picasso began to paint figures and heads in which the anatomy is distorted and dislocated with an extravagance exceeding even that of the Woman in an Armchair (p. 147). In the Figure reproduced above the human form has undergone a metamorphosis so radical that foot, head, breast and arm are not readily recognizable. Only a few rather isolated drawings of 1914 anticipate such fantastic anatomy (p. 89). But the design of the Figure in its severity and firmness also recalls the finest cubist papiers collés (pages 80, 88).

149

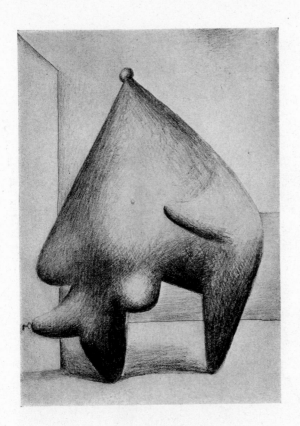

them placed along the promenade de la Croisette (bibl. 529, p. 342).

It is probable that Picasso who was being courted by the surrealists at this time may have seen the early paintings of Tanguy; he surely knew the metamorphic figure paintings of his friend, Joan Miro. Possibly he felt the influence of the younger men but in any case these two series of sculptural drawings anticipate remarkably some of the biomorphic or organic abstractions and "human concretions" done by sculptors during the past fifteen years.

left: BATHER. Cannes, summer 1927. Charcoal. Owned by the artist. Repro. from *Cahiers d'Art*, vol. XIII, 1938.

below: FIGURE. Paris, early 1928. Bronze. Owned by the artist.

opposite: DESIGN FOR A MONUMENT. Dinard, July 28, 1928 (dated). Ink. Repro. from *Cahiers d'Art*, vol. IV, 1929.

METAMORPHIC DRAWINGS AND SCULPTURE

During the previous fifteen years almost all Picasso's cubist and metamorphic paintings, as opposed to his more classic or traditional works, had been flat designs with little or no modeling and perspective. At Cannes in the summer of 1927 he suddenly translated flat figures such as the Woman in an Armchair (p. 147) and the Figure (p. 149) into strongly modeled forms which give a bold three-dimensional effect. The charcoal drawing illustrated above is one of an extraordinary series of variations in which Picasso carried his passion for metamorphosis further than ever before. Each drawing represents a bather on the beach; the one above turning the key of her cabin.

During the following winter he carried the sculpturesque style of the Cannes drawings into actual sculpture (right), his first perhaps since the Glass of Absinthe of 1914 (p. 90).

Then at Dinard in the summer of 1928 he made a new series of drawings which he conceived as designs for a row of "monuments"—an idea which, Zervos states, had first come to him the year before at Cannes when he imagined

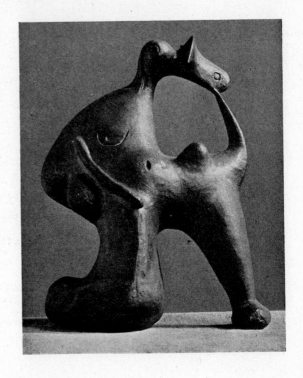

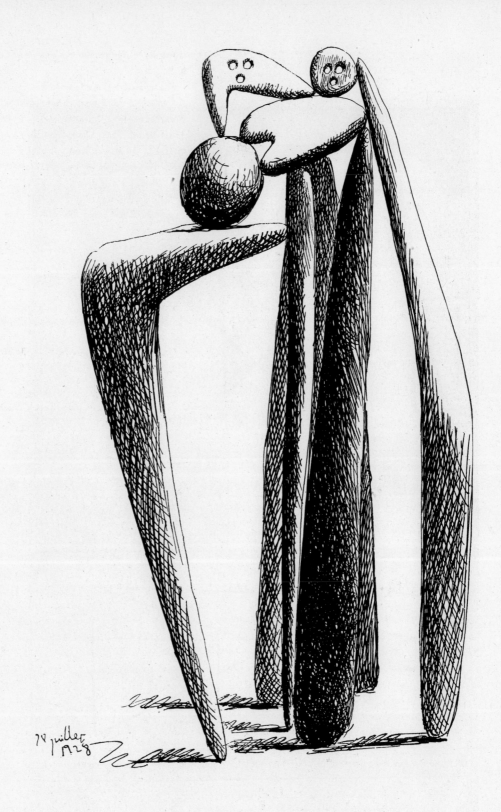

THE STUDIO. 1927-28 (dated on back). Oil, 59 x 91 inches. Museum of Modern Art, New York, gift of Walter P. Chrysler, Jr.

Though soft organic curves characterize much of Picasso's work of the later '20s, in a few works he passed to the opposite extreme. The Studio, a large, precisely calculated composition of straight lines and rectangles once more recalls cubism of 1912-13 (pages 78, 80). At the left is the painter, brush in hand; at the right a table covered by a red cloth on which rests a bowl of fruit and a white plaster bust, a subject somewhat comparable to the The Studio (p. 139) but handled here with ascetic economy.

Early in 1928 Picasso made what was probably his first sculpture in many years. In the fall he was working again on constructions: "guitars" made out of painted metal rather like the paper ones of 1912 (p. 86); and metal constructions in radically new forms such as the one in light iron rods reproduced at the left. Its spare linear character relates it to some of the paintings of the period, notably The Studio above. It makes one think, too, of the line and dot drawings of 1926 used to adorn Le Chef-d'œuvre inconnu. Constructed shortly after the summer of 1928 it may also bear some relation in its compositional lines to the series of ball-playing bathers* painted at Dinard (p. 157).

Years before, Rodchenko and the Russian constructivists had made space diagrams of metal and wood but never with the lyrical tension of this construction by Picasso (bibl. 313, p. 134).

CONSTRUCTION. Autumn 1928. Iron wire, about 30 inches high. Owned by the artist.

above: HEAD OF A WOMAN. 1928. Oil and sand, 21⅝ x 21⅝ inches. Owned by the artist.

right: HEAD. 1928. Oil, 21¾ x 13 inches. Private collection.

In these two paintings teeth, hair, eyes, nose and breasts are redistributed with a practised virtuosity.

Himself a past master of metamorphosis, Picasso accepts and modifies a classic case, the Minotaur, a man-beast which in the 1930s he used again and again. Though a painting, the Running Minotaur suggests a pasted paper technique even more than the Figure (p. 149) to which it is related in style; the line is, however, much freer, recalling the ballet drawings of 1925 (p. 140). A very similar figure actually done with pasted paper was used as a cartoon for a large Gobelin tapestry woven in 1936.

PAINTING (RUNNING MINOTAUR). April 1928 (dated on back). Oil, 63¾ x 51¼ inches. Owned by the artist.

155

THE PAINTER AND HIS MODEL. 1928 (dated). Oil, 51⅝ x 63⅞ inches. Collection Sidney Janis.

Similar in subject to the somewhat earlier Studio *(p. 152)* The Painter and His Model *is more elaborate and concentrated. The painter sits at the right, brush or palette knife in his right hand, palette in his left. At the left is the model. Between them is the canvas on which the artist has drawn a profile which is conventionally realistic in contrast to the heads of the painter and model. By doing this Picasso, with a certain humor, reverses the normal relationship of art and "nature" such as is shown in the Balzac etching (p. 145). Of this painting Harriet Janis has made an interesting though in part debatable analysis (bibl. 313, p. 101).*

The Head, opposite, is clearly of the same race as the tripod-like artist in The Painter and His Model.

At Dinard in the summer of 1928 Picasso painted a famous series of small beach scenes such as this one in which three bathers toss a ball in front of a cabin. Possibly the Dinard series is reminiscent of Le Train Bleu, *the Diaghilev-Cocteau ballet which had interested Picasso. In this ballet, dancers in striped bathing suits carried on seaside athletics before two cubist bathing cabins in a setting designed by the sculptor Henri Laurens.* However, Picasso had been composing ballet-like beach scenes for many years (p. 120) and had even put his figures in striped bathing suits six years before Chanel's costumes for* Le Train Bleu *(p. 106). Picasso's bathing cabins are not cubist but cryptic (pages 150, 158).*

156

ON THE BEACH. Dinard, August 19, 1928.
Oil, 7½ x 12¾ inches. Collection George
L. K. Morris.

HEAD. October 1928. Construction
in painted metal, about 10 inches
high. Owned by the artist.

157

Through the end of the decade Picasso continued to work in both his classic and metamorphic styles. The lithograph at the left is striking for its "closeup" cutting. In the thirty etchings done for Ovid's Metamorphoses, Picasso revived the neo-classic tradition of illustrating Greek and Roman authors by outline drawings which Flaxman had popularized more than a hundred years before. However, Flaxman's inflexible academic contours are superseded by easy flowing lines which follow the profiles of limbs and trunks with effortless distortion. The spirit and even the composition have little to do with Wedgwood neo-classic but seem more related to the congested, flaccid sarcophagus reliefs of the Antonine sculptors.

The lithograph, Figure, is a 1929 version of the metamorphic bather before her cabin. It may be compared with its 1928 and 1927 predecessors (pages 157 top, 150).

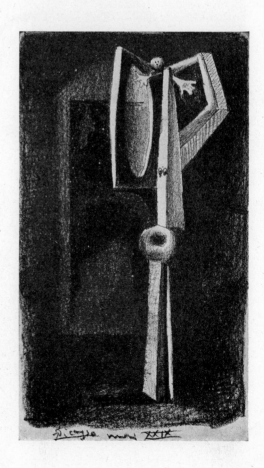

above: FACE. 1928. Lithograph, 8 x 5½ inches (G. 243). Museum of Modern Art, New York, gift of Mrs. John D. Rockefeller, Jr.

FIGURE. May, 1929. Transfer lithograph, 9 x 5¼ inches (G. 246). Published for subscribers to the review *Le manuscrit autographe*, Paris, A. Blaizot et fils. Plate *hors-texte* of no. 21, May-June 1929. Collection Jean Goriany.

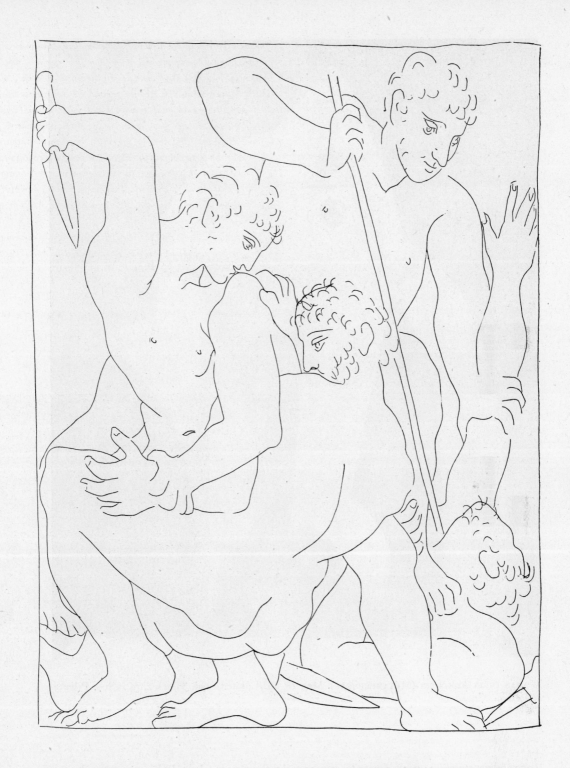

COMBAT OF PERSEUS AND PHINEUS OVER ANDROMEDA. 1930. Etching, 8¾ x 6⅝ inches (G. 152). Illustration for Ovid: *Les Métamorphoses*, Lausanne, Skira, 1931 (see p. 277). Museum of Modern Art, New York, gift of James Thrall Soby.

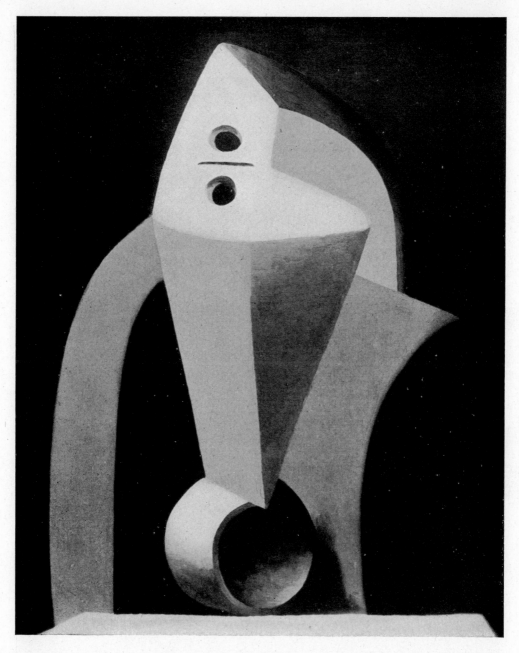

WOMAN IN AN ARMCHAIR (MÉTAMORPHOSE). May 13, 1929 (dated). Oil, 36⅜ x 28¾ inches. Private collection.

Two paintings of similar subjects done in the same year; the one serene in color, calm as a monument; the other a convulsively racked and scrambled form flung against harsh reds and greens. Compare the figure opposite with the Woman in an Armchair *of 1927 (p. 147) and the left-hand figure of the* Three Dancers *of 1925 (p. 142).*

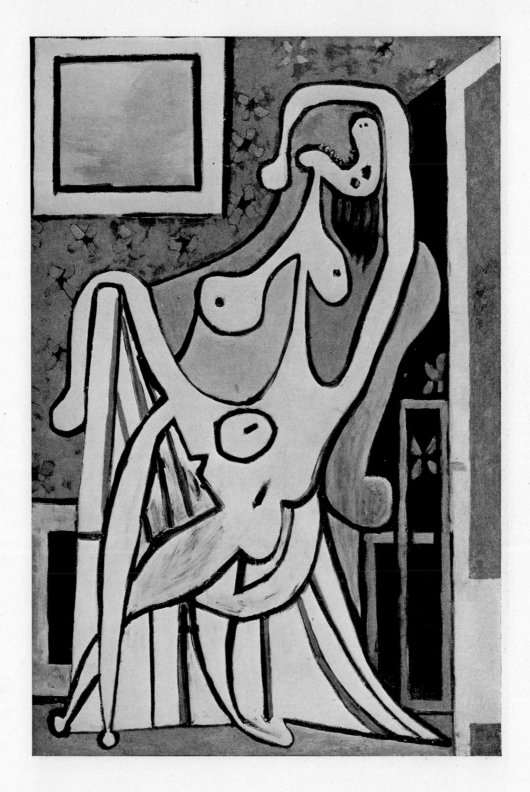

WOMAN IN AN ARMCHAIR. May 5, 1929 (dated on back). Oil, 76¾ x 51⅛ inches. Owned by the artist.

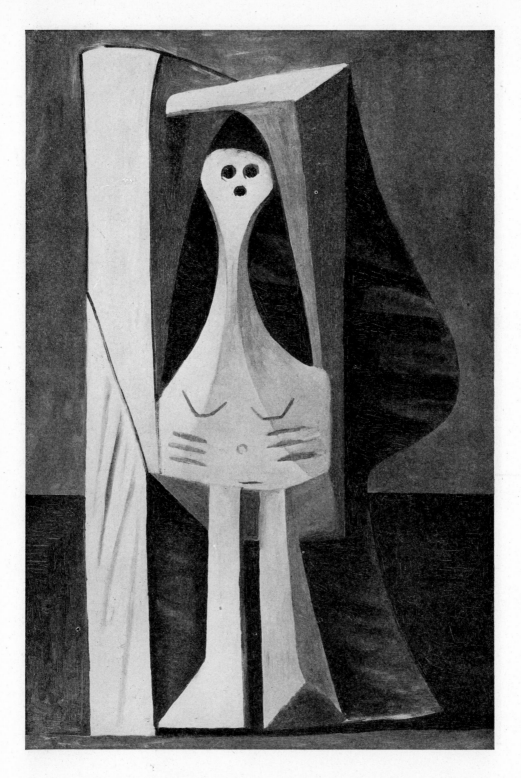

*Picasso's renewed interest in abstract sculptural form, which first showed itself in the drawings made at Cannes in 1927,
scarcely touched his painting until 1929 when it appears in several large figures such as the bathers on these pages. Some of
the paintings like the one opposite are called "bone" pictures because of their superficially skeletal character.*

162

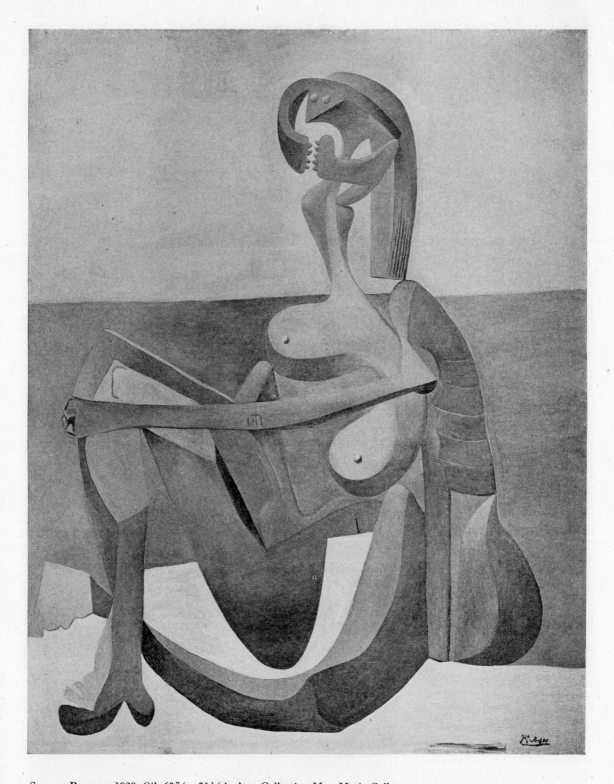

SEATED BATHER. 1929. Oil, 63⅞ x 51⅛ inches. Collection Mrs. Meric Callery.

opposite: STANDING BATHER. May 26, 1929 (dated on back). Oil, 76¾ x 51⅛ inches. Owned by the artist.

SWIMMING WOMAN. November 1929 (dated on back). Oil, 51⅛ x 63⅞ inches. Owned by the artist.

Picasso has composed the Swimming Woman *so that it may be hung with any edge up. The head is also a visual pun for a pointing hand.*

The Object with a Glove *was done by the sea during the summer. The hand, made from a glove, the head of bent felt, the hair of raveled cloth are all coated with sand. The head resting on the hand often appears in Picasso's art after the peasant drawing of 1919 (p. 106) but here in one composition abstract head and realistic hand are piquantly juxtaposed.**

OBJECT WITH A GLOVE (BY THE SEA). Juan les Pins, August 22, 1930 (dated on back). Various materials covered with sand, 10⅝ x 13¾ inches. Owned by the artist.

164

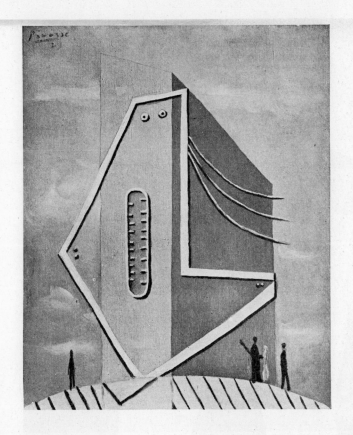

PROJECT FOR A MONUMENT (WOMAN'S HEAD).
1929 (dated). Oil.

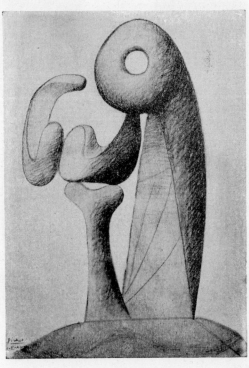

Picasso continued to play with the idea of translating his
paintings into monuments in sculpture or architecture
(above). The clouds in the sky and the tiny figures around
the base give scale to the immense head of a woman smiling
vertically like a sphinx awry.

At the right the "monument" is conceived in terms of
gigantic, magically balancing bone-like forms, set high on
a mound.

PROJECT FOR A MONUMENT (MÉTAMORPHOSE). Febru-
ary 19, 1930 (dated). Oil on wood, 26 x 19⅛ inches.
Collection Mrs. Meric Callery.

165

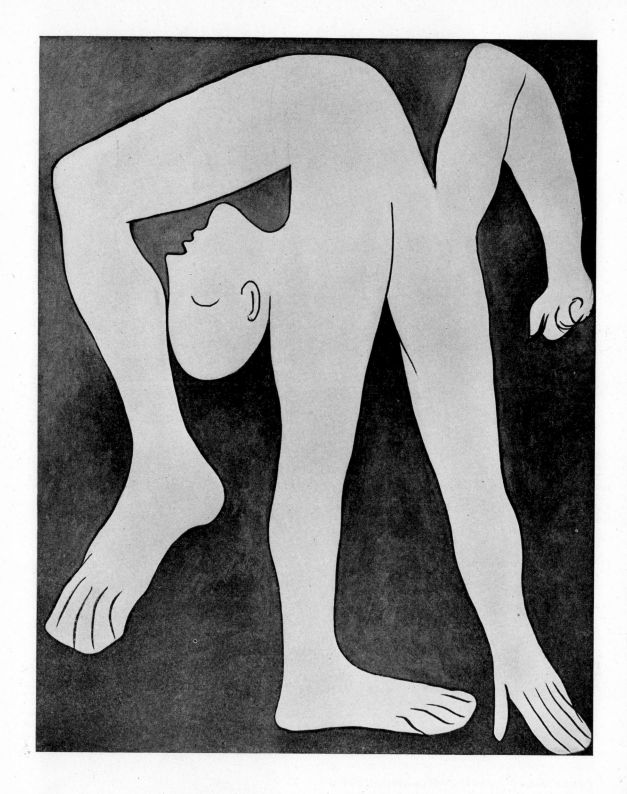

Acrobat. Janaury 18, 1930 (dated on back). Oil, 63⅞ x 51⅜ inches. Owned by the artist.

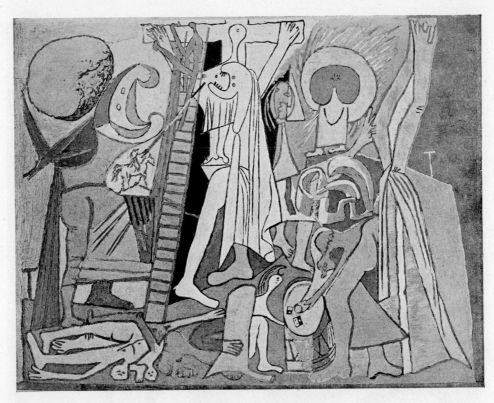

CRUCIFIXION. February 7, 1930 (dated on back). Oil on wood, 20 x 26 inches. Owned by the artist.

The Crucifixion is a small picture but it is unique among Picasso's paintings of this period because of its subject, its involved composition and its complex color harmonies of brilliant reds and yellows shot with blue and blue-green. The composition seems to be a potpourri of traditional iconography. The figure on the ladder driving a nail, the miniature mounted figure delivering the lance thrust, the soldiers in the foreground throwing dice on a drum head for Christ's cloak—these motives are fairly clear. At the extreme left and right are the empty T-crosses of the two thieves whose bodies, apparently, are those lying in the left foreground. The rough round shape in the upper left hand corner is perhaps the vinegar-soaked sponge, enlarged to gigantic size and isolated like one of the objects in the traditional paintings of the symbols of the Passion. The strange figure standing on the structure to the right of the cross is directly related to the contorted Magdalen in some extraordinary studies of 1929 (bibl. 79, plate 124 ff).

This fantastic Calvary seems entirely devoid of religious significance. Yet its strange mixture of styles, its violent distortions, its richness of invention and the concentrated intensity of its color suggest that it must have had some special significance to the painter.

*Picasso had drawn and painted a rather generalized entombment long before, in 1901, but since then he had probably not touched religious subject matter until 1927 when he began to make drawings for a crucifixion in a curvilinear, metamorphic style, the gigantic arms of Christ stretching the full width of the paper (bibl. 91, pp. 49, 51). He made further drawings in 1929, including the Magdalen studies mentioned above. Picasso was to return again to the Crucifixion subject in 1932, constructing the figures in the bone-and-stone style of the 1929 monument projects (p. 165). These later drawings are based on the Isenheim altarpiece of Matthias Grünewald, the great contemporary of Dürer (bibl. 354, pp. 30-32). In the painting reproduced here there is perhaps something of Grünewald in the agonized upraised arms at the right.**

167

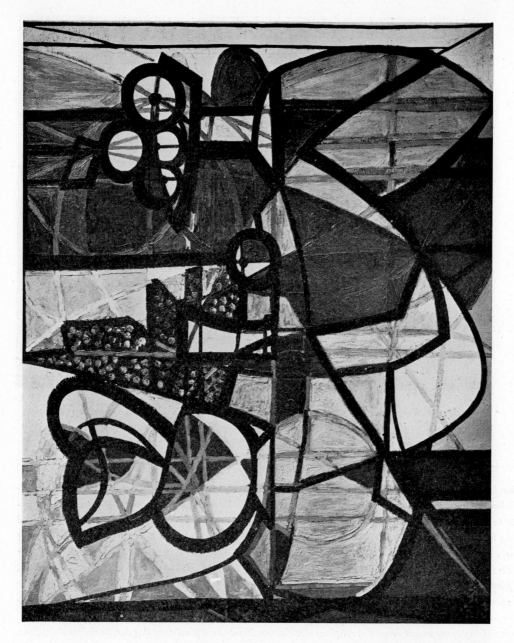

In 1931 Picasso painted a
series of large still lifes and in-
teriors using a kind of curvi-
linear cubist method of compo-
sition. This, one of the finest,
recalls medieval stained glass
in color and in the use of heavy
black lines resembling leading.

The large painting Figure
Throwing a Stone, below, is re-
lated to some of the sculpture of
the period such as the piece
shown in the left foreground of
the view of Picasso's studio
(p. 179).

PITCHER AND BOWL OF FRUIT. February 22, 1931 (dated). Oil, 51½ x 64 inches. Collection Henry P. McIlhenny.

168

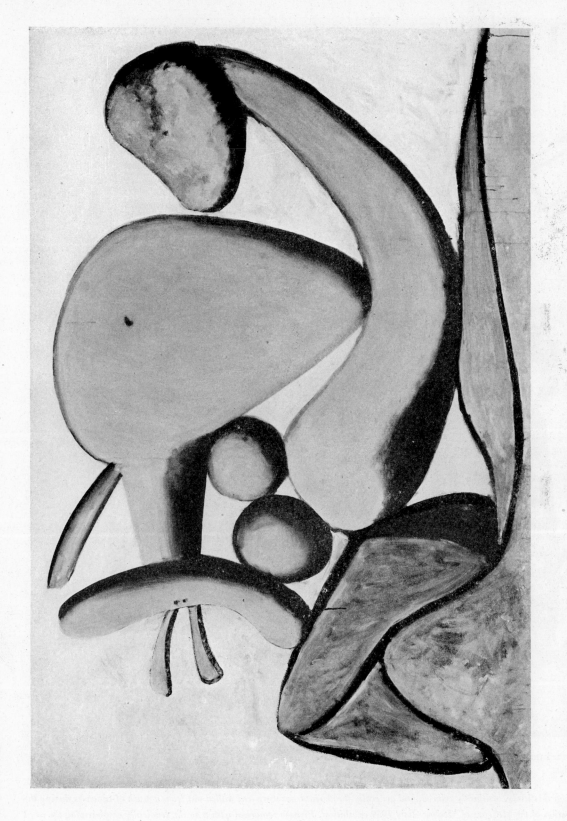

FIGURE THROWING A STONE. March 8, 1931 (dated on back). Oil, 51¼ x 76⅝ inches. Owned by the artist.

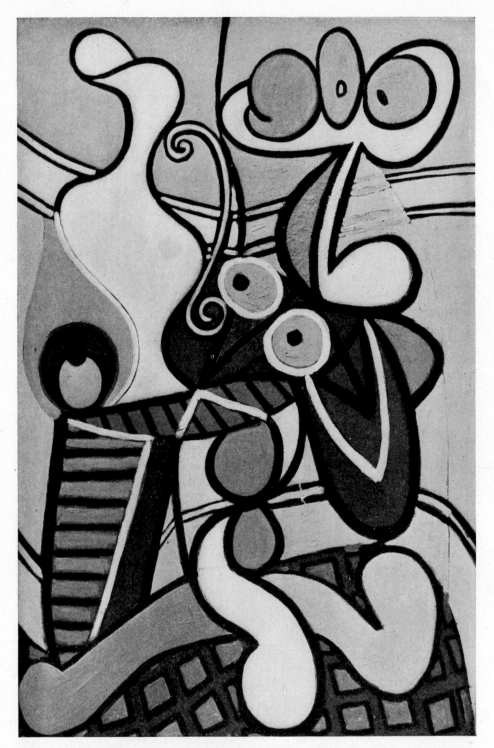

STILL LIFE ON A TABLE. March 11, 1931 (dated on back). Oil, 76¾ x 51⅛ inches. Owned by the artist.

When this lively, brilliantly colored, and generally flamboyant painting was pulled out from a stack of canvases during the selection of the Museum of Modern Art's 1939 exhibition, Picasso remarked with a smile, ironically emphasizing the word "morte": "En voilà une nature morte."

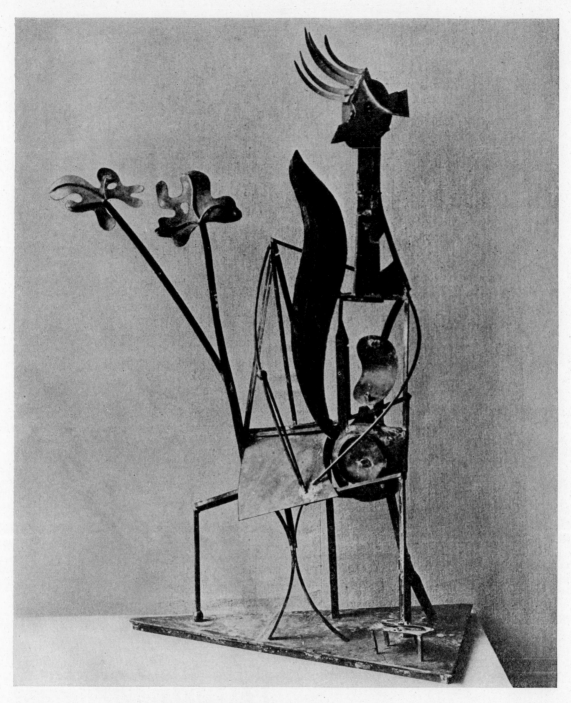

CONSTRUCTION. c. 1931. Wrought iron, 82¾ inches high. Owned by the artist.

With the help of his old friend the sculptor and master "blacksmith" Julio Gonzalez, Picasso made several wrought iron constructions in 1930 and '31. The largest and most complicated of them is the one illustrated above. It combines a semi-abstract head with wire-like geometrical forms and the naturalistic leaves of a philodendron. Gonzalez writes of Picasso's great pleasure and excitement while working on such constructions.* After it was exhibited at the big Picasso show of 1932 a bronze cast was placed out of doors near Boisgeloup (bibl. 67, p. 20, photo).

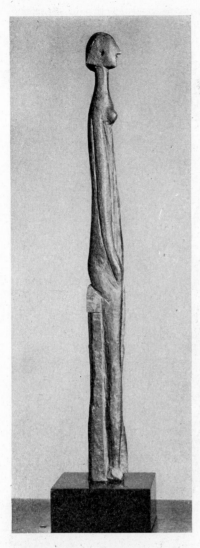

This small elongated figure is one of half a dozen similar figures whittled out of pieces of frame molding in 1931, though not exhibited until 1936 after it had been cast in bronze (bibl. 197, pp. 189-191).

Although the slender figure recalls certain archaic Etruscan bronzes the originality of these two pieces—the sculpture and the construction on the page before—is remarkable. Yet each represents a passing and isolated moment in Picasso's art. He was shortly to begin, perhaps had already started a much more sustained period of work in sculpture (pages 179-182).

Two drawings (below) dramatically illustrate on the same sheet of paper two of the several styles in which Picasso worked in 1932. The sketch at the left is a study for the canvas, Figure in a Red Chair (opposite).

SEATED WOMAN AND BEARDED HEAD. 1932. Ink and pencil. 11⅛ x 10⅛ inches. Collection Walter P. Chrysler, Jr.

FIGURE. 1931. Bronze, cast from whittled wood, 21½ inches high. Collection Mrs. Meric Callery.

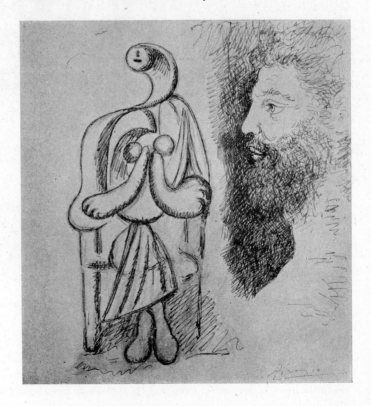

172

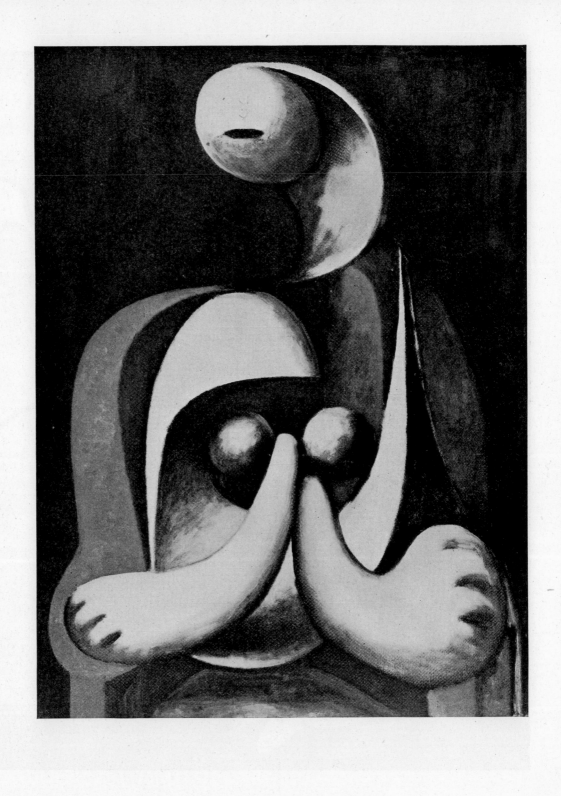

FIGURE IN A RED CHAIR. 1932. Oil, 51⅛ x 38¼ inches. Owned by the artist.

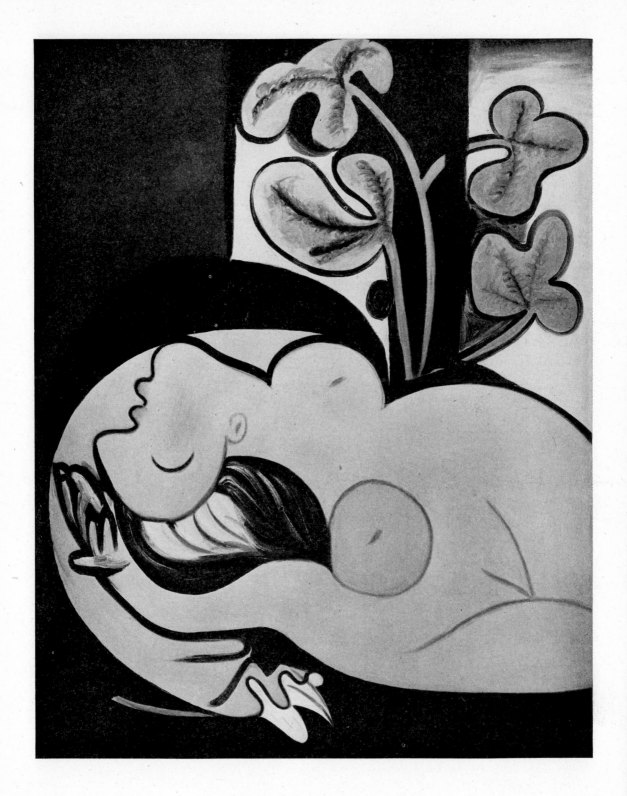

NUDE ON A BLACK COUCH. March 9, 1932 (dated). Oil, 63¾ x 51¼ inches. Collection Mrs. Meric Callery.

174

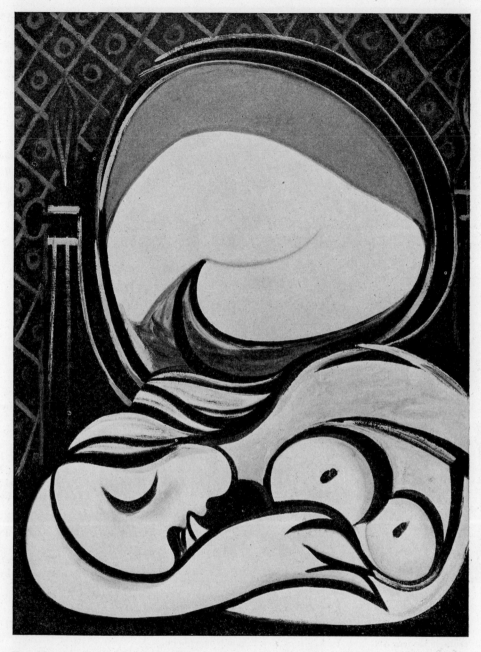

THE MIRROR. Paris, March 12, 1932 (dated on back). Oil, 51¼ x 38¼ inches. Owned by the artist.

In the spring of 1932 Picasso produced with amazing energy a long series of large canvases of women, usually sleeping or seated, unlike anything he had done before in their great sweeping curves, which are echoed in several paintings by philo-dendron leaves. Such a figure as that in the Nude on a Black Couch, *with all its extravagant distortion, recalls the flowing contours of the women, heavy, sensual, abandoned to sleep, in Ingres'* Le Bain turque, *or Füssli's* Nightmare *of one hundred and fifty years before (bibl. 314, plate 112).*

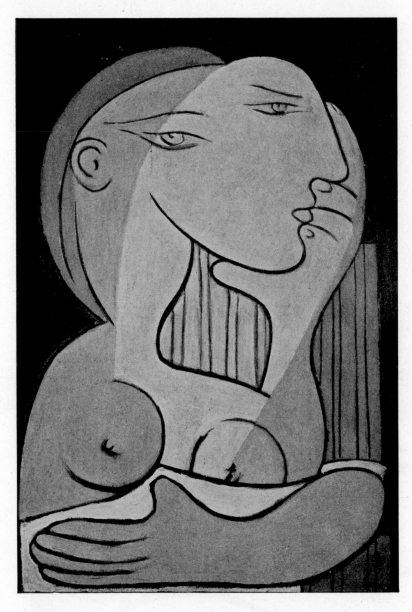

Painted entirely in greys, the Seated Woman (*left*) is one of the most sphinx-like of Picasso's images.

The two pictures of bathers, opposite, were painted a few months apart. They show again Picasso's rapidly alternating concern with a flat brightly colored, and a sombre sculptural, style. The three women playing ball with such abandon may be compared to the three ball players of Dinard (*p. 157*) and the three bathers in By the Sea *painted a decade earlier* (*p. 130*).

SEATED WOMAN. 1932. Oil on wood, 29¼ x 20⅝ inches. Collection Lee A. Ault.

opposite above: THREE WOMEN BY THE SEA. Paris, November 28, 1932 (dated on back). Oil, 32 x 39⅜ inches. Owned by the artist.

opposite below: TWO WOMEN ON THE BEACH. Paris, January 11, 1933 (dated on back). Oil, 28⅞ x 36¼ inches. Owned by the artist.

Color frontispiece: GIRL BEFORE A MIRROR, Paris, March 14, 1932 (dated on back). Oil, 63¾ x 51¼ inches. The Museum of Modern Art, New York, gift of Mrs. Simon Guggenheim.

Of all Picasso's paintings of the early 1930s this is one of the most elaborately designed and sumptuously painted. Its magnificent color, heavy dark lines, and diamond-patterned background call to mind Gothic stained glass. The intricate metamorphosis of the girl's figure—"simultaneously clothed, nude and x-rayed"—and its image in the mirror, the paradoxical tension between a subject of quiet contemplation and a composition of maximum activity in color and design, all suggest poetic and metaphysical implications rare in Picasso's art of this period. *

In the summer of 1932, at the time of the great retrospective exhibition of his work, Picasso said he preferred this painting to any of the others in the long series he had completed that spring.†

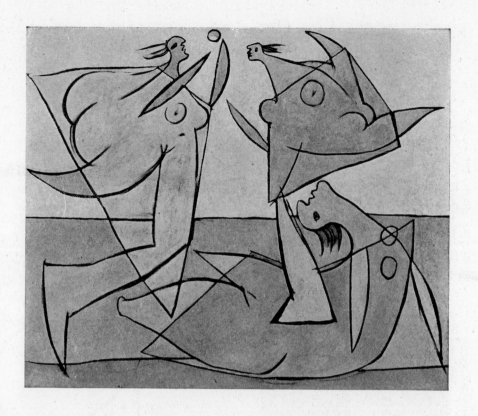

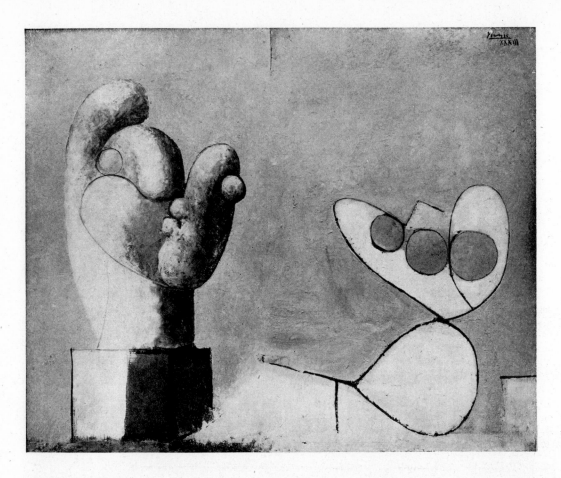

SCULPTURE: 1931-33

After the opening of his first great retrospective exhibition in June, 1932, Picasso worked more and more at his sculpture. Perhaps he was tired of painting after the sustained efforts of the spring; and possibly there was something about the Château de Boisgeloup near Gisors, which he had just bought, that may have induced him to concentrate for a while on sculpture.

Although most of it has been published from time to time (bibl. 67, p. 376), his sculptures done since 1932, numbering scores of pieces, have never been exhibited except for two big plaster heads near the Spanish building in the Paris World's Fair of 1937 and four bronzes shown at the Salon d'Automne of 1944. In fact until recently almost all the pieces have remained at Boisgeloup in plaster although Picasso had intended to have many of them cast in bronze for the exhibition at the Museum of Modern Art in 1939 had not the War intervened. Under these circumstances Picasso is rather little known as a sculptor. Apparently he himself has not encouraged an interest in this comparatively private side of his work, nor has he placed any but early pieces on sale since 1914.

Gallatin's photograph taken in 1933 shows Picasso's sculpture studio at Boisgeloup. At the left and right are two of the colossal heads of women, perhaps the most characteristic and striking pieces of the period. In the left foreground is a smaller more abstract sculpture—possibly a head—which is reminiscent of such paintings as the Project for a Monument *(p. 165, below) and* Figure Throwing a Stone *(p. 169). The little rectangular head on the table in the background is very like the plaster reproduced on page 186.*

Bronzes of the left-hand bust, and of the Cock *(p. 182) were among the four shown in the "Victory Salon," the* Salon d'Automne *of 1944 (see page 246).*

The canvas reproduced above, Plaster Head and Bowl of Fruit, *is, in a sense, a compliment from Picasso the painter to Picasso the sculptor. The head in the painting is a variant of one of the big plaster heads shown in the photograph opposite.*

178

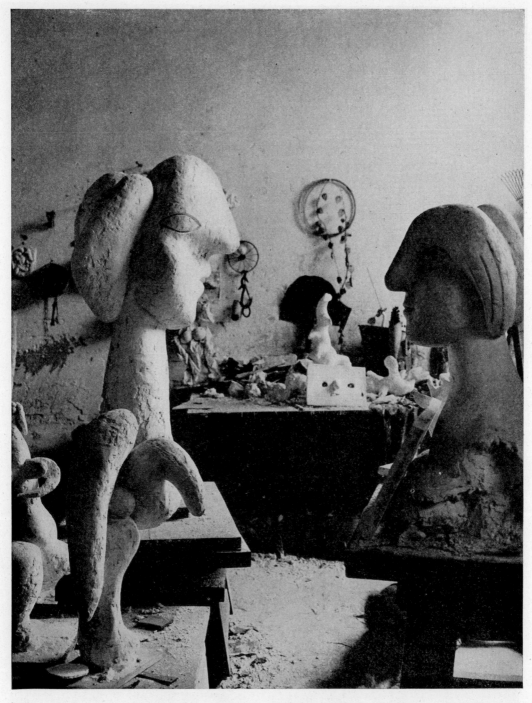

Sculpture in Picasso's studio at Boisgeloup, Gisors, 1933. Photograph by A. E. Gallatin.

opposite: PLASTER HEAD AND BOWL OF FRUIT. January 29, 1933 (dated). Oil, 28⅞ x 36¼ inches. Collection Mr. and Mrs. Joseph Pulitzer, Jr.

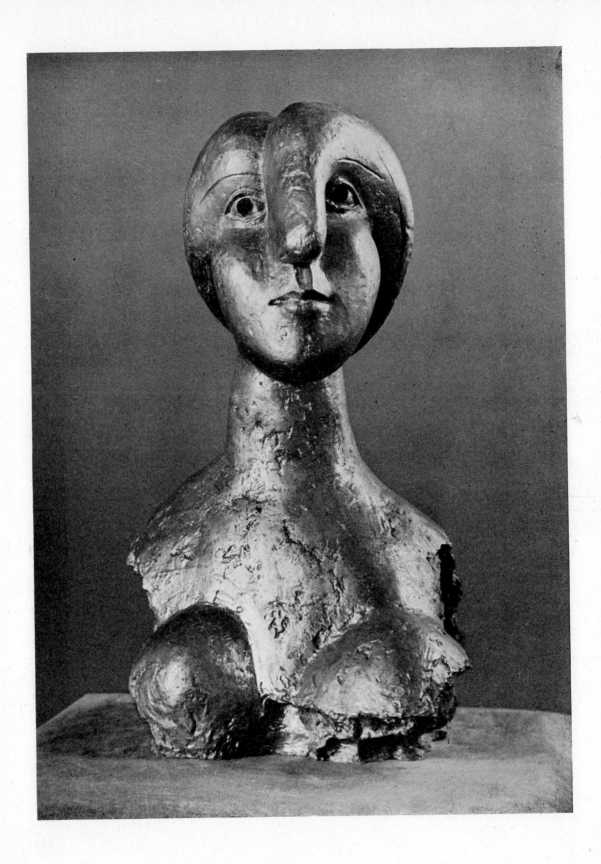

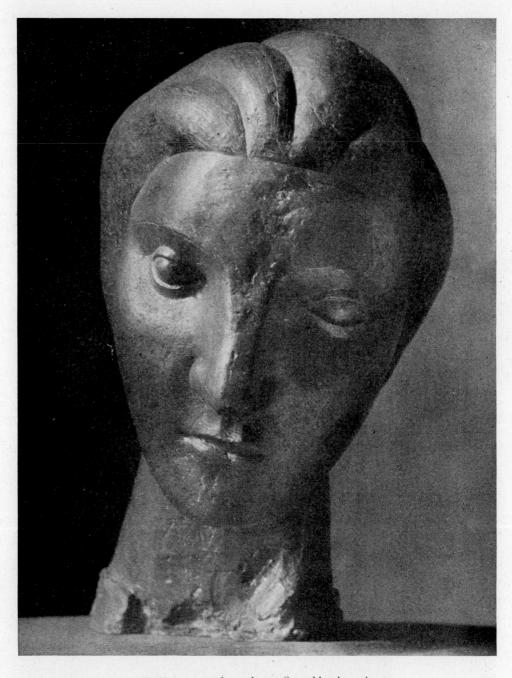

HEAD. Boisgeloup, 1932? Gilt bronze, cast from plaster. Owned by the artist.

Of the large heads done in 1931-33 this is the most traditional; it lacks the disquieting protuberances which distinguish its three or four companion pieces, such as the one illustrated opposite. No other sculpture by Picasso of this period shows a comparable restraint and classic severity.

opposite: BUST OF A WOMAN. Boisgeloup, 1932? Gilt bronze, cast from plaster, over life size. Owned by the artist.

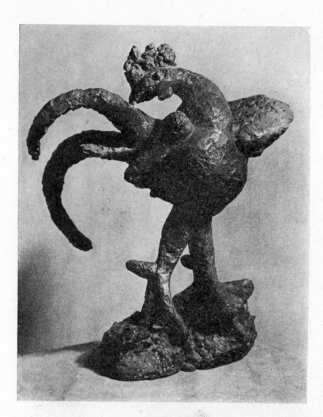

More spontaneously handled are the Cock and Heifer which preserve to the full a sense of the wet plaster out of which these sculptures were originally modeled.

Picasso continued to produce a good deal of sculpture during the rest of 1933 and 1934 but on the whole it lacks the large scale and vitality of the previous year. (See page 186.)

The fecundity of Picasso's plastic invention may be seen in the drawings called An Anatomy, a series of thirty or more designs for sculpture of which twenty-four are reproduced on the opposite page. Several times before Picasso had produced such a tour de force of variations on a theme: we have illustrated single examples of the designs for constructions, 1912 (p. 86), of the soft sculpturesque bather series of 1927 (p. 150) and the pen and ink designs for monuments of 1928 (p. 151). These of 1933 are also "bathers."*

left: COCK. Boisgeloup, 1932? Bronze, cast from plaster. Owned by the artist.

below: HEIFER. Boisgeloup, 1932? Bronze, cast from plaster. Owned by the artist.

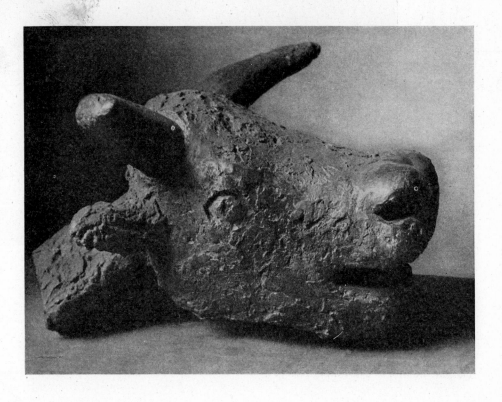

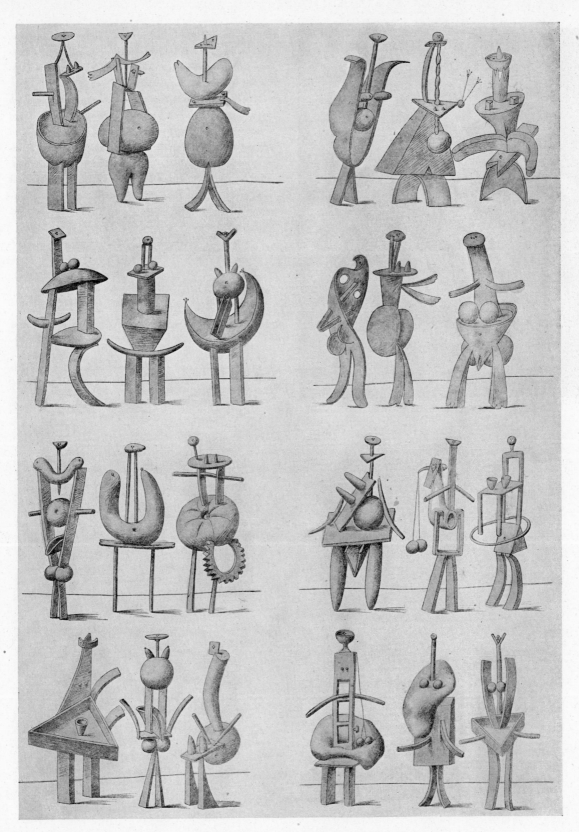

AN ANATOMY. February 22, 1933 (dated). Pencil (repro. from *Minotaure*, bibl. 353).

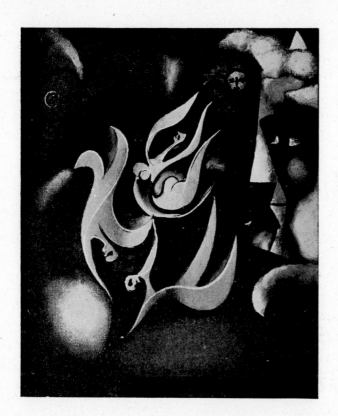

In February 1933, just before he drew An Anatomy,
Picasso painted a half-dozen small circus pictures of acro-
bats with long wing-like draperies whirling above the up-
turned heads of the shadowy crowd.

At Cannes in the summer he made some drawings which
seem more orthodoxly surrealist than any he had produced
before—gesticulating figures composed of furniture and
severed limbs. More serious and original are the long series
of gouaches painted during the same weeks. They range
from the classic, contemplative mood of the Sculptor and
His Statue to The Balcony, *a moonlit night piece of un-
abashed romanticism.*

left: CIRCUS (ACROBATS). Paris, February 6, 1933 (dated
on back). Oil, 18⅛ x 14⅞ inches. Owned by the artist.

below: TWO FIGURES ON THE BEACH. Cannes, July 28,
1933 (dated). Ink, 15¾ x 19⅝ inches. Museum of
Modern Art, New York.

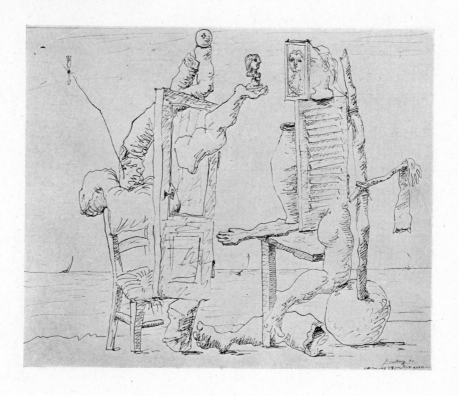

184

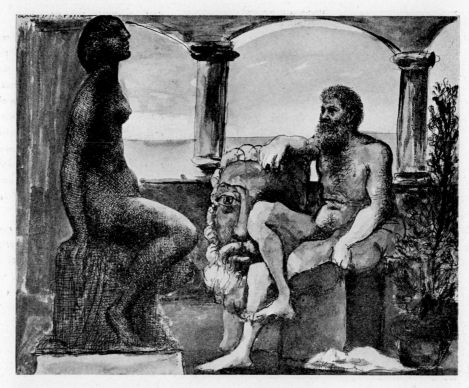

SCULPTOR AND HIS STATUE. Cannes, July 20, 1933 (dated). Gouache, 15⅜ x 19½ inches. Private collection.

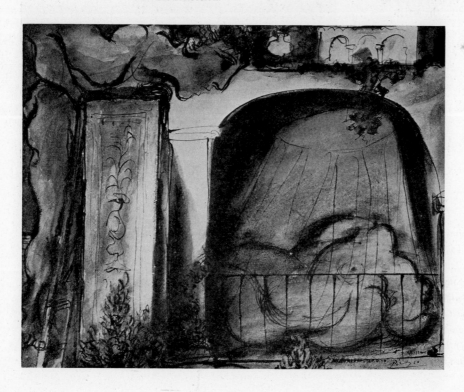

THE BALCONY. Cannes, August 1, 1933 (dated). Gouache, 16 x 19⅞ inches.

185

SCULPTURE: 1933-34

Picasso's sculpture of 1933-34 more or less brings to an end the period which began with the Cannes drawings of 1927 and came to a climax with the large pieces of 1932. These later pieces are for the most part smaller in scale and pictorial, even picturesque, in character as if his interest in sculpture as a solid, three-dimensional art had dwindled. The Man with a Bouquet is ingeniously devised with the use of corrugated paper and real leaves but the result, however charming, borders on the precious. The little oblong head below may be an unconscious reminiscence of the square pierced relief he had seen at Pompeii in 1917 (p. 96).

Perhaps the almost incredible quantity and richness of his work done in 1932 caused a certain lassitude in Picasso during 1933 for in that year with very few exceptions he produced works small in size and minor in key—and this held true for his painting as well as for his sculpture.

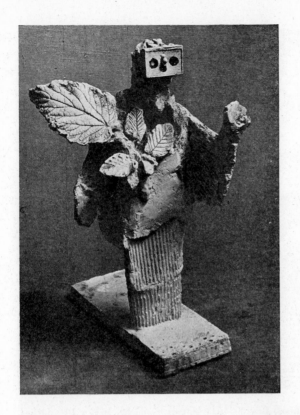

above: MAN WITH A BOUQUET. Boisgeloup, 1934 (Z). Plaster. Owned by the artist.

right: HEAD. Boisgeloup, 1934? Plaster. Owned by the artist.

BULLFIGHTS

During the summer at Cannes he had visited Barcelona where he went to the bull ring. In September he began the long series of more or less fantastic bullfight pictures which after many strange mutations were to culminate four years later in the Guernica (p. 200). Two of the 1934 canvases are shown. He had painted or drawn the bull ring before: with picturesque impressionism in 1901, as a decoration for the Tricorne curtain in 1919, and as a coldly classic composition in 1923. With these earlier pictures his bullfights of the mid 30s have little in common. Instead they are of an unsurpassed violence, complicated at times by an element of nightmare allegory in which a dying female matador plays an important role. To evoke the stuck bull (opposite) Picasso uses his mastery of expressionist distortion with almost intolerable insistence. In the small canvas, above, the agony of the picador's horse and the ferocity of the bull are almost lost in the whirling linear fury which rises from the spiraling dust to the snapping pennants far above.

BULLFIGHT. Boisgeloup, September 9, 1934 (dated). Oil, 13 x 16⅛ inches. Collection Henry P. McIlhenny.

THE BULL. Boisgeloup, July 16, 1934 (dated). Oil, 13¼ x 21¾ inches. Collection Keith Warner.

*The physical and psychological violence of the bullfight paintings was balanced throughout 1934 and the early months of 1935 by a score or more of paintings of girls gravely reading, writing or drawing, with demurely lowered eyes. Superficially their mood is quiet; yet the deep glowing color, the heavy drawing, and the silent concentration of the figures suggest in some of these paintings an inward intensity of feeling.**

TWO GIRLS READING. March 28, 1934 (dated on back). Oil, 31⅞ x 25½ inches. Collection Mrs. John W. Garrett.

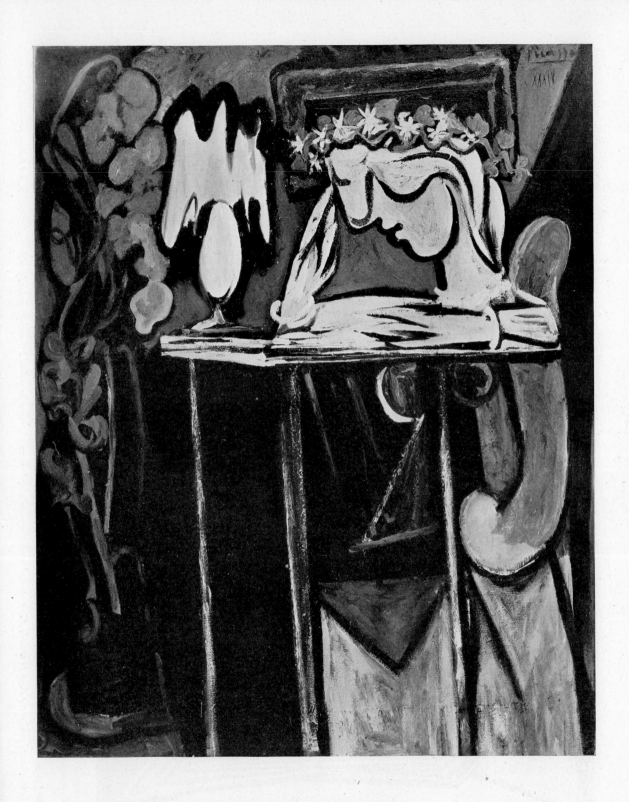

GIRL WRITING. 1934 (dated). Oil, 63⅞ x 51⅜ inches. Collection Peter Watson.

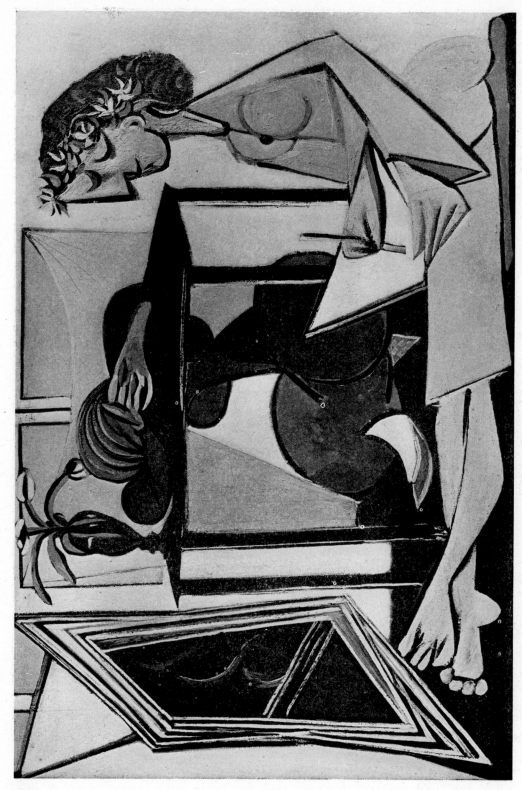

190

INTERIOR WITH A GIRL DRAWING. Paris, February 12, 1935 (dated on back). Oil, 51⅛ x 76⅝ inches. Collection Mrs. Meric Callery. A series of studies for this composition is illustrated in bibl. 77, following p. 258.

The Interior with a Girl Drawing was painted in February 1935 after consider- ably more trial and error than is usual. After several earlier variants and many preparatory drawings he painted a large composition; but finding it unsatisfac- tory he painted it over completely with a new version, the canvas reproduced above.

The Interior with a Girl Drawing occupies a special place in Picasso's work of the mid-thirties for not only is it the culmination of the long series of similar subjects which he had begun early in 1934 but it is apparently the last important canvas he painted until early in 1937, a period of almost two years.

The color of the Interior with a Girl Drawing is comparatively sparse and cool with green and violet predominant. The small Girl Sleeping painted a few days earlier is remarkable for its hot, rich harmony of red against gold arabesque.

One of Picasso's preoccupations of the late '20's is revived in the little Harlequin (Project for a Monument) though it is far less architectural or sculptural in character than the designs of 1929-30 (p. 165).

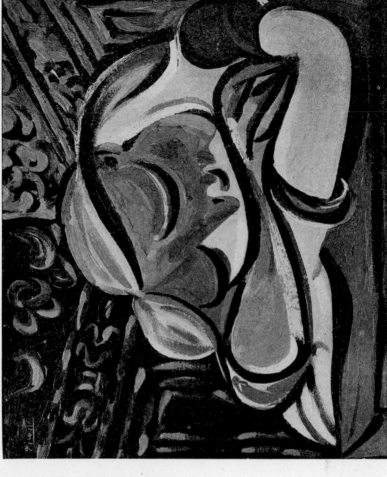

HARLEQUIN (PROJECT FOR A MONUMENT). Paris, March 10, 1935 (dated). Oil, 24½ x 20 inches. Buffalo Fine Arts Academy, Albright Art Gallery, Buffalo.

right: GIRL SLEEPING. February 3, 1935 (dated on back). Oil, 18⅛ x 21⅝ inches. Collection Walter P. Chrysler, Jr.

191

MINOTAUROMACHY

Whatever reasons may have caused Picasso to stop painting early in 1935—and they seem to have been personal and circumstantial—his creative energies for some twenty months thereafter were to find expression in graphic art and poetry, though the results were meager by comparison with any previous period of similar length.

Picasso's most remarkable composition of 1935—and possibly the most important of all his prints—is the Minotauromachy (opposite). This large etching is so rich in Picasso's personal symbolism and so involved with the iconography of his previous and subsequent work that it requires some analysis, however brief. The bison-headed Minotaur advances from the right, his huge right arm stretched out toward the candle held high by a little girl who stands confronting the monster fearlessly, flowers in her other hand. Between the two staggers a horse with intestines hanging from a rent in his belly. A female matador collapses across the horse's back, her breasts bared, her espada held so that the hilt seems to touch the left hand of the Minotaur while the point lies toward the horse's head and the flower girl. At the left a bearded man in a loin cloth climbs a ladder to safety, looking over his shoulder at the monster. In a window behind and above two girls watch two doves walk on the sill. The sea with a distant sail fills the right half of the background.

The flower girl appears several times in Picasso's earlier work—in 1903 and 1905 (bibl. 524, I, plates 61, 113); in the

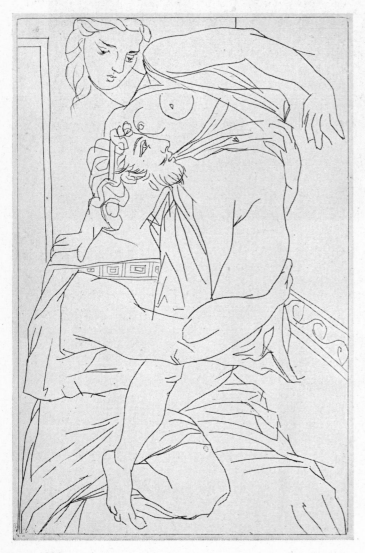

LYSISTRATA

MYRRHINA AND KINESIAS. 1934. Etching, 8⅝ x 6 inches. Illustration for Aristophanes: *Lysistrata*, a new version by Gilbert Seldes, New York, Limited Editions Club, 1934 (see p. 277). Museum of Modern Art, New York.

Picasso's most important book illustrations published in the 1930's were done for Aristophanes' Lysistrata. The etchings and reproductions of drawings are a spirited, racy burlesque of neoclassic primness; and they come nearer to following the text than had any of Picasso's earlier book illustrations.

192

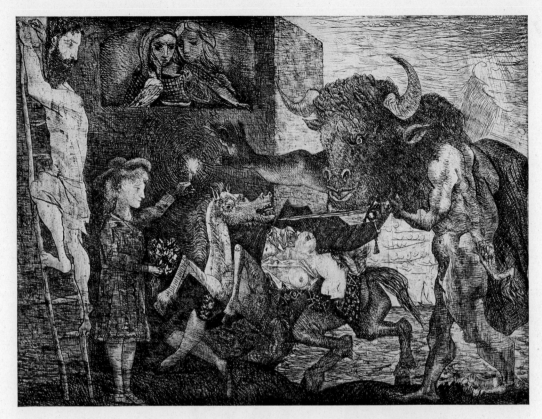

MINOTAUROMACHY. 1935. Etching, 19½ x 27¼ inches. Collection Henry P. McIlhenny.

large Grecoesque Composition of 1906 (p. 49), and its studies—but never before in such a crucial role. The ladder, usually on the left-hand side of the composition, occurs in the 1905 paintings and etchings of acrobats; is climbed by a monkey in the curtain for Parade (p. 98); by a man with a hammer in, significantly, the Crucifixion of 1930 (p. 167); by an amorous youth in a gouache of 1933 (p. 185); by a shrieking woman in a study for the Guernica (p. 205).

One of the earliest of the bull ring series of the previous years shows a female matador falling from a horse which is borne, like Europa, on the back of the bull, though her sword has been plunged, ineffectually, into the bull's neck (bibl. 78, p. 57). The agonized, disemboweled horse bares his teeth in many of these same bullfights, and in 1937, after dying in The Dream and Lie of Franco, revives to become the central figure of the Guernica.

Minotaur himself appears as a decorative running figure in 1928 (p. 155) but takes on his true character in 1933 when Picasso designed the cover for the first issue of the magazine Minotaure, and made numerous etchings and drawings in which the monster holds a dagger like a sceptre (Minotaure, no. 1, 1933, p. 1) or makes love (bibl. 315, p. 75). In a drawing of April 1935 he struts with hairy nakedness across the bull ring toward a frightened horse (View, Dec. 1933, p. 127).

As a kind of private allegory the Minotauromachy tempts the interpreter. But explanation, whether poetic or pseudo-psychoanalytic, would necessarily be subjective. It is clear that the ancient and dreadful myth of the Minotaur which originated, together with the bull ring, on the island of Crete, has here been woven into Picasso's own experience of the modern Spanish toromachia. To this he has added certain motives associated with his theatre pictures and his Crucifixion.

Apparently the scene is a moral melodramatic charade of the soul, though probably of so highly intuitive a character that Picasso himself could not or would not explain it in words. Of three extraordinary allegories it is the first: it was followed, in 1937, by a nightmare comic strip and a great mural painting.

Illustrations for Eluard, *La Barre d'appui*, Paris, Cahiers d'Art, 1936 (see p. 277). Paris, Spring 1936. Etching, plate for four designs, 12½ x 8½ inches. Collection Miss Caroline C. Coudert.

PICASSO AND THE SURREALISTS

During his long fallow period Picasso drew closer to the Surrealists, particularly the poets. André Breton had long before claimed him for Surrealism and had retroactively included even his cubist paintings within the Surrealist canon (bibl. 68). Picasso did not sign the Surrealist manifesto but he did contribute to official Surrealist exhibitions and publications; and toward the end of 1935 he wrote some thoroughly Surrealist poetry which was published in* Cahiers d'Art *with an enthusiastic introduction by Breton (bibl. 5).*

With the greatest of the Surrealist poets, Paul Eluard, and his wife, Nusch, Picasso came to have a close and lasting friendship. In the spring of 1936 he made several etchings for two volumes of Eluard's poetry. The illustrations for La Barre d'appui *are characteristic of his graphic art of the period—at least in so far as it is publicly known. The style of the upper right-hand panel (opposite) is particularly significant for it is like a fusion of writing and drawing—a half-automatic hieroglyphics, curiously Arab or Cufic in character. The portrait of Nusch Eluard to the left makes her fragile beauty seem doll-like; the sleeping girl below is related in style to paintings of 1935 (p. 191).*

Such a work is perhaps minor and casual in character; yet, with Picasso's poetry, a few other drawings, and some cliché verre photographic portraits done under Man Ray's inspiration,† it is all that we know of Picasso's work of 1936 up to the end of the year when he began to paint again—small canvases of still life, the first of a series which was to continue through several years.

PICASSO AND THE SPANISH CIVIL WAR

Perhaps Picasso painted these decorative still lifes as therapeutic relief, for however difficult his personal problems may have been during the previous two years he was now profoundly disturbed by an event of world importance (though at the time many felt it to be a crisis on merely a national scale). In July the Spanish Civil War began.

As James Soby has suggested,‡ this first European campaign of World War II enlisted the sympathies of artists throughout the world more than had any struggle since the Greek War of Independence over a hundred years before. And Picasso was not only an artist—he was a Spaniard.

Previously Picasso had shown no public interest in politics but he now championed the cause of Republican Spain with conspicuous energy and generosity.§ In order to raise money he sold paintings which he had intended to

PORTRAIT OF D. M. 1936. Photograph (combination of *cliché verre* and rayogram). Reproduced from *Cahiers d'Art*, vol. XII, 1937.

keep. As a gesture of loyalty he accepted the Directorship of the Prado (in his case an honorary position though he did report on the condition of the paintings which had been removed from Madrid to Valencia to save them from Franco's bombs).‖ And he fought with his own words and pictures.

Early in January 1937 Picasso etched The Dream and Lie of Franco *and wrote the accompanying poem. There are two plates, each divided into nine rectangular scenes like traditional woodcut stories or contemporary American comic strips, which Picasso admires. In fourteen scenes Picasso expresses his hatred and contempt for El Caudillo. Again the bull, the disembowled horse appear in a story which is not as lucid as a comic strip but clear enough for dreams and lies. Franco himself is transformed into a flaccid scarecrow figure with a head like a soft hairy sweet potato—or, to borrow Picasso's phrases, "an evil-omened polyp . . . his mouth full of the chinch-bug jelly of his words . . . placed upon the ice-cream cone of codfish fried in the scabs of his lead-ox heart . . ."¶*

The poem and the second plate with five of the Franco scenes are reproduced on the following pages.

THE DREAM AND LIE OF FRANCO

fandango of shivering owls souse of swords of evil-omened polyps scouring brush of hairs from priests' tonsures standing naked in the middle of the frying-pan— placed upon the ice cream cone of codfish fried in the scabs of his lead-ox heart— his mouth full of the chinch-bug jelly of his words—sleigh-bells of the plate of snails braiding guts—little finger in erection neither grape nor fig—commedia dell'arte of poor weaving and dyeing of clouds—beauty creams from the garbage wagon—rape of maids in tears and in snivels—on his shoulder the shroud stuffed with sausages and mouths—rage distorting the outline of the shadow which flogs his teeth driven in the sand and the horse open wide to the sun which reads it to the flies that stitch to the knots of the net full of anchovies the sky-rocket of lilies—torch of lice where the dog is knot of rats and hiding-place of the palace of old rags—the banners which fry in the pan writhe in the black of the ink-sauce shed in the drops of blood which shoot him—the street rises to the clouds tied by its feet to the sea of wax which rots its entrails and the veil which covers it sings and dances wild with pain—the flight of fishing rods and the alhigui alhigui of the first-class burial of the moving van—the broken wings rolling upon the spider's web of dry bread and clear water of the paella of sugar and velvet which the lash paints upon his cheeks—the light covers its eyes before the mirror which apes it and the nougat bar of the flames bites its lips at the wound—cries of children cries of women cries of birds cries of flowers cries of timbers and of stones cries of bricks cries of furniture of beds of chairs of curtains of pots of cats and of papers cries of odors which claw at one another cries of smoke pricking the shoulder of the cries which stew in the cauldron and of the rain of birds which inundates the sea which gnaws the bone and breaks its teeth biting the cotton wool which the sun mops up from the plate which the purse and the pocket hide in the print which the foot leaves in the rock.

fandango de lechuzas escabeche de espadas de pulpos de mal agüero estropajo de pelos de coronillas de pié en medio de la sartén en pelotas — puesto sobre el cucurucho del sorbete de bacalao frito en la sarna de su corazón de cabestro — la boca llena de la mermelada de chinches de sus palabras — cascabeles del plato...

THE DREAM AND LIE OF FRANCO (SUEÑO Y MENTIRA DE FRANCO). Etching and aquatint, 12⅜ x 15⅝ inches. The Museum of Modern Art, New York. Below is illustrated the 2nd of two plates, 3rd state. First state, etching only, January 8 and 9, 1937; 2nd state with aquatint, May 25th; 3rd state with four additional scenes, June 7th. Subsequently the 18 designs were reproduced on post cards and sold for the benefit of the Spanish Republican Government (bibl. 355, p. 50 and before, illustrating all states).

The first few lines of the poem Sueño y Mentira de Franco in Picasso's own handwriting are reproduced above.

The first five scenes reading from right to left continue the story of the nine scenes of the first plate. Franco has just driven his lance through the winged horse which expires at his feet (scene 10—upper right-hand corner). The dying horse gives place to a prostrate woman (scene 11) and then to a white horse whose neck rests upon the chest of a bearded man (scene 12). In a close-up (scene 13) Franco is confronted by a bull. In the final scene (central picture) Franco having been turned to a centaur-like beast with a horse's body is ripped open by the bull and dies.* The four remaining scenes, added later, are closely related to Guernica which Picasso undertook May 1st and finished in June.

Throughout 1937 and later Picasso continued adding to the series of still lifes begun at the end of the previous year. They are as untroubled as a Manet, intimate in scale, and richly painted in marked contrast to the stark, heroic agonies of the Guernica and the disquieting atmosphere of other paintings of the same period such as Girls with a Toy Boat. This beach scene recalls the style and color of the 1929 Seated Bather (p. 163). The astounding head looming over the horizon suggests the violently foreshortened figure rushing, in the reverse direction, toward the horizon in By the Sea (p. 130).

above: NEGRO SCULPTURE BEFORE A WINDOW. April 19, 1937 (dated). Oil, 27¾ x 23⅝ inches. Private collection.

left: PITCHER AND CANDLE. Paris, January 30, 1937 (dated). Oil, 15 x 18⅛ inches. Collection Mr. and Mrs. Henry Hope.

GIRLS WITH A TOY BOAT. February 12, 1937 (dated on back). Oil and charcoal, 51⅛ x 76¾ inches. Art of This Century, New York.

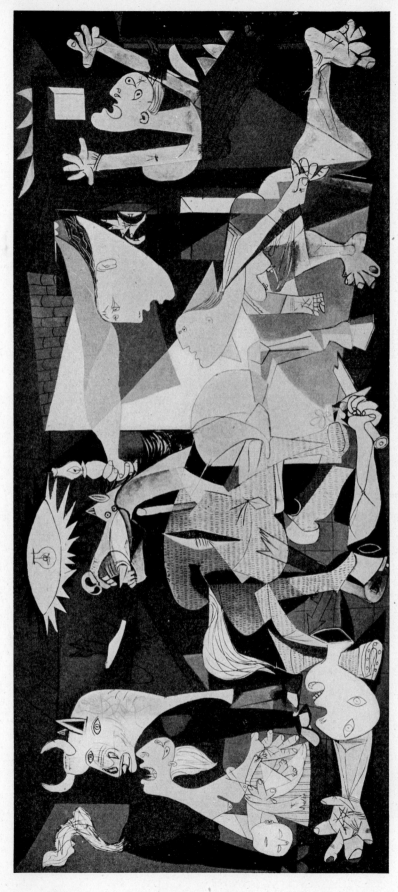

GUERNICA. May—early June 1937. Oil on canvas, 11 feet 6 inches x 25 feet 8 inches. Owned by the artist.

On April 28, 1937 the Basque town of Guernica was reported destroyed by German bombing planes flying for General Franco. Picasso, already an active partisan of the Spanish Republic, went into action almost immediately. He had been commissioned in January to paint a mural for the Spanish Government Building at the Paris World's Fair; but he did not begin to work until May 1st, just two days after the news of the catastrophe.*

Picasso has given no detailed explanation of Guernica. Briefly, one sees: at the right a woman with arms raised falling from a burning house, another rushing in toward the center of the picture; at the left a mother with a dead child, and on the ground the hollow fragments of a warrior's figure, one hand clutching a broken sword near which a flower is growing. At the center of the canvas is a dying horse pierced by a spear hurled or dropped from above; at the left a bull stands surveying the scene in apparent triumph. Between the heads of the bull and the horse is a bird with upraised open beak. Above, to the right of the center a figure leans from a window holding a lamp which throws an ineluctable light upon the carnage. And over all shines the radiant eye of night with an electric bulb for a pupil.

Guernica is painted entirely in black, white, and grey. There is no modeling and most of the drawing is quite flat in effect with only occasional foreshortening as in the hands of the fallen warrior or the mouth of the horse. But however flat

200

the style there are indications of space in the perspective lines in the upper corners.*

The composition is clearly divided in half; and the halves are cut by diagonals which together form an obvious, gable-shaped triangle starting with the hand at the left, the foot at the right, and culminating at the top of the lamp in the center— a triangle which suggests the pedimental composition of a Greek temple.

The insistent angularities and some of the transparencies, patternings, and fragmentations recall cubism and cubist collage but here they serve to suggest the confusion, and augment the explosive emotion of the scene.

Many of the motifs in the Guernica appear in his previous work. The Dream and Lie of Franco with its bull ring symbolism is of course a direct prelude. The bullfight series of 1933-35 provides the shrieking horse; the Crucifixion of 1930 (p. 167) is comparable in its iconographic complexity and certain details. Above all the Minotauromachy anticipates the Guernica in the important dramatic relationship between the bull and the woman holding the lamp over the dying horse—though in the etching of 1935 the symbols perhaps concern personal rather than public experience (p. 193).

above: Composition study for *Guernica*, May 1, 1937 (dated). Pencil on blue paper, 8¾ x 10⅝ inches. Owned by the artist.

below: Composition study for *Guernica*. May 9, 1937 (dated). Pencil on white paper, 9½ x 17⅝ inches. Owned by the artist.

Dated May 1st, the drawing reproduced above is the first composition study for the Guernica. It is a shorthand note showing the bull at the left, the horse lying on its back in the center, and, at the right, the house with the lamp-holding figure leaning out the window.

On May 9th he made the drawing at the right, the final study for the composition as a whole. By May 11th Picasso had outlined the picture on the 26-foot canvas, but thereafter he made radical revisions in the composition as he painted. For instance, shortly before the completion of the painting, the body of the bull, as can be seen by comparing the mural with the sketch at the right, was swung around from the right to the left of its own head, thereby making space to fling up the head of the horse. (Photographs by Dora Maar of the mural in eight progressive stages, together with many studies, are reproduced in Cahiers d'Art, bibl. 79.)

In May 1937, while Picasso was painting the Guernica, he declared his feelings in a statement made available two months later at the time of an exhibition of Spanish Republican posters in New York. It had previously been rumored that he was pro-Franco. Picasso wrote in part:

*"The Spanish struggle is the fight of reaction against the people, against freedom. My whole life as an artist has been nothing more than a continuous struggle against reaction and the death of art. How could anybody think for a moment that I could be in agreement with reaction and death? When the rebellion began, the legally elected and democratic republican government of Spain appointed me director of the Prado Museum, a post which I immediately accepted. In the panel on which I am working which I shall call Guernica, and in all my recent works of art, I clearly express my abhorrence of the military caste which has sunk Spain in an ocean of pain and death. . . ."**

That Picasso felt very strongly there can be little doubt. Yet the mural was painted for a public building at a world's fair; it was a public statement intended to arouse public feeling against the horrors of war and implicitly, at least, against Franco and his German bombers. Therefore it has been asked: does Picasso in fact "clearly express his abhorrence"?

In spite of the convulsively distraught humanity in the Guernica it is the horse and the bull who dominate the painting and one's memory of it. The two animals, accompanied only by the woman with the lamp, appear in the very first sketch for this mural (p. 201) and in the same role of victim and aggressor many times before in earlier pictures.

In The Dream and Lie of Franco the bull is a brute force which defeats and then destroys the dictator. In Guernica the bull again appears to be the symbol of implacable power. To an American interviewer, Pfc. Jerome Seckler, Picasso recently confirmed this obvious interpretation but when asked if the bull did not represent fascism in a specific sense he replied "No the bull is not fascism, but it is brutality and darkness. . . . the horse represents the people. . . . the Guernica mural is symbolic. . . . allegoric. That's the reason I used the horse, the bull, and so on. The mural is for the definite expression and solution of a problem and that is why I used symbolism." (Bibl. 435, p. 5)

"Guernica is a great painting, without doubt" wrote the critic of The Springfield Republican, Elizabeth McCausland. "It speaks, however, within a limited range, to those whose ears are attuned by previous experience to the language it uses—an intellectual, sophisticated idiom, removed by historical events from the understanding of the common man. What Picasso wanted was to cry out in words no one could fail to understand. Instead he spoke, albeit honestly and poignantly, to those who by historical circumstance also had come to use a language unintelligible to popular ears." (Bibl. 272, p. 30)

Vernon Clark believes the Guernica to be "the culmination ad absurdum of all the trends, artistic and psychological, that the artist has developed in the past." He argues that Picasso has used his art to mute and "de-emotionalize" the passionate impact of the subject. Instead of expressive color he has used black, white and grey; instead of a natural union of form and subject such as Goya† achieved in his Horrors of War etchings, Picasso has combined various formal devices such as cubism and expressionism to obscure the subject; instead of representing the subject directly, Picasso has used an elaborate symbolism; and even his symbols seem contrary to the avowed purpose of the mural for "the bull, villain of the piece, is the only figure in the mural that has any dignity" while his victims are "scarecrow figures" with eyes set awry and "stuffed and clumsy" hands, "a warrior whose decapitation reveals the hollow body of a mannequin," and "a bemattressed, disembowled horse" which in the bull ring is a comic symbol "of the decrepit, the broken down, the ridiculously outworn." Clark concludes that Picasso is more concerned about the destruction of his own ivory tower than about the "ruin of a Basque town." (Bibl. 104)

The Guernica has also been attacked from the conservative right as well as from the left. The Director of the Metropolitan Museum of Art for instance cannot forgive its "banality of overstatement" and compares it to Tennyson's Charge of the Light Brigade.‡

The Guernica has in general, however, been greatly admired§ and to such a degree that hostile criticism is almost drowned out. Yet not even enthusiasts would deny that Picasso has spoken of world catastrophe in a language not immediately intelligible to the ordinary man. For better or for worse Picasso has used his own language which is neither traditional nor journalistic nor demagogic. And, if this work of art does not entirely explain itself, it can be defended very easily: let those who find the Guernica inadequate, point to a greater painting produced during the past terrible decade or, for that matter, during our century.

202

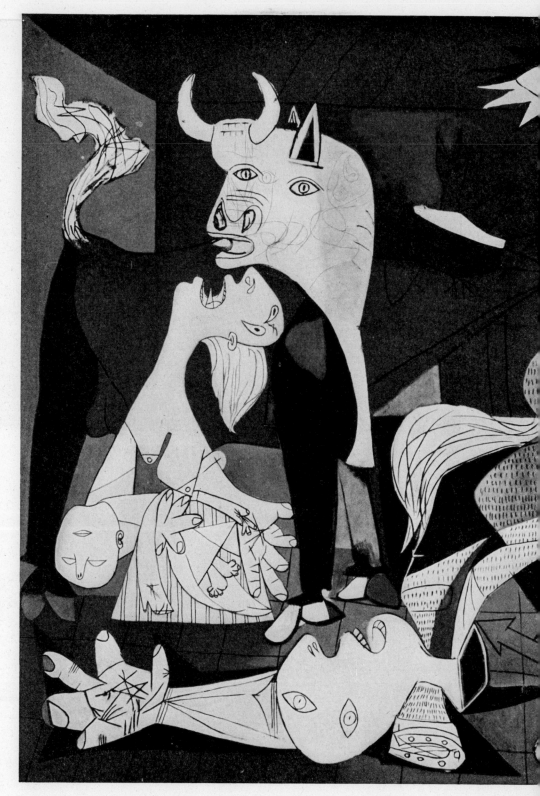

Detail of *Guernica*.

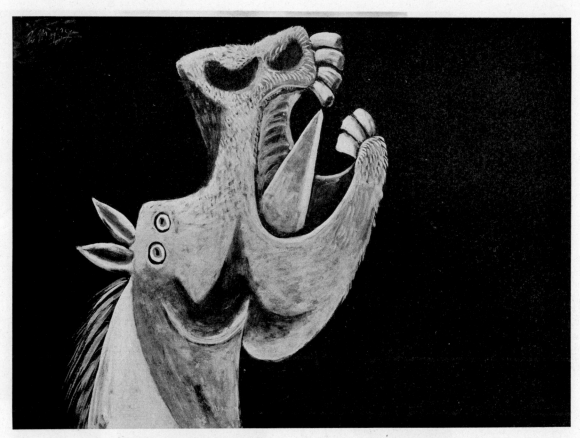

HORSE'S HEAD. May 2, 1937 (dated). Oil on canvas, 25½ x 36¼ inches. Owned by the artist.

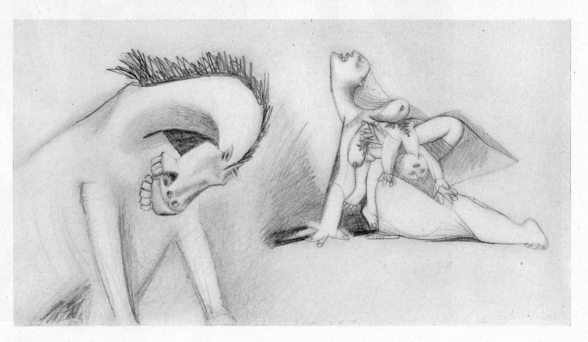

HORSE AND WOMAN WITH DEAD CHILD. May 8, 1937. Pencil on white paper, 9½ x 17⅞ inches. Owned by the artist.

GUERNICA STUDIES

Picasso may have made as many as a hundred studies for, and after, the Guernica. Of the seventy that have been published less than sixty were probably done before the painting was finished in June; and of these twenty or more have little to do directly with the mural but must be considered, along with the later "postscripts," to be variants or elaborations of Guernica themes.

In his early studies the horse seems to have concerned Picasso most. The horse appears in all the first day's sketches, and on the following day, May 2nd, he made four studies for the animal's head, among them the oil sketch in white and black (opposite), one of the most unforgetable images in Picasso's entire work.

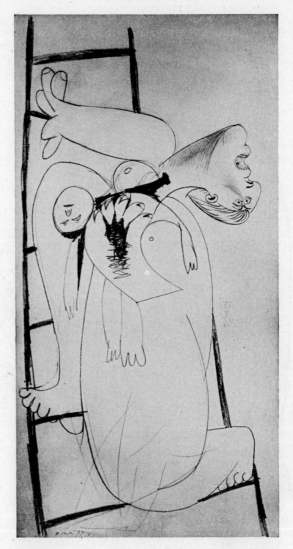

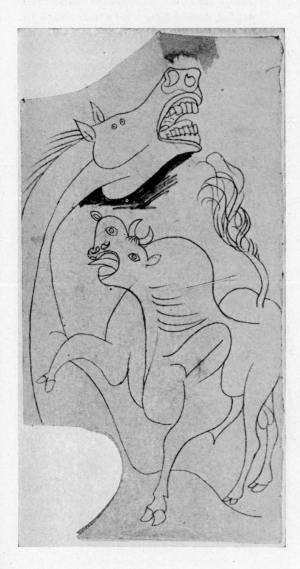

Beneath it is a drawing of May 8th of the horse with its head down, the position it took during the early stages of the mural (see study, p. 201). The woman at the right of this study appears little changed in the final composition though there she is drawn without her dead child.

The woman reeling from a ladder was drawn on May 9th but by May 11th was abandoned for the woman falling in flames (bibl. 79, p. 146).

above: WOMAN WITH DEAD CHILD ON A LADDER. May 9, 1937 (dated). Pencil on white paper, 17⅞ x 9½ inches. Owned by the artist.

left: HORSE AND BULL. Early May 1937. Pencil on tan paper, 8⅞ x 4¾ inches. Owned by the artist.

205

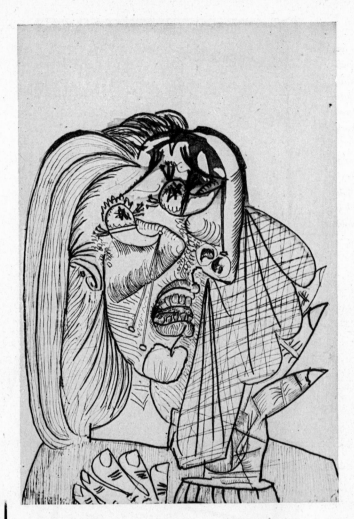

In June the Guernica was installed in the Spanish Building at the Paris World's Fair of 1937. In the foreground of the photograph (opposite) is the fountain for displaying mercury by the American, Alexander Calder. Outside, near the steps, were placed two colossal plaster sculptures by Picasso (p. 246, left side, and bibl. 79, pp. 155, 156). Joan Miro also painted a mural for the pavilion, called variously the Catalan Peasant in Revolt or The Reaper. The architects, Luis Lacasa and José Luis Sert, were highly sympathetic toward the work of the three artists.

GUERNICA "POSTSCRIPTS"

Though dated June 3rd, before the Guernica was finished, the head below is not a study directly for the mural, but one of half a dozen variations on the theme of the shrieking woman. The eyes, eyelids, hair and tears are stylized almost into a decorative diagram.

The etching Weeping Woman is one of a long series beginning about June 20th and ending with several paintings done in October. These Guernica postscripts demonstrate powerfully that "taste for paroxysm" which Paul Haesaerts finds so essential in Picasso and in Spain (bibl. 207).

left: WEEPING WOMAN. July 2, 1937 (dated). Etching and aquatint, first state, 27¼ x 19½ inches. Owned by the artist.

WEEPING HEAD. June 3, 1937 (dated). Pencil and color crayon on white paper, 9¼ x 11½ inches. Owned by the artist.

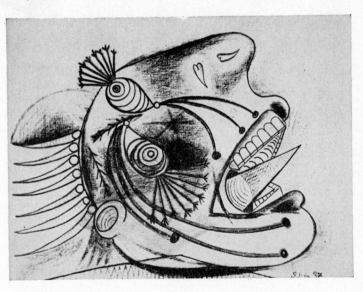

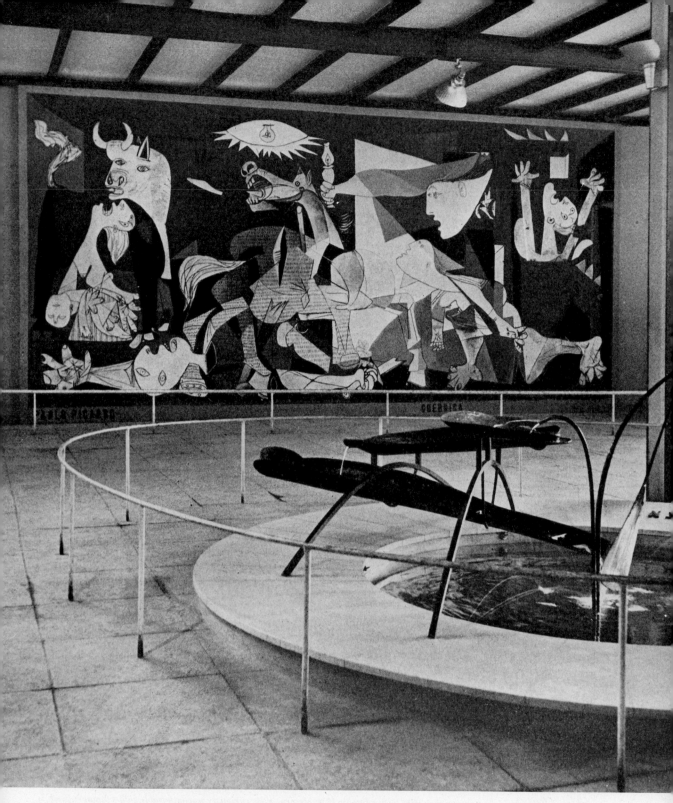

"GUERNICA. Le grand peintre espagnol Pablo Picasso, créateur du Cubisme, et qui influença si puissamment l'art plastique contemporain, a voulu exprimer dans cette oeuvre la désagrégation du monde en proie aux horreurs de la guerre."—*from a souvenir postcard of the mural published by the Spanish Republican Government.*

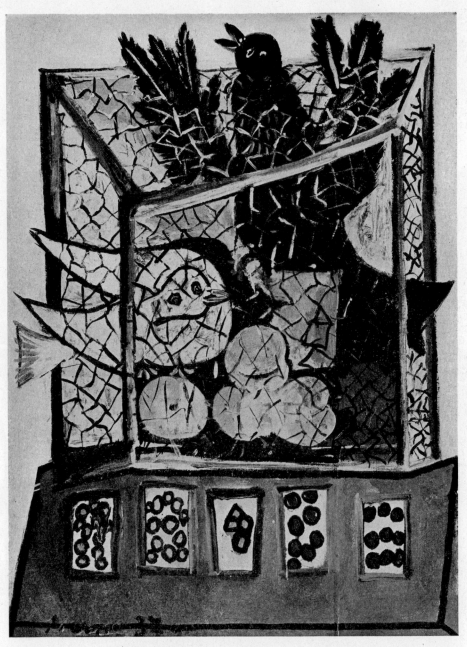

BIRDCAGE AND PLAYING CARDS. 1937 (dated). Oil, 32 x 23¾ inches. Collection Mme Elsa Schiaparelli.

This still life stands out among the series begun late in 1936 because of its curiously uncomfortable subject matter. Both it and the portrait opposite are highly decorative in color.

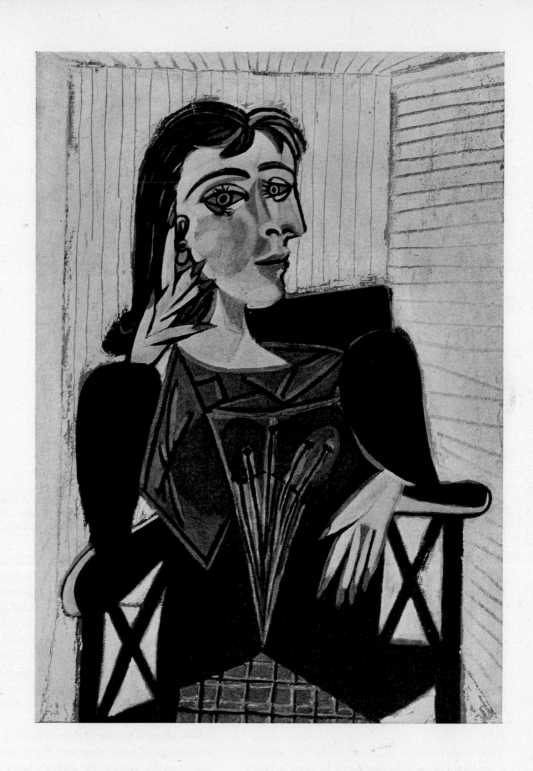

PORTRAIT OF A LADY. 1937 (dated on back). Oil, 36¼ x 25½ inches. Owned by the artist.

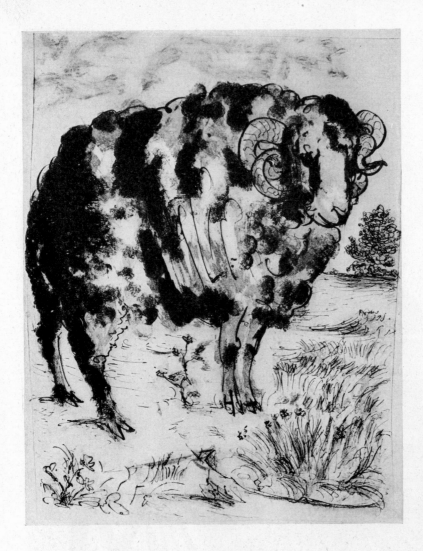

RAM. 1937-38. Aquatint. Illustration for Buffon, *Histoire naturelle*, Paris, Fabiani, 1942 (see p. 278).

THE BUFFON ETCHINGS

With Ambroise Vollard, the greatest publisher of books illustrated by modern artists, Picasso collaborated over a period of years on two magnificent volumes: Balzac's Le chef-d'oeuvre inconnu *begun in 1927 and published in 1931 (p. 145); and Buffon's* Histoire naturelle *which was published by Fabiani in 1942, three years after Vollard's death, although Picasso began work on its 31 etchings in 1937.*

The Buffon etchings are surprising in their sensitive naturalism. The use of aquatint gives a variety of soft tones which enrich drawing of extraordinary delicacy. Some of the prints have a lacy, decorative effect; others such as the Ram *are almost monumental in character; but the idio-*

syncratic character of the animal and its form are presented with mingled poetry and respect for natural appearances.

Picasso is rarely thought of as an artist interested in animals, though he has always had them about him—dogs, cats and kittens, a monkey, a pigeon. Of course the human figure and still life have served him as subjects in the overwhelming proportion of his works. Yet in recent years the bull and the horse have been his most important dramatis personae (in the Guernica human beings are reduced almost to the rôle of chorus); he has done bronzes or paintings of cocks, doves and a cat; and his lively interest in his etchings for Buffon's bestiary contrasts markedly with the rather routine neo-classic illustrations for a sonnet series by Iliazd done during the same period.*

210

*Vollard published not only Picasso's book illustrations but also got out editions of his early etchings and bronzes (pages 38, 39, 40, 69), and gave him his first Paris exhibition (p. 278). Picasso made several portraits of him: the famous cubist painting of 1910, the elaborately precise drawing of 1915, and in the 1930's, a number of etched portraits such as the aquatint here reproduced, done it is said directly on the plate.**

In the drawing below the Minotaur finally confronts his own dying grimace in a mirror held by a sea goddess—a sea goddess whose face is like that of the flower girl holding a candle against the threatening monster in the Minotauromachy (p. 193).

HEAD OF VOLLARD. 1937. Aquatint. Repro. from *Signature* (London), no. 8, 1938.

THE END OF A MONSTER. Paris, December 6, 1937 (dated). Pencil, 15⅛ x 22¼ inches. Collection Roland Penrose.

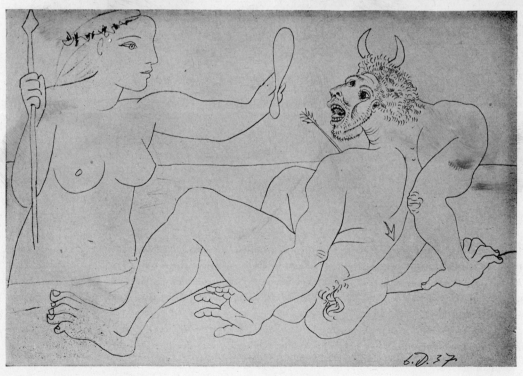

211

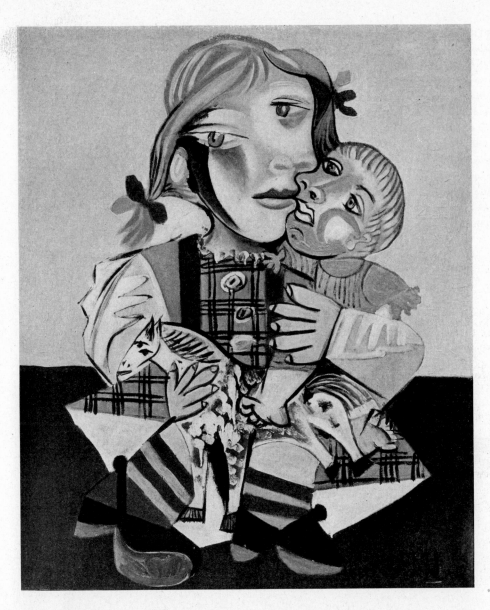

LITTLE GIRL WITH A DOLL. Paris, January 22, 1938 (dated). Oil. Owned by the artist.

1938

During 1938 Picasso worked with unusual energy and richness of invention. Some of his troubles of the previous years were over and while the Spanish Civil War went from bad to worse its disasters were no longer directly reflected in Picasso's art, although he continued to give generously to the Republican cause. The rather mild still-life paintings which, except for the Guernica, had occupied him during much of 1937 now gave way to a great variety of figure pieces, most of them vivid in color and psychologically active.

Among his figures of 1938 Girl with a Cock (opposite) is the most shocking in subject. Through the power of Picasso's imagery what might seem perverse and minor sadism takes on the character of hieratic ritual, perhaps even a symbolic significance. This child is the eldritch daughter of the Seated Woman of 1927 (p. 148).*

212

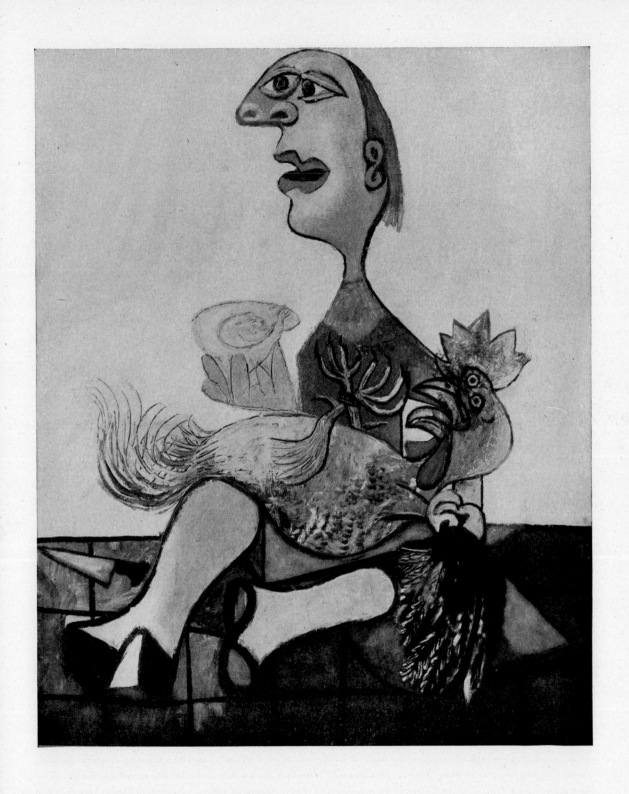

GIRL WITH A COCK. Paris, February 15, 1938 (dated on back). Oil, 57¼ x 47½ inches. Collection Mrs. Meric Callery.

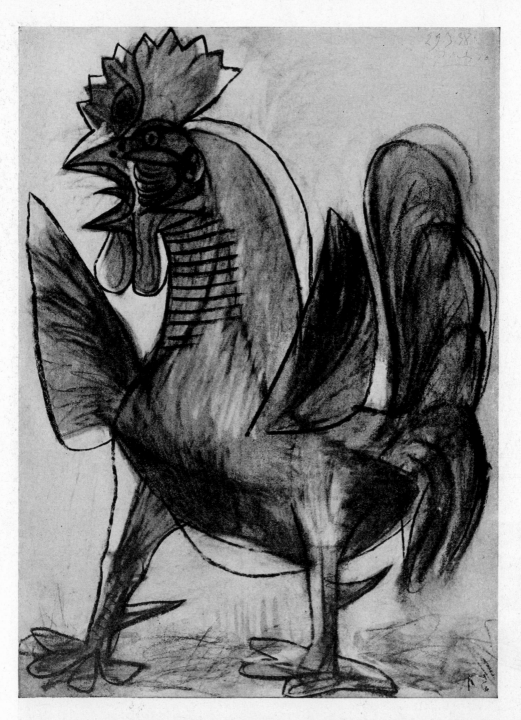

In several large drawings and pastels done a few weeks later the trussed, prone and helpless fowl in the **Girl** *with a* **Cock** *revives to match the strength and pride of the eagle. While he was at work on one of the series a young American painter, Xavier Gonzales, came to see him. "Cocks," Picasso said, "there have always been cocks, but like everything else in life we must discover them—just as Corot discovered the morning and Renoir discovered girls . . . Cocks have always been seen, but never as well as in American weather vanes."**

214

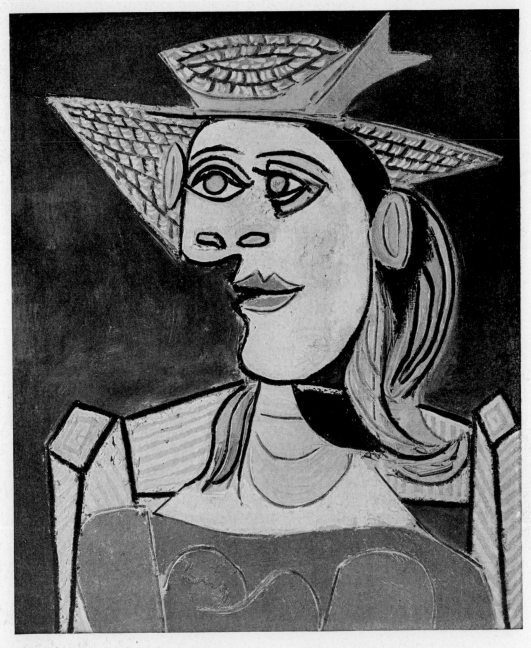

Portrait. May 24, 1938 (dated). Oil, 28½ x 24½ inches. Collection Walter P. Chrysler, Jr.

opposite: Cock. Paris, March 29, 1938 (dated). Pastel, 30½ x 22¼ inches. Private collection.

The heads of this period are popularly called "double-faced". Actually in this magnificently painted Portrait Picasso has kept the usual number of features: he has merely drawn the face in profile with the mouth and one eye in front view and both ears and both nostrils visible, liberties which he had taken since cubism. After all, Mercator in his commonly used flat projection of the map of the world distorts the physiognomy of his spheroid more than Picasso does his when he creates on a flat canvas his projection of a woman's head.

215

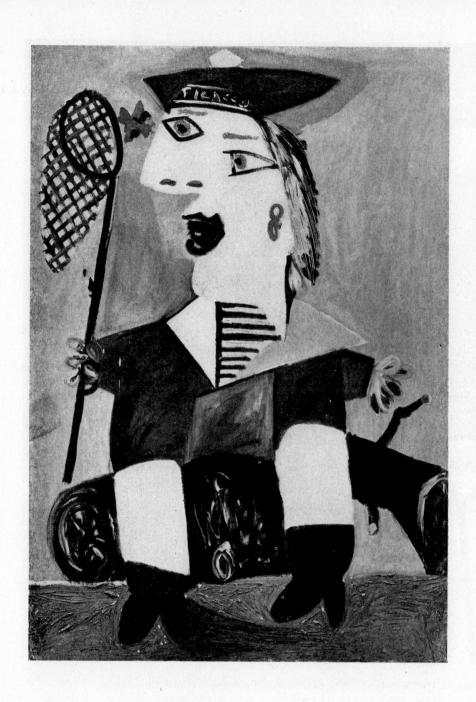

BUTTERFLY HUNTER. 1938 (P). Oil. Owned by the artist.

216

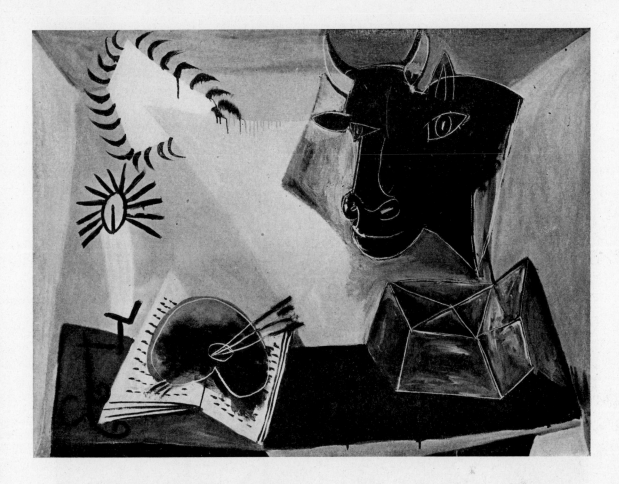

STILL LIFE WITH A BULL'S HEAD. 1938 (P). Oil. Owned by the artist.

Like the Girl with a Cock *these two paintings of 1938 are especially remarkable for their subject matter. The* Butterfly Hunter *is, it seems, actually a self-portrait in which Picasso has pictured himself as a child in a sailor suit seated on a log with a red butterfly flying between his eyes and the net.* The butterfly hunter appears to be of the same generation as the little girl with a doll (p. 212) though he was probably portrayed a few months later. Both recall Rousseau's paintings of children.†*

The Still Life with a Bull's Head *is so singular in its iconography that some deliberate symbolism seems intended. The open book, the palette and brushes, the candle, the radiant light above, all seem menaced by the great dark head of the bull— the bull who is first cousin to the white-headed bull of* Guernica *(p. 203) and all the more sinister for being turned to red. As in the* Guernica *and the* Minotauromachy *(p. 193) the bull appears to defy or threaten the light. Whether intentional or not the quasi-symbolic character of the* Still Life with a Bull's Head, *the* Girl with a Cock *(p. 213) and, possibly, the* Butterfly Hunter *seems more than coincidental, especially since all three were painted within a few months.*

Both the portrait and the still life were practically unknown until, years after they were painted, they were shown in the "Liberation Salon" of 1944. There they aroused the curiosity of a young American soldier and painter who cross-questioned Picasso about their meaning (p. 247).

217

218

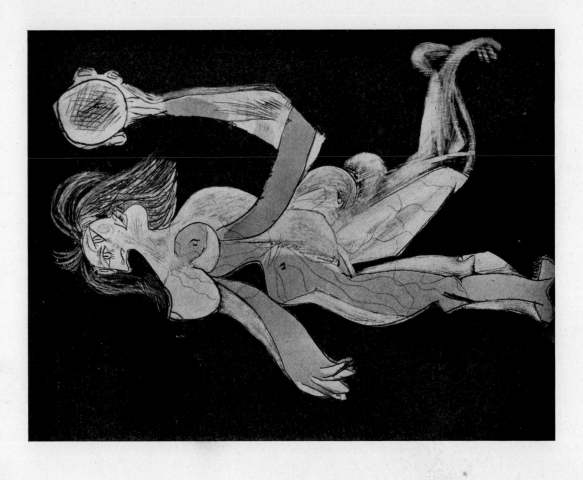

above left: MAN WITH AN ALL-DAY-SUCKER. August 20, 1938 (dated). Oil, 26⅞ x 18 inches. Collection Walter P. Chrysler, Jr.

above right: HEAD OF A WOMAN. Mougins, September 8, 1938 (dated). Ink, 26¾ x 17⅝ inches. Collection Mrs. Meric Callery.

right: DANCER WITH A TAMBOURINE. 1938 (K). Etching with aquatint, 26¼ x 20⅛ inches. Museum of Modern Art, New York.

*During the spring of 1938 Picasso began to draw figures which seem to be made of basketry or chair caning. The Man with an All-day-sucker (above) done at Mougins in the summer suggests that Picasso had looked twice at the work of the 16th century Italian mannerist, Arcimboldo, who painted figures composed of woven straw, fruits and vegetables.**

The ink drawing, above, outlines laconically one of the variants of a woman's head (sometimes called "horse-faced") which Picasso has used repeatedly during the past decade. Here the head rises from a demure collar and ascot.

The etching Dancer with a Tambourine is the most striking and one of the largest of Picasso's prints. The dislocations, which might be explained technically as the simultaneous presentation of all sides of the figure in one picture, have an early precedent in such drawings as the cubist nude (p. 72, left). But, in this maenadic figure, dislocating "simultaneity" is doubly functional since it augments the expression of both movement and dionysiac abandon.

219

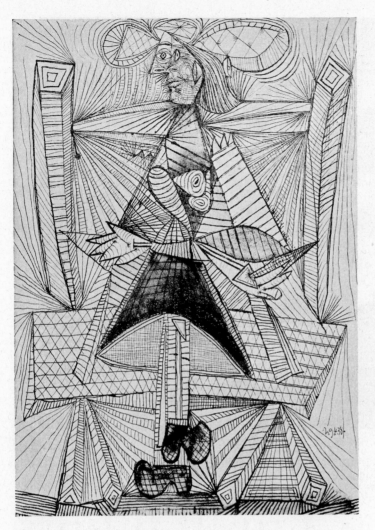

WOMAN IN AN ARMCHAIR. Paris, April 29, 1938 (dated). Color crayon over ink wash, 30⅛ x 21¾ inches. Collection Mrs. Meric Callery.

This large crayon drawing, as complicated as a figure of spider webs, is one of a series begun in April, 1938, and elabo rated during the summer at Mougins. In the fall, one of them was translated into the decorative painting Woman in a Garden.

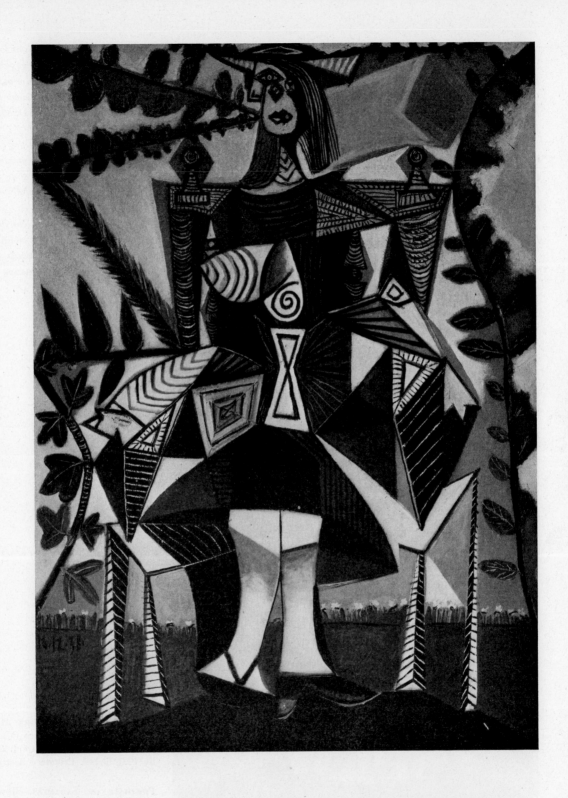

WOMAN IN A GARDEN. December 10, 1938 (dated). Oil, 51 x 38 inches. Collection Mrs. Meric Callery.

Such a portrait as the Girl with Dark Hair (opposite) is remarkable not so much for its formal metamorphosis as for its psychological intensity. The redistribution of features is far less radical than in certain heads of 1928 (p. 154). After one has got used to them, these dislocations, which in actuality would be unbearably monstrous, seem to reveal a personality, or at least to create a presence, with uncanny insistence. Actually the portrait resembles the subject sufficiently to be a recognizable likeness but the fascinating almost hypnotic power of this mask springs not from the brunette charm of Mademoiselle D. M. but from the dark magic of the artist.*

Although the dislocations, which imply a time element, are inherited from cubist simultaneity (p. 68), the rich, strong color, the sensuality of painted surface and the emotional character of the distortions brings Picasso's work of this kind within the general area of expressionism, perhaps more than of cubism or of surrealism. However, the grotesque extravagance of the full-length portrait of the same lady (p. 223) and its systematic quasi-cubist style far exceed the spontaneous and usually more naturalistic bounds of expressionism.

The fixed staring eyes of the portrait opposite tend to stabilize the total impression of the mask in spite of the centrifugal features. But in the portrait of the poet Sabartés, below, the axis of the head is ambiguous, the contours plastic and fluid. The spectacles turned toward the right pull against the sharp-nosed profile which faces left and slightly downwards. The realism of the modeling and of the eyes behind the thick lenses increases the tension of this humorous but disquieting and vertiginous portrait.

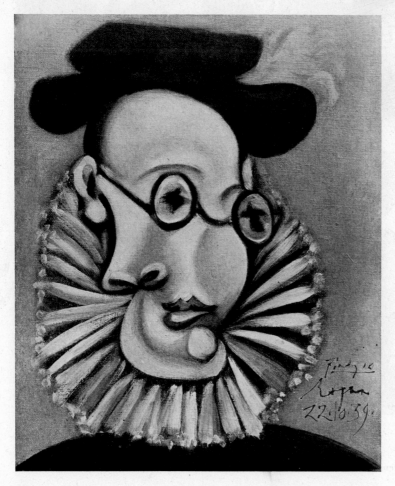

opposite: **GIRL WITH DARK HAIR** (PORTRAIT OF D. M.). Paris, March 29, 1939 (dated). Oil on wood, 23¾ by 17⅞ inches. Private collection.

PORTRAIT OF SABARTÉS. Royan, October 22, 1939 (dated). Oil.

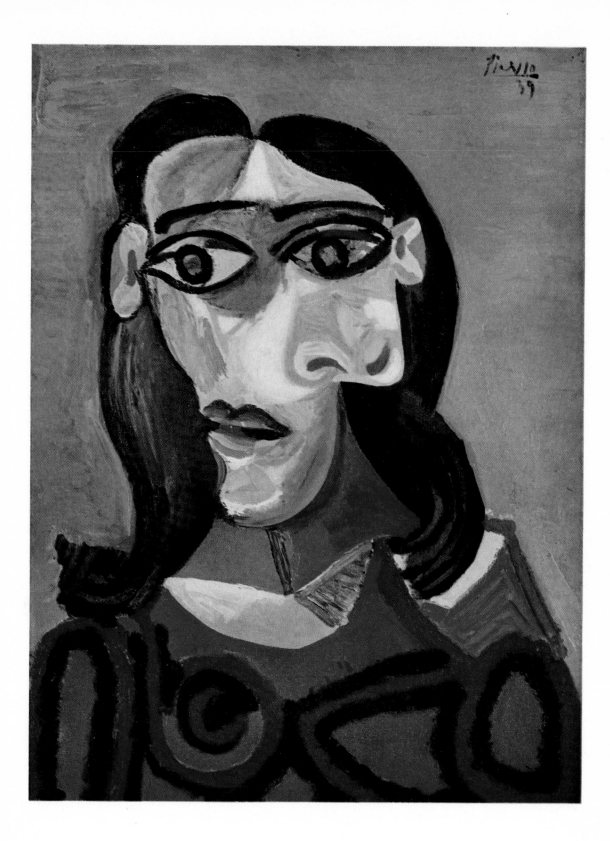

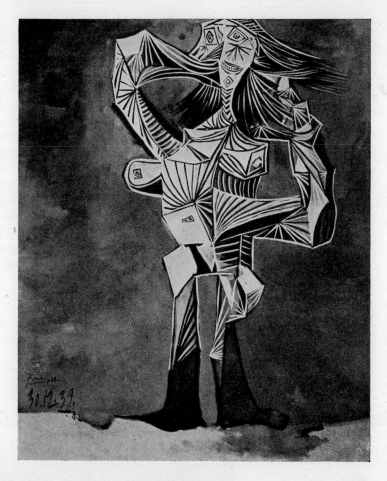

SUMMER AT ANTIBES; THE WAR BEGINS; ROYAN, AUTUMN 1939

During the ominous spring of 1939 Picasso moved from his apartment on the rue la Boétie to 7 rue des Grands Augustins, the large 17th century house which he had taken the year before as a studio. He spent the summer at Antibes. After war broke out in September he went to Royan near Bordeaux where he lived until the autumn of 1940, returning to Paris briefly in the spring of that year, before the German conquest.

In August, the last month of peace, Picasso painted Night Fishing at Antibes, *probably his largest canvas since* Guernica. *(Reproduction page 309.) At the right a couple of girls with a bicycle stand on a stone jetty watching two fishermen in a boat. In the background at the left are the dark houses and towers of the town. The mauve and brown tones of the night are disturbed by a yellow moon, lanterns, bright fish and the blue-and-white jersey of the fishermen with the four-tined spear. Both in composition and mood this nocturne seems altogether exceptional in Picasso's art.**

Throughout 1939 Picasso continued his variations on the theme of women's heads. For the most part they lack the frightening intensity of the Girl with Dark Hair. *In spite of their even more juggled features and square-ended probosces they seem as decorative in spirit as the frequently elaborate hats with which Picasso adorns them. The series is relieved by occasional naturalistic still lifes with animal skulls (reproduced, p. 269) and, toward the end of the year, by a renewed interest in neocubist geometrizing such as appears in the full-length* Portrait of D. M. *Here the linear elaborations of the 1938 "basketry" (pages 218, 220) decorate forms which recall facet cubism of 1909.*

This distraught figure and some of the macabre still lifes with skulls were painted in Royan after the Germans had moved into Poland. Possibly they express some awareness of the War; but even after the Germans had taken Paris, Picasso's art during the war years developed without any obvious reference to the catastrophe. "I have not painted the war," Picasso is quoted as saying in 1944, "because I am not the kind of painter who goes out like a photographer for something to depict. But I have no doubt that the war is in these paintings I have done. Later perhaps the historians will . . . show that my style has changed under the war's influence. Myself, I do not know." (Bibl. 503.)

ROYAN: 1940

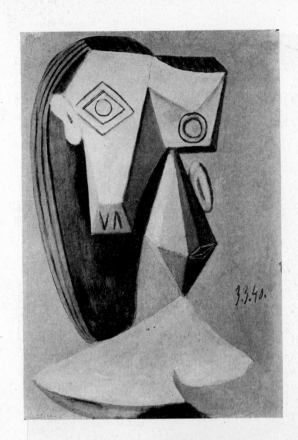

In the most serious and characteristic paintings of 1940 Picasso eliminates the linear elaborations of the figure on the previous page and, for the first time since 1937 (p. 199), produces simple, sculpturesque, sharp-edged volumes by vigorous modelling and cast shadows. The geometrical clarity of the Head (left) and the powerful forms of the Nude Dressing Her Hair (opposite) contrast with the flat arabesque of the Still Life with Eels (below). This still life, like that shown on page 269, represents the casual, naturalistic style to which Picasso returns from time to time, perhaps for refreshment and relaxation.

All three of these canvases were painted in the little seaport of Royan in March, 1940. The large head of a man shown in the photograph of Picasso on page 244 is apparently of about the same period.

HEAD. Royan, March 3, 1940 (dated). Oil on paper, 25½ x 18½ inches. Collection Pierre Loeb.

below: STILL LIFE WITH EELS. Royan, March 27, 1940 (dated). Oil, 29½ x 37 inches. Louise Léiris Gallery, Paris.

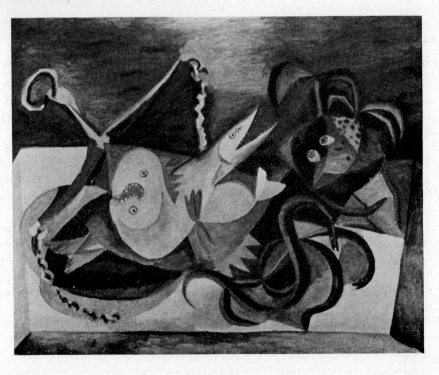

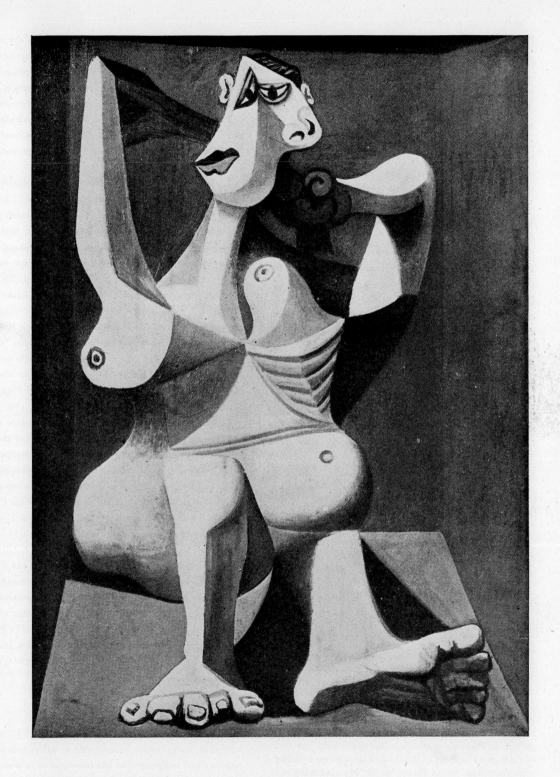

Nude Dressing Her Hair. Royan, March 5, 1940 (dated on back). Oil, 51⅛ x 38¼ inches. Repro. from *Cahiers d'Art*, bibl. 80.

PARIS UNDER THE NAZIS: 1940-1944

Picasso had been urged to seek safety in the United States or Mexico but instead he decided in October to return to Paris to his ancient many-roomed studio on the rue des Grands Augustins. There he lived for the duration of the war.

Picasso's life in Paris during the German occupation has been embellished by journalistic legend. All the facts are not yet available but it is certainly true that for many reasons he could scarcely have been persona grata *to the Nazis. He was not a Jew nor at that time a Communist but he was reported to be both. His art was anathema to Hitler. For many years he had been the most renowned and for-midable master of "degenerate" art, the Kunstbolschewis-mus which Hitler hated and feared; he had mercilessly lampooned Hitler's faithful ally in his* Dream and Lie of Franco *(p. 197), had given money to the Spanish Republi-can cause, and had painted* Guernica *on the occasion of the destruction of a Spanish town by German bombers, thereby creating the most famous of all anti-Axis propaganda pictures. Yet the Germans permitted him to return to Paris and live there unharmed for almost four years. Why? A precise, detailed answer cannot yet be given, but several interrelated factors contributed to Picasso's safety: his stature and world-wide fame as an artist gave him a certain immunity in the eyes of the Nazi officials who were eager*

A CORRIDOR IN SORDID'S HOTEL. *Picasso's sketch for the first scene of Act II of his play* Le Désir attrapé par la queue*. In Picasso's words the scene opens with "the feet of each guest in front of the door of their room twisting with pain. The feet of Room No. 3: 'My chilblains my chilblains my chilblains.' The feet of Room No. 5: 'My chilblains my chilblains,' " etc.

as a matter of policy to win credit in the eyes of the world by some show of solicitude for the cultural values, works of art, and distinguished artists of the conquered countries.†
Several Nazis came to see his pictures but they seem to have made no successful overtures to him as they did to several other well-known artists of Paris. Indeed they forbade him to exhibit publicly in spite of the fact that so advanced a painter as Braque was permitted to hold a large one-man show.

Though Picasso was personally unmolested during the German occupation he was maliciously attacked,‡ not so much by the Germans it now appears as by the French (and American) collaborationist critics and artists, some of them reactionaries as old as Pétain, others jealous con-temporaries of Picasso who were pleased to join in the chorus which denounced him as a charlatan, a Jew,§ a decadent pornographer, or a psychotic. André Lhote who had been a cubist before 1914 and always an eloquent champion of French classicism, lived, like Picasso, through the Occupation. "Never," he wrote after it was over, "never was independent art . . . exposed to more idiotic annoy-ances or ridiculed in terms more absurd . . . 'Into the ash can with Matisse!' and 'To the booby hatch with Picasso!' were the fashionable cries" (bibl. 312, p. 6).

Picasso made no reply to these cacklings which were nothing new to him, though the German victory had greatly increased their intensity. Throughout the Occupation period he lived quietly, sharing the common difficulties of eating and keeping warm (which he refers to in a neo-dada play called Le Désir attrapé par la queue*). With Vichy and Berlin he made no compromises; at the same time he made no overt gestures against them, unless one may count his reputed handing out postcards of* Guernica *to German visitors‖ or his attendance at the funeral of his old friend Max Jacob who died in 1944 in a concentration camp. He did not take a military part in the Resistance movement, yet as the sad, confusing, humiliating, heroic years of the Occupation passed by, Picasso, because he stayed in Paris —and remained Picasso—gradually assumed a rôle of great symbolic importance which in the fall of 1944, after the Liberation, approached apotheosis.*

PAINTING: 1940-44

During the occupation years Picasso worked with his usual incredible energy which he was able to canalize into his painting and sculpture with less interruption or diversion than in peace time.

To judge by the paintings which have been reproduced

226

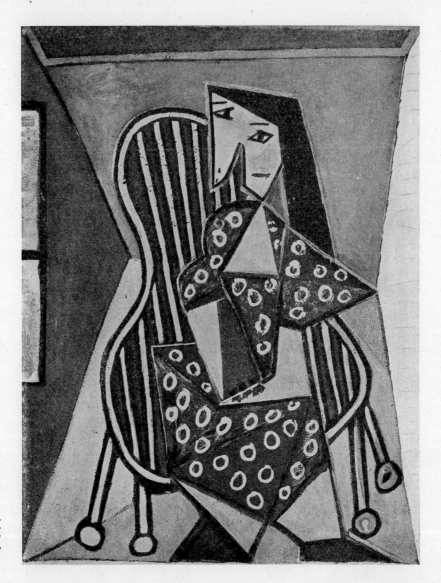

SEATED WOMAN. Paris, September 1941. Oil, 51⅛ x 38¼ inches. Owned by the artist. Repro. from bibl. 135.

Picasso soon gave up the strong three-dimensional effect of such works as the Nude Combing her Hair done at Royan in 1940. Possibly the sculptural character of some of his best Royan paintings had served as a substitute for sculpture itself which may have been impracticable in his temporary quarters in the little town. Once back in Paris in the fall of 1940 he was able to work at his sculpture in the large studio which he set aside for that purpose (p. 239).

In any case Picasso returned to a flat, two-dimensional mode in his painting during the winter of 1940-41 and has continued down to the present to keep his pictures fairly near the surface of the canvas with the exception of a few rather conventionally modeled portraits.

It appears that the paintings of 1940 and early '41 are fairly subdued in tone but as the year wore on Picasso painted a number of figures and still lifes of exceptional gaiety both in color and pattern. The circle-dotted blue dress of the Seated Woman is spread against angular quarterings of the brightest green, red, white and blue-violet. The insistent angles of this and many other canvases of Picasso's past five years recall synthetic cubism, though the images are never so abstract as the harlequins of 1915 (p. 92).

227

The gouache (left) of a girl's head seen from the rear and the ink drawing of a woman's head below are fresh solutions of Picasso's self-set problem of reorienting the complete complement of human features in one picture. From such variations Picasso returns to the original, undistorted theme in the simply rendered "realistic" Portrait of Inez (on p. 229, below).

HEAD OF A WOMAN. Paris, July 16, 1941 (dated). Ink. 10⅝ x 8¼ inches. Museum of Modern Art, New York.

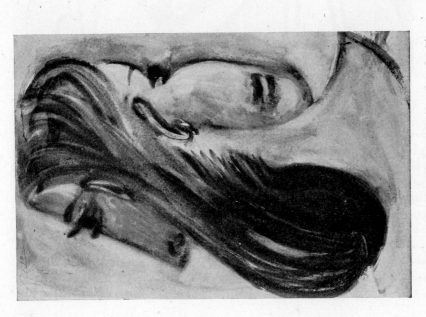

GIRL'S HEAD. Paris, April 29, 1941 (dated on back). Gouache, 15¾ x 10¾ inches. Collection Pierre Loeb.

The Portrait of the Author (below) is a "trick angle" self-portrait of Picasso drawn for the publication of his play Le Désir attrapé par la queue (p.226). The hesitant line of this drawing contrasts strikingly with the calligraphic virtuosity and fury of the woman's head at the right.

228

PORTRAIT OF INEZ. Paris, April 4, 1942 (dated on back). Oil, 22 x 18¼".

PORTRAIT D'AUTEUR

PORTRAIT OF THE AUTHOR. Picasso's self portrait drawn for a published version of his play *Le Désir attrapé par la queue* (see pages 226 and 278).

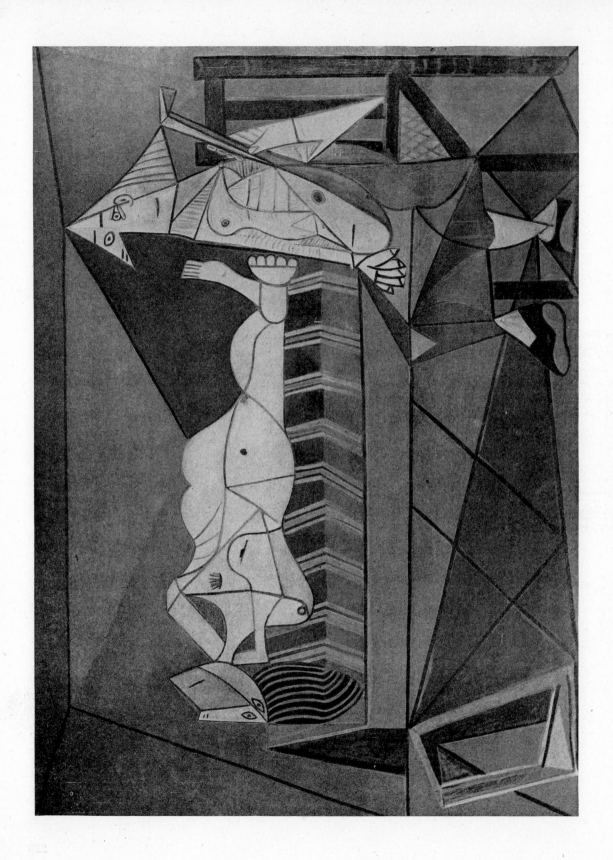

The sombre Nude with a Musician is probably the largest canvas Picasso painted in Paris during the War. Straight lines and angles dominate as they did in the equally flat and even more abstract Studio of 1927 (p. 152). Yet however ingenious and far-fetched the distortions in Picasso's recent paintings, the figures preserve their integrity of form. Very rarely do they merge with background or accessories as in cubism of the analytical period.

Except for the fact that the musician is here a woman, the subject is one that goes back a long way in Picasso's art to the Avignon album of 1914 (p. 89) and beyond that in a general way to a melancholy drawing of 1904 (bibl. 524, pl. 105).

Very different in spirit is the robust, handsomely colored Still Life with a Guitar in which Picasso brings his yellow, blue and black tones to focus by the scarlet sword hilt. By a characteristic conceit the strongest three-dimensional effect in the composition is the reflection in the mirror.

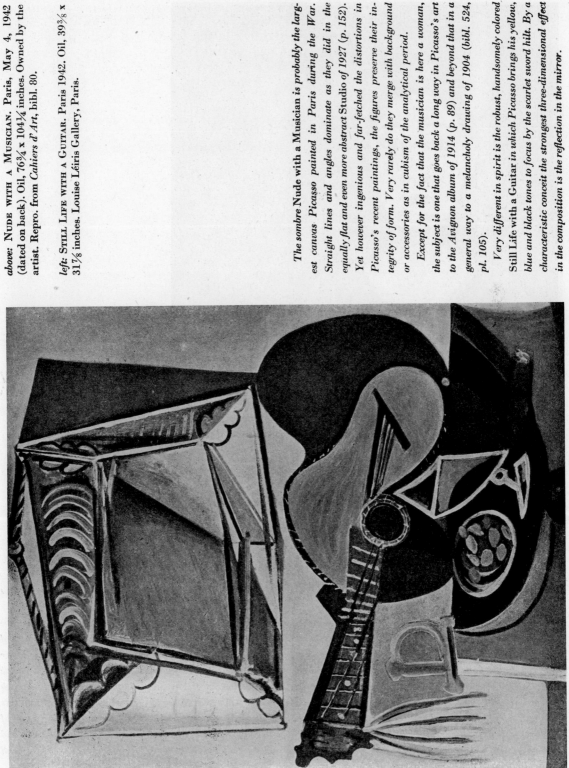

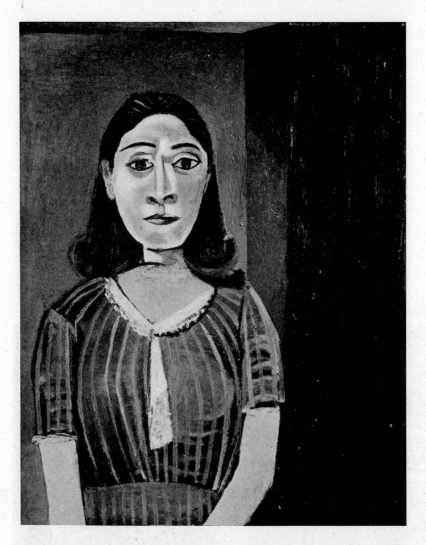

PORTRAIT OF D.M. Paris, October 9, 1942 (dated on back). Oil, 36¼ x 28¾ inches. Louis Carré Gallery, Paris.

The simplifications and slight dislocations in this Portrait of D. M. *heighten the vivid intentness of the image without obviously departing from natural appearances.*

The impact of Picasso's obsessive concern with distortion and dislocation is perhaps strongest or, at least, purest when the subject in actuality might be conventionally pretty, a young woman's head for instance. When he turns loose the dynamics of his recent style on a subject such as the First Steps *(opposite) the effect is ambiguous for the distortions then seem to enhance the original subject rather than destroy it. In a sense the act of the child taking its first steps is funny or touching; but for the child himself it is a moment of crisis in which eagerness, determination, insecurity and triumph are mingled. Through his drawing, composition and magnified scale, Picasso suggests the momentous drama of the scene, not its charm. In this large canvas the child is well over life size so that his raised foot, his face puckered with effort, and the over-arching figure of the mother take on something of the monumental character as well as the intensity of a Romanesque mural. The human and formal relationship between the two heads is remarkable, and so is the continuous flat shape formed by the mother's face and nape. In design and feeling this is one of Picasso's most notable recent paintings.*

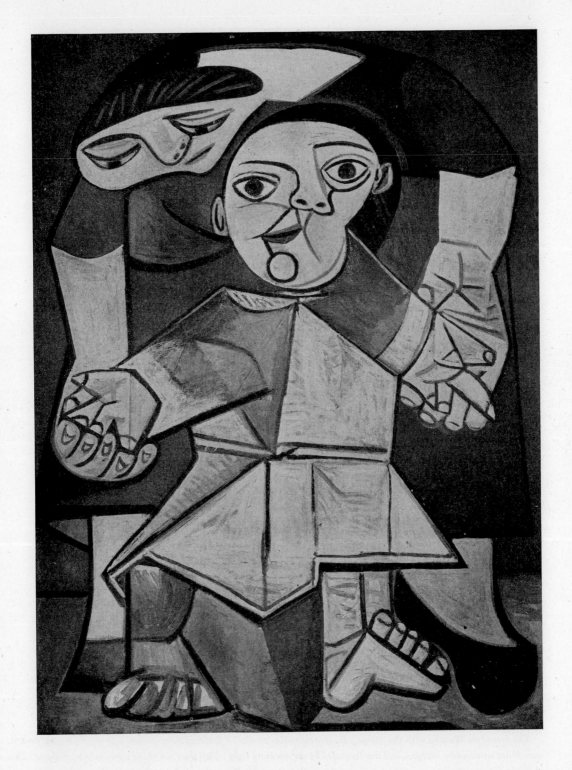

FIRST STEPS. Paris, May 21, 1943 (dated on back). Oil, 51⅛ x 38¼ inches. Repro. from *Cahiers d'Art*, bibl. 80.

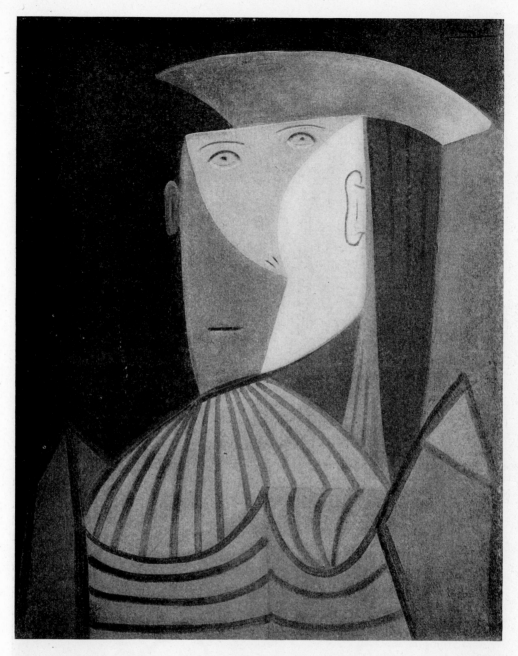

WOMAN WITH THE STRIPED BODICE. Paris, September 20, 1943 (dated on back). Oil, 40 x 32½ inches. Louis Carré Gallery, Paris.

The face of the Woman with the Striped Bodice *resembles an almost flattened three-planed slab in which eyes, nostrils and mouth are rendered by intaglio, and then revealed by an uncanny light which does not shine upon hair or clothing. This and the canvas opposite are among the most memorable in the scores of half-length paintings of women Picasso has produced in the past decade.*

234

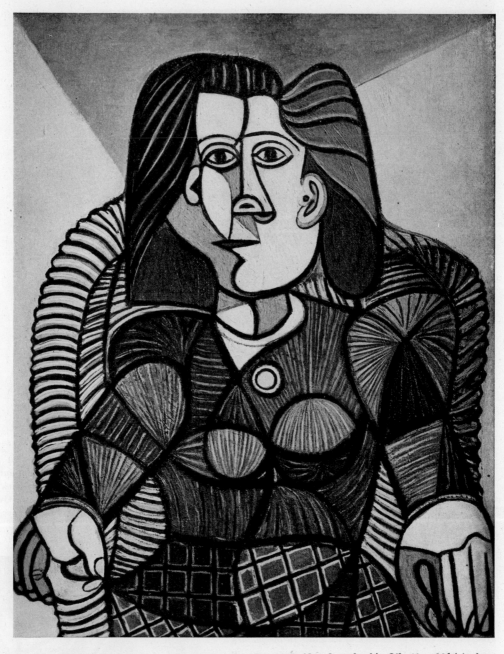

WOMAN IN A WICKER CHAIR. Paris, September 24, 1943 (dated on back). Oil, 40 x 32½ inches. Louis Carré Gallery, Paris.

In the Woman in a Wicker Chair *Picasso uses the insistent eyes to establish a rigidly frontal axis from which he unhinges contradictory profiles, complicating the result by contradictory cast shadows. The bodice borrows its Arcimboldo-like texture and pattern from the wicker chair; chair and bodice merge at the shoulders. (See note to p. 219.)*

These four canvases suggest the variety and strength of Picasso's still-life composition during the last two years of the Occupation period. All show some vestiges of cubism in the angular cutting of shapes and shadows, the free handling of perspective and the extension of profiles into space (for example, the curve of the back of the chair in the picture reproduced above). However, as in most of his recent still lifes the characteristic shapes of objects are not disintegrated as in cubism, but are fortified by the use of heavy dark contours.

SKULL AND JUG. August 15, 1943 (dated). Oil, 20 x 24½ inches. Louise Léiris Gallery, Paris.

STILL LIFE WITH CANDLE. Paris, April 4, 1944 (dated on back). Oil, 23⅝ x 36¼ inches. Louise Léiris Gallery, Paris.

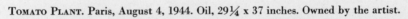

TOMATO PLANT. Paris, August 4, 1944. Oil, 29¼ x 37 inches. Owned by the artist.

DEATH'S HEAD. 1941. Bronze. Owned by the artist.

opposite: Picasso in his sculpture studio, September 1944. At the left is the *Shepherd Carrying a Lamb* for which Picasso was making drawings in the summer of 1942 (bibl. 356a); in the background are the big plaster *Head* reproduced on page 240 and other sculptures, old and new, and a painting by Modigliani. With Picasso is his dog Kazbek. Photograph Robert Capa, courtesy *Life*.

SCULPTURE: 1940?-44

During the Occupation, Picasso seems to have been more actively concerned with sculpture than at any time since the early thirties. From the workshop at Boisgeloup (p. 179), where he had done most of his sculpture before the war, he brought into Paris many of his earlier plasters some of which he had cast in bronze. The photograph opposite taken by the Spanish photographer Robert Capa just after the Liberation shows Picasso in the big room in his Paris house where he stored his old sculpture and worked on new pieces.

The most ambitious of Picasso's recent sculptures, is the large Shepherd Carrying a Lamb *which is so unlike anything he had attempted before that it may have some special significance which we do not yet know. As is the case with this figure Picasso ordinarily builds up his sculpture in wet plaster rather than working in clay.*

Skulls, human and animal, have appeared occasionally in Picasso's art of the past but during the war they were a frequent motive in his still-life compositions (pages 236, 269). Judging from the photograph the Death's Head in bronze is modeled with exceptional tactile interest and plastic power. It seems one of the simplest and least forced of Picasso's sculptures and one of the most convincing.

238

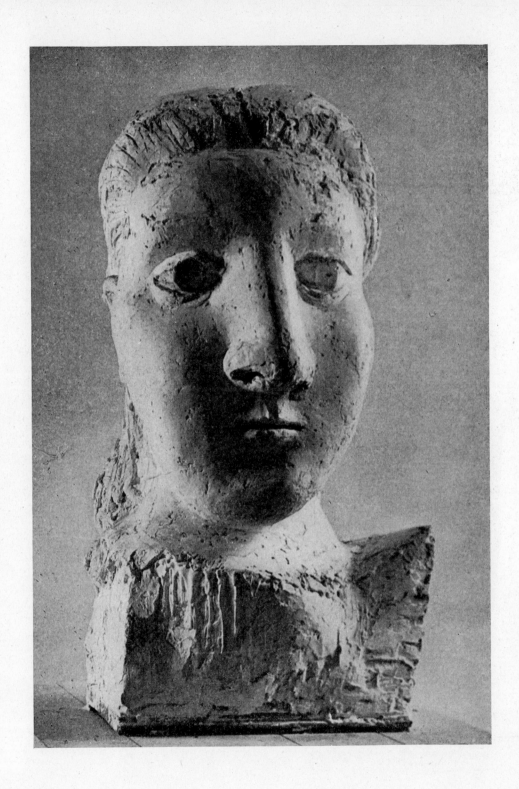

HEAD. Plaster. 1943-44? Owned by the artist.

BICYCLE SEAT (BULL'S HEAD). Handlebars and seat of a bicycle. Owned by the artist.

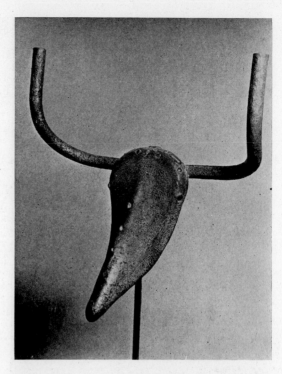

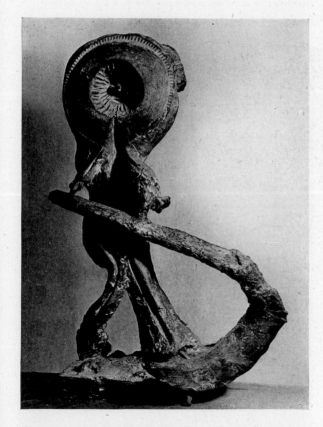

REAPER IN THE BIG STRAW HAT. 1941-44? Bronze. Owned by the artist.

The "bull's head" which he assembled from parts of a wrecked bicycle so pleased Picasso that he pointed it out with special pride to several journalists and sent it as one of his five pieces of sculpture to the Liberation Salon of 1944. The Surrealists would classify it as an objet trouvé aidé, a natural or man-made object in which someone accidentally discovers a value or beauty or resemblance which he then makes clear by some alteration or combination.

In a recent conversation with André Warnod, Picasso whimsically develops the idea: "You remember that bull's head I exhibited recently? Out of the handle bars and the bicycle seat I made a bull's head which everybody recognized as a bull's head. Thus a metamorphosis was completed; and now I would like to see another metamorphosis take place in the opposite direction. Suppose my bull's head is thrown on the scrap heap. Perhaps some day a fellow will come along and say: 'Why there's something that would come in very handy for the handlebars of my bicycle . . .' And so a double metamorphosis would have been achieved." (Bibl. 4a.)

The Reaper in the Big Straw Hat like the Man with a Bouquet of 1934 (p. 186) is modeled with the help of commonplace objects and surfaces, in this case, apparently a cake mold.

The colossal plaster head, opposite, continues the series which Picasso began about 1931 (pages 180, 181).

241

THE LIBERATION: AUGUST 1944

Well into the summer of 1944 Picasso continued to paint as he had before, figures, still life, and, as an innovation, some small views of Paris. About the middle of August as the Allies were drawing near the French capital he began a series of "realistic" heads and portraits. On the 25th the Germans were driven out. American and British soldiers and correspondents and photographers came in quick succession to Picasso's studio wiring or writing the news that he was safe, photographing his studio and giving their accounts of what he had done during the long years of occupation and the long week of street fighting in Paris.

John Pudney, an R.A.F. Squadron Leader and poet, was among Picasso's first English visitors (bibl. 379). They walked together through the studio looking at his two Matisses, his Rousseau and then his own pictures including the paintings of "the pot of growing tomatoes which stood in the window" and "four very exact likenesses of a boy." (Pages 237, 244) Pudney reports Picasso's saying: "A more disciplined art, less unconstrained freedom in a time like this is the artist's defense and guard. Very likely for the poet it is a time to write sonnets. Most certainly*

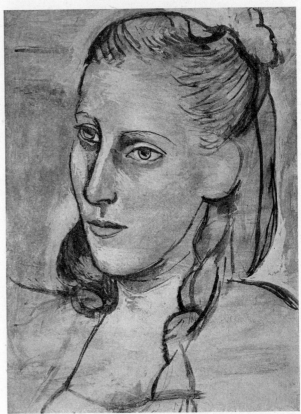

above: DAUGHTER OF THE ARTIST. Paris, August 1944. Watercolor. Owned by the artist. Photographed by Pfc. Francis Lee.

HEAD OF A GIRL. Paris, August 22, 1944. Watercolor, 16¼ x 12¼ inches. Repro. from *Cahiers d'Art*, bibl. 80.

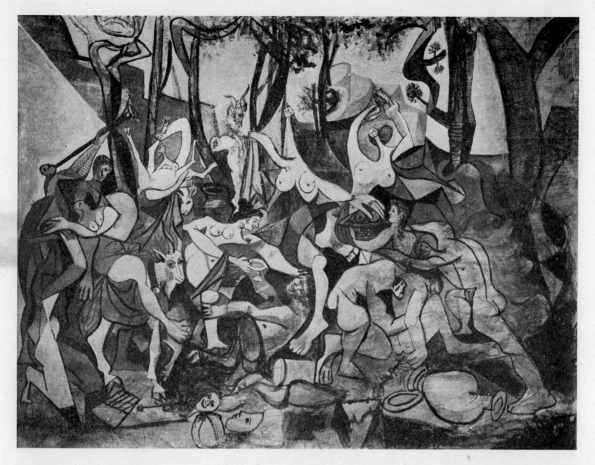

BACCHANALE, AFTER POUSSIN. Paris, August 24 to 29, 1944. Watercolor and gouache, 12¼ x 16¼ inches. Owned by the artist. The original painting by Poussin was in the collection of the late Paul Jamot and is reproduced on page 267.

it is not a time for the creative man to fail, to shrink, to stop working . . ." As they looked at his pictures Picasso "pointed out the significance of the dates. There were sketches dated day by day during the battle of Paris. On August 24 when Tiger tanks were fighting around the corner of the 'Boul Mich,' when Germans and French Fascists were fortified in the Luxembourg, when the Prefecture just across the river was a strong point, Picasso glanced at a work by Poussin. As the windows rattled with the fighting he began copying Poussin's design. 'It was an

exercise, a self discipline . . .' [Picasso remarked]. He worked at it throughout the loud, angry day of the Liberation on August 25."

Picasso's version of Poussin's Bacchanale (above) is in fact dated August 24 to 29; the watercolor portrait of a girl (opposite), August 22. According to the photographer, the portrait of Picasso's daughter was also drawn during the same nerve-racking period when Picasso seems to have taken pleasure in working from an objective model, whether a human face or a work of art.*

243

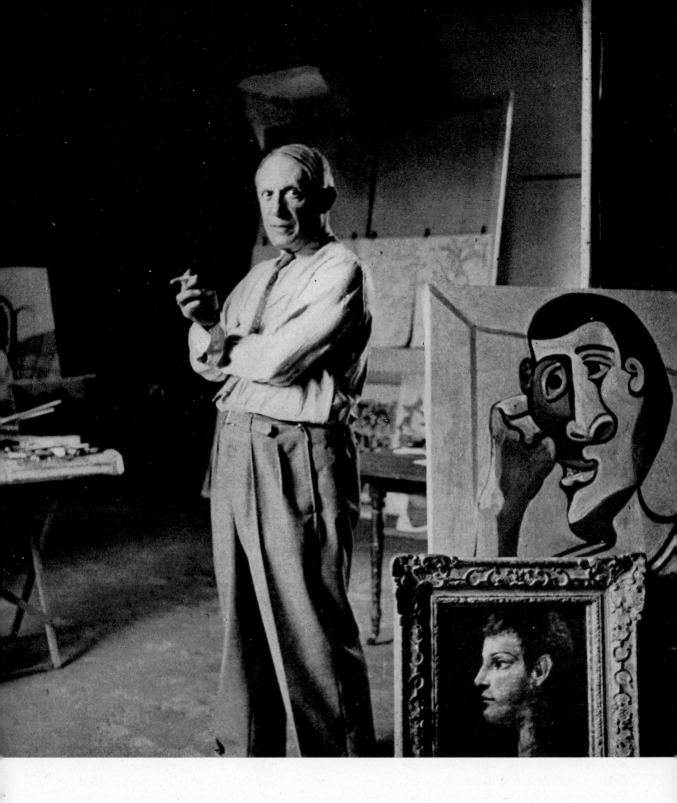

Picasso in his studio, September 1944. The small painting in the right foreground was done in mid-August 1944. Photograph by Lee Miller, courtesy *Vogue*.

PICASSO'S POSITION AFTER THE LIBERATION

The many early post-Liberation accounts of Picasso seemed quickly to fall into a consistent pattern. There are similar descriptions of his various studios in the hôtel on the rue des Grands-Augustins, and repeated references to Picasso's cordiality, the large number of paintings he had produced during the Occupation, his sculpture, especially the constructions made of odds and ends, the behavior of the Germans, the misbehavior of certain French collaborationist artists, the tedious lack of soap, cigarettes and coal, the tomato plant, the dog Kasbek. More striking still are the indications of Picasso's new importance as a public personality. The old friends Sabartés, Cocteau, Paul and Nusch Eluard appear in the studio photographs and the reportage but there is a new sense of many people going and coming, the phone ringing, the pressure of visitors and business. John Groth, the American artist-correspondent, describes how on August 27, two days after the Liberation, Eluard brought into Picasso's studio a large book to be filled by the artists and writers of the Resistance movement for presentation to General de Gaulle: Picasso was asked to do the first drawing (bibl. 201, 312).

Picasso, unlike his friends Paul Eluard and another ex-Surrealist poet Louis Aragon, had taken no active part in the underground Resistance movement, yet, as has been indicated, Picasso's presence in Paris while the Germans were there had gradually taken on an aura of great symbolic importance (p. 226). His attitude had been passive but it had been implacable and uncompromising and had created a legend which had probably been more effective than if he himself had joined the F.F.I. and gone underground.

THE AUTUMN SALON OF 1944

In any case Picasso now found himself greatly esteemed for his part in the Resistance and invited to present a large number of his recent works at the Salon d'Automne. Ordinarily this is the most important of the big annual Paris exhibitions. But the Autumn Salon of 1944 was uniquely significant. Held just six weeks after August 25th, it became the Salon de la Libération, the first great manifestation of art in France after four years of German domination. Often in the past some distinguished French artist had been given a one-man show at the Salon to serve as a high point among the hundreds of exhibitors. Now, although he was not a Frenchman and had never even shown at the Autumn Salon before, Picasso alone among the living artists of Paris was given a gallery to himself where nearly eighty of his works were exhibited. No greater tribute could be paid by his French colleagues to the man whose art had been maligned by the partisans of Vichy and forbidden by the Nazis.

ANTI-PICASSO DEMONSTRATION

The Picasso gallery made a strong impression on the public. The artist had never shown before in one of the several large annual Salons—his big retrospective exhibition of 1932 and several smaller shows had all been held in dealers' galleries. Though the Germans had generally permitted modern exhibitions—Braque's for instance—reactionary tastes had generally been encouraged by Nazi rule so that the people of Paris were less prepared than usual to bridge the gap between their own inexperience and the revolutionary violence of Picasso's recent art. Public reaction was intensified by three other circumstances: Picasso, a foreigner, had been given the central place in a cultural event of patriotic and national importance; at the time of the opening of the Salon, Picasso had declared his adherence to the French Communist Party; and on the 8th of October, two days after the Salon opening, there had been a demonstration in the Picasso gallery and a number of his paintings had been unhung from the walls with shouts of "Take them down! Money back! Explain! Explain!"

Accounts differ as to just who the rioters were and why they misbehaved, but it is now generally accepted that they were Beaux-Arts students who had grown up during the Occupation and were demonstrating with sophomoric iconoclasm against a master whose art they—and their teachers —did not like. However, reactionary politics seems to have played a part. André Lhote gives first-hand evidence to prove that the demonstration was a Royalist manoeuver and implies that the rioters were influenced by Doriot. Jean Lurçat, hailing Picasso as an important and active member of the Resistance, writes with vehement scorn of "kids, bred in the school of Maurras" who "find it easier to massacre a water color than to rot with frozen feet in the mud of the Front."† Whether the demonstrators were followers of Doriot or Maurras or simply Latin Quarter irresponsibles, political implications were unavoidable at a time when Picasso himself had just taken a political stand.*

245

These two gallery photographs show about half of the 74 paintings and four of the five sculptures Picasso sent to the *Salon d'Automne* of 1944. In the view above the principal paintings are the *Chair with Gladiolas* (p. 236), the *First Steps* (p. 233) and the huge *Nude with a Musician* (p. 230). The bronze *Cat* was modeled in 1941, the large bronze *Head* about ten years earlier (p. 179) though it had never been exhibited before.

The other side of the bronze *Head* is shown in the photograph below (left), together with the *Cock* (p. 182). On the wall may be seen the large *Woman with a Bouquet*, the *Still Life with a Bull's Head* (p. 217), and at the right the animal's head listed in the Salon catalog as *La selle de bicyclette* (p. 241).

Among other works exhibited were the *Little Girl with a Doll* (p. 212), the *Butterfly Hunter* (p. 216), the *Skull and Jug* (p. 236) and the bronze *Death's Head* (p. 238). Both photographs are by Marc Vaux, courtesy Pfc. Jerome Seckler.

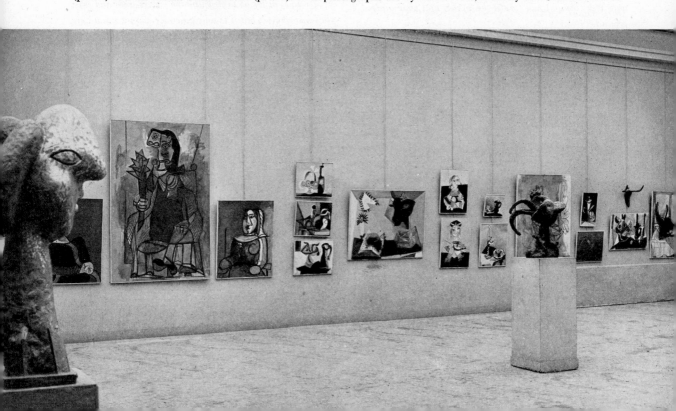

PICASSO THE COMMUNIST

Picasso has explained very clearly why he joined the French Communist Party. In an interview given about October 20th to Pol Gaillard for the New Masses,* *Picasso is quoted as saying that he had long stood with the Communists, as his friends Eluard, Aragon and Cassou well knew; that he believed the Communists "worked the hardest to understand and construct the world, . . . that they had been the bravest whether in France, in the U.S.S.R. or in his own Spain," that while he had been an exile from his own country the French Communist Party had opened its arms to him; and that among the Communists he found all those whom he most esteemed, "the greatest scientists, the greatest poets, and all the beautiful faces of the Paris insurgents" whom he had seen during the August fighting.*

PICASSO THE INDIVIDUALIST

The Communists did indeed open their arms to Picasso but greeted his art with mixed feelings, especially abroad, where Communist art theories conform more generally to orthodox principles sanctioned by Moscow, than in France where the Party was both more independent and more tolerant of avant garde heresies surviving from "bourgeois leftism." Picasso's art did not conform. Since Guernica, seven years before, he had painted nothing which could be considered conscious propaganda. Furthermore his work as displayed at the Salon d'Automne, revealed no change of heart, no new willingness to make his art agreeable or even intelligible to the general public, the proletarian (or, for that matter, the aristocrat or bourgeois).

Picasso without in any way compromising his political stand made his position as an artist extremely clear in two interviews he gave an American soldier, Pfc. Jerome Seckler,† who had been an enthusiastic visitor to the Picasso gallery in the Liberation Salon. Seckler, himself a talented painter, gave Picasso his own interpretation of two paintings shown in the Salon. Seckler insisted for instance that the color of the red butterfly in the Butterfly Hunter *must have some political significance (p. 216). Then, quite plausibly, he argued that the objects in the* Still Life with a Bull's Head *were also symbolic (p. 217). Picasso at first denied any intentional or conscious symbolism in either picture. Of the still life he said "the bull is a bull, the palette a palette and the lamp is a lamp. That's all. But there is definitely no political connection there for me." Then admitting only the most general symbolism he explained that the bull, just as it had in the Guernica, signified "darkness and brutality, yes, but not*

fascism . . . If I were a chemist, Communist or fascist—if I obtain in my mixture a red liquid it doesn't mean that I am expressing Communist propaganda, does it? I am a Communist and my painting is Communist painting. But if I were a shoemaker, Royalist or Communist or anything else, I would not necessarily hammer my shoes in a special way to show my politics."

With patient good humor, Picasso debated these points with Seckler through two long conversations. He made one concession: that there might be unconscious symbolism in his paintings, but he refused to take any responsibility for it. He also rejected the idea that he might, now that he was a Communist, change his style or clarify his symbolism. "I can't use an ordinary manner just to have the pleasure of being understood."

In spite of such statements the relation between Picasso's politics and his art created intense controversy‡ all during the winter of 1944-45. People who liked his politics but not his art questioned both his sincerity and his value to Communism. Those who disapproved his politics but admired his art were inclined to view the former as a kind of betrayal or, at best, an aberration of genius. Those who detested both were confirmed in their supposition that Communism and modern art were sinister allies (a theory overwhelmingly at odds with the facts). And, finally, those who approved both his politics and his art were embarrassed by the problem of reconciling Picasso's intransigent individualism with his adherence to a collectivist movement.

Early in the spring of 1945 a French correspondent Simone Téry interviewed Picasso. In February there had been a spurious rumor that the French Army had given Picasso a commission to go to the Front as a War artist.§ Picasso joked with Téry about this and other stories but became serious when she told him of an American newspaper report that his Communism was a mere caprice and, moreover, that he had explained that art and politics had nothing in common. Picasso was scandalized, denied having made such a remark, and then impetuously wrote down on paper a statement "about which no one could have any doubts":

PICASSO'S WRITTEN STATEMENT

"What do you think an artist is? An imbecile who has only his eyes if he's a painter, or ears if he's a musician, or a lyre at every level of his heart if he's a poet, or even, if he's a boxer, just his muscles? On the contrary, he's at the same time a political being, constantly alive to heart-rending, fiery or happy events, to which he responds in every way.

247

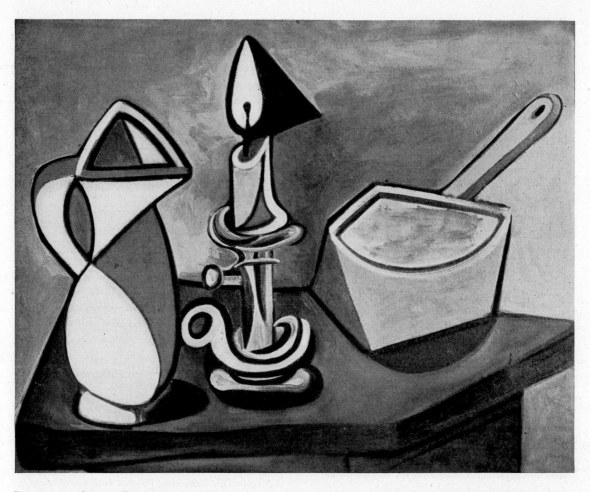

PITCHER AND CANDLE. Paris, February 16, 1945 (dated on back). Oil, 33¼ x 43 inches. Louis Carré Gallery, Paris.

opposite above: PARIS. Paris, February 26, 1945 (dated on back). Oil, 32 x 48 inches, Louis Carre Gallery, Paris.

opposite below: STILL LIFE WITH A SKULL. Paris, March 14, 1945 (dated). Oil. Owned by the artist.

How would it be possible to feel no interest in other people and by virtue of an ivory indifference to detach yourself from the life which they so copiously bring you? No, painting is not done to decorate apartments. It is an instrument of war for attack and defense against the enemy." *

Picasso has been true to his words. Since the Liberation his studio has been no ivory tower but a center of continuous activity. For a while he cordially welcomed visitors and journalists, even opening his studio once a week to crowds of bewildered G.I.s and other allied troops on sightseeing tours. He served on committees to choose French war artists, to help his refugee countrymen, to organize French intellectuals for the support of Republican Spain. He ac-

cepted his rôle as a public figure, though not without causing his friends some misgivings.

And he continued to paint.

PICASSO'S PAINTING: 1945

Early in the summer of 1945 an exhibition of thirty canvases painted by Picasso since 1940 supplemented the larger Salon show of the previous fall. The paintings of 1945 suggest no dissipation of his energies as an artist though, with one important exception, they mark no radically new departures. The Still Life with a Skull (opposite), was one of two paintings Picasso exhibited at the Salon d'Automne of 1945.

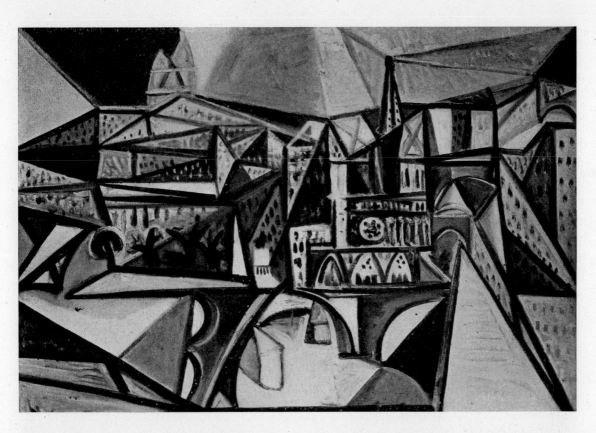

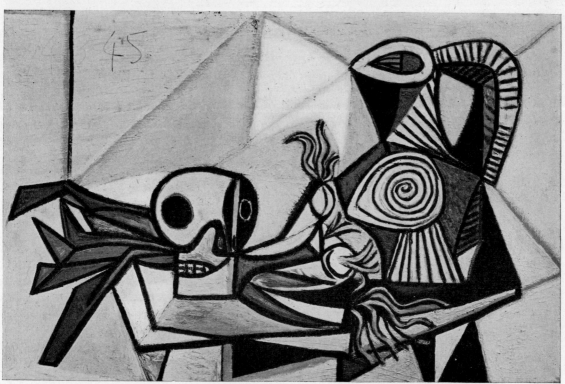

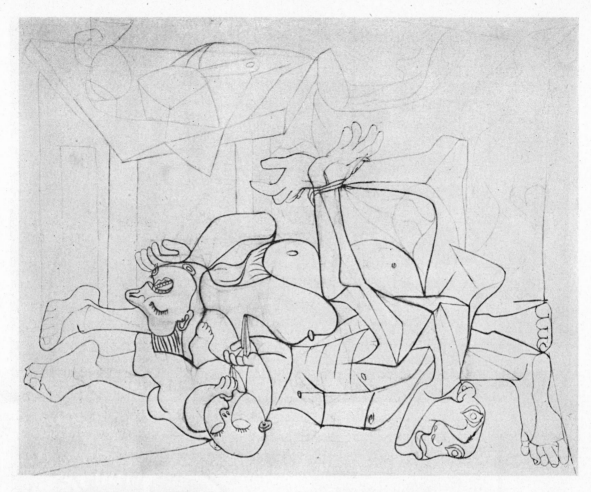

CHARNEL-HOUSE. Unfinished painting, begun summer 1945; about 7 x 9 feet. Owned by the artist.

During '43 and '44 he had done a number of small neo-cubist views of Paris in brilliant colors. In February 1945 he painted Paris, one of his largest landscapes, choosing perhaps as a challenge one of the tritest and most often painted scenes in art. Out of the trees and bridges of the Seine, the façade of Notre Dame and a pavilion of the Louvre, he made a picture of the city he had faithfully loved.

In London toward the end of the year Picasso showed twenty-five of his recent paintings at the Victoria and Albert Museum. Unfortunately Picasso's most important postwar composition was not finished in time to be included. The Charnel-House might have sobered those who found Picasso's distortions an outrageous effrontery; it might have embarrassed those defenders who, ignoring the psychological tensions of his recent art, still tried to seek refuge in the esthetic of form and color so dogmatically popularized in the 1920s; and it might have stilled those who demanded that Picasso deal more directly and explicitly with the state of the world.*

The Charnel-House is a very large canvas, one of the largest Picasso has painted since Guernica.† And like Guernica it was obviously inspired by the day's atrocious news. The Guernica was a modern Laocoon, a Calvary, a doom picture. Its symbols transcend the fate of the little Basque city to prophesy Rotterdam and London, Kharkov and Berlin, Milan and Nagasaki—our dark age.

In the Charnel-House there are no symbols and, perhaps, no prophecy. Its figures are facts—the famished, waxen cadavers of Buchenwald, Dachau and Belsen. The fury and shrieking violence which make the agonies of Guernica tolerable are here reduced to silence. For the man, the woman, and the child this picture is a pietà without grief, an entombment without mourners, a requiem without pomp.

"No, painting is not done to decorate apartments. It is an instrument of war" against "brutality and darkness." Twice in the past decade Picasso has magnificently fulfilled his own words.

250

Besides documentation these notes include some illustrations and data which were available too late for incorporation in the text. Illustrations of comparative material are limited to a few of many possible examples.

"Junyer (questionnaire, 1945)" refers to information kindly supplied by an old friend of Picasso's, Carles Junyer of Barcelona, in reply to questions written to him in the fall of 1945 through Mr. and Mrs. Joan Junyer of New York.

"Picasso (questionnaire, October, 1945)" refers to information supplied by Picasso and Jaime Sabartés in response to a questionnaire forwarded through Lt. Commander James S. Plaut. Picasso has not replied to a second questionnaire, December, 1945.

PAGE 14

* This condensed account of Picasso's early years in Spain (1881-1904) is based on Miguel Utrillo (bibl. 478); Merli (bibl. 293); Rafael Benet (bibl. 45); Guillermo de Torre (bibl. 171); Ramón Gómez de la Serna (bibl. 195); Professor José Lopez-Rey of New York University and Smith College (conversation and correspondence); and Picasso himself (questionnaire, October 1945). If, as is reported, Picasso's old friend Jaime Sabartés is at work on a biography, a more complete and dependable story of Picasso's youth will be available. All the Spanish publications, especially the article in the standard *Enciclopedia Universal Ilustrada* (bibl. 350b), seem confused and inaccurate. Carles Junyer has clarified certain problems (questionnaire, 1945).

† The many confusions which obscure the Picasso legend begin with his name. There is general agreement that his father was Basque. (Prampolini, bibl. 376, p. 14, may be right in giving his father's name as "Blasco Ruiz y Etcheverria.") Most authorities accept the legend that his mother was Italian in origin. It is true that Picasso is a Genoese name—in fact there was a Genoese painter Matteo Picasso (1800—c. 1866) whose works now hang in the Palazzo Rosso in Genoa; but Pablo Picasso, according to Guillermo de Torre (bibl. 171), denies his supposed Italian blood, explaining that his name, originally "Picazo," was Italianized while one of his Spanish ancestors was living in Italy. Picasso is in any case an old Malagan name.

Picasso's father died May 3, 1913; his mother, January 17, 1938. (Carles Junyer, questionnaire, 1945.)

‡ At Malaga Picasso's father was a professor in the Escuela de Artes y Oficios.

At Corunna where his father was professor in the Escuela de Bellas Artes, the small artist had his first one-man show in the doorway of an umbrella maker's shop—Ramón Gómez de la Serna (bibl. 195, p. 39).

One Spanish biographical note states that Picasso spent some time during his childhood in Pontevedra, a town in the northwest corner of Spain (bibl. 171, p. 99).

PAGE 15

* The story of Picasso's academic triumphs is repeated by Merli (bibl. 293), Zervos (bibl. 524, I) and others without question. Picasso, presumably, read over Zervos' account before publication.

PAGE 16

* This brief description of Picasso's Barcelona background is drawn in part from Merli (bibl. 293). Merli, however, neglects the non-French influences which appear so strongly in the magazine *Joventut*. On the other hand these are greatly exaggerated by Soffici who goes so far as to say that the Barcelona maga-zine *Pèl & Ploma* is derived from *Jugend* of Munich when, obviously, it is thoroughly French and not German at all in inspiration (bibl. 102, p. 25).

† Merli calls Picasso the *corifeo*, the leader, of the younger circle (bibl. 293, p. 15); Carles Junyer remembers him rather as the "Benjamin" (questionnaire, 1945).

‡ Casas' magazines were *Pèl & Ploma* (Brush and Pen) and *Forma*. *Pèl & Ploma*, 1899-1904, with Casas as art editor and Utrillo as literary editor, was at first a bohemian and "artistic" weekly, then after mid-1901 a serious monthly which reviewed contemporary Spanish art and the art of the Spanish past including early articles in praise of El Greco, Catalan Romanesque, etc. *Forma*, 1902-1908, continued and expanded the rôle of the monthly *Pèl & Ploma*.

§ The *Enciclopedia Universal Ilustrada* (bibl. 350b) gives 1900 as the date of Picasso's first show in Barcelona, but Merli who dates it in 1897 is quite circumstantial in his account (bibl. 293, pp. 18-19). For a review of the exhibition see bibl. 407a.

‖ Concerning the prize-winning painting: Professor José Lopez-Rey believes it to be the bust of a girl, more or less in the Lautrec-Steinlen manner, which for years lay forgotten in the storerooms of the Museum of Modern Art in Madrid (letter to the author, October 1945). Guillermo de Torre confirms the picture's neglect, says it won a Third Medal, but does not describe it (bibl. 171). The *Enciclopedia Universal Ilustrada* states that he painted a large and unique picture in the Catalan village of Valldama (apparently in 1900 or 1901) and with it won an honorable mention in the Madrid Exhibition (bibl. 350b, p. 516). Since Picasso was in Madrid from January to May 1901, it seems probable that the prize was won during that period.

¶ The address was no. 8 calle Conde del Asalto; the year 1899-1900; the rent was payed largely by Angel F. de Soto—according to Carles Junyer (questionnaire, 1945).

PAGE 17

* Picasso's ceramics are mentioned by Merli (bibl. 293, p. 22). Picasso's frescos are mentioned by Merli (bibl. 293, p. 22) and in the *Enciclopedia Universal Ilustrada* which states that they were done after his return from Paris (bibl. 350b).

† *Joventut* was edited by Lluís Vía (literature) and Alexandre de Riquer (art and illustrations). Besides contemporary painting, sculpture and photography it published certain older works such as a Romanesque sculptured tympanum and a Crivelli *Pietà*.

Picasso's drawing for Bridgman's *El Clam de las Verges* shows a half-length nude woman apparently

Picasso: Illustration for Joan Oliva Bridgman's *Ser ó no ser.* Barcelona, 1900.

dreaming of the man whose apparition emerges from the background (issue of July 12, 1900, p. 345). The head is extraordinarily like that of a nude in a photograph illustrating an earlier poem by Bridgman (April 26, 1900, p. 169). For *Ser ó no ser* Picasso drew a stormy sea with some rather medieval boats breasting the waves (August 16, 1900, p. 424); repro. above.

It was Utrillo, editor of *Pèl & Ploma*, who gives the rival *Joventut* priority in having published Picasso's first drawings (bibl. 478, p. 17).

Joventut, with the Picasso illustrations, is in Widener Library, Harvard University.

‡ Picasso's caricature of Rusiñol appears in *Pèl & Ploma*, II, no. 65, December 1, 1900, p. 4. Titles of other drawings and the issues in which they appear are: *Rastaquoéres*, III, no. 80, September 1901, p. 110; *Caricature of Mir*, III, no. 81, October 1901, p. 160; and *Bailaora*, IV, no. 100, December 1903, p. 368.

Pèl & Ploma did not devote a whole issue to Picasso as Merli states (bibl. 293, p. 10). But in its first issue as a monthly, June 1901, Utrillo wrote a short and favorable article—perhaps the first—on Picasso reproducing some of his drawings and a vivid pencil portrait by Casas, reproduced on page 12 (bibl. 478). Later, *Forma* (1904, p. 374) published an oil portrait by Sebastián Junyent of Picasso standing before *La Vie* (cf. p. 27).

Complete sets of *Pèl & Ploma* and *Forma* are in the Frick Art Reference Library, New York.

Merli states that "Picasso founded in Barcelona a review entitled *Renacímiento*" in which, in emulation of Ramón Casas, "he was his own unique collaborator" (bibl. 293, p. 25). Picasso seems never to have heard of this venture (questionnaire, October 1945).

PAGE 19

* Much of this account of Picasso's life in Paris from 1900 to 1906 is based on Zervos (bibl. 524, I), Level (bibl. 256) and Fernande Olivier (bibl. 325).

† Berthe Weill: "I bought from Mañach the first three canvases Picasso sold in Paris, a series of bull fights: the three for 100 francs. I sold them right away for 150 francs to Adolphe Brisson, editor of *Annales* to M. Huc, an important painting *Le Moulin de la Galette*, sold (*eh! eh!*) 250 francs!" (Bibl. 495, pp. 65, 67)

‡ The longest account of Picasso's Madrid period is given by Gómez de la Serna (bibl. 195, pp. 39-42). He states that "un señor Soler . . . del 'Cinturón eléctrico' " founded a periodical *Juventud* the masthead of which bore the name "D. Pablo Ruiz Picasso" as art director; and that this *Juventud* is not to be confused with another magazine of the same name of which only two numbers appeared. (Apparently Gómez de la Serna confuses one of the two with *Arte Joven*.) Gómez de la Serna also says that Picasso sold several dark-toned and fairly conventional canvases of Spanish life to the collector Huelin.

§ Merli implies incorrectly that *Arte Joven* was published during Picasso's Madrid visit of 1896 (bibl. 293, p. 17). That *Arte Joven* was published in Madrid between January and May 1901 is confirmed by Picasso himself (questionnaire, October 1945). Utrillo, writing of events which had taken place just a few weeks before, says that Picasso "and the writer Soler founded *Arte Joven*" (bibl. 478, p. 17). Professor Lopez-Rey gives the full name of Picasso's collaborator as Francisco de Asis Soler (letter to the author, October 1945). Zervos also mentions Picasso's Madrid period and *Arte Joven* as of the year 1901 but dates all the Madrid drawings and paintings as of 1900! (Bibl. 524, I, English text, page XXIV and plates 16, 18, 19) The author knows of no record of Picasso's having been in Madrid in 1900. Carles Junyer adds that Ramon Reventos of Barcelona was a third collaborator (questionnaire, 1945).

‖ Ardengo Soffici, who met Picasso in Paris in 1900 or shortly after, reports that they often encountered each other in museums "where they fed upon good painting, old and new." In the Luxembourg, Picasso studied in the room of the Impressionists; at the Louvre, Soffici recalls that Picasso liked Egyptian and Phoenician antiquities (bibl. 446, pp. 365-66).

PAGE 22

* "Explanations" of the blue period are various and questionable. It has been suggested: that Picasso used a blue monochrome because he painted at night by a weak lamp which made it difficult to use colors; that he was too poor to buy a variety of colors and there-

fore used only one; that he was, perhaps unconsciously, influenced by the prevalence of blue prints which were widely used at the time by amateur photographers as a cheap substitute for other and more permanent positives. Gertrude Stein says the blue period was the result of Picasso's return to Spain in 1902 when the monotony and sadness of Spanish coloring influenced him after his Paris sojourn (bibl. 458, English edition, pp. 5-6). She, like Merli, ignores the fact that Picasso began to paint blue pictures in Paris in 1901 before he went back to Barcelona.

† Nonell and Picasso: During the mid-90's Isidre Nonell painted landscapes in an impressionist style. He was in Paris from 1897 to 1899 and showed at Berthe Weill's and Vollard's. He returned to Barcelona in 1899 having changed his style under the influence of Daumier and, apparently, van Gogh and Lautrec. Ordinarily, he painted single figures of gypsies, madmen or desperate, poverty-stricken women with hunched, shawled shoulders and emaciated profiles. His colors were dark reds, greens and blues.

Some of his figures and his method of cross hatching in draperies and background resemble Picasso's blue period pictures but his dated paintings which seem closest to Picasso are almost all relatively late. Merli insists on Nonell's influence on Picasso both in figure style and color: "A la vista de la limitada paleta usada por Nonell, concibe Picasso sus cuadros en los que predomina la gama azul." (Bibl. 293, p. 35) Rafael Benet states that "one of the glories of Nonell is his influence on Picasso." (See "Isidro Nonell com a bandera," *Art* [Barcelona], 1934, no. 10, pp. 291-316, with many illustrations.) Benet elsewhere speaks of the effect on Picasso of Nonell's paintings of the idiots of Bohé (cf. the drawing reproduced on page 29). He adds that Picasso began his blue period in Barcelona (bibl. 45, pp. 3-4). This is scarcely true since the blue canvases reproduced on pages 23, 24, 25 of this book were painted in Paris, as well as the transitional picture, page 22; that is, if Zervos' dating of these paintings is correct. Carles Junyer denies the influence of Nonell upon Picasso (questionnaire, 1945). Junyer knew both artists well.

PAGE 29

* The mannered pose of *The Old Guitarist* has been compared to the bearded, cross-legged viol players of the 12th century Gloria Portal of the church of Santiago de Compostela (bibl. 276, pl. II).

Much remains to be studied in the first dozen years of Picasso's art. The mannerisms and archaisms which appear again and again seem derived from many sources—Egypt, Greece and its provincial tradition in Spain, Romanesque and Gothic art, 16th century Spanish painting. In various combinations they are fused with contemporary influences, directly or indirectly from Paris. But after 1901 Picasso

stamps his borrowings with his own unmistakable character.

PAGE 30

* Questionnaire, October 1945.

PAGE 31

* Fernande Olivier, *Picasso et ses amis*, Paris, 1933, p. 25. These memoirs are the liveliest and most detailed account we have of Picasso's life during the years 1904 to 1914. She attests to the very real distress of his life at the time they first met. Yet looking back, she asks, "was the work all cerebral, as I have understood it since, or did it record a profound and desperate love of humanity, as I thought then?" (*Ibid.*, p. 325)

PAGE 37

* When asked if he had known Rilke, Picasso replied yes (questionnaire, October 1945).

† Leishman and Spender analyze the relation between poem and picture in some detail (bibl. 406, American edition, pp. 101-04). Rilke saw in the giant letter D, so clearly composed by the group of acrobats, "des Dastehns grosser Anfangsbuchstab . . ." (the great initial letter of Thereness . . .)

‡ Shchukine bought fifty of the fifty-three Picassos now in the Museum of Modern Western Art, Moscow. Many of them were large oils, including those illustrated on pages 61, 62, 64, 68. However, according to Gertrude Stein, *Les Demoiselles d'Avignon* was too difficult for him (bibl. 458, English edition, p. 18). Fernande Olivier notes that it was Matisse who first brought Shchukine to Picasso (bibl. 325, p. 143).

PAGE 38

* The two most important exceptions are a bronze cubist head of 1909 (p. 69) and the painted bronze *Glass of Absinthe* of 1914 (p. 90). There were, of course, many constructions in paper, wood and metal, done from 1913 on, which are sometimes classified as sculpture (cf. also p. 86).

PAGE 39

* Geiser, bibl. 179, reproduces the whole series.

PAGE 43

* Picasso says he met Matisse in 1905 (questionnaire, October 1945). Gertrude Stein says the two artists first met in the fall of 1906 after Picasso's return from Gosol (bibl. 458, English edition, p. 22). The memory of neither is dependable.

† *La Coiffure* seems so advanced in style when compared with *La Toilette* (p. 44), for instance, that the author would be inclined to put it in 1906, perhaps after Gosol. Picasso, however, supports Zervos' date of 1905 (questionnaire, October 1945).

PAGE 45

* Fernande Olivier speaks of the summer at Gosol as a time when Picasso, improved in health and spirits, worked with great regularity (bibl. 325, p. 116). She says the trip to Gosol was financed by the sale of thirty canvases to Vollard for 2000 francs, about $400 (*ibid.*, p. 58).

PAGE 46

* There has been considerable confusion about the development of Picasso's work during the crucial years of 1905 and 1906. Zervos (bibl. 524, I), for instance, lists some fourteen works as done at Gosol in 1905, including *La Toilette*, the *Woman with Loaves*, the *Fernande* and the *Boy with Cattle* (p. 48). But Picasso was never in Gosol in 1905 and has confirmed the fact that he went there only in 1906 in a conversation with Kahnweiler (letter to the author, December 1939). Kahnweiler believes that *La Toilette, Fernande* (certainly), *Woman with Loaves* were all done at Gosol in the summer of 1906 (letter to the author, November 1944). Through Paul Rosenberg, July 1945, Picasso himself has confirmed Gosol, 1906, as the place and date of *La Toilette*.

The date 1905 on the *Woman with Loaves* was an error made by Picasso when he signed the canvas years after it was painted. It is sometimes hard for an artist to remember the precise year when a picture was painted, but easier to remember the place. Doubtless because of this, Picasso gave to Zervos the right provenance for other Gosol paintings, but the wrong date. Picasso has recently confirmed the fact that the *Woman with Loaves* was painted in Gosol in 1906 (questionnaire, October 1945).

The Gosol paintings range in style from a rather soft classical manner to the beginning of archaic severity in drawing and modeling.

The writer believes the following were done at Gosol in the earlier part of the summer of 1906:

Standing Nude, gouache, Cleveland Museum (Zervos I, pl. 146)
Harem, oil, Leonard C. Hanna, Jr., Cleveland (Zervos I, pl. 147)
Les Adolescents, oil, (Zervos I, pl. 150)
La Toilette, Albright Art Gallery, Buffalo, oil (p. 44)
Fernande Olivier, oil, private collection, Cambridge, Mass. (p. 45)

and the following during the latter part of the summer:

Nu Couché, oil (Zervos I, pl. 143)
Woman with a Kerchief, gouache, T. Catesby Jones, New York (Zervos I, pl. 145)
Boy with Cattle, gouache, Columbus Museum (p. 48)
Woman with Loaves, oil, Philadelphia Museum (p. 47)
Two Women, drawing, on loan to Worcester Museum, (Zervos I, pl. 159)
Peasants from Andorra, drawing, Art Institute of Chicago (p. 46)
Standing Woman, drawing, Mrs. Mary Bullard, New York

In the author's opinion several other paintings now dated 1905 should, on the evidence of the Gosol pictures, be dated 1906 though the chronology of many paintings of this period is still unclear, particularly as Picasso may well have carried on two parallel styles simultaneously.

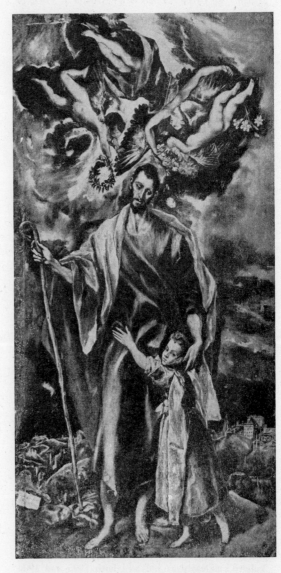

El Greco: St. Joseph with the Child Jesus. 1597-99. Oil, 42⅞ x 21⅝ inches. San Vicente Museum, Toledo.

PAGE 48

* El Greco's *St. Joseph and the Child Jesus* (p. 255) was reproduced in the monograph *Domenico Theotocopulos* by Miguel Utrillo, Barcelona 1906, and in two French articles by Paul Lafond: "Domenikos Theotolopuli dit Le Greco," *Les Arts*, no. 58, October 1906, p. 10, and "La Chapelle San José de Tolède et ses peintures du Greco," *Gazette des Beaux Arts*, XXXVI, November 1906, p. 385. The *St. Joseph and the Child Jesus* exists in two versions, both in Toledo. Both were very probably unknown to Picasso before these publications. Neither was reproduced in Utrillo's earlier article. "Le Greco," *L'Art et les Artistes* I, 1904, p. 201-207.

Picasso's *Composition* has hitherto been dated 1905. Dr. Albert C. Barnes who bought the painting from Vollard in 1913 writes: "I don't believe that anybody could answer with certainty your question about the date of the big Picasso which you call 'Peasants,' the title of which Picasso himself gave me as 'Composition.' The reason for the uncertainty is that Picasso constantly reverted to previous technical devices in a composition which as a whole comes out as a new entity. In this particular picture, the general effect is predominantly Grecoesque, but when I talk about the picture to students, I put it alongside of a number of Cézannes, which show that his use of color-patches, arranged in the form of planes, is just as prevalent and just as clearly discernible as his Greco twists. When I asked him to give me the date, his answers were so vague that I had to make my own guess about it, supporting it with observation of analogous objective qualities in his other paintings." (Letter to the author, December 1944)

† Because of its advanced quasi-cubist style and because the closely related *St. Joseph and the Child Jesus* by El Greco was not published before 1906 the writer believes the *Composition* to have been painted in Paris in the fall of that year after the return from Gosol. Picasso when asked recently, would not give the year but said that he had not painted it at Gosol in the summer of 1906 (questionnaire, October 1945).

When asked about the influence of El Greco in this picture Picasso was noncommittal. He denied ever having seen in actuality a blind flower seller guided by a little girl, as the drawing (p. 48) suggests. The author's questionnaire inadvertently used the word *vaches* in describing the cattle. Picasso corrected this to *boeufs*.

‡ Cézanne's influence, as Dr. Barnes suggests in the letter quoted above, is probably strong in the *Composition*. Picasso had doubtless seen Cézannes at Vollard's as early as 1901. In both 1905 and 1906 there had been several Cézannes at the Autumn Salon.

PAGE 50

* For Miss Stein's account of the painting of her portrait see bibl. 458, English edition, pp. 7-8.

PAGE 51

* Picasso's statement to Zervos about Iberian sculpture appears in bibl. 524, II, page 10 and is quoted below in notes to page 56.

† There is a marked resemblance between the style of this *Self Portrait* and that of the *Negro Attacked by a Lion*, an Iberian stone sculpture from Osuna installed in the Louvre in 1906. (Cf. Sweeney, bibl. 463, fig. 2).

PAGE 53

* Fernande Olivier writes of a feeling of tension between Matisse and Picasso (bibl. 325, p. 103). This is confirmed by Gertrude Stein (bibl. 454, p. 79). Pierre Matisse reports (1945) that his father and Picasso, after years of coolness, recently resumed their friendship and even exchanged pictures. For the date of their first meeting see note to page 43.

PAGE 54

* Besides these composition studies for *Les Demoiselles d'Avignon* reproduced on page 56, Zervos illustrates 14 more (bibl. 524, II, nos. 629, 632-644). These do not include dozens of figure studies.

† Several of Cézanne's paintings anticipate *Les Demoiselles d'Avignon* either in composition or in single figures. Compare nos. 94, 261, 265, 273, 276, 543, 547, 726 in Lionello Venturi, *Cézanne*, II, Paris, 1936.

El Greco: ASSUMPTION OF THE VIRGIN (lower half). 1577. Oil, 158 x 90 inches. Art Institute of Chicago.

‡ The lower half of El Greco's *Assumption of the Virgin* is reproduced above to illustrate his "compact figure composition and angular highlights."

§ Other studies for the figure at the left, pulling back the curtain, occur not only in the composition studies and in the *Two Nudes* (p. 52) but also in works reproduced in Zervos, bibl. 524, I, plates 165, 166, 173.

WOODEN MASK. Itumba. 14 inches high. Museum of Modern Art, New York, Mrs. John D. Rockefeller, Jr. Purchase Fund.

PAGE 55

* This mask from the Itumba region of the French Congo may be compared with the upper right-hand face of *Les Demoiselles d'Avignon*.

PAGE 56

* Picasso's statement about his interest in Iberian Sculpture and his discovery of African Negro art is reported by Zervos (bibl. 524, II, p. 10) as follows:

"On a toujours prétendu, et Mr. Alfred Barr Jr. vient de le répéter dans le Catalogue de la magnifique exposition d'oeuvres de Picasso qu'il a organisée à New York, sous le titre Quarante ans de son art, que les figures des Demoiselles d'Avignon dérivent directement de l'art de la Côte d'Ivoire ou du Congo Français. La source est inexacte. Picasso a puisé ses inspirations dans les sculptures ibériques de la collection du Louvre. En ce temps, dans le milieu de Picasso, on faisait un grand cas de ces sculptures, et l'on se souvient peut-être

encore du vol d'une de ces pièces commis au Louvre, affaire à laquelle Apollinaire fut à tort mêlé.

"Picasso qui, dès cette époque n'admettait pas que l'on pût se passer, sans niaiserie du meilleur que nous offre l'art de l'antiquité, avait renouvelé, dans une vision personnelle, les aspirations profondes et perdurables de la sculpture ibérique. Dans les éléments essentiels de cet art il trouvait l'appui nécessaire pour transgresser les prohibitions académiques, dépasser les mesures établies, remettre toute légalité esthétique en question. Ces temps derniers Picasso me confiait que jamais la critique ne s'est donné la peine d'examiner son tableau d'une façon attentive. Frappée des ressemblances très nettes qui existent entre les Demoiselles d'Avignon et les sculptures ibériques, notamment du point de vue de la construction générale des têtes, de la forme des oreilles, du dessin des yeux, elle n'aurait pas donné dans l'erreur de faire dériver ce tableau de la statuaire africaine. L'artiste m'a formellement certifié qu'à l'époque où il peignit les Demoiselles d'Avignon, il ignorait l'art de l'Afrique noire. C'est quelque temps plus tard qu'il en eut la révélation. Un jour en sortant du Musée de Sculpture Comparée qui occupait alors l'aile gauche du Palais du Trocadéro, il eut la curiosité de pousser la porte en face, qui donnait accès aux salles de l'ancien Musée d'Ethnographie. Aujourd'hui encore, à plus de trente trois ans de distance et en dépit des événements actuels qui le tourmentent profondément, Picasso parle avec une profonde émotion du choc qu'il reçut ce jour là, à la vue des sculptures africaines."

† At the request of the writer, Paul Rosenberg asked Picasso whether the two right-hand figures had not been completed some time after the rest of *Les Demoiselles d'Avignon*. Picasso said, yes they had (July 1945). Later when asked whether he had painted the two figures before or after the summer of 1907, Picasso was noncommittal (questionnaire, October 1945).

‡ J. J. Sweeney (bibl. 463, p. 197) first proposed the case of the Gertrude Stein portrait as a precedent for Picasso's possibly having finished the two negroid heads considerably later and after his discovery of African Negro art.

§ Soffici writes of seeing *Les Demoiselles d'Avignon* in Picasso's studio on the rue Schoelcher where the artist lived between 1913 and 1915 (bibl. 446, p. 37).

Early books on modern art very rarely if ever reproduce the picture. Reproductions are common only after 1925, and it was apparently not until 1938 that a monograph on Picasso included a reproduction (bibl. 458, French edition). The earliest reproduction known to the writer was published in *The Architectural Record*, XXVII, May 1910, in an article called "The Wild Men of Paris" by Gelett Burgess.

The painting seems to have been publicly exhibited for the first time in 1937 at the Petit Palais during the Paris World's Fair. That was after the death of the collector Jacques Doucet who years before had had it set like a mural painting into the wall of the stairwell of his house.

|| An analytical comparison of *Les Demoiselles d'Avignon* with Matisse's *Joie de Vivre* would be rewarding. Both were completed in the year 1907, the Picasso probably later than the Matisse. Both are very large compositions of human figures in more or less abstract settings, the Picasso a draped interior, the Matisse a tree-bordered meadow. In both, color is freely used with a broad change of tone from left to right. The Picasso is compact, rigid, angular and austere, even frightening in effect; the Matisse open, spacious, composed in flowing arabesques, gay in spirit. The Picasso was the beginning of cubism; the Matisse was the culmination of fauvism. The Picasso lived a "private life" for thirty years; the Matisse made a sensation at the Salon des Indépendants in 1907 and has been famous ever since. Both canvases were epoch-making.

PAGE 57
* For earlier compositions of nudes which point toward *Les Demoiselles d'Avignon* see Zervos, bibl. 524, I, plates 147, 160, 165. As already noted Zervos illustrates altogether fourteen composition studies besides the three reproduced on page 56.

† According to Zervos, Picasso recalls that André Salmon gave *Les Demoiselles d'Avignon* its title (Zervos, bibl. 524, II, p. 10). Kahnweiler, in a letter of 1940, writes that the title was given the picture shortly after the war of 1914-1918, possibly by Louis Aragon who was at the time advising the collector Jacques Doucet to whom Picasso sold the painting.

In his *Der Weg zum Kubismus*, 1920, Kahnweiler calls the painting simply "a large painting with women, fruit and curtains," but gives it no title, an omission which confirms his opinion that the name is post-World War I. Fernande Olivier writing of the period 1904-1914 does not mention the picture by name in her memoirs first published in 1931 (bibl. 325). The painting was reproduced for the first time with its present title in *La Révolution Surréaliste* (Paris), no. 4, July 15, 1925. André Breton, the editor of this magazine, says that it was he who, around 1921, persuaded Doucet to buy the picture, but he cannot recall who invented the title.

‡ "Postscripts" of this figure are reproduced in Zervos, bibl. 524, II, nos. 44, 45, 47, 619, 621, 623, 664, 671-76.

PAGE 58
* For a general account of the "discovery" of African Negro art in Paris see Goldwater, bibl. 193.

PAGE 59
* For Picasso's account of his own discovery see first note to page 56.

Kahnweiler, who began to buy from Picasso in 1907 and became his dealer in 1908, knew him well and kept photographic and chronological records of much of his work. Kahnweiler describes in some detail Picasso's development during 1907-08, including *Les Demoiselles*, but does not mention Negro art until he comes to early 1908 (bibl. 240, pp. 17-23). On the other hand, Kahnweiler does not mention Picasso's interest in Iberian sculpture at all, nor, apparently, does any other historian or artist, including Picasso himself, until 1939.

Warnod quotes Henri Matisse in a discussion of Montmartre in the days of the "bateau-lavoir":

"Warnod—C'est vous qui avez apporté là-haut l'art nègre?

"Matisse—Je passais alors souvent rue de Rennes, devant la boutique du père Sauvage. Dans son étalage il y avait des statuettes nègres. J'étais frappé de leur caractère, de la pureté de leur lignes. C'etait beau comme de l'art égyptien. Alors j'en ai acheté une et la montrai à Gertrude Stein, chez qui j'allais ce jour-là. Voilà que survient Picasso. Toute de suite il en a été enthousiasmé. Tous se sont mis alors à chercher des statuettes nègres. On en découvrait alors assez aisément."

André Warnod, "Matisse est de retour," *Arts* (Paris), no. 26, July 27, 1945, p. 1.

Gertrude Stein confirms Matisse's story and indicates the date, although her chronology is often uncertain. She writes: "Upon his return from . . . Gosol, he became acquainted with Matisse through whom he came to know African sculpture." (Bibl. 458, English edition, p. 22) That would have been the fall of 1906.

† Picasso's account of the purchase of this painting is reported in Florent Fels, *Propos d'Artistes*, Paris, La Renaissance du Livre, 1925, p. 144:

"Rousseau . . . represents perfection in a certain category of thought. The first work of the *douanier* which I chanced to purchase obsessed me from the moment I saw it. I was walking along the Rue des Martyrs. A second-hand dealer had piles of canvases arranged along the whole store-front. A head stuck out, a woman's face with a hard look, [a work] of French insight, of decision and clearness. The canvas was immense. I asked the price of it. 'Five francs,' said the shop-keeper, 'you can paint over it.'

"It is one of the most revealing French psychological portraits."

‡ One of the earliest and most complete accounts of the banquet is Maurice Raynal's "Le Banquet Rousseau," *Les Soirées de Paris*, III, no. 20, January 15, 1913, pp. 69-72.

Ancestral Figure. Gabun, BaKota. Copper over wood, 22¾ inches high.

PAGE 60

* J. J. Sweeney (bibl. 464, p. 17) was probably the first to point out the relation between the *Dancer* and Gabun grave figures such as that reproduced above. Zervos reproduces a study for the *Dancer* which is even closer in certain ways to the Gabun figures (bibl. 524, II, no. 666).

PAGE 62

* Years later in 1931 Picasso told his friend, the wrought iron sculptor Gonzalez, that in 1908 he has been particularly interested in sculptural values in his paintings. "Ces peintures, me disait Picasso, il suffirait de les découper—les couleurs n'étant somme toute, que des indications de perspectives différentes, des plans inclinés d'un côté ou de l'autre,—puis les assembler selon des indications données par la couleur, pour se trouver en présence d'une 'Sculpture'. La peinture disparue n'y manquerait point. Il en était si convaincu qu'il a exécuté quelques sculptures parfaitement réussies."

Recalling this period of his work Picasso said, "I have never been so happy." (J. Gonzalez, bibl. 197, p. 189)

PAGE 63

* The word "cubism" probably first appeared in print in the spring of 1909 when Vauxcelles used the phrase "Peruvian Cubism" in discussing two paintings of Braque in his review of the Salon des Indépendants in *Gil Blas*. Vauxcelles had also first published the epithet *fauves* in describing the paintings of Matisse, Derain, Rouault and the others when reviewing the Autumn Salon of 1905 (bibl. 240, pp. 15-16).

PAGE 66

* The fact that the *Woman with a Book* was painted before the summer in Horta de Ebro is confirmed by Picasso (questionnaire, October 1945). The painting has been dated late 1909 by some authorities.

† Princet lived in the "bateau-lavoir" (p. 31) and is often mentioned as a source of mathematical influence upon cubism (Lemaitre, for instance, in bibl. 255, p. 80). André Lhote goes so far as to quote a "famous and legendary question" addressed by Princet to Picasso and Braque:

"Vous représentez à l'aide d'un trapèze une table telle que vous la voyez, déformée par la perspective, mais qu'arriverait-il s'il vous prenait fantaisie d'exprimer la table type? Il vous faudrait la redresser sur le plan de la toile, et, du trapèze, revenir au rectangle véridique. Si cette table est recouverte d'objets également déformés par la perspective, le même mouvement de redressement devra s'opérer pour chacun d'eux. C'est ainsi que l'ovale d'un verre deviendra le cercle exact. Mais ce n'est pas tout: ce verre et cette table considérés sous un autre angle ne sont plus, la table qu'un plateau horizontal, de quelques centimètres d'épaisseur, le verre, qu'un profil dont la base et le faîte sont horizontaux. D'où nécessité d'un autre déplacement . . . " (bibl. 224a, p. 216).

The question though imaginary is suggestive, but Picasso when asked if he had discussed mathematics or the fourth dimension with Princet replied that he had not (questionnaire, October 1945). Concerning the somewhat mysterious Princet, Picasso said that he was an actuary; Lemaitre states that he was an accountant. Marcel Duchamp recalls that Princet was a school teacher and could scarcely be considered an expert in higher mathematics. Duchamp remembers that Metzinger, influenced by Princet, was particularly interested in the fourth dimension, Braque rather little and Picasso scarcely at all. Princet, he thinks, certainly influenced Braque by proposing the elementary idea of painting the face and profile simultaneously on a flat surface—the principal idea presented by Lhote (above). Picasso, Duchamp con-

cludes, may have been affected by these ideas without being aware of it, but was intellectually and temperamentally averse to a mathematical basis for art. Duchamp is inclined to be skeptical of reports that Picasso ever used mathematical calculations or formulas in his painting. (Conversation with Duchamp, December 1945)

André Breton seems convinced that the cubists used mathematics though he does not indicate what method. He writes: "Recently I saw Picasso studying one of his unfinished works of 1911 or '12. He had already filled several pages with mathematical calculations, and he confided to me that in order to clarify this painting for himself he was obliged to embark on a whole series of measurements. What troubles me, however, is not this immediate seal of secrecy on a work of art, even when it turns against its author, but that the nature of these calculations, no doubt very simple, should be so well concealed that it is impossible for anyone to reconstruct them. Who would dare to undertake this task among all those who discourse so knowingly about Cubism?" (Bibl. 308, p. 15)

‡ Plato's words are:

"Socrates: What I am saying is not indeed directly obvious. I must therefore try to make it clear. I will try to speak of the beauty of shapes, and I do not mean, as most people think, the shapes of living figures, or their imitations in paintings, but I mean straight lines and curves and the shapes made from them, flat or solid, by the lathe, ruler and square, if you see what I mean. These are not beautiful for any particular reason or purpose, as other things are, but are always by their very nature beautiful, and give pleasure of their own quite free from the itch of desire; and colors of this kind are beautiful, too, and give a similar pleasure."—*Philebus*, 51c.

A valuable examination of this passage in relation to modern esthetics is to be found in A. Philip McMahon, "Would Plato find artistic beauty in machines?" *Parnassus*, VII, 6-8, February 1935, pp. 6-8. Prof. McMahon questions the use of Plato's words to sanction cubism or machine esthetic.

PAGE 67
* See Zervos, bibl. 524, II, no. 865.

PAGE 68
* Joachim Weyl, "Science and Abstract Art," *College Art Journal*, Vol. II, no. 2, January 1943, p. 45.

PAGE 69
* Merli insists that Picasso stayed not at Horta de Ebro but at Horta de San Juan (bibl. 293, p. 61). When asked about this Picasso confirmed Horta de Ebro as the place (questionnaire, October 1945).

Carles Junyer (questionnaire, 1945) says there is no such place as Horta de Ebro but mentions several other Hortas including Horta de Saint Joan (San Juan in Spanish).

PAGE 70
* Fanny Tellier, Picasso says was the name given by the model for the *Girl with a Mandolin* (questionnaire, October 1945). The fact that Picasso used a model explains the portrait-like character and relates it to the earlier Braque, and the contemporaneous Kahnweiler and Vollard portraits. The more abstract figures of 1911 lose any sense of a personality behind their "geometry."

PAGE 71
* Uhde, bibl. 477, p. 56.

† Under the name Daniel Henry, Kahnweiler wrote *Der Weg zum Kubismus*, Munich, 1920, the most authoritative, first-hand account of the cubism of Picasso and Braque during the years 1907 to 1914.

PAGE 74
* Mondrian, at least during his early years in Paris (1910-1914), had no interest in practical design either, and even after his association with the Stijl group in the Netherlands in 1916 he remained almost exclusively concerned with painting. Yet his art served as a kind of laboratory of pure design from which his Dutch colleagues, who included architects and furniture designers, could draw instruction and inspiration, which later they spread throughout the world.

While Picasso's most *important* influence on the arts of design passed through the art of such painters as Mondrian and the Russian Malevich, his most *obvious* influence lay in the direct effect of synthetic cubism upon the *decorative* arts of the period 1920-1930.

PAGE 80
* Purists prefer to reserve the term *papier collé* for cubist compositions, using the more general word *collage* for the later fantastic pastings of the dadaists and surrealists. However, the *collage* which Picasso believes to be his earliest is not a *papier collé* but pasted oilcloth (page 79) and many others of his *collages* involve cloth, wood, tin, etc.; therefore, *collage* is used here as a generic term for compositions made by pasting or gluing.

† Those who would belittle *collages* say that Picasso and Braque originally employed this technique as a shorthand method of laying out a composition which was later to be executed in oils. When asked whether this was in fact the way *papiers collés* came to be invented Picasso replied that they were always intended to be what they are: pictures in their own right (questionnaire, October 1945).

PAGE 84
* Cf. Meyer Schapiro, "Nature of Abstract Art," *Marxist Quarterly*, I, no. 1, January 1937, p. 92.

PAGE 86

* Picasso had made three cubist sculptures: the bronze *Head* of 1909 (p. 69), another somewhat similar but more abstract *Head* in terra cotta, and a plaster *Apple* early in 1910 (Zervos, bibl. 524, II, nos. 717, 718). All three were conceived as solid mass with the surface cut into facets or ridges as if translated from the heads and still life in the paintings of the same period.

† Jacques Lipchitz recalls Tatlin's enthusiasm after his visits to Picasso's studio about 1913-14 (conversation with the author).

PAGE 88

* Picasso's name often appears in the comprehensive bibliographical commentary by Anne Anastasi and John P. Foley, Jr.: *A Survey of the Literature on Artistic Behavior in the Abnormal. II. Approaches and Interrelationships.* New York, 1941. (Annals of the New York Academy of Sciences, XLII, Art 1, pp. 1-112). For the most part the editors succeed in revealing the fact that many psychiatrists are ignorant or prejudiced about art.

† George L. K. Morris, the owner of the painted *Head*, is a leading American abstract painter and champion of abstract art.

‡ Roland Penrose, the owner of the collage *Head*, is one of the best-known English surrealist painters and poets.

PAGE 94

* When asked if there were some reason why he should so suddenly have made realistic portrait drawings about 1915, Picasso replied there was no practical or personal reason for the change in style (questionnaire, October 1945).

So far as the author knows the earliest dated portrait drawing in the new "realistic" manner is the *Seated Man*, reproduced on this page. The technique and, even more, the pose suggest Cézanne more than Ingres. (*Cf.* L.Venturi, *Cézanne*, II, no. 688; compare also no. 696, Cézanne's portrait of Vollard, with Picasso's.) Picasso's etching *Apples*, 1914 (Geiser 38) also recalls Cézanne.

J. J. Sweeney calls attention to a fairly realistic sketch by Picasso of Alfred Jarry published by Apollinaire in *Les Soirées de Paris*, no. 21, Feb. 1914, p. 87. Possibly the sketch was done from memory at that time but it seems more probable that Picasso made it before Jarry's death in 1907. The drawing accompanies Jarry's letters of 1906.

PAGE 96

* Fernande Olivier is not always an accurate reporter, but a sentence in her *Picasso et ses amis* is worth quoting apropos of Picasso's interest in Ingres: "*En peinture, ses goûts d'alors le portaient vers le Greco,*

Picasso: SEATED MAN. Avignon, summer 1914. Pencil 12¾ x 9¾ inches. Private collection.

Goya, les primitifs, et surtout vers Ingres, qu'il se plaisit à aller étudier au Louvre." (Bibl. 325, p. 172) This statement occurs in her chapter on the years 1910-14, the period just before Picasso began his "Ingres-like" drawing.

Cocteau, however, insists that Picasso's drawings of 1916-17 have little resemblance to those of Ingres— or none at all. (Cocteau, bibl. 107a, p. 247)

† Mention of Picasso's acting as godfather to Jacob is made in Lemaitre, bibl. 255, p. 129.

PAGE 97

* Cocteau, bibl. 107a, p. 237.

† Answer to questionnaire, October 1945.

PAGE 98

* Some of this account of *Parade* is taken from Cocteau, bibl. 107a, pp. 49-55 and 236-239; and the original *Ballets Russes* program for the Paris season of 1917, which includes Apollinaire's essay "*Parade*" *et l'Esprit nouveau*. A detailed description of the choreography of *Parade* is given in Cyril W. Beaumont, *Complete Book of Ballets*, London, 1937, p. 851-856.

† Fernande Olivier was impressed by Satie's understanding of cubism (bibl. 325, p. 220).

Jean Cocteau: PICASSO AND STRAWINSKY

PAGE 99

* Cocteau, bibl. 107a, pp. 53-54.

† (Caption to *Chinese Conjurer's Costume.*) The symbolism is given in Cyril W. Beaumont, *Five Centuries of Ballet Design*, London, 1939, p. 130.

PAGE 110

* Picasso's interest in music was limited. Zervos describes the evening in 1901 when Max Jacob first met Picasso and his Spanish friends. They could not speak a common language so they sat about singing the symphonies of Beethoven "all save Picasso who did not know them." (Bibl. 524, I, French edition, p. XXIX) Fernande Olivier recalls that Picasso liked gypsy music, guitar music, but did not understand symphony (bibl. 325, pp. 153, 214).

PAGE 120

* Picasso cannot recall whether the *Dog and Cock* was painted before or after the *Three Musicians*, but is sure that it was painted in Paris, not in Fontainebleau (questionnaire, October 1945).

PAGE 122

* The wider version of the *Three Musicians* has sometimes been considered the earlier. Picasso, however, states that he worked on them simultaneously (questionnaire, October 1945).

PAGE 123

* Hayden's *Three Banjo Players* was painted in 1918 and exhibited in that year at Léonce Rosenberg's gallery which Picasso had frequented during the war. It is reproduced in bibl. 224a, p. 260 and bibl. 334, p. 110. Hayden himself derived his style from Braque and Picasso, perhaps by way of Marcoussis.

PAGE 127

* J. J. Sweeney calls attention to a pastel drawing lent by James W. Barney to Yale University in which a figure in evening clothes kneels and plays in the pose of the pipes player in the *Pipes of Pan*.

PAGE 130

* J. T. Soby first suggested the analogy of camera foreshortening to *By the Sea* which he reproduces in his book *After Picasso* preceding it by a trick photograph of a similarly foreshortened figure (bibl. 442, plates 12, 13). He writes that in *By the Sea* Picasso "exploited a wide range of disparate angles of vision." (*Ibid*, p. 30) Actually the perspective, however exaggerated, seems fairly consistent.

† The Matisse *Women by the Sea* is reproduced in *Henri-Matisse*, Museum of Modern Art, 1931, plate 17.

PAGE 138

* Anton Dolin tells how Picasso's small son who owned the toy theatre used often to come to rehearsals of the ballet, *Le Train Bleu*, in 1924 (bibl. 139a, p. 80).

PAGE 140

* Picasso in Monte Carlo, cf. Dolin, bibl. 139a, p. 106.

PAGE 153

* J. J. Sweeney's suggestion.

PAGE 156

* Laurens' setting for *Le Train Bleu* is illustrated in Cyril W. Beaumont, *Complete Book of Ballets*, London, 1937, opp. p. 809. For Picasso's curtain design for this ballet see color plate opposite page 126 of this book.

PAGE 164

* The surrealists were later to assemble somewhat similar *objets trouvés aidés* (bibl. 314, plates 444 and 510). The ancestry of the surrealist object is however to be found in the cubist collage of 1912-14 and Duchamp's dada "readymades," ordinary utensils or gadgets endowed with significance only by the artist's fiat functioning, in some cases, through a far-fetched title.

PAGE 167

* The strangely proportioned figure of Christ, like the figure of the bather (p. 162), seems related to certain prehistoric Cycladic figures.

PAGE 171

* For Gonzalez' article see bibl. 197.

PAGE 176

* Marion Bernardik has made a sensitive, subjective analysis of the *Girl before a Mirror* in an essay written for a class of Prof. Meyer Schapiro at the New School for Social Research. A copy is in the library of the Museum of Modern Art, New York.

† Picasso's preference for *Girl before a Mirror* was stated to Mrs. Alfred H. Barr, Jr.

Paul Eluard and Picasso, 1936

PAGE 182

* A series of etchings dated 1624 and showing metamorphic variations of human figures composed of carpentry, ribbons, solid geometrical shapes and pieces of furniture by the Genoese mannerist painter Bracelli were published in *Formes* in 1931. They may be compared with Picasso's fantastic *Anatomy* of 1933. Cf. "A Seventeenth Century Anthropomorphist Giovanni Battista Bracelli," *Formes*, no. 18, Oct. 1931, p. 139 ff; also bibl. 314, no. 53.

PAGE 188

* An interesting subjective analysis of the *Girl Writing* (p. 189) is given by Melville (bibl. 291).

PAGE 195

* Picasso contributed illustrations to books by Aragon and Breton in the early '20s before the Surrealist movement began; then, in the '30s to Surrealist publications by Tzara, Péret, Char, Mabille, as well as by Eluard. (See list on pages 276-77.)

† Nancy Newhall, acting Curator of Photography at the Museum of Modern Art, New York, analyzes the photograph as a combination of *cliché verre* drawing and rayogram, the latter technique accounting for the lace curtain background. Man Ray, the American surrealist, painter and photographer, knew Picasso well and may have helped him in this and other experimental prints reproduced in *Cahiers d'Art* (bibl. 385). (Man Ray's magnificent portrait of Picasso is reproduced on page 8.) Years before, Fernande Olivier reports, when Picasso was smoking hashish with Princet "he cried out that he had discovered photography"—a surrealist intimation (bibl. 325, p. 165).

‡ Soby's analogy between the two wars is given in *Romantic Painting in America*, Museum of Modern Art, 1943, p. 14. To his comparison may be added the thought that a hundred years from now the deaths of the two poets Byron and Lorca, and the painting of two canvases, Delacroix's *Massacre at Chios* and Picasso's *Guernica*, may be more widely remembered than the wars themselves.

§ There are many unauthenticated stories about Picasso's gifts. When the artist was asked whether "he had furnished funds for the Spanish Republic for planes, tanks, ambulances or food," he would not commit himself (October 1945). The following statement was published in January 1939:

"Selon une information parue dans de nombreux journaux il y a quelques semaines déjà, Pablo Picasso aurait fait un don de 100,000 francs français pour les enfants de la République Espagnole. Ces renseignements ne sont pas rigoureusement exacts et nous sommes trop heureux de pouvoir les rectifier. Ce n'est pas à 100,000 francs mais à 300,000 francs que s'élève en vérité le don de Picasso. Et le célèbre peintre assure qu'il a l'intention de continuer dans cette voie. Voilà un merveilleux exemple soumis à la méditation des esthètes bourgeois tout préoccupés de leurs propres intérêts." (*London Bulletin*, no. 8-9, January-February 1939, p. 59)

Juan Larrea, one of the Spanish officials in charge of relief during the civil war, states that to his knowledge Picasso gave 400,000 francs for relief supplies including milk and food, and more, later, to help Spanish intellectuals, in addition to numerous gifts to individuals.

Senor Larrea tells the following incident of Picasso's generosity:

"In the spring of 1939 an exhibition of the work of exiled Spanish artists was organized in the Maison de la Culture in Paris in which first class works were seen alongside of those who were not so gifted. After having walked through the salon Picasso focused his attention on a canvas pictorially lamentable, a kind of abominable enlargement of a picture postcard, one meter high, which was hung in the most obscure place. He immediately took steps to acquire the picture for a good price. When a friend asked him: 'But Picasso, how can you buy such a daub?' he answered: 'Poor little thing! The others have already found buyers. On the other hand, this is the picture which nobody but I is capable of buying. After all, doesn't its author not need help as much as the others?' And not only did he pay, but he took it to his house on the rue de la Boétie and incorporated it into his collection of curiosities. The satisfaction and the pride of the artist cannot be described." (Letter to the author, September 1945)

‖ Concerning his Prado directorship Picasso made several remarks which are incorporated in two statements reprinted below (p. 202, first note). Picasso, however, did not, it appears, personally go to Spain in any official capacity.

¶ J. J. Sweeney has suggested that the figure of Franco might have been inspired by Jarry's famous character, Ubu. When asked about this possibility Picasso replied—with Jarry's vocabulary—that he had been *"inspiré par l'étron"* (questionnaire, October 1945).

PAGE 196

* This interpretation of the etching owes much to the careful analysis of W. S. Lieberman.

PAGE 200

* J. L. Sert, one of the architects of the Spanish Pavilion, recalls that the mural was commissioned in January 1937 but he believes Picasso took no steps to begin work until after the news of the bombing of Guernica reached Paris on April 28. A few days later Picasso showed Sert the "little blue sketches," dated May 1st, one of which is reproduced on page 201, left. Sert cannot remember whether Picasso spoke of naming the painting *Guernica* at that moment but he does recall that Picasso like many others was deeply moved by the massacre.

The precise date of the completion of *Guernica* is not known to the writer. J. L. Sert thinks that it was finished toward the end of June. Dora Maar's photographs of the work in progress are undated but the last one, which shows the painting very near completion, suggests that no studies dated later than June 4 were used in the composition (see p. 205) and that the painting was finished by the end of the first week in June. Picasso, when asked whether the *Guernica* was finished five weeks or eight weeks after he began work on it, was noncommittal (questionnaire, October 1945).

PAGE 201

* The lines in the upper corners, the open door at the right, the lines of the floor tiles below, the electric bulb, all of which suggest an interior space like a stage, were added as Picasso was nearing the completion of the canvas, in spite of the fact that they conflict with the indications of exterior space such as roof tiles, animals, flaming buildings. This spatial ambiguity is related to cubist simultaneity of point of view—but in the *Guernica* it appears that Picasso changed his conception from exterior to interior space as the actual painting progressed.

W. S. Lieberman, who has written a long analysis of the *Guernica*, first pointed out to the writer this curious change of scene from outdoors to indoors.

PAGE 202

* This paragraph is taken from a statement made by Picasso in May or June 1937 and issued at the time of an exhibition of Spanish war posters shown in New York under the auspices of the North American Committee to Aid Spanish Democracy and of the Medical Bureau to Aid Spanish Democracy. It was reprinted by Elizabeth McCausland in the *Springfield Republi-*

can, July 18, 1937 and in bibl. 272, p. 21. The rest of Picasso's statement follows:

"The ridiculous story which the fascist propagandists have circulated throughout the world has been exposed completely many times by the great number of artists and intellectuals who have visited Spain lately. All have agreed on the great respect which the Spanish people in arms have displayed for its immense artistic treasures and the zeal which it had exhibited in saving the great store of pictures, religious paintings and tapestries from fascist incendiary bombs.

"Everyone is acquainted with the barbarous bombardment of the Prado Museum by rebel airplanes, and everyone also knows how the militiamen succeeded in saving the art treasures at the risk of their lives. There are no doubts possible here. On the one hand, the rebels throw incendiary bombs on museums. On the other, the people place in security the objectives of these bombs, the works of art. In Salamanca, Milan Astray cries out, 'Death to intelligence.' In Granada, Garcia Lorca is assassinated.

"In the whole world, the purest representatives of universal culture join with the Spanish people. In Valencia I investigated the state of pictures saved from the Prado, and the world should know that the Spanish people have saved Spanish art. Many of the best works will shortly come to Paris, and the whole world will see who saves cultures and who destroys it.

"As to the future of Spanish art, this much I may say to my friends in America. The contribution of the people's struggle will be enormous. No one can deny the vitality and the youth which the struggle will bring to Spanish art. Something new and strong which the consciousness of this magnificent epic will sow in the souls of Spanish artists will undoubtedly appear in their works. This contribution of the purest human values to a renascent art will be one of the greatest conquests of the Spanish people."

Half a year later the *New York Times* of December 19, 1937 published a second statement on the occasion of the meeting of the American Artists' Congress in New York:

"I am sorry that I cannot speak to the American Artists' Congress in person, as was my wish, so that I might assure the artists of America, as director of the Prado Museum, that the democratic government of the Spanish Republic has taken all the necessary measures to protect the artistic treasures of Spain during this cruel and unjust war. While the Rebel planes have dropped incendiary bombs on our museums, the people and the militia, at the risk of their lives, have rescued the works of art and placed them in security.

"It is my wish at this time to remind you that I have always believed and still believe, that artists who live and work with spiritual values cannot and should not remain indifferent to a conflict in which the highest values of humanity and civilization are at stake."

† Like several other critics Clark (bibl. 104) calls upon Goya's *Disasters of War* to discredit *Guernica*. However inadequate Picasso may appear in the eyes of those who wish him to be a propagandist or a social commentator, he at least spoke out in a moment of crisis in 1937 and later held his ground in the midst of the enemy during 1940-44. Goya's *Disasters of War*, however, never reached the public at all till long *after* the conclusion of the Spanish War of Liberation, that is, after the time when they might have been effective; and Goya himself was so compromised during the Napoleonic occupation that the term "collaborator" might justly have been applied to him.

Delacroix's *Massacre at Chios* (Salon of 1824) painted in protest against a Turkish slaughter of Greek patriots is a closer analogy to the *Guernica* than is any work of Goya.

‡ ". . . But what we cannot forgive is the banality of overstatement, or the projection of irrelevancies into the foreground with the stamp of creative originality. The romantically Victorian mural of the Spanish Civil War, *Guernica* by Picasso, is a case in point. Sitting before it, one seems to hear a faint refrain of Tennyson's Balaklava: 'Forward the Light Brigade'; 'Rode the Six Hundred.' A contemporary said of the poem, 'Glorious. But is it war?' Brilliant as the painting may be, Picasso, too, has failed to evoke the heroism of Guernica itself. He has only substituted Gertrude Stein for Florence Nightingale."—Francis Henry Taylor, *Babel's Tower*, New York, 1945, p. 46.

Mr. Taylor confuses events in British military and literary history—at least.

§ Herbert Read has analyzed and eloquently defended *Guernica* (bibl. 396). He calls it "a monument to disillusion, to despair, to destruction" and explains: "It was inevitable that the greatest artist of our time should be driven to this conclusion. Frustrated in his creative affirmations, limited in scope and scale by the timidities and customs of the age, he can at best make a monument to the vast forces of evil which seek to control our lives: a monument of protestation. When those forces invade his native land, and destroy with calculated brutality a shrine peculiarly invested with the sense of glory, then the impulse to protest takes on a monumental grandeur."

He then rejects the criticism that the mural is obscure and concludes: "It is not sufficient to compare the Picasso of this painting with the Goya of the *Desastres*. Goya, too, was a great artist, and a great humanist; but his reactions were individualistic—his instruments irony, satire, ridicule. Picasso is more universal: his symbols are banal, like the symbols of Homer, Dante, Cervantes. For it is only when the widest commonplace is infused with the intensest passion that a great work of art, transcending all schools and categories, is born; and being born, lives immortally."

PAGE 210

* Many writers, Fernande Olivier especially, have observed Picasso's love of animals (bibl. 325, pp. 98-99). His dog Kasbek takes an important rôle in one of Picasso's conversations with Jaime Sabartés (bibl. 88, p. 34). And very recently Picasso appeared in a series of photographs with a pet pigeon (bibl. 340a, pp. 1, 4).

PAGE 211

* Una Johnson, bibl. 236, pp. 46, 111.

PAGE 212

* The American sculptress, Mary [Meric] Callery, a friend of Picasso and the owner of the *Girl with a Cock*, recalls that either Picasso or Zervos explained to her that this painting symbolized the destruction of helpless humanity by the forces of evil. She points out that the picture was painted during the Spanish Civil War and adds that Picasso esteemed the picture highly and reluctantly sold it to her only because he wanted to raise money for Spanish relief. Picasso was later reported to have insisted that none of his paintings was symbolic except the *Guernica* (p. 200), but almost in the same breath he stated that the bull's head in the still life reproduced on p. 217 did in fact symbolize "brutality."

Meyer Schapiro suggests that the head of the girl resembles no other female head by Picasso so much as it does his own head seen in left profile, with the lock of hair combed down over the temple.

PAGE 214

* From a typescript in the Library of the Museum of Modern Art. Gonzales published some of his recollections of Picasso in the *New Masses* (bibl. 196).

The resemblance between the cock here illustrated and American weather vanes is much less strong than in the pastel drawn on the same day and now in the Walter P. Chrysler Collection (bibl. 405, no. 186, illustrated).

PAGE 217

* *Butterfly Hunter* a self portrait: see Seckler's interview with Picasso, page 247 and note†.

† Besides the *Boyon Rocks* by Rousseau illustrated p. 266, Rousseau's *Child with a Doll* (bibl. 313, p. 27) may be compared with Picasso's two child portraits of 1938. Of course Rousseau's influence upon Picasso, if any, is probably quite unconscious in these paintings as well as in the *Woman in a Garden* (p. 221) which may be compared with several of Rousseau's full-length portraits of women and his portrait of Joseph Brummer (repro. in D. C. Rich, *Henri Rousseau*, Museum of Modern Art, 1942, p. 59).

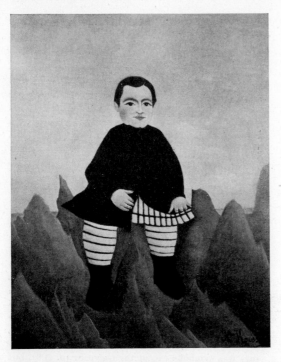

Henri Rousseau. Boy on Rocks, 1895-97. Oil, 21½ x 17¾ inches. The Chester Dale Collection.

PAGE 219

* The composite head *Summer* by Giuseppe Arcimboldo (Milan c. 1530-1593) was reproduced several times in 1936-38 (*Fantastic Art, Dada, Surrealism,* Museum of Modern Art, New York 1936, plate 6; *Cahiers d'Art,* XII, 1937, 6-7, p. 198; *XXe Siècle,* I, no. 1, March 1938, p. 37). Arcimboldo interested the surrealists who surrounded Picasso, particularly Man Ray.

PAGE 222

* Certain Eskimo masks from Alaska offer remarkable analogies to Picasso's scrambling and distortion of facial features. For examples see Frederick H. Douglas and René d'Harnoncourt *Indian Art of the United States,* New York, Museum of Modern Art, 1941, pp. 43, 190, 191.

Similar distortions may be seen in the schizophrenic drawings illustrated by Hans Prinzhorn in *Bildnerei der Geisteskranken,* Berlin, 1922, p. 99.

PAGE 223

* For the photograph of *Night Fishing at Antibes* (reproduced page 309) and the notes on its color, the author is indebted to Miss Gigi Richter. Another very large work, a wall-paper collage measuring some 11½ x 16½ feet, was made by Picasso about 1938 as a design for a tapestry. It is reproduced in color in *Architecture d'Aujourd'hui,* numero hors-serie: *Art,* 1946, p. 107-08.

PAGE 226

* The play, a burlesque more or less in the shocking, slapstick tradition of Alfred Jarry, was written in January 1941 during Picasso's first winter in German-occupied Paris. It was given a semi-public reading at the house of Michel Léiris on March 19, 1944 a few months before the Liberation. The parts were read by Picasso's friends including Louise Léiris, Dora Maar, Jean-Paul Sartre, Raymond Queneau and others. This performance was directed by Albert Camus with a musical accompaniment arranged by Georges Hugnet.

The play was published in *Messages* (bibl. 10a) with drawings by Picasso, including the drawing on page 226 and the self portrait on page 229. The drawings may be later than 1941.

† Picasso, whose painting was officially abominated, is said to have been protected by those Nazi authorities who represented the more worldly and cultivated element in the upper echelons of the SS—a faction with secret and unhitlerian taste for forbidden art.

‡ Picasso's friend and secretary, Jaime Sabartés, has forwarded to the writer the following bibliography of publications which made malicious attacks on the artist. The numbers after the word *"autorisation"* refer to German Occupation publication permits. Only one, by the aged American pro-fascist expatriate John Hemming Fry, is so far available in this country. For notes on Fry see bibl. 312, p. 4. Reference is made by Zervos to Vlaminck's assault (bibl. 80, p. 1). Sabartés' notes follow:

"Vlaminck publia un article, 'Sur la peinture,' dans *Comoedia* (deuxième année, no. 50, le samedi 6 juin 1942, section 'Opinions libres'). Vlaminck fulmine contre Picasso le long de cet article, comme il l'a fait dans son livre, *Portraits avant décès,* Editions Albin Michel.

"Vanderpyl publia aussi quelque chose dans son livre, *L'art sans patrie un mensonge: le pinceau d'Israel,* Mercure de France, 1942, autorisation no. 64460/9-42.

"Il ne faut pas oublier *Art Décadent* de John Hemming Fry avec le sous-titre 'sous le règne de la Démocratie et du Communisme.' (En vente à la Librairie de l'Alma, Henri Colas éditeur, 16 Avenue George V, achevé d'imprimer à Paris le 22 novembre 1940.)

"Camille Mauclair publia en 1944, sous le no. d'autorisation 24463, *La Crise de l'art moderne,* imprimerie spéciale du C.E.A., 21 rue la Boétie."

§ That Picasso is a Jew or partly Jewish is frequently repeated. To settle the matter Paul Rosenberg once put the question to him directly. Picasso replied that so far as he knew he had no Jewish blood—then added, characteristically, "but I wish I had!"

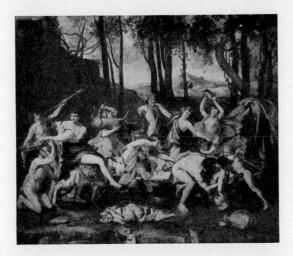

Nicolas Poussin: BACCHANALE: THE TRIUMPH OF PAN. 1638-39. Oil, 54¾ x 61¾ inches. The Louvre Museum, Paris.

‖ The famous legend about the Germans and *Guernica* has been repeated in many variants of which the following is typical: Not long after the conquest Otto Abetz, the infamous, though cultivated, German agent, called on Picasso to invoke his "collaboration." Picasso received him coldly, refused his offer of fuel and showed him to the door. On his way out of the studio the embarrassed Nazi noticed a photograph of the *Guernica.* "Ah, M. Picasso," he said, adjusting his monocle, "so it was you who did that." "No," replied Picasso as he closed the door, "you did!"

The experienced French journalist, Simone Téry, asked Picasso about this story in an interview published in *Lettres Françaises* in March 1945. She reports his answer: "Oui, dit Picasso en riant, c'est vrai, c'est à peu près vrai. Quelquefois, il y avait des Boches qui venaient chez moi sous prétexte d'admirer mes tableaux: je leur distribuais des cartes reproduisant ma toile, *Guernica,* et je leur disais: 'Emportez. Souvenir! Souvenir!'" (Bibl. 4)

PAGE 242

* These references to discipline and traditional forms are at variance with Picasso's later remarks upon the revolutionary character of his art (p. 249), yet they may well have reflected his mood at the time Pudney interviewed him. However, it may be remarked that Pudney himself had just published *Almanack of Hope,* a book of sonnets.

PAGE 243

* Another portrait of Picasso's daughter painted the year before is published in Eluard's recent book (bibl. 148, p. 141).

PAGE 245

* André Lhote: "Je savais que cette manifestation aurait lieu. N'avais-je pas entendu, la veille, un monsieur hargneux dire à un autre monsieur hors de lui: 'Je reviendrai demain avec des amis royalistes pour manifester.' Je n'invente rien, d'autres ont entendu comme moi. Tout s'est passé comme prédit. Des jeunes écervelés aux allures doriotistes, qui avaient mieux à faire qu'à s'enrôler parmi les F.F.I., et des messieurs d'âge et trop bien pensants, parcoururent les cimaises de la salle Picasso en hurlant: 'Remboursez!' et 'Décrochez!'" From a clipping in the library of the Museum of Modern Art, newspaper not identifiable. The adjective *doriotistes* refers to the French fascist leader Doriot who was however no royalist.

† Jean Lurçat, Remy and Jean Agamemnon: "De 1940 à 44, Picasso fut un Résistant conséquent et, qui plus est, actif: les Allemands ne l'ignoraient point, mais craignant, dans un reste de lucidité, les réactions de l'opinion internationale, n'osèrent pas y toucher, se contentant de lui interdire toute exposition publique.

"C'est donc assez pour que de petits gamins, couvés dans les disciplines maurassiennes, organisent, dans les parages des terrasses des cafés Biard du Quartier Latin, des monomes tapageurs, et tentent, au Salon d'Automne, de crever du bout de leurs parapluies les toiles peintes. Il est plus aisé de massacrer une aquarelle que de moisir, pieds gelés, dans les marécages du Front." (Bibl. 269, p. 53) The adjective "maurassienne" of course refers to Maurras, the royalist leader.

PAGE 247

* Pol Gaillard's interview with Picasso was cabled to the *New Masses* (New York) which published it in condensed form, October 24, 1944. A few days later Gaillard's original interview was published in *L'Humanité* (Paris), October 29-30, 1944 (bibl. 3). Picasso's statement as reported by Gaillard is reprinted here:

"J'aimerais beaucoup mieux vous répondre par un tableau, nous dit-il; je ne suis pas écrivain, mais puisqu'il n'est pas très facile d'envoyer mes couleurs par câble, je vais essayer de vous dire.

"Mon adhésion au Parti communiste est la suite logique de toute ma vie, de toute mon oeuvre. Car, je suis fier de le dire, je n'ai jamais considéré la peinture comme un art de simple agrément, de distraction; j'ai voulu, par le dessin et par la couleur, puisque c'étaient là mes armes, pénétrer toujours plus avant dans la connaissance du monde et des hommes, afin que cette connaissance nous libère tous chaque jour davantage; j'ai essayé de dire, à ma façon, ce que je considérais comme le plus vrai, le plus juste, le meilleur, et c'était naturellement toujours le plus beau, les plus grands artistes le savent bien.

"Oui, j'ai conscience d'avoir toujours lutté par ma peinture, en véritable révolutionnaire. Mais j'ai compris maintenant que cela même ne suffit pas; ces années d'oppression terrible m'ont démontré que je devais combattre non seulement par mon art, mais de tout moi-même.

"Et alors, je suis allé vers le Parti Communiste sans la moindre hésitation, car au fond j'étais avec lui depuis toujours. Aragon, Eluard, Cassou, Fougeron, tous mes amis le savent bien; si je n'avais pas encore adhéré officiellement, c'était par 'innocence' en quelque sorte, parce que je croyais que mon oeuvre, mon adhésion de coeur étaient suffisantes, mais c'était déjà mon Parti. N'est-ce pas lui qui travaille le plus à connaître et à construire le monde, à rendre les hommes d'aujourd'hui et de demain plus lucides, plus libres, plus heureux? N'est-ce pas les communistes qui ont été les plus courageux aussi bien en France qu'en U.R.S.S. ou dans mon Espagne? Comment aurais-je pu hésiter? La peur de m'engager? Mais je ne me suis jamais senti plus libre au contraire, plus complet! Et puis, j'avais tellement hâte de retrouver une patrie: j'ai toujours été un exilé, maintenant je ne le suis plus; en attendant que l'Espagne puisse enfin m'accueillir, le Parti Communiste Français m'a ouvert les bras, j'y ai trouvé tous ceux que j'estime le plus, les plus grands savants, les plus grands poètes, et tous ces visages d'insurgés parisiens si beaux que j'ai vus pendant les journées d'août, je suis de nouveau parmi mes frères!"

† In civilian life, Pfc. Jerome Seckler worked in the lumber business and is an amateur painter of talent. His first interview with Picasso took place on November 18, 1944. At the second interview on January 6th, Picasso approved Seckler's notes on the first. Picasso had no opportunity to approve the account of the second talk, but both interviews appear to be conscientiously reported, with the repetitions and false starts which characterize actual conversation. Picasso seems to have been both friendly and extraordinarily patient throughout, as if he as well as Seckler wanted to reach the precise truth. A copy of Seckler's complete typescript is in the archives of the Museum of Modern Art. The *New Masses* publication (bibl. 3a) is somewhat condensed. A very brief summary, with some excerpts, follows:

First Seckler gave his interpretation of the *Butterfly Hunter* (p. 216): it was a "self-portrait—the sailor's suit, the net, the red butterfly showing Picasso as a person seeking a solution to the problems of the times, . . . the sailor's garb being an indication of an active participation in this effort."

Picasso replied: "Yes, it's me, but I did not mean it to have any political significance at all," and pulling open his shirt, went on to explain that he had painted himself as a sailor because he always wore a sailor's striped jersey as an undershirt. (See photo, p. 10)

Seckler cross-questioned him about the red butterfly: "Didn't you deliberately make it red because of its political significance?" Picasso answered: "Not particularly. If it has any, it was in my subconscious!"

After some discussion of the *Guernica* (p. 200), which Picasso agreed was deliberately symbolic, Seckler turned to the *Still Life with a Bull's Head* (p. 217). The bull, Seckler proposed, is a symbol of fascism, the lamp, the palette and the book "represented culture and freedom—the things we're fighting for—the painting showing the fierce struggle going on between the two." Picasso denied this, saying that the bull was not a symbol of Fascism but simply of "brutality and darkness." When Seckler suggested that we might now look forward in Picasso's art to a "changed and more simple and clearly understood symbolism" the painter was not encouraging.

Then Seckler pointed to the big *Nude with a Musician* (p. 230) and told Picasso he could not understand it. "Why," he asked, "do you paint in such a way that your expression is so difficult for people to understand?"

Picasso explained that it had taken many years to develop his art and he could not now take a backward step. He could not "use an ordinary manner just to have the satisfaction of being understood." He did not "want to go down to a lower level . . ." and confessed: "You're a painter and you understand it's quite impossible to explain why you do this or that. I express myself through painting and I can't explain through words." "Now is the time" Picasso went on, "in this period of change and revolution to use a revolutionary manner of painting and not to paint like before . . . the proof that my paintings are revolutionary is how the students rise up against me. They would strip me naked and lynch me. 'Picasso à poil! Picasso au poteau!'"

Throughout these interviews Picasso held his ground against Seckler's persistent effort to get him to admit that his paintings carried conscious political implications. Picasso admitted the possibility of unconscious symbolism and the interest and value of some symbolic interpretation by others: "embroidery on the subject—it's stimulating." But he refused to consider the idea of changing his style or subject matter to meet any possible social or political obligations. In the end, however, he agreed that there was a connection between art and politics.

‡ The controversy over Picasso was nowhere hotter than in the *New Masses* where, according to the editor, Seckler's interview "created more discussion and controversy than any other article we have ever published." Rockwell Kent led in the attack on Picasso picking out for his particular scorn the big still life reproduced on page 217 of this book: the candle, "my little granddaughter of six could do as well"; the

palette and book, "stupid"; the bull, "it doesn't look the least bit like a bull." (Bibl. 242a, p. 26)

Recent though undocumented reports from Paris indicate that Picasso's art, and specifically a portrait of the communist leader Thorez, has been criticized in Party journals on grounds of style.

‡ The rumor that Picasso had been commissioned an officer in the French army came about through a misinterpretation of the committee appointment announced in the following official news release:

"The French Press and Information Service, An Agency of the Provisional Government of the French Republic, New York, Feb. 10, 1945. For immediate release.

"FRENCH PAINTERS MOBILIZE FOR MILITARY ART DUTY.

"A first-hand opportunity to record the dynamic themes of war is being offered to a number of French artists, who are to be commissioned as army lieutenants and sent to the front on temporary missions for this new branch of military service. This official department of war art was created at the instigation of General Charles de Gaulle.

"The army painters, who will be under no obligation to furnish the state with any particular number of paintings or sketches, are to be permitted complete freedom of expression.

"A special committee, headed by Adieneau, widely known architect, and assisted by the famous Pablo Picasso, Pierre Daragnes and Georges Fautrier, has been entrusted with the task of choosing these artists."

PAGE 248

* The original French of the written statement Picasso gave Simone Téry is as follows:

Que croyez-vous que soit un artiste? Un imbécile qui n'a que des yeux s'il est peintre, des oreilles s'il est musicien, ou une lyre à tous les étages du coeur s'il est poète, ou même, s'il est un boxeur, seulement des muscles? Bien au contraire, il est en même temps un être politique, constamment en éveil devant les déchirants, ardents ou doux événements du monde, se façonnant de toute pièce à leur image. Comment serait-il possible de se désintéresser des autres hommes, et, en vertu de quelle nonchalance ivoirine, de se détacher d'une vie qu'ils vous apportent si copieusement? Non, la peinture n'est pas faite pour décorer les appartements. C'est un instrument de guerre offensive et défensive contre l'ennemi. (Bibl. 4)

PAGE 250

* The exhibition ran through December 1945; a retrospective of Matisse's paintings was shown at the same time (bibl. 266a). Though there was no direct physical action against the paintings as there had been in Paris in 1944 (p. 245), there were outcries in the museum and dozens of vehement letters and articles in the press, perhaps more than any art exhibition had ever aroused in England.

† John Ferren, the American painter, saw the *Charnel-House* in July 1945 with the figures drawn in but not yet painted, much as the reproduction indicates. Zervos writing in the fall states that it was not yet finished (bibl. 226a).

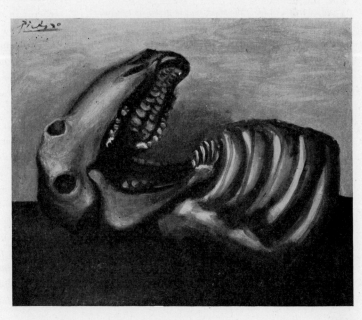

Picasso: STILL LIFE WITH SHEEP'S SKULL. October 6, 1939. Oil. Louise Léiris Gallery. Paris.

Statement by Picasso: 1923

The following statement was made in Spanish to Marius de Zayas. Picasso approved de Zayas' manuscript before it was translated into English and published in *The Arts*, New York, May, 1923, under the title *Picasso Speaks*. It is here reprinted with the kind permission of Forbes Watson, editor of *The Arts* (see bibliography, item 1).

PICASSO, about 1923. Photograph by Man Ray

I can hardly understand the importance given to the word research in connection with modern painting. In my opinion to search means nothing in painting. To find, is the thing. Nobody is interested in following a man who, with his eyes fixed on the ground, spends his life looking for the pocketbook that fortune should put in his path. The one who finds something no matter what it might be, even if his intention were not to search for it, at least arouses our curiosity, if not our admiration.

Among the several sins that I have been accused of committing, none is more false than the one that I have, as the principal objective in my work, the spirit of research. When I paint my object is to show what I have found and not what I am looking for. In art intentions are not sufficient and, as we say in Spanish: love must be proved by facts and not by reasons. What one does is what counts and not what one had the intention of doing.

We all know that Art is not truth. Art is a lie that makes us realize truth, at least the truth that is given us to understand. The artist must know the manner whereby to convince others of the truthfulness of his lies. If he only shows in his work that he has searched, and re-searched, for the way to put over lies, he would never accomplish anything.

The idea of research has often made painting go astray, and made the artist lose himself in mental lucubrations. Perhaps this has been the principal fault of modern art. The spirit of research has poisoned those who have not fully understood all the positive and conclusive elements in modern art and has made them attempt to paint the invisible and, therefore, the unpaintable.

They speak of naturalism in opposition to modern painting. I would like to know if anyone has ever seen a natural work of art. Nature and art, being two different things, cannot be the same thing. Through art we express our conception of what nature is not.

Velasquez left us his idea of the people of his epoch.

Undoubtedly they were different from what he painted them, but we cannot conceive a Philip IV in any other way than the one Velasquez painted. Rubens also made a portrait of the same king and in Rubens' portrait he seems to be quite another person. We believe in the one painted by Velasquez, for he convinces us by his right of might.

From the painters of the origins, the primitives, whose work is obviously different from nature, down to those artists who, like David, Ingres and even Bouguereau, believed in painting nature as it is, art has always been art and not nature. And from the point of view of art there are no concrete or abstract forms, but only forms which are more or less convincing lies. That those lies are necessary to our mental selves is beyond any doubt, as it is through them that we form our esthetic point of view of life.

Cubism is no different from any other school of painting. The same principles and the same elements are common to all. The fact that for a long time cubism has not been understood and that even today there are people who cannot see anything in it, means nothing. I do not read English, an English book is a blank book to me. This does not mean that the English language does not exist, and why should I blame anybody else but myself if I cannot understand what I know nothing about?

I also often hear the word evolution. Repeatedly I am asked to explain how my painting evolved. To me there is no past or future in art. If a work of art cannot live always

270

in the present it must not be considered at all. The art of the Greeks, of the Egyptians, of the great painters who lived in other times, is not an art of the past; perhaps it is more alive today than it ever was. Art does not evolve by itself, the ideas of people change and with them their mode of expression. When I hear people speak of the evolution of an artist, it seems to me that they are considering him standing between two mirrors that face each other and reproduce his image an infinite number of times, and that they contemplate the successive images of one mirror as his past, and the images of the other mirror as his future, while his real image is taken as his present. They do not consider that they all are the same images in different planes.

Variation does not mean evolution. If an artist varies his mode of expression this only means that he has changed his manner of thinking, and in changing, it might be for the better or it might be for the worse.

The several manners I have used in my art must not be considered as an evolution, or as steps toward an unknown ideal of painting. All I have ever made was made for the present and with the hope that it will always remain in the present. I have never taken into consideration the spirit of research. When I have found something to express, I have done it without thinking of the past or of the future. I do not believe I have used radically different elements in the different manners I have used in painting. If the subjects I have wanted to express have suggested different ways of expression I have never hesitated to adopt them. I have never made trials nor experiments. Whenever I had something to say, I have said it in the manner in which I have felt it ought to be said. Different motives inevitably require different methods of expression. This does not imply either evolution or progress, but an adaptation of the idea one wants to express and the means to express that idea.

Arts of transition do not exist. In the chronological history of art there are periods which are more positive, more complete than others. This means that there are periods in which there are better artists than in others. If the history of art could be graphically represented, as in a chart used by a nurse to mark the changes of temperature of her patient, the same silhouettes of mountains would be shown, proving that in art there is no ascendant progress, but that it follows certain ups and downs that might occur at any time. The same occurs with the work of an individual artist.

Many think that cubism is an art of transition, an experiment which is to bring ulterior results. Those who think that way have not understood it. Cubism is not either a seed or a foetus, but an art dealing primarily with forms, and when a form is realized it is there to live its own life. A mineral substance, having geometric formation, is not made so for transitory purposes, it is to remain what it is and will always have its own form. But if we are to apply the law of evolution and transformation to art, then we have to admit that all art is transitory. On the contrary, art does not enter into these philosophic absolutisms. If cubism is an art of transition I am sure that the only thing that will come out of it is another form of cubism.

Mathematics, trigonometry, chemistry, psychoanalysis, music and whatnot, have been related to cubism to give it an easier interpretation. All this has been pure literature, not to say nonsense, which brought bad results, blinding people with theories.

Cubism has kept itself within the limits and limitations of painting, never pretending to go beyond it. Drawing, design and color are understood and practiced in cubism in the spirit and manner that they are understood and practiced in all other schools. Our subjects might be different, as we have introduced into painting objects and forms that were formerly ignored. We have kept our eyes open to our surroundings, and also our brains.

We give to form and color all their individual significance, as far as we can see it; in our subjects, we keep the joy of discovery, the pleasure of the unexpected; our subject itself must be a source of interest. But of what use is it to say what we do when everybody can see it if he wants to?

Statement by Picasso: 1935

Christian Zervos put down these remarks of Picasso immediately after a conversation with him at Boisgeloup, his country place, in 1935. When Zervos wanted to show Picasso his notes Picasso replied: "You don't need to show them to me. The essential thing in our period of weak morale is to create enthusiasm. How many people have actually read Homer? All the same the whole world talks of him. In this way the homeric legend is created. A legend in this sense provokes a valuable stimulus. Enthusiasm is what we need most, we and the younger generation."

Zervos reports however that Picasso did actually go over the notes and approved them informally. They were published under the title *Conversation avec Picasso* in "Cahiers d'Art," 1935, volume 10, number 10, pages 173-8. The following translation is based on one by Myfanwy Evans.

We might adopt for the artist the joke about there being nothing more dangerous than implements of war in the hands of generals In the same way, there is nothing more dangerous than justice in the hands of judges, and a paintbrush in the hands of a painter. Just think of the danger to society! But today we haven't the heart to expel the painters and poets from society because we refuse to admit to ourselves that there is any danger in keeping them in our midst.

It is my misfortune — and probably my delight — to use things as my passions tell me. What a miserable fate for a painter who adores blondes to have to stop himself putting them into a picture because they don't go with the basket of fruit! How awful for a painter who loathes apples to have to use them all the time because they go so well with the cloth. I put all the things I like into my pictures. The things — so much the worse for them; they just have to put up with it.

In the old days pictures went forward toward completion by stages. Every day brought something new. A picture used to be a sum of additions. In my case a picture is a sum of destructions. I do a picture — then I destroy it. In the end, though, nothing is lost: the red I took away from one place turns up somewhere else.

It would be very interesting to preserve photographically, not the stages, but the metamorphoses of a picture. Possibly one might then discover the path followed by the brain in materializing a dream. But there is one very odd thing — to notice that basically a picture doesn't change, that the first "vision" remains almost intact, in spite of appearances. I often ponder on a light and a dark when I have put them into a picture; I try hard to break them up by interpolating a color that will create a different effect. When the work is photographed, I note that what I put in to correct my first vision has disappeared, and that, after all, the photographic image corresponds with my first vision before the transformation I insisted on.

A picture is not thought out and settled beforehand. While it is being done it changes as one's thoughts change. And when it is finished, it still goes on changing, according to the state of mind of whoever is looking at it. A picture lives a life like a living creature, undergoing the changes imposed on us by our life from day to day. This is natural enough, as the picture lives only through the man who is looking at it.

At the actual time that I am painting a picture I may think of white and put down white. But I can't go on working all the time thinking of white and painting it. Colors, like features, follow the changes of the emotions. You've seen the sketch I did for a picture with all the colors indicated on it. What is left of them? Certainly the white I thought of and the green I thought of are there in the picture, but not in the places I intended, nor in the same quantities. Of course, you can paint pictures by matching up different parts of them so that they go quite nicely together, but they'll lack any kind of drama.

I want to get to the stage where nobody can tell how a picture of mine is done. What's the point of that? Simply that I want nothing but emotion to be given off by it.

Work is a necessity for man.

A horse does not go between the shafts of its own accord. Man invented the alarm clock.

When I begin a picture, there is somebody who works with me. Toward the end, I get the impression that I have been working alone — without a collaborator.

When you begin a picture, you often make some pretty discoveries. You must be on guard against these. Destroy the thing, do it over several times. In each destroying of a beautiful discovery, the artist does not really suppress it, but rather transforms it, condenses it, makes it more substantial. What comes out in the end is the result of discarded finds. Otherwise, you become your own connoisseur. I sell myself nothing.

Actually, you work with few colors. But they seem like a lot more when each one is in the right place.

Abstract art is only painting. What about drama?

There is no abstract art. You must always start with something. Afterward you can remove all traces of reality. There's no danger then, anyway, because the idea of the object will have left an indelible mark. It is what started the artist off, excited his ideas, and stirred up his emotions. Ideas and emotions will in the end be prisoners in his work. Whatever they do, they can't escape from the picture. They form an integral part of it, even when their presence is no longer discernible. Whether he likes it or not, man is the instrument of nature. It forces on him its character and appearance. In my Dinard pictures and in my Pourville pictures I expressed very much the same vision. However, you yourself have noticed how different the atmosphere of those painted in Brittany is from those painted in Normandy, because you recognized the light of the Dieppe cliffs. I didn't copy this light nor did I pay it any special attention. I was simply soaked in it. My eyes saw it and my subconscious registered what they saw: my hand fixed the impression. One cannot go against nature. It is stronger than the strongest man. It is pretty much to our interest to be on good terms with it! We may allow ourselves certain liberties, but only in details.

Nor is there any "figurative" and "non-figurative" art. Everything appears to us in the guise of a "figure." Even in metaphysics ideas are expressed by means of symbolic "figures." See how ridiculous it is then to think of painting without "figuration." A person, an object, a circle are all "figures"; they react on us more or less intensely. Some are nearer our sensations and produce emotions that touch our affective faculties; others appeal more directly to the intellect. They all should be allowed a place because I find my spirit has quite as much need of emotion as my senses. Do you think it concerns me that a particular picture of mine represents two people? Though these two people once existed for me, they exist no longer. The "vision" of them gave me a preliminary emotion; then little by little their actual presences became blurred; they developed into a fiction and then disappeared altogether, or rather they were transformed into all kinds of problems. They are no longer two people, you see, but forms and colors: forms and colors that have taken on, meanwhile, the idea of two people and preserve the vibration of their life.

I deal with painting as I deal with things, I paint a window just as I look out of a window. If an open window looks wrong in a picture, I draw the curtain and shut it, just as I would in my own room. In painting, as in life, you must act directly. Certainly, painting has its conventions, and it is essential to reckon with them. Indeed, you can't do anything else. And so you always ought to keep an eye on real life.

The artist is a receptacle for emotions that come from all over the place: from the sky, from the earth, from a scrap of paper, from a passing shape, from a spider's web. That is why we must not discriminate between things. Where things are concerned there are no class distinctions. We must pick out what is good for us where we can find it—except from our own works. I have a horror of copying myself. But when I am shown a portfolio of old drawings, for instance, I have no qualms about taking anything I want from them.

When we invented cubism we had no intention whatever of inventing cubism. We wanted simply to express what was in us. Not one of us drew up a plan of campaign, and our friends, the poets, followed our efforts attentively, but they never dictated to us. Young painters today often draw up a program to follow, and apply themselves like diligent students to performing their tasks.

The painter goes through states of fullness and evaluation. That is the whole secret of art, I go for a walk in the forest of Fontainebleau. I get "green" indigestion. I must get rid of this sensation into a picture. Green rules it. A painter paints to unload himself of feelings and visions. People seize on painting to cover up their nakedness. They get what they can wherever they can. In the end I don't believe they get anything at all. They've simply cut a coat to the measure of their own ignorance. They make everything, from God to a picture, in their own image. That is why the picture-hook is the ruination of a painting—a painting which has always a certain significance, at least as much as the man who did it. As soon as it is bought and hung on a wall, it takes on quite a different kind of significance, and the painting is done for.

Academic training in beauty is a sham. We have been deceived, but so well deceived that we can scarcely get back even a shadow of the truth. The beauties of the Parthenon, Venuses, Nymphs, Narcissuses, are so many lies. Art is not the application of a canon of beauty but what the instinct and the brain can conceive beyond any canon. When we love a woman we don't start measuring her limbs. We love with our desires — although everything has been done to try and apply a canon even to love. The Parthenon is really only a farmyard over which someone put a roof;

colonnades and sculptures were added because there were people in Athens who happened to be working, and wanted to express themselves. It's not what the artist does that counts, but what he is. Cézanne would never have interested me a bit if he had lived and thought like Jacques Emile Blanche, even if the apple he painted had been ten times as beautiful. What forces our interest is Cézanne's anxiety — that's Cézanne's lesson; the torments of van Gogh — that is the actual drama of the man. The rest is a sham.

Everyone wants to understand art. Why not try to understand the songs of a bird? Why does one love the night, flowers, everything around one, without trying to understand them? But in the case of a painting people have to understand. If only they would realize above all that an artist works of necessity, that he himself is only a trifling bit of the world, and that no more importance should be attached to him than to plenty of other things which please us in the world, though we can't explain them. People who try to explain pictures are usually barking up the wrong tree. Gertrude Stein joyfully announced to me the other day that she had at last understood what my picture of the three musicians was meant to be. It was a still life!

How can you expect an onlooker to live a picture of mine as I lived it? A picture comes to me from miles away: who is to say from how far away I sensed it, saw it, painted it; and yet the next day I can't see what I've done myself. How can anyone enter into my dreams, my instincts, my desires, my thoughts, which have taken a long time to mature and to come out into the daylight, and above all grasp from them what I have been about — perhaps against my own will?

With the exception of a few painters who are opening new horizons to painting, young painters today don't know which way to go. Instead of taking up our researches in order to react clearly against us, they are absorbed with bringing the past back to life — when truly the whole world is open before us, everything waiting to be done, not just redone. Why cling desperately to everything that has already fulfilled its promise? There are miles of painting "in the manner of"; but it is rare to find a young man working in his own way.

Does he wish to believe that man can't repeat himself? To repeat is to run counter to spiritual laws; essentially escapism.

I'm no pessimist, I don't loathe art, because I couldn't live without devoting all my time to it. I love it as the only end of my life. Everything I do connected with it gives me intense pleasure. But still, I don't see why the whole world should be taken up with art, demand its credentials, and on that subject give free rein to its own stupidity. Museums are just a lot of lies, and the people who make art their business are mostly imposters. I can't understand why revolutionary countries should have more prejudices about art than out-of-date countries! We have infected the pictures in museums with all our stupidities, all our mistakes, all our poverty of spirit. We have turned them into petty and ridiculous things. We have been tied up to a fiction, instead of trying to sense what inner life there was in the men who painted them. There ought to be an absolute dictatorship . . . a dictatorship of painters . . . a dictatorship of one painter . . . to suppress all those who have betrayed us, to suppress the cheaters, to suppress the tricks, to suppress mannerisms, to suppress charms, to suppress history, to suppress a heap of other things. But common sense always gets away with it. Above all, let's have a revolution against that! The true dictator will always be conquered by the dictatorship of common sense . . . and maybe not!

Picasso: Curtain design for the ballet *Le Rendezvous.* Paris, 1945.

Theatre Productions in which Picasso has collaborated

The list of ballets prepared by Paul Magriel for Picasso: Forty Years of His Art *has here been considerably revised and expanded.*

PARADE

Ballet in one act produced for the *Ballets Russes* by Sergei Diaghilev. Book by Jean Cocteau. Music by Eric Satie. Choreography by Léonide Massine. Curtain, scenery and costumes by Pablo Picasso. First produced: Théâtre du Châtelet, Paris May 18, 1917.

The curtain, a costume and a costume design are illustrated on pages 98 and 99.

LE TRICORNE

Ballet in one act produced for the *Ballets Russes* by Sergei Diaghilev. Book by Martinez Sierra. Music by Manuel de Falla. Choreography by Léonide Massine. Curtain, scenery and costumes by Pablo Picasso. First produced: Alhambra Theatre, London, July 22, 1919.

An oil study for the curtain and an ink study for the setting are illustrated on page 108.

PULCINELLA

Ballet in one act produced for the *Ballets Russes* by Sergei Diaghilev. Music by Igor Strawinsky (after Pergolesi). Choreography by Léonide Massine. Curtain, scenery and costumes by Pablo Picasso. First produced: Théâtre National de l'Opera, Paris, May 15, 1920.

A watercolor of the setting and two drawings related to the costumes are illustrated on pages 101 and 110.

CUADRO FLAMENCO

Suite of Andalusian dances and songs produced for the *Ballets Russes* by Sergei Diaghilev. Folk music arranged by Manuel de Falla. Scenery and costumes by Pablo Picasso, made at the house of Jove, Paris, under the direction of Mme Bongard. First produced: Théâtre de la Gaîté-Lyrique, Paris, May 22, 1921.

A section of the scenery representing a theatre box is illustrated on page 109.

ANTIGONE

Play in one act by Jean Cocteau, free adaptation after Sophocles. Produced by Charles Dullin and his troupe. Incidental music for harp and oboe by Arthur Honegger. Scenery by Jean Cocteau and Pablo Picasso. Costumes by Chanel. First produced: Théâtre de l'Atelier, Paris, December 20, 1922.

A photograph of the play in action is reproduced in Der Querschnitt, *III, no. 1-2, Summer 1923 between pages 134-5. The masks and columns were painted by Picasso.*

MERCURE

Poses plastiques produced for the Soirées de Paris by Count Etienne de Beaumont. Music by Eric Satie. Choreography by Léonide Massine. Scenery and costumes by Pablo Picasso. First produced: Paris, June 15, 1924.

A photograph of the setting is illustrated on page 132.

LE TRAIN BLEU

Operette dansée in one act produced for the *Ballets Russes* by Sergei Diaghilev. Book by Jean Cocteau. Music by Darius Milhaud. Scenery by Henri Laurens. Costumes by Chanel. Choreography by Bronislava Nijinska. Curtain by Pablo Picasso. First produced: Théâtre des Champs-Elysées, Paris, June 20, 1924.

The curtain was an enlargement of the gouache, The Race, *1922, reproduced in color opposite page 126.*

LE DESIR ATTRAPE PAR LA QUEUE

Play in six acts by Pablo Picasso. First presented at a reading at the home of Michel Léiris, Paris, March 19, 1944, under the direction of Albert Camus with music arranged by Georges Hugnet.

Two of Picasso's illustrations to a published version of the play are reproduced on pages 226 and 229.

LE RENDEZ-VOUS

Ballet produced by the *Ballets des Champs-Elysées*. Book by Jacques Prévert. Music by Pierre Kosma. Scenery by Brassai. Costumes by Mayo. Choreography by Roland Petit. Curtain by Pablo Picasso. First produced: Théâtre des Champs-Elysées, Paris, spring 1945.
The design for the curtain is illustrated opposite.

Illustrations by Picasso

1900 OLIVA BRIDGMAN, JOAN. "El clam de las Verges," *Joventut* (Barcelona), vol. I, no. 22, July 12, 1900, pp. 345-6. Illustrated with reproduction of 1 drawing.

1900 OLIVA BRIDGMAN, JOAN. "Ser ó no ser," *Joventut* (Barcelona). vol. I, no. 27, August 16, 1900, p. 424. Illustrated with reproduction of 1 drawing. (see p. 253)

1905 SALMON, ANDRÉ. *Poèmes*. Paris, Vers et Prose. About 10 copies contain 1 drypoint (G.6).

1911 JACOB, MAX. *Saint Matorel*. Paris, Henry Kahnweiler. Illustrated with 4 etchings (G.23-26).

1913 APOLLINAIRE, GUILLAUME. *Alcools*. Paris, Mercure de France. Contains reproduction of 1 portrait drawing of the author.

1914 JACOB, MAX. *Le siège de Jérusalem*. Paris, Henry Kahnweiler. Illustrated with 3 etchings and drypoints (G.35-37). (see p. 89)

1917 JACOB, MAX. *Le cornet à dés*. Paris, published by the author. 14 copies contain 1 burin engraving (G.54).

1918 APOLLINAIRE, GUILLAUME. *Calligrammes*. Paris, Mercure de France. Contains reproduction of 1 portrait drawing of the author. Copies of the deluxe edition contain in addition 1 etching by R. Jaudon after a drawing by Picasso.

1918 COCTEAU, JEAN. *Le coq et l'arlequin*. Paris, Editions de la Sirène. Contains reproductions of 1 portrait drawing of the author and 2 monograms.

1918 JACOB, MAX. *Le phanérogame*. Paris, published by the author. 20 copies contain 1 zinc etching (G.55).

1919 JACOB, MAX. *La défense de Tartufe*. Paris, Société Littéraire de France. 25 copies contain 1 burin engraving (G.52).

1919 SALMON, ANDRÉ. *Le manuscrit trouvé dans un chapeau*. Paris, Société Littéraire de France. Contains reproductions of 38 drawings.

1919 STRAWINSKY, IGOR. *Ragtime*. Paris, Editions de la Sirène. Cover design. (see p. 110)

1920 ARAGON, LOUIS. *Feu de joie*. Paris, Au Sans Pareil. Contains reproduction of 1 drawing.

1921 HUIDOBRO, VINCENT. *Saisons choisies*. Paris, La Cible. Contains reproduction of 1 portrait drawing of the author.

1921 SALMON, ANDRÉ. *Peindre*. Paris, Editions de la Sirène. Contains reproduction of 1 portrait drawing of the author.

1921 VALÉRY, PAUL. *La jeune parque*. Paris, Nouvelle Revue Française. Contains 1 transfer-lithograph, a portrait of the author (G.224).

†1922 PARNAK, VALENTIN. *Karabkaetsja akrobat*. Paris, Editions Frankorusskaja Pečatj. Contains reproduction of 1 portrait drawing of the author.

1922 REVERDY, PIERRE. *Cravates de chanvre*. Paris, Nord-Sud. 132 copies illustrated with 3 zinc etchings including a portrait of the author (G.62-65).

1923 BILLY, ANDRÉ. *Apollinaire vivant*. Paris, Editions de la Sirène. Contains reproductions of 2 portrait drawings of Apollinaire.

1923 BRETON, ANDRÉ. *Clair de terre*. Paris, published by the author. 40 copies contain 1 drypoint portrait of the author (G.110), the others, a reproduction.

1923 GEORGES-MICHEL, MICHEL. *Les Montparnos*. Paris, Arthème Fayard. The cover of the first edition reproduces 1 gouache. (see p. 101, right)

1923 JACOB, MAX. *Le cornet à dés* (revised edition). Paris, Librairie Stock. Contains reproduction of 1 portrait drawing of the author.

1924 COCTEAU, JEAN. *Le secret professionnel*. Paris, Librairie Stock. Contains reproduction of 1 portrait drawing of the author.

1924 REVERDY, PIERRE. *Pablo Picasso*. Paris, La Nouvelle Revue Française, Les Peintres Français Nouveaux, no. 16. Contains 1 wood engraving by Georges Aubert after a self-portrait drawing by Picasso.

1925 RADIGUET, RAYMOND. *Les joues en feu.* Paris, Bernard Grasset. Contains 1 autotype of a portrait drawing of the author (G.223).

1925 REVERDY, PIERRE. *Ecumes de mer.* Paris, Nouvelle Revue Française. Contains reproduction of 1 portrait drawing of the author.

1926 GEORGE, WALDEMAR. *Picasso dessins.* Paris, Editions des Quatre Chemins. 100 copies contain 1 lithograph (G.240).

1926 ZERVOS, CHRISTIAN. *Picasso, Oeuvres 1920-26.* Paris, Cahiers d'Art. 56 copies contain 1 zinc etching (G.99). (see p. 132)

1928 LEVEL, ANDRÉ. *Picasso.* Paris, G. Crès. 120 copies contain 1 lithograph (G.243). (The lithograph was also printed separately; see p. 158.)

†c.1928 REVERDY, PIERRE. *Les sources du vent.* Paris, Maurice Saxe. Contains reproduction of 1 portrait of the author.

1929 APOLLINAIRE, GUILLAUME. *Contemporains pittoresques.* Paris, Editions de la Belle Page. Contains 1 portrait etching of the author.

1929 *Le Manuscrit Autographe* (Paris, Auguste Blaizot et fils), no. 21, May-June 1929, plate hors-texte. 1 transfer lithograph (G.246) was published for subscribers of the review. (see p. 158)

1929-30 (?) DELGADO Y GALVEZ, JOSÉ (pseud. Pepe Hillo). *Tauromaquia.* Preface by Henry de Montherlant. Barcelona, Gustav Gili (unpublished). Illustrated with 6 etchings (G.136-141).

1930 D'ORS, EUGENIO. *Pablo Picasso.* Paris, Editions des Chroniques du Jour. 50 copies contain 1 lithograph (G.247).

1930 STEIN, GERTRUDE. *Dix portraits.* Accompanied by a French translation by Georges Hugnet and Virgil Thomson. Preface by Pierre de Massot. Paris, Editions de la Montagne. 100 copies contain reproductions of 3 drawings.

1931 BALZAC, HONORÉ. *Le chef-d'oeuvre inconnu.* Paris, Ambroise Vollard. Illustrated with 13 etchings (G.123-125) and 67 wood engravings by Aubert, after drawings by Picasso. (see pp. 144 and 145)

1931 OVID. *Les métamorphoses.* Translated by Georges Lafaye. Lausanne, Albert Skira. Illustrated with 30 etchings (G.143-72). (see p. 159)

1933 AIMOT, J.-M. *Manné-Katz.* Preface by Paul Fierens. Paris, Marcel Seheur. Contains reproduction of 1 portrait drawing of Manné-Katz.

1933 COCTEAU, JEAN. *Orphée.* Translated by Carl Wildman. London, Oxford University Press. Contains reproduction of 1 drawing.

1933 *Minotaure* (Paris, Albert Skira), vol. I, no. 1. 1 collage and 4 etchings reproduced as the cover and frontispiece.

1933 TZARA, TRISTAN. *L'antitête.* Paris, Editions des Cahiers Libres. 18 copies contain proofs of 1 etching printed by the artist.

1933 WEILL, BERTHE. *Pan! dans l'oeil!* . . . Paris, Librairie Lipschutz, 1933. Contains reproductions of 2 drawings including a portrait of the author.

1934 ARISTOPHANES. *Lysistrata*, a new version by Gilbert Seldes. New York, Limited Editions Club. Illustrated with 6 etchings and reproductions of 33 drawings. (see p. 192)

1934 LEVINSON, ANDRÉ. *Serge Lifar.* Paris, Bernard Grasset. Contains reproduction of 1 drawing of the dancer.

1934 PÉRET, BENJAMIN. *De derrière les fagots.* Paris, José Corti. 24 copies contain 1 etching.

1934 *Petite anthologie poétique du surréalisme.* Introduction by Georges Hugnet. Paris, Jeanne Bucher. 28 copies contain 1 etching.

†1935 CHAR, RENÉ. *Dépendance de l'adieu.* Paris, G.L.M. 70 copies contain reproduction of 1 drawing.

1936 ELUARD, PAUL. *La barre d'appui.* Paris, Cahiers d'Art. 40 copies illustrated with 3 etchings. The first 6 copies contain the 3 etchings in 4 states. (see p. 194)

1936 ELUARD, PAUL. *Thorns of thunder.* Selected poems edited by George Reavey. London, Europa Press and Stanley Nott. Contains reproduction of 1 portrait drawing of the author.

1936 ELUARD, PAUL. *Les yeux fertiles.* Paris, G.L.M. Contains reproductions of: 1 portrait drawing of the author; 3 etchings for *La barre d'appui*; and marginal decorations for a poem "Le grand air."

†1937 ELUARD, PAUL. *O solitude! O fontaines!* Paris, G.L.M. 275 copies contain reproduction of 1 drawing.

1938 DECAUNES, LUC. *L'indicatif présent, ou L'infirme tel qu'il est.* Paris, Soutes. 30 copies contain 1 etching.

1939 *L'hommage à la Tchécoslovaquie.* Edited by "the group of Czechoslovakian artists." Paris. Text by F. Langer, Paul Claudel and Paul Valéry. Contains 1 lino-cut by Picasso.

1940 ILIAZD (Ilya Zdanevitch). *Afat.* Paris, published by the author. Illustrated with 6 etchings.

†1940 MABILLE, PIERRE. *Le miroir de merveilleux.* Paris, Sagi Haire. 19 copies contain 1 etching.

1942 COMTE DE BUFFON (Georges Louis LeClerc). *Histoire naturelle.* Paris, Fabiani. Illustrated with 31 aquatints commissioned by Ambroise Vollard. (see p. 210)

1942 HUGNET, GEORGES. *Non vouloir.* Paris, Jeanne Bucher. Contains 4 wood engravings.

1943 *Grâce et mouvement.* Edited with an introduction by Louis Grosclaude. Zurich, Louis Grosclaude. 14 poems by Sappho accompanied by 14 engravings after drawings by Picasso.

1943 HUGNET, GEORGES. *La chèvre-feuille.* Paris, Godit. Contains 6 wood engravings. 25 copies contain

the 6 engravings in three printings and in addition 1 etching.

1944 PICASSO, PABLO. "Le désir attrapé par la queue," in *Messages,* no. 2. Paris, Risques, Travaux et Modes. Illustrated with reproductions of 4 drawings including a self portrait. (see pp. 226 and 229)

1945 ELUARD, PAUL. *Au rendez-vous allemand.* Geneva, Editions des Trois Collines. Contains reproduction of 1 portrait drawing of the author.

N.D. JARRY, ALFRED. *Poèmes.* Paris. 30 copies printed at the expense of an amateur. Contains reproduction of 1 portrait drawing of the author.

N.D. SUARÈS, ANDRÉ. *Hélène chez Archimède.* Paris, Ambroise Vollard (unpublished). Illustrated with 1 etching and reproductions of 50 drawings.

Exhibitions of Picasso's Work

1897 BARCELONA. Reviewed by Rodríguez Codolá, bibl 407a
1901 PARIS, Ambroise Vollard Gallery. With Iturrino. Reviewed by Fagus, bibl 156
1902 PARIS, B. Weill Gallery. Catalog preface by Farge, bibl 157
1902 PARIS, Ambroise Vollard Gallery
1909 PARIS, Ambroise Vollard Gallery
1909 MUNICH, Thannhauser Gallery
1911 NEW YORK, Photo-Secession Gallery. Catalog preface by De Zayas, bibl 136
1911 MUNICH, Thannhauser Gallery
1912 BARCELONA, Dalmau Gallery
1912 COLOGNE, special room in Sonderbund exhibition
1912 LONDON, Stafford Gallery
1913 MUNICH, Thannhauser Gallery. Bibl 469
1913 PRAGUE
1913 BERLIN, Neue Galerie
1913 BERLIN, Sezession Galerie
1913 COLOGNE, Rheinische Kunstsalon
1914 BERLIN, Neue Galerie
1914 DRESDEN, E. Richter Gallery
1914 MUNICH, Caspari Gallery
1914-15 NEW YORK, Photo-Secession Gallery
1919 PARIS, Galerie de l'Effort Moderne (Léonce Rosenberg)
1919 PARIS, Paul Rosenberg Gallery
1920 PARIS, Paul Rosenberg Gallery
1920 ROME, Valori Plastici Gallery
1921 LONDON, Leicester Galleries. Bibl 253
1921 PARIS, Paul Rosenberg Gallery
1922 MUNICH, Thannhauser Gallery
1923 CHICAGO, Arts Club. Drawings. Bibl 29
1923 NEW YORK, Wildenstein Galleries. Bibl 507
1923 PRAGUE, Mánes Art Society
1924 PARIS, Paul Rosenberg Gallery
1926 PARIS, Paul Rosenberg Gallery
1927 BERLIN, Flechtheim Gallery. Bibl 165
1927 PARIS, Paul Rosenberg Gallery. Drawings. Bibl 413

1927 NEW YORK, Wildenstein Galleries. Drawings
1928 CHICAGO, Arts Club. Drawings. Bibl 30
1928 PARIS, Pierre Gallery
1928 NEW YORK, Wildenstein Galleries. Drawings. Bibl 506
1930 CHICAGO, Arts Club. Bibl 31
1930 NEW YORK, John Becker Gallery. Drawings and gouaches. Bibl 40
1930 NEW YORK, Reinhardt Gallery. With Derain. Bibl 400
1930 PARIS, M. G. Aron Gallery
1931 CAMBRIDGE, MASS., Harvard Society for Contemporary Art. Bibl 213
1931 LONDON, Alex. Reid & Lefevre. Bibl 399
1931 NEW YORK, Demotte Galleries. Bibl 133
1931 NEW YORK, Marie Harriman Gallery. Ovid illustrations
1931 NEW YORK, Valentine Gallery. Bibl 479
1931 PARIS, Percier Gallery
1931 PARIS, Paul Rosenberg Gallery
1932 CAMBRIDGE, MASS., Harvard Society for Contemporary Art. Ovid illustrations. Bibl 212
1932 HANNOVER, Kestner-Gesellschaft. With Schlemmer. Bibl 209
1932 MUNICH, Graphische Kabinett. Ovid illustrations
1932 PARIS, Georges Petit Gallery. Bibl 346
1932 ZURICH, Kunsthaus. Bibl 530
1933 NEW YORK, Valentine Gallery. Bibl 480
1934 BUENOS AIRES
1934 HARTFORD, CONN., Wadsworth Atheneum. Bibl 211
1935 PARIS, Pierre Gallery. *Papiers collés.* Bibl 370
1936 LONDON, Zwemmer Gallery
1936 MADRID, Amigos de las Artes Nuevas. Bibl 15
1936 NEW YORK, Jacques Seligmann & Co. Bibl 438
1936 NEW YORK, Valentine Gallery. Bibl 484
1936 PARIS, Cahiers d'Art Gallery. Sculpture
1936 PARIS, Renou & Colle Gallery. Drawings
1936 PARIS, Paul Rosenberg Gallery. Bibl 414
1937 CHICAGO, Arts Club
1937 LONDON, Zwemmer Gallery. Drawings. Bibl 532

1937 LONDON,Zwemmer Gallery.With Chirico. Bibl 531

1937 LONDON, Rosenberg and Helft. Bibl 416

1937 NEW YORK, Jacques Seligmann & Co. Bibl 439

1937 NEW YORK, Valentine Gallery. Bibl 481

1937 PARIS, Kate Perls Gallery. Bibl 342

1938 BOSTON, Museum of Modern Art. With Matisse. Bibl 62

1938 LONDON, London Gallery. Drawings and collages

1938 LONDON, New Burlington Galleries. *Guernica.* Bibl 306

1938 NEW YORK, Valentine Gallery. Bibl 483

1939 NEW YORK, Marie Harriman Gallery. Bibl 210

1939 LONDON, London Gallery. Catalog in bibl 266

1939 NEW YORK, Perls Galleries. Bibl 343

1939 LONDON, Rosenberg & Helft Gallery. Bibl 415

1939 PARIS, Paul Rosenberg Gallery. Bibl 412

1939 NEW YORK, Perls Gallery. With Lam. Drawings

1939 NEW YORK,Westermann Gallery. Prints. Bibl 498

1939 CHICAGO, Arts Club. Drawings. Bibl 32

1939 NEW YORK, Valentine Gallery. *Guernica.* Bibl 482

1939 NEW YORK, Bignou Gallery. Bibl 53

1939 LOS ANGELES, Stendahl Art Galleries. *Guernica*

1939 SAN FRANCISCO, Museum of Fine Arts. *Guernica*

1939 CHICAGO, Arts Club. *Guernica*

1939 NEW YORK, Museum of Modern Art. *Picasso, Forty Years of his Art.* Bibl 320 (see also below)

1940 CHICAGO, Art Institute. *Picasso, Forty Years of his Art*

1940 PARIS, Mai Gallery. Drawings and watercolors

1940 NEW YORK, Buchholz Gallery. Drawings and watercolors. Bibl 71

1941 NEW YORK, Bignou Gallery. Bibl 52

1941 NEW YORK, Museum of Modern Art

1941 CAMBRIDGE, MASS.,Fogg Museum of Art. *Guernica*

1941 COLUMBUS, Gallery of Fine Arts. *Guernica*

1941 CHICAGO, Katherine Kuh Gallery. Watercolors and drawings

1942 NEW YORK, Paul Rosenberg Gallery. Bibl 411

1942 CAMBRIDGE, MASS.,Fogg Museum of Art. *Guernica*

1942 HAVANA, Lyceum Club

1942 WELLESLEY, MASS., Wellesley College

1943 NEW YORK, Paul Rosenberg Gallery.With Braque

1943 CAMBRIDGE, MASS., Fogg Museum of Art. With Wright and Maillol. Bibl 83

1943 NEW YORK, Paul Rosenberg Gallery

1943 NEW YORK, Pierre Matisse Gallery. Bibl 284

1944 WASHINGTON, D. C., Phillips Memorial Gallery. Bibl 491

1944 MEXICO CITY,Sociedad de Arte Moderno. Bibl 444

1944 PARIS, Salon d'Automne. 74 paintings, 5 sculptures. Bibl 432

1944 NEW YORK, Paul Rosenberg Gallery. With Braque and Matisse

1945 PHILADELPHIA, Philadelphia Museum of Art. With Léger. Bibl 348

1945 NEW YORK, Buchholz Gallery. Bibl 70

1945 LONDON, Modern Art Gallery

1945 PHILADELPHIA, Philadelphia Museum of Art. With Braque

1945 PARIS, Louis Carré Gallery. Bibl 89

1945 LONDON, Victoria and Albert Museum.~With Matisse. Bibl 266a

The exhibition *Picasso: Forty Years of His Art* after being shown in New York and Chicago was sent on tour by the Museum of Modern Art. The complete schedule, with the approximate number of items shown, follows:

NEW YORK, The Museum of Modern Art—November 15, 1939 to January 7, 1940 (344 items)

CHICAGO, The Art Institute of Chicago—February 1 to March 3, 1940 (236 items)

ST. LOUIS, City Art Museum of St. Louis—March 16 to April 14, 1940 (236 items)

BOSTON, Museum of Fine Arts (under auspices of Institute of Modern Art)—April 26 to May 25, 1940 (236 items)

SAN FRANCISCO, San Francisco Museum of Art—June 25 to July 22, 1940 (236 items)

CINCINNATI, Cincinnati Museum of Art (under auspices of Cincinnati Modern Art Society)—September 28 to October 27, 1940 (170 items)

CLEVELAND, Cleveland Museum of Art—November 7 to December 8, 1940 (170 items)

NEW ORLEANS, Isaac Delgado Museum (under auspices of Picasso Exhibition Committee)—December 20, 1940 to January 17, 1941 (170 items)

MINNEAPOLIS, Minneapolis Institute of Arts—February 1 to March 2, 1941 (170 items)

PITTSBURGH, Carnegie Institute—March 15 to April 13, 1941 (170 items)

A much smaller exhibition of about 30 items from the original show was sent on tour during the season 1941–42 to:

UTICA, N. Y., Munson-Williams-Proctor Institute—November 1 to November 24, 1941

DURHAM, N. C., Duke University—November 29 to December 20, 1941

KANSAS CITY, Mo., William Rockhill Nelson Art Gallery—January 24 to February 14, 1942

MILWAUKEE, WIS., Milwaukee Art Institute—February 20 to March 13, 1942

GRAND RAPIDS, MICH., Grand Rapids Art Gallery—March 23 to April 13, 1942

HANOVER, N. H., Dartmouth College—April 27 to May 18, 1942

POUGHKEEPSIE, N. Y., Vassar College—May 20 to June 15, 1942

A second small exhibition of about 10 items from the original show was sent on tour during the season 1942–43 to:

WELLESLEY, MASS., Wellesley College—September 27 to October 18, 1942

SWEET BRIAR, VA., Sweet Briar College—October 28 to November 18, 1942

WILLIAMSTOWN, MASS., Williams College—November 28 to December 19, 1942

BLOOMINGTON, IND., Indiana University—January 1 to January 22, 1943

ALTON, ILL., Monticello College—February 5 to February 26, 1943

PORTLAND, OREGON, Portland Art Museum—April 1 to April 30, 1943

Some sixty pictures from the 1939 show were included in the Picasso exhibition organized with the assistance of the Museum of Modern Art by the Sociedad de Arte Moderno, Mexico City, June 1944.

Works by Picasso in American Museums

A page number in parentheses follows each item illustrated in this book. The list may not be complete. The titles are those used by the owners. Prints are not included. This list was prepared by Dorothy C. Miller (1939) and William S. Lieberman (1945).

BALTIMORE, MARYLAND. BALTIMORE MUSEUM OF ART

 Two Nudes. 1905? Watercolor, 13½ x 17″
 Abstraction with a Table and Blue Screen. 1921. Pencil and pastel, 12½ x 9¾″
 Abstraction. 1924. Oil, 14¼ x 17½″. Extended loan from Mrs. Saidie A. May
 Also three drawings, extended loan from Philip Perlman

BUFFALO, NEW YORK. BUFFALO FINE ARTS ACADEMY, ALBRIGHT ART GALLERY

 Famille au Souper. 1903–04. Watercolor, 12½ x 17″
 La Toilette. 1905. Oil, 59½ x 39½″ (p. 44)
 Arlequin (Project for a Monument). 1935. Oil, 24½ x 20″ (p. 191)

CAMBRIDGE, MASSACHUSETTS. FOGG MUSEUM OF ART, HARVARD UNIVERSITY

 Portrait of Fonte. 1900 or before. Crayon and wash, 20½ x 12⅞″
 Portrait of Rocarol. 1900 or before. Crayon and watercolor, 19 x 13″
 Mother and Child. 1904. Crayon, 13½ x 10½″ (p. 29)
 Standing Nude Man. 1904. Ink (reverse of preceding item)
 Woman Having Her Hair Combed. 1905. Crayon, 24⅛ x 19½″
 Bathers. 1918. Pencil, 9⅛ x 12¼″ (p. 102)
 A Philosopher. 1918? Pencil, 13⅝ x 10⁷⁄₁₆″
 A Clown. Pencil, 13⅜ x 9¾″
 A Reclining Nude. 1923. Pencil, 10¼ x 13¾″
 Weeping Woman (Guernica "postscript"). 1937. Ink and watercolor, 16¼ x 10¾″

CHICAGO. ART INSTITUTE OF CHICAGO

 On the Upper Deck. 1901. Oil, 15½ x 24½″ (p. 20)
 Woman with Cats. 1901. Oil on cardboard, 17½ x 16″
 The Old Guitarist. 1903. Oil on wood, 47¾ x 32½″ (p. 28)
 Au Cabaret. Crayon, 4⅞ x 8¼″
 Girl and Man. Ink, 9⅝ x 12⅝″
 Nude Man. Pencil, 12 x 8″
 Peasants from Andorra. 1906. Ink, 22⅞ x 13½″ (p. 46)
 Two Nudes. 1906. Charcoal, 24½ x 17½″
 Still Life. 1907-08. Ink and watercolor, 13 x 20″
 Head of a Woman. 1909. Gouache, 25½ x 19″
 Woman with Mirror. 1909. Oil, 23⅞ x 20³⁄₁₆″
 Musical Instruments. 1916. Gouache, 5¾ x 4⅝″
 Large Standing Nude. 1923. Ink and watercolor, 42⅝ x 28¼″

 EXTENDED LOAN FROM THE CHESTER DALE COLLECTION

 The Gourmet. 1901. Oil, 36 x 27″
 The Tragedy. 1903. Oil on panel, 41½ x 27¼″
 Study for the Juggler. 1905? Drawing, 10¼ x 7¼″
 Juggler with Still Life. 1905. Gouache on cardboard, 38¾ x 27¼″
 Two Youths. 1905. Oil, 59¼ x 36¾″
 Family of Saltimbanques. 1905. Oil, 84 x 90⅜″ (p. 36)
 Still Life, Mandolin. 1918. Oil, 38 x 51¼″
 Classical Head. 1922. Oil, 24 x 19¾″
 Portrait of Mme Picasso. 1923. Oil, 39½ x 32″
 The Lovers. 1923. Oil, 50 x 38″

CHICAGO. ARTS CLUB OF CHICAGO

 Head of a Woman. 1923. Red chalk, 23½ x 17½″

CINCINNATI, OHIO. CINCINNATI ART MUSEUM

 Head of a Woman. 1922. Oil, 39 x 31½″

CLEVELAND, OHIO. CLEVELAND MUSEUM OF ART

 Standing Nude. 1905. Gouache, 25¼ x 19¼″
 La Vie. 1903. Oil, 77⅜ x 50⅞″ (p. 27)

COLUMBUS, OHIO. COLUMBUS GALLERY OF FINE ARTS

 The Appetizer. 1901. Watercolor, 17 x 13½″
 Boy with Cattle. 1905. Gouache, 23½ x 18½″ (p. 48)
 Figure with words "J'aime Eva." 1912. Oil, 38¾ x 25″
 Still Life. 1915. Oil, 25 x 31½″
 Abstraction. 1916. Watercolor, 17½ x 13¼″

DETROIT, MICHIGAN. DETROIT INSTITUTE OF FINE ARTS

 Portrait of E. Forert. Charcoal, 19¼ x 7″

HARTFORD, CONNECTICUT. WADSWORTH ATHENEUM

 Sketch for setting of *Le Tricorne.* 1919. Ink, 5 x 7½″ (p. 108)
 Standing Nude. 1922. Oil on wood, 7½ x 5½″ (p. 125)
 Two Ballet Dancers Resting. 1925. Ink, 13½ x 9¾″

HONOLULU, HAWAII. ACADEMY OF ARTS

 Pierrot. 1927. Oil, 22 x 18″

LOS ANGELES, CALIFORNIA. LOS ANGELES COUNTY MUSEUM

 Figure. 1908-11. Watercolor and pencil, 18 x 11¼″
 Woman at Mirror. 1934. Watercolor and crayon, 13¾ x 9⅜″

MERION, PENNSYLVANIA. BARNES FOUNDATION

 Girl with Cigarette. 1901. Oil, 28¾ x 19½″
 Baby Seated on Chair. 1901. Oil, 25½ x 21¼″
 Man Seated at Table. 1903. Oil, 46¾ x 31¾″
 Acrobat. "Blue" period
 Harlequins. 1905. Oil, 75 x 42½″
 Figures and Goat. 1905. Oil, 54¾ x 40″
 Composition (Oxen and peasants). 1906? Oil, 86⅜ x 51″ (p. 49)
 Nude Standing in Red Arch. 1905. Oil, 10¼ x 7⅛″
 Standing Figure. 1905-06
 Three Nudes. 1906. Oil, 9½ x 11⅛″
 Punch. "Negro" period
 Judy. "Negro" period
 Still Life (Cubist)
 Still Life (Cubist)
 Violin and Bottle (Cubist)
 Music. 1914-15. Oil, 19½ x 16″

and the following works the dates of which are not at present available:

Basket of Vegetables with Jugs. Oil with gouache
Still Life. Oil
Nude Seated on Bed. Oil
The Loge. Oil
Still Life. Oil
Woman Seated. Oil
Jar and Three Pieces of Fruit. Gouache
Three Figures. Oil, 3¾ x 4″
Group of Men. Oil
Two Figures. Oil, 4 x 5″
Man Seated. Oil
Glass and Lemon. Oil with gouache
Still Life. Oil
and sixteen drawings, mostly of the "acrobat" period, about 1905

NEW YORK. ART OF THIS CENTURY

The Poet. 1911. Oil, 51½ x 35¼″
"Lacerba." 1914. Collage, 28½ x 23″
L'Atelier. 1928. Oil, 64 x 51½″
Girls with a Toy Boat. 1937. Oil and charcoal, 51⅛ x 76¾″ (p. 199)

NEW YORK. METROPOLITAN MUSEUM OF ART

Woman's Head. "Blue" period (1901-03). Oil, 15⅞ x 14″. Extended loan from Miss Adelaide M. de Groot

NEW YORK. MUSEUM OF MODERN ART

La Coiffure. 1905. Oil, 68⅞ x 39¼″ (p. 43)
Boy Leading a Horse. 1905. Oil, 86½ x 51¼″. Extended loan from William S. Paley (color plate opp. p. 42)
Hercules. 1905? Ink, 6¾ x 4¼″
Les Demoiselles d'Avignon. 1906-07. Oil, 96 x 92″ (color plate opp. p. 54) (p. 55)
Fernande. 1909? Oil, 24¼ x 16¾″. Extended loan from Henry Church (p. 68)
Fruit Dish. 1909. Oil, 29¼ x 24″ (p. 65)
Woman's Head. 1909. Bronze, 16¼″ high (p. 69)
Head. 1909. Gouache, 24 x 18″ (p. 66)
"Ma Jolie." 1911-12. Oil, 39⅜ x 25¾″ (p. 76)
Study for a Construction. 1912-13. Ink, 6¾ x 4⅞″ (p. 86)
Cubist Study. 1912?-13. Ink, 7¼ x 5¼″
Man with a Hat. 1913. Collage, charcoal, ink, 24½ x 18¼″ (p. 80)
Card Player. 1914. Oil, 42½ x 35¼″ (p. 83)
Green Still Life. 1914. Oil, 23½ x 31¼″ (p. 90)
Seated Woman. 1918. Gouache, 5½ x 4½″
Dog and Cock. 1921. Oil, 61 x 30¼″ (color plate opp. p. 120)
Woman in White. 1923. Oil, 39 x 31½″ (p. 129)
Still Life with a Cake. 1924. Oil, 38½ x 51½″ (p. 134)
Four Ballet Dancers. 1925. Ink, 13½ x 10″ (p. 140)
Seated Woman. 1926-27. Oil, 51½ x 38½″ (p. 146)
The Studio. 1927-28. Oil, 59 x 91″ (p. 152)
Girl before a Mirror. 1932. Oil, 63¾ x 51¼″ (color frontispiece)
Two Figures on the Beach. 1933. Ink, 15¾ x 19⅝″ (p. 184)
Head of a Woman. 1941. Ink, 10⅝ x 8¼″ (p. 228)

NEW YORK. MUSEUM OF NON-OBJECTIVE PAINTINGS

> *Fruit Bowl.* 1908. Oil, 25⅜ x 28¼″
> *Accordionist.* 1911. Oil, 51¼ x 35⅛″ (p. 75)
> *Landscape, Céret.* 1914. Oil, 25½ x 19¾″
> *Musician.* 1914. Oil, 25 x 19½″
> *Abstraction.* 1916. Collage, 18½ x 24½″
> *Abstraction.* 1918. Oil, 14 x 11″
> *Composition.* 1918. Oil, 13½ x 10½″
> *Lemon.* 1927. Oil, 7 x 5¼″

NORTHAMPTON, MASSACHUSETTS. SMITH COLLEGE MUSEUM OF ART

> *The Table.* 1919-20. Oil, 51 x 29⅝″ (p. 113)

OBERLIN, OHIO. THE DUDLEY PETER ALLEN MEMORIAL ART MUSEUM

> *Woman with Peplum.* 1923. Gouache, 8 x 6⅜″

PHILADELPHIA. PHILADELPHIA MUSEUM OF ART

> *Woman with Loaves.* 1905. Oil, 39 x 27½″ (p. 47)

> A. E. GALLATIN COLLECTION
> *Self Portrait.* 1906. Oil, 36 x 28″ (p. 51)
> Composition study for *Les Demoiselles d'Avignon.* 1907. Watercolor, 6¾ x 8¾″ (p. 56)
> *Bowls and Jug.* 1908. Oil, 32 x 25½″ (p. 64)
> *Pipe and Violin.* 1911. Oil, 22½ x 18″
> *Drawing.* 1912. Charcoal, 18 x 23″
> *Still Life with Fruit.* 1913. Collage and charcoal, 25½ x 19½″
> *Guitar and Bottle.* 1913. Pencil, 12 x 15¾″
> *Composition.* 1914. Watercolor and pencil, 7½ x 11¼″
> *Still Life.* 1914. Oil, 12 x 16¼″
> *Glass of Absinthe.* 1914. Painted bronze, 8¾″ high (p. 90)
> *Open Window.* 1919. Watercolor, 13¼ x 8¾″
> *Three Musicians.* 1921. Oil, 80 x 74″ (p. 123)
> *Composition.* 1922. Oil, 6¼ x 8½″
> *Still Life.* 1923. Oil, 32 x 29½″
> *Still Life.* 1924. Conté crayon with oil wash, 9¼ x 6¾″
> *Composition.* 1926. Ink and pastel, 12¼ x 18¼″
> *Dinard.* 1928. Oil, 9½ x 6½″
> Study for *Lysistrata* illustrations. 1934. Ink, 9½ x 13¾″

PROVIDENCE, RHODE ISLAND. MUSEUM OF ART, THE RHODE ISLAND SCHOOL OF DESIGN

> *Standing Nude.* 1905? Pencil, 24½ x 18 1/16″
> *Two Nudes.* 1923. Ink, 8½ x 7 13/16″

ROCHESTER, NEW YORK. MEMORIAL ART GALLERY

> *Flowers in a Blue Vase.* 1904? Gouache, 24¼ x 18½″

SAN FRANCISCO, CALIFORNIA. SAN FRANCISCO MUSEUM OF ART

> *Mother and Child.* "Blue" period. Oil, 35⅜ x 25⅛″. Extended loan
> *Still Life with Jug.* 1937. Oil, 19⅞ x 24″

ST. LOUIS, MISSOURI. CITY ART MUSEUM

> *The Mother.* 1901. Oil, 29½ x 20¼″
> *Nude.* 1907. Oil on panel, 14⅛ x 8½″
> *Mandolin and Vase of Flowers.* 1934. Oil, 32 x 39½″

TOLEDO, OHIO. TOLEDO MUSEUM OF ART

> *Woman with a Crow.* 1904. Gouache and pastel, 25⅝ x 19½" (p. 30)
> *Head of a Woman.* 1905. Gouache, 25⅛ x 19"

WASHINGTON, D. C. PHILLIPS MEMORIAL GALLERY

> *The Blue Room.* 1901. Oil, 20 x 24½" (p. 22)
> *Jester.* 1905. Bronze, 16¼" high (p. 38)
> *Woman.* 1918. Oil, 13¾ x 10½"
> *Studio Corner.* 1921. Watercolor, 8 x 10¼"
> *Bull Fight.* 1934. Oil, 19¾ x 25¾"

WORCESTER, MASSACHUSETTS. WORCESTER ART MUSEUM, Anonymous Extended Loan

> *Mother and Child.* 1901. Oil, 16 x 12¾"
> *The Watering Place.* 1905. Gouache, 14⅞ x 23" (p. 42)
> Also twelve drawings

Where Picasso has lived: a chronology

For the years 1881-1906 Christian Zervos' introduction to Volume I of his catalogue raisonné of Picasso's work (bibl. 524) is the principal authority. For subsequent years a list especially prepared by Henry Kahnweiler has proved indispensable.

A. H. B., JR.

1881 October 25th. Born in Malaga, Spain.

1891 Moves with parents to Corunna.

1896 Moves with parents to Barcelona; visits Madrid, 1896; Barcelona studio no. 8 calle Conde del Asalto, 1899-1900 (see note ¶, p. 252)

1900 Leaves Barcelona for visit to Paris (October-November), 49 rue Gabrielle.

1901 Madrid (January-May); Malaga; Barcelona; Paris (June-December?), 130ter Boulevard de Clichy; Barcelona.

1902 Barcelona (until August?); Paris (autumn), Hotel Champollion, rue Champollion; Hotel du Maroc, rue de Seine; Hotel Voltaire, Boulevard Voltaire; 33 Boulevard Barbès.

1903 Barcelona.

1904 Barcelona; Paris (spring), 13 rue Ravignan, now 13 Place Emile-Goudeau, where he lived until 1909.

Paris Addresses	Summer Vacations and Other Excursions
1905 13 rue Ravignan	Holland (summer, a few weeks).
1906 " " "	Gosol (summer).
1907 " " "	
1908 " " "	La Rue des Bois (Oise), near Amiens, (a few weeks, autumn).
1909 From 13 rue de Ravignan to 11 Boulevard de Clichy	Horta on the Ebro, Spain.
1910 " " "	Cadaqués, Spain.
1911 " " "	Céret, French Pyrenees.
1912 From 11 Boulevard de Clichy to 242 Boulevard Raspail	Sorgues sur l'Ouvèze (Vaucluse).

1913	To 5bis rue Schoelcher	Céret, French Pyrenees.
1914	" " "	Avignon (until August, then Paris).
1915	" " "	
1916	To 22 rue Victor Hugo, Montrouge (Seine) . .	
1917	" " " "	Rome, Naples, Florence (February for a month). Madrid, Barcelona (summer).
1918	From Montrouge to 23 rue la Boétie (October)	Biarritz.
1919	" " "	London (early summer); St. Raphaël (Var) (summer).
1920	" " "	Juan les Pins.
1921	" " "	Fontainebleau.
1922	" " "	Dinard.
1923	" " "	Cap d'Antibes (A.M.).
1924	" " "	Juan les Pins.
1925	" " "	Monte Carlo (spring); Juan les Pins.
1926	" " "	Juan les Pins.
1927	" " "	Cannes.
1928	" " "	Dinard.
1929	" " "	"
1930	" " "	Juan les Pins.
1931	" " "	" " "
1932	" " "	buys Château du Boisgeloup at Gisors (Eure).
1933	" " "	Cannes, Barcelona.
1934	" " "	Boisgeloup, San Sebastian, Madrid, Toledo, Escorial, Barcelona.
1935	" " "	Boisgeloup.
1936	" " "	Mougins (A.M.).
1937	" " "	"
1938	takes studio, 7 rue des Grands-Augustins, but lives at 23 rue la Boétie	"
1939	" " "	Antibes (summer). Royan, near Bordeaux (September until October, 1940).
1940	7 rue des Grands-Augustins	Royan (until October) with a visit to Paris in the spring.
1941-1945	7 rue des Grands-Augustins; also an apartment overlooking the Seine.	

Bibliography

This bibliography is a revised and much enlarged version of the one published in four editions of the catalog, *Picasso, Forty Years of His Art*, 1939. The original compilation was made by Beaumont Newhall, then Librarian, who used as basis the works of the bibliographers Bazin (37), Grohmann (200), Torre (171), and Scheiwiller (525), editing these and adding to them much new material. The bibliography, as it appears here, has all the original entries, augmented by an almost equal number of new references which round out the list and bring it up to date. Omitted are brief exhibition notices and non-critical statements that have appeared in American, European and Latin American newspapers and magazines. Every item, with the exception of thirteen marked †, has been examined by the compiler.

The arrangement is alphabetical, under the name of the author wherever possible. Unsigned magazine articles are listed under title with cross-reference from the name of the periodical. Catalogs of exhibitions in public museums are listed under the name of the city where the museum is located, while private exhibition galleries are listed under the name of the gallery.

ABBREVIATIONS. Ap *April*, Ag *August*, col *color(ed)*, D *December*, ed *editor(s, edition)*, F *February*, front *frontispiece*, il *illustration(s)*, Ja *January*, Je *June*, Jl *July*, Mr *March*, My *May*, n.d. *no date of publication*, n.p. *no place of publication*, n.s. *new series*, O *October*, p *page(s)*, por *portrait*, pseud *pseudonym*, pts *parts*, S *September*, sec *section*, ser *series*.

SAMPLE ENTRY and explanation for magazine article: LEWIS, WYNDHAM. Picasso. 5il Kenyon Review 2:196-211 Spring 1940. EXPLANATION. An article by Wyndham Lewis entitled "Picasso," including 5 illustrations, will be found in Kenyon Review, volume 2, pages 196 through 211, the Spring 1940 issue.

* indicates material in the Museum Library.

DOROTHY SIMMONS

Statements by Picasso

Note: These fall into the following four catagories:
a. Statements presumably written by Picasso himself. See 2a, 2b, 4.
b. Statements said to be approved by Picasso in interviews written by others following conversations with him. See 1, 3, 3a.
c. Statements apparently not reviewed or confirmed by Picasso following interviews. See 2, 3a, 4a, 196, 201, 379, 468.
d. Statements said to be rejected by Picasso as false. See 1a.

* 1 PICASSO SPEAKS. The Arts 3:315-26 My 1923
Forbes Watson, former editor of The Arts states (1939) that this interview was given in Spanish to Marius De Zayas, and that Picasso approved the manuscript before its translation into English. This interview is reprinted in Picasso, 2 statements. p3-21 New York, Los Angeles, Armitage, 1936. A French version, with additional paragraphs dealing with "Douanier" Rousseau, negro art, and literature, appeared in Florent Fels. Propos d'artistes. p139-45 Paris, Renaissance du Livre, 1925. German translations are to be found in Weltkunst no16 1930, and in Paul Westheim. Künstlerbekenntnisse. p144-7 Berlin, Propyläen-Verlag, 1925. A Czech version is in Volné Směry 24:27-8 1925-26. For a Spanish translation see 9 and 444. Reprinted in English in 194.
Reprinted in this volume, page 270.

1a [LETTER ON ART] Ogoniok (Moscow) no20 My 16 1926
Published without indication of source. Picasso says (1939) that the letter is spurious It has been republished in the following: Formes no2:2-5 1930; Deutsche Kunst und Dekoration 58:277-84 1926; Creative Art 6:383-5 Je 1930; Picasso, 2 statements. p23-49 New York, Los Angeles, Armitage, 1936; Europe, an American monthly F 1936.

* 2 CONVERSATION AVEC PICASSO. Cahiers d'Art 10:173-8 1935
An interview given to Christian Zervos. English translation in Myfanwy Evans, ed. The painter's object. p81-8 London, Howe, 1937. Spanish translation in Gaceta de Arte (Tenerife) ns no37:10-13 Mr 1936; Ars (Mexico) 1no4:21-3 Ap 1942; and 444. Reprinted in English in 194. Danish translation in 54a.
Reprinted in this volume, page 272.

2a [STATEMENT REJECTING THE FASCIST POSITION OF THE FRANCO REBELS] Jl 1937
Made at the time of the exhibition of Spanish war posters sponsored by the North American Committee to Aid Spanish Democracy and the Medical Bureau to Aid Spanish Democracy. Reprinted in 272.
Reprinted in this volume, pages 202 and 264.

* 2b [PICASSO TO AMERICAN ARTISTS CONGRESS] New York Times D 18 1937
Statement relayed from Switzerland by telephone. Reprinted in 272.
Reprinted in this volume, page 264.

* 3 POURQUOI J'AI ADHÉRÉ AU PARTI COMMUNISTE. 1il L'Humanité (Paris) 41no64:1-2 O 29-30 1944
An interview given to Pol Gaillard at the request of the magazine New Masses. English condensation of Picasso's statement in New Masses 53no4:11 O 24 1944. Reprinted in Angry Penguins (Melbourne) p4 1945. Quoted in part in Art Digest 19:11 N 1 1944.
Reprinted in this volume, page 267.

* 3a PICASSO EXPLAINS. 3il New Masses 54no11:4-7 Mr 13 1945
Interviews given to Jerome Seckler, the first of which was read and approved by Picasso before publication. French translation in Fraternité (Paris) 4no56:2 S 20 1945. Manuscript, giving a fuller account of both interviews, in the Museum Library.

* 4 PICASSO N'EST PAS OFFICIER DANS L'ARMÉE FRANÇAISE. 1il Lettres Françaises (Paris). Mr 24 1945
An interview given to Simone Téry, including a statement written by Picasso. Written statement reprinted in Pierre Courthion. Bonnard. p166 Lausanne, Marguerat, 1945; and in 88.
Reprinted in this volume, pages 247,248 (English), page 269 (French).

* 4a EN PEINTURE TOUT N'EST QUE SIGNE, NOUS DIT PICASSO. 1il Arts (Paris) no22:1,4 Je 29 1945
An interview given to André Warnod.
Reprinted in this volume, page 241.

Poetry by Picasso

* 5 CAHIERS D'ART 10:185-91, 225-38 1935
Commentary by André Breton and Jaime Sabartés. Two of these poems appeared in Gaceta de Arte (Tenerife) ns no37:17-19 1936.

* 6 CAHIERS D'ART 13no3-10:156-7 1938
Facsimile of a manuscript.

7 CONTEMPORARY POETRY AND PROSE (LONDON) 1no4-5 Ag-S 1936
"Picasso Poems Number." 6 poems translated by George Reavy.

DREAM AND LIE OF FRANCO. See 10, 355

* 8 LONDON BULLETIN no 15-16 My 15 1939
With English translation.

* 9 PICASSO, POEMAS Y DECLARACIONES. 45p 4il México, Darro y Genil, 1944

* 10 SUEÑO Y MENTIRA DE FRANCO. [Paris] 1937
Facsimile of manuscript, Spanish transcription, French translation. Published in folio with proofs of the etchings. English translation inserted. Etchings reproduced in Graphis (Zurich) 1 no11-12:385-5 O-D 1945, and in 355. English translation reprinted in 272.
Reprinted in this volume, page 196

Play by Picasso

10a LE DÉSIR ATTRAPÉ PAR LA QUEUE. 62p Paris, Gallimard, 1945. (Collection Métamorphoses XXIII)
First published in Messages II. [p1-20] 4il Paris, Risques, Travaux & Modes, 1944. Text dated Jan. 1941.

Literature on Picasso

* 11 ABBOTT, JERE. An abstract painting by Picasso [La table, 1920] 5il Smith College Museum of Art Bulletin no14:1-6 My 1933

* 11a ABRIL, MANUEL. De la naturaleza al espíritu. p153-6 1il Madrid, Espasa-Calpe, 1935.

* 12 ACTIVIDADES DE PICASSO. Tiempo (Mexico) 6no134:35 N 24 1944

ADLAN. See 15

AGAMEMNON, JEAN. See 269

* 12a AHLERS-HESTERMANN, FRIEDRICH. Pablo Picassos Modellierender Mann. 1il Freude (Lauenstein) 1:154-5 1920

* 13 AKSENOV, IVAN ALEKSANDROVICH. Picasso i okrestnosti. 64p 12il Moscow, Tsentrifuga, 1917
Text dated June 1914.

* 13a ALBERTI, RAFAEL. Picasso. Sur (Buenos Aires) 14no130:40-4 Ag 1945
A poem. Reprinted in the author's A la pintura, cantata de la línea y del color. p30-3 Buenos Aires, Imprenta López, 1945.

* 14 AMBLER, JAQUELIN. A 1934 Picasso "Still Life." 1il St. Louis City Art Museum Bulletin 20no1-2:5-9 Ap 1945

* 15 AMIGOS DE LAS ARTES NUEVAS, MADRID. Picasso. 16p 7il 1936
Exhibition catalog. Text by Guillermo de Torre.

* 16 ANTONIORROBLES. Picasso, el estilo y la chimenea. por Jueves de Excelsior (Mexico) Ag 24 1944

* 17 APOLLINAIRE, GUILLAUME. Il y a. p199-200 Paris, Messein, 1925
Poem, "Pablo Picasso."

* 18 —— Les jeunes; Picasso, peintre. 5il La Plume (Paris) 17:478-83 My 15 1905

19 —— Pablo Picasso. Sic (Paris) no17:[5] My 1917

* 20 —— Les peintres cubistes. 9e éd. p31-9 Paris, Figuière, 1913
English translation of the pages on Picasso in Little Review 9:41-6 Autumn 1922. A new translation by Lionel Abel in The cubist painters. p17-20 6il New York, Wittenborn, 1944.

21 —— Picasso et les papiers collés. Montjoie (Paris) p6 Mr 14 1913
Reprinted in Cahiers d'Art 7no3-5:117 1932.

—— See also 76, 88

* 22 ARAGON LOUIS. La peinture au défi. p11-12 3il Paris, Corti, 1930
Introduction to an exhibition of collages at Galerie Goemans, Paris.

—— See also 88

* 23 ARAI, ALBERTO T. Picasso, inventor de sentimientos. Letras de Mexico 4no22:4 O 1944

* 24 ARCHAMBAULT, G. H. Picasso . . . 8il por New York Times Magazine p18-19,39 O 29 1944

* 25 ARMITAGE, MERLE. Accent on America. p267-9 New York, Weyhe, 1944

* 26 ARNAUTOFF, VICTOR. Arnautoff and the critics discuss "Guernica." San Francisco Art Association Bulletin 6:3 S 1939

* 27 ARP, HANS AND NEITZEL, L. H. Neue französische Malerei. p9-10 4il Leipzig, Verlag der weissen Bücher, 1913

ART CHRONICLE. See 368

ART DIGEST. See 51, 82, 205, 214, 281, 367, 461

ART FRONT. See 364

ART NEWS. See 204a, 323a

ARTE Y PLATA. See 155

* 28 ART'S ACROBAT. col il Time 33no7:44-6 F 13 1939
On cover: color photograph of Picasso by Dora Maar.

29 ARTS CLUB OF CHICAGO. Catalogue of an exhibition of original drawings by Picasso. 6p 1il 1923

30 —— Catalogue of an exhibition of original drawings by Picasso, loaned by Wildenstein & Co. folder 1928

* 31 —— Catalogue of an exhibition of paintings by Pablo Picasso. folder 1il 1930

32 —— Exhibition of drawings by Pablo Picasso, loaned by Mr. Walter P. Chrysler, Jr., New York. folder 1il 1939

ARTWORK. See 470

AYRTON, MICHAEL. See 423

33 B., G. Un bilan: l'exposition Picasso [à la Galerie Georges Petit] 4il Amour de l'Art 13:246-7 1932

* 34 BARNES, ALBERT COOMBS. The art in painting. 3d ed. p357-8,369-73 4il New York, Harcourt, Brace, 1937.

BARON, JACQUES. See 137

BARR, ALFRED H., JR. See 310, 312-14, 317-21

35 BASLER, ADOLPHE. Fünfzehn Jahre Lügen. 3il Kunst und Künstler 26:143-7 1928

* 36 —— Pablo Picasso und der Kubismus. 5il Der Cicerone 13:237-44 1921
* Reprinted in Jahrbuch der Jungen Kunst 2:153-60 1921.

BATAILLE, GEORGES. See 137

* 37 BAZIN, GERMAIN. Pablo Picasso. In R. Huyghe, ed. Histoire de l'art contemporain; la peinture. p221-6 Paris, Alcan, 1935
Includes bibliography.

* 38 BEATON, CECIL. Six photographs of Picasso's studio. 6il Horizon (London) 11no61:48-9 Ja 1945

* 39 BEAUX-ARTS ET LA GAZETTE DES BEAUX-ARTS, PARIS. Les créateurs du cubisme. 2e éd. 32p il 1935. (Les étapes de l'art contemporain, V)
Exhibition catalog. Preface by Maurice Raynal, chronology by Raymond Cogniat.

* 40 BECKER, JOHN [ART DEALER] NEW YORK. Drawings and gouaches by Pablo Picasso. folder 1il [1930]
Exhibition catalog. Foreword by Frank Crowninshield.

41 BECKER, JOHN [PUBLISHER]. Dix reproductions [des oeuvres de Picasso] 10 col il New York, 1933

42 BELL, CLIVE. Matisse and Picasso. Athenaeum (London) no4698:643-4 My 14 1920
* Reprinted in 253. A revised version appeared in New Republic 22:379-80 My 19 1920; in Arts and Decoration 14:42,
* 44 1920; and in the author's Since Cézanne, p83-90 London, Chatto and Windus, 1922.

43 —— Picasso: aesthetic truth and futurist nonsense. Outlook 137:20-3 My 7 1924

44 —— Picasso's mind. New Statesman and Nation (London) 11:857-8 My 30 1936
* Reprinted in Living Age 350:532-4 Ag 1936.

* 45 BENET, RAFAEL. Picasso i Barcelona. 24il Art (Barcelona) no1:3-13 O 1933

46 BERDYAEV, NIKOLAI. Picasso. Sofia (Moscow) no3:57-62 1914

* 47 BERGAMÍN, JOSÉ. Francia y España: Toulouse-Lautrec y Picasso ("una furtiva lagrima"). Mañana (Mexico) p22,66 O 7 1944

—— See also 78

* 48 BERTRAM, ANTHONY. Pablo Picasso. 9p 24il New York, Studio, 1934

* 49 BEUCLER, ANDRÉ. Sur le précubisme de Picasso. 6il Formes no14:59-61 1931

50 BIDOU, HENRY. À propos de Picasso. Europe Nouvelle (Paris) 22:133 F 4 1939

* 51 BIGGEST CANVASES AT ROSENBERG GALLERIES. Art Digest 18:10 D 15 1943

52 BIGNOU GALLERY, NEW YORK. Picasso, early and late. folder 1941
Exhibition catalog.

53 —— Twentieth century French painters and Picasso. 14p il 1939
Exhibition catalog.

* 54 BILBO, JACK. Pablo Picasso; thirty important paintings from 1904 to 1943. 8p 30il London, Modern Art Gallery, 1945

54a BILLE, EJLER. Picasso, surrealisme, abstrakt kunst. p13-67 50il (1 col) por Copenhagen, Helios, 1945
Includes statements by Picasso (translated from 2) and remarks on his "Guernica."

* 55 BILLINGS, HENRY. The Picasso exhibition. 8il Magazine of Art 33:29-32 Ja 1940

* 55a BIRD, WILLIAM. Louvre council bars Picasso. New York Sun p33 N26 1937

BIRTLES, DORA. See 61

56 BISSIÈRE, ROGER. L'exposition Picasso [à la Galerie Rosenberg] 4il Amour de l'Art 2:209-12 1921

57 BLANCHE, JACQUES-ÉMILE. Les arts plastiques. p257-63 Paris, Éditions de France, 1931

57a —— Rétrospective Picasso. 6il Art Vivant (Paris) 162:333-5 Jl 1932

58 BLUNT, ANTHONY. A cubist father. Spectator (London) 153:484 O 5 1934

59 —— A new Picasso. Spectator (London) 156:15 Ja 3 1936

60 —— Picasso, 1930-1934. Spectator (London) 158:664 Ap 9 1937

61 —— Picasso unfrocked. Spectator (London) 159:584 O 8 1937
Discussion by Herbert Read, William Coldstream, Roland Penrose and Dora Birtles in same 159:636,687,747,804 O 15-N 5 1937.

* 62 BOSTON. MUSEUM OF MODERN ART. Picasso; Henri-Matisse. 4p 1938
Exhibition catalog.

* 63 BOYESEN, HJALMAR H. Story of Picasso. Saturday Review of Literature 27no53:14 D 30 1944

* 64 BRANSTEN, ELLEN H. The significance of the clown in paintings by Daumier, Picasso and Rouault. 5il Pacific Art Review 3:21-39 1944

* 65 BREESKIN, ADELYN D. Picasso, the greatest modern classicist. lil Prints 6:187-8 Ap 1936

* 66 BRENNER, ANITA. Picasso versus Picasso. 12il por New York Times Magazine p12-13 N 12 1939

* 67 BRETON, ANDRÉ. Picasso dans son élément. 45il Minotaure no1:9-29 1933

* 68 —— Le surréalisme et la peinture. p16-20 15il Paris, Éditions de la Nouvelle Revue Française, 1928
A new enlarged edition published by Brentano's, New York, 1945.

—— See also 5, 77, 171

* 68a BREYSIG, KURT. Eindruckskunst und Ausdruckskunst. p96-101 Berlin, Georg Bondi, 1927

* 69 BRIAN, DORIS. The Picasso annual, 1938. 2il Art News 37:8,19-20 N 12 1938

69a BRIZIO, ANNA MARIA. Ottocento novecento. passim il Torino, Unione Tipografico, 1939 (Storia universale del'arte, v.6)

* 70 BUCHHOLZ GALLERY, NEW YORK. Exhibition of paintings and drawings by Pablo Picasso from a private collection. 8p 2il 1945
Exhibition catalog.

* 71 —— Pablo Picasso, drawings & watercolors. 8p 10il [1940]
Exhibition catalog.

* 72 BULLIET, CLARENCE JOSEPH. The significant moderns. p48-54 17il New York, Covici-Friede, 1936

* 73 BURGER, FRITZ. Cézanne und Hodler. [3d ed.] p116ff 3il München, Delphin-Verlag, 1919

* 73a BURGI, SANDRO. Jeu et sincérité dans l'art. p33-49 Neuchâtel, Éditions de la Baconnière, 1943

BURLINGTON, NEW, GALLERIES, LONDON. See 306

74 BURY, ADRIAN. Oil painting of to-day. 136p il London, Studio, 1938.
"Matisse and Picasso" p18-20.

74a BUYS, H. Picasso en zijn invloed op de bouwkunst. 10il Elsevier's Geïllustreerd Maandschrift (Amsterdam) 97:1-9 1939

75 CABOT, JUST. Picasso al Museu d'Art de Catalunya. 19il Butlleti dels Museus d'Art (Barcelona) 7:298-306 O 1937

* 76 CAHIERS D'ART 7no3-5:85-196 1932
Special Picasso number, with 157 illustrations and text by Zervos, Salmon, Apollinaire, Strawinsky, Guéguen, Hugnet, Ramón Gómez de la Serna, Cocteau, J. J. Sweeney, H. S. Ede, Carl Einstein, Oskar Schürer, Will Grohmann, Maud Dale, Vicente Huidobro, Giovanni Scheiwiller, and others.

* 77 CAHIERS D'ART 10no7-10:145-261 1935
Special Picasso number on works of the years 1930-35, with 92 illustrations and text by Zervos, Eluard, Breton, Péret, Man Ray, Dali, Hugnet, Sabartés, Louis Fernández, Julio González, Joan Miro.

* 78 CAHIERS D'ART 12no4-5:105-56 1937
Special Picasso number on his painting "Guernica," with 69 illustrations, and text by Zervos, Cassou, Duthuit, Mabille, Eluard, Leiris, Bergamín.

* 79 CAHIERS D'ART 13no3-10:73-80 1938
Special Picasso number, with 120 illustrations, an article by Zervos, and a poem by Paul Eluard.

* 80 CAHIERS D'ART 15-19 1940-1944
Special Picasso number, with 58 illustrations, an article by Jacques Prévert, and two poems on Picasso.

* 81 CALLERY, MARY [MERIC]. Last time I saw Picasso. 4il (1 col) Art News 41:21-3 Mr 1 1942

CALLERY COLLECTION. See 348

* 82 CALLING PICASSO; ENTRY PERMIT TO MEXICO. Art Digest 15:12 My 15 1941

* 83 CAMBRIDGE, MASS. FOGG ART MUSEUM. Masters of four arts: Wright, Maillol, Picasso, Strawinsky. p16-18 1il 1943
Exhibition catalog.

CAMERA WORK. See 154

* 84 ČAPEK, JOSEF. Hommage à Picasso. 1il Review-43 (London) 1no1:41-4 Spring 1943
Translated by M. Weatherall. A Spanish version with 9il in
* Revista Belga (New York) 2no9:36-47 S 1945.

* 85 CARCO, FRANCIS. Le nu dans la peinture moderne (1863-1920). p77-88 1il Paris, Crès, 1924

86 CAREW, KATE. The American studies "sublime elementalism" in the presence of no less lofty a post-impressionist than Picasso . . . 2il por New-York Tribune 72sec6:4 Ap 6 1913
Reprinted in part under title Interviewing a cubist, in Literary Digest 46:890-2 Ap 19 1913.

* 87 CARRÀ, CARLO. Picasso. Valori Plastici (Rome) 2no9-12:101-7 1920
* French translation in the author's Le néoclassicisme dans l'art contemporain. p54-9 Rome, Valori Plastici, 1923.

——— See also 102

88 CARRÉ, LOUIS, ed. Picasso libre, 21 peintures, 1940-1945. 63p 21il Paris, Louis Carré, 1945
Publication issued at the time of the exhibition, "Picasso, peintures récentes," at the Galerie Louis Carré. Text includes poems by Paul Eluard, "Souvenirs" by Jaime Sabartés, extracts from the writings of Félicien Fagus, Guillaume Apollinaire, Jean Cocteau, Christian Zervos, Aragon, Jean Cassou, as well as statements by Picasso.

89 CARRÉ, LOUIS, GALERIE, PARIS. Picasso, peintures récentes; exposition organisée au profit des Oeuvres de secours du Comité France-Espagne. folder 1945.
Exhibition catalog.

90 CARTER, HUNTLY. The Plato-Picasso idea. il New Age ns10:88 N 23 1911

* 91 CASSOU, JEAN. Derniers dessins de Picasso. 6il Cahiers d'Art 2:49-54 1927
German translation in 165.

* 92 ——— Paysages de Picasso. 11il Prométhée (Paris) no3:35-42 Mr 1939
* Translation condensed in French Digest (Concord, N. H.) 1no1:34-5 Mr-Ap 1940.

* 93 ——— Picasso. 64p 62il Paris, Braun, 1937
Text in French, English and German.

* 94 ——— Picasso; translated . . . by Mary Chamot. 167p 146il (16 col) New York, Hyperion Press, 1940
Bibliography, p161-4.

* 95 ——— Rétrospectives. 2il Cahiers d'Art 1:21-2 1926

96 ——— Les solitudes de Picasso. 28il Renaissance de l'Art Français 21:2-14, 49 Ja 1939
With English summary.

——— See also 78, 88

96a CASTELFRANCO, GIORGIO. La pittura moderna. p63-7, 78-80 9il Firenze, Luigi Gonnelli, 1934.

97 CENDRARS, BLAISE. Aujourd'hui. p112-15 Paris, Grasset, 1931

* 98 CHARENSOL, GEORGES. Pablo Picasso. 6il Renaissance de l'Art Français 15:142-6 Jl 1932

99 —— Picasso et l'Espagne. 10il Art Vivant (Paris) 7:142-5 Ap 1931

* 100 CHICAGO. ART INSTITUTE. Twentieth century French paintings from the Chester Dale collection. 62p il 1943
 8 illustrations of Picasso's work.

CHRYSLER COLLECTION. See 405

101 CHURCHILL, ALFRED VANCE. Picasso's "failure." Forum (New York) 73:776-83 Je 1925

CICERONE. See 515

102 CINQUANTA DISEGNI DI PABLO PICASSO (1905-1938). Con scritti di Carlo Carrà, Enrico Prampolini, Alberto Savinio, Gino Severini, Ardengo Soffici. 28p 50il por Novara, Posizione, 1943

103 CLARK, KENNETH. Recent paintings by Picasso now on exhibition at Rosenberg and Helft's. 2il The Listener 21:517-18 Mr 9 1939

* 104 CLARK, VERNON. Guernica mural—Picasso and social protest. Science & Society 5nol:72-8 Winter 1941

* 105 COCTEAU, JEAN. Ode à Picasso. 65p Paris, Bernouard, 1919
 Reprinted in the author's Poésie 1916-1919. p281-8 Paris, Gallimard, 1927; also in his Morceaux choisis. p65-72 Paris, Gallimard, 1932.

* 106 —— Picasso. 32p 16il Paris, Stock, 1923
 Reprinted in 107a.

* 107 —— Picasso, a fantastic modern genius. 4il Arts and Decoration 22:44,72-4 D 1924

107a —— Le rappel à l'ordre. p273-96 Paris, Stock, 1926
*
 English translation: A call to order. p223-48 London, Faber and Gwyer, 1926.

—— See also 76, 88

CODOLÁ. See RODRIGUEZ CODOLÁ, MANUEL

* 108 COGNIAT, RAYMOND. Décors de théâtre. 11il Paris, Chroniques du Jour, 1930
 List of ballets with décors by Picasso on unnumbered pages at end of book.

109 —— Picasso et la décoration théâtrale. 5il Amour de l'Art 9:299-302 1928

* 109a —— Problème du jour: le cubisme et Picasso. Arts (Paris) no22:1,4 Je 29 1945

—— See also 39

COLDSTREAM, WILLIAM. See 61

* 110 [CONTROVERSY OVER THE EXHIBITION OF WORKS BY PICASSO AND MATISSE AT THE VICTORIA AND ALBERT MUSEUM, LONDON] The Times (London) D 15-20 1945
 Includes letters from John Pollock, H. H. Bashford, Thomas Bodkin, D. S. MacColl, Harman Grisewood, Evelyn Waugh, Feliks Topolski, and others. Further discussion in Saturday Evening Post (London) and Daily Telegraph (London) of the same period. Includes letters from John Coldstream, J. C. Johnstone, Holger Holst, and others. Article, prompted by public reaction to exhibition, in Daily Sketch (London) D 31 1945 under title, "Picasso and the itch for persecution."

* 110a COQUIOT, GUSTAVE. Cubistes, futuristes, passéistes. 3e éd. p145-50 1il Paris, Ollendorff, 1914

* 111 —— Les indépendants. 4e éd. p160-1 1il Paris, Ollendorff [after 1920]

* 112 CORTISSOZ, ROYAL. Portrait of Picasso. Art Digest 15:6 D 15 1940

113 COSSIO DEL POMAR, FELIPE. Con los buscadores del camino. Gandhi, Rolland, Picasso, Papini, Unamuno, Ferrero, Bourdelle. p105-32 Madrid, Ulises, 1932

* 113a —— Nuevo arte. p119-23 3il Buenos Aires, "La Facultad", 1934
 Second edition published by Editorial America, Mexico, 1939.

* 113b —— La rebelion de los pintores. 346p il Mexico, Editorial Leyenda, 1945
 "El proceso del arte Picassiano" p230-46 1il.

114 COURTHION, PIERRE. Couleurs. p97-104 Paris, Éditions des Cahiers Libres, 1926

115 —— La obra de Pablo Picasso. 7il Revista Española de Arte (Madrid) 2:338-47 Je 1933

115a —— Quelques aspects d'Eluard et de Picasso. Labyrinthe (Geneva) 1no9:5 Je 15 1945

* 116 —— Le visage de Matisse. 135p il Lausanne, J. Marguerat, 1942
"Matisse et Picasso" p89-101.

* 117 COURVILLE, XAVIER DE. Les décors de Picasso aux Ballets russes. Revue Musicale (Paris) 2:187-8 F 1921

* 118 COUTURIER, MARIE-ALAIN. Art et catholicisme. 92p Westmount, Montréal, Éditions de l'Arbre, 1941
"Picasso et les catholiques" p73-82.

119 —— Picasso and ourselves. Commonweal 33no17:419-21 F 14 1941
Discussion in same 33no20:495-6 Mr 7 1941.

120 —— Picasso and the *Normandie*. Commonweal 35no20:479-80 Mr 6 1942

* 121 CRAVEN, THOMAS. Modern art. p177-92 2il New York, Simon and Schuster, 1934

* 122 —— Picasso waning? Art Digest 9:9 N 15 1934

* 123 CRESPO DE LA SERNA, JORGE J. Algunos cuadros de la exposición de Picasso. Excelsior (Mexico) Ag 6 1944

* 124 CROWNINSHIELD, FRANK. The case of Pablo Picasso. col il Vogue 89no11:108,112 Je 1 1937

* 125 —— The gourmet, by Picasso. 1il Vanity Fair 37:48-9 O 1931

—— See also 40

* 126 DALE, MAUD. Picasso. 8p 62il New York, Knopf, 1930

—— See also 76

DALI, SALVADOR. See 77

127 DALY, D. Pablo Ruiz Picasso. 1il Rhode Island School of Design Bulletin 23no4:62-4 O 1935

* 128 DANZ, LOUIS. Personal revolution and Picasso. 165p front New York, Longmans, Green, 1941
Entire work deals with "Guernica."

* 129 DASBURG, ANDREW. Cubism—its rise and progress. 4il The Arts 4:278-84 N 1923

130 DÄUBLER, THEODOR. Picasso. 1il Lacerba (Florence) 2no9:129-34 My 1 1914

* 131 DAVIDSON, MARTHA. Second annual Picasso festival. 4il Art News 36:10-11,22 N 6 1937

* 132 DELMAS, GLADYS. French art during the occupation: Picasso. Magazine of Art 38no3:84-6 Mr 1945

133 DEMOTTE GALLERIES, NEW YORK. Pablo R. Picasso, catalogue of an exhibition of paintings. 4p 6il 1931

* 133a DERI, MAX. Die neue Malerei. p44-51 4il Leipzig, E. A. Seemann, 1921

* 134 DESHAIRS, LÉON. Pablo Picasso. 12il Art et Décoration 47:73-84 1925

* 135 DESNOS, ROBERT. Picasso: seize peintures, 1939-1943. 6p 16 col plates Paris, Éditions du Chêne, 1943

—— See also 137

136 DE ZAYAS, MARIUS. Pablo Picasso. 1911
A pamphlet distributed at the Photo-Secession Gallery. New York, at the time of the first American Picasso exhibition. Reprinted in Camera Work no35-6:65-7 1911.
*

—— See also 1

* 137 DOCUMENTS (Paris) 2no3:113-84 1930
Special Picasso issue, with 57 illustrations, and texts by Jacques Baron, Georges Bataille, Robert Desnos, Carl Einstein, Maurice Heine, Eugène Jolas, Marcel Jouhandeau, Edouard Kasyade, Michel Leiris, Camille Mauclair, Marcel Mauss, Georges Monnet, Léon Pierre-Quint, Jacques Prévert, Charles-Henri Puech, Dr. Reber, Georges Ribémont-Dessaignes, Georges Henri Rivière, André Schaeffner, Roger Vitrac. "Notice documentaire," a chronology, p180-2.

138 DODGE, JOSEPH J. Boy holding a blue vase. 1il Art Quarterly 6no3:226-7+ 1943

* 139 DODICI OPERE DI PICASSO. 12il Firenze, Libreria della Voce, 1914

* 139a DOLIN, ANTON. Divertissement. p65,80 por London, Sampson Low, Marston, 1931

* 140 DREIER, KATHERINE S. Western art and the new era. p81-4 2il New York, Brentano's, 1923

140a DREYFUS, ALBERT. Picasso (1922). 6il Der Querschnitt (Berlin) 3no1-2:56-9 Summer 1923

DUDENSING, VALENTINE. See 480

DUTHUIT, GEORGES. See 78, 535

* 141 EARP, T. W. The modern movement in painting. p28-34 2col il London, Studio, 1935

141a —— The Picasso exhibition [at Alex. Reid & Lefevre Galleries, London] 2il Apollo 14:40-2 1931

142 ECK, G. VAN. Picasso. 6il Maandblad voor Beeldende Kunsten (Amsterdam) 12:210-17 1935

* 143 EDDY, ARTHUR JEROME. Cubists and post-impressionism. p67-8,98-101,123 4il Chicago, McClurg, 1919, c1914

EDE, H. S. See 76

* 144 EINSTEIN, CARL. Die Kunst des 20. Jahrhunderts. [2d ed.] p68-87 41il Berlin, Propyläen-Verlag, 1926

* 145 —— Pablo Picasso: quelques tableaux de 1928. 13il Documents (Paris) 1:35-47 Ap 1929

146 —— Picasso. Neue Schweizer Rundschau (Zurich) 21no4:266-73 1928

147 —— Picasso, anlässlich der Ausstellung in der Galerie Georges Petit. 6il Weltkunst (Berlin) 7:1-2 Je 19 1932

—— See also 76, 137

148 ELUARD, PAUL. À Pablo Picasso. 168p 99il (8 por) Genève-Paris, Éditions des Trois Collines, 1944. (Collection Les grandes peintres par leurs amis)
Poetry and prose.

149 —— Donner à voir. p209-13 Paris, Gallimard, 1939
"À Pablo Picasso," poem.

150 —— Thorns of thunder; selected poems. p20 London, Europa Press & Stanley Nott [n.d.]
"Pablo Picasso," poem translated by George Reavy.

—— See also 77-9, 88, 171, 535

* 151 ENTERS, ANGNA. Picasso and John Marin (notes from my journal) Twice a Year 5-6:288-94 Fall 1940-Summer 1941

* 151a EPSTEIN, JACOB. The sculptor speaks. p103-5 Garden City, New York, Doubleday, Doran, 1932

152 ESTIVILL, ANGEL. Picasso en Barcelona! 3il La Noche (Barcelona) 13no319:16-17 Ja 17 1936

* 152a ESTRADA, GENARO. Genio y figura de Picasso. 61p por México, Imprenta Mundial, 1936

* 153 EVANS, MYFANWY. Beginning with Picasso. 4il Axis no2:3-5 1935

—— See also 2

* 154 EXHIBITION AT "291." 1il Camera Work 36:29-68 1911

155 EXPOSICIÓN PICASSO, SOCIEDAD DE ARTE MODERNO. 2il Arte y Plata (Mexico) p26-8 S 1944

156 FAGUS, FÉLICIEN. L'invasion espagnole; Picasso. Revue Blanche (Paris) 25:464-5 1901
* Reprinted in Cahiers d'Art 7:96 1932.

—— See also 88

157 FARGE, ADRIEN. [Preface to catalog of Picasso exhibition at B. Weill gallery, Paris] 1902
* Reprinted in Cahiers d'Art 7:96 1932.

* 158 FAURE, ELIE. Les dessins de Picasso. 2il Feuillets d'Art (Paris) no6:267-70 S 1922

* 158a —— Peinture d'aujourd'hui. 5il Cahiers d'Art 1:24-7 1926

159 FAY, BERNARD. Portrait de Picasso. 6il Transatlantic Review (Paris) 1no6:489-91 Jl 1924

FELS, FLORENT. See 1

* 160 FERNÁNDEZ, JUSTINO. Prometeo; ensayo sobre pintura contemporánea. 219p il México, Editorial Porrua, 1945
"Picasso y Braque" p25-8. "Picasso" p77-103 15il.

FERNÁNDEZ, LOUIS. See 77

160a FIERENS, PAUL. Influence de Picasso sur le décor moderne. 9il Art et Décoration 61:269-78 1932

161 —— Notes sur Picasso. Le Flambeau (Brussels) 12:288-305 1929

* 162 —— Picasso and the human figure. 2il XXe Siècle no5-6:39-40 1939

163 FISHKIN, R. M. Cézanne, Rousseau, Picasso. 1il Chicago Art Institute Bulletin 20:62-4 My 1926

* 164 FLANNER, JANET. One-man group. New Yorker 15:32-7 D 9 1939

* 165 FLECHTHEIM, ALFRED, GALERIE, BERLIN. Pablo Picasso; Zeichnungen, Aquarelle, Pastelle, 1902-1927. 16p 13il 1927
Exhibition catalog. The text is a translation of 91.

166 FLETCHER, RICHARD. The new Picassos. 3il Drawing and Design ns2:170-8 1927

167 FOLCH I TORRES, JOAQUIM. Dibuixos d'en Picasso a la col.lecció Junyent. 6il Gaseta de les Arts (Barcelona) no8:1 1924

* 168 FRANKFURTER, ALFRED M. Picasso in retrospect: 1939-1900. 43il Art News 38:10-21,26-30 N 18 1939

* 169 ——The triple celebration of Picasso. 11il Art News 35:10-14 O 31 1936

* 169a FRY, JOHN HEMMING. Art décadent; sous le règne de la démocratie et du communisme. p33, 48-9 2il Paris, Librairie de l'Alma, 1940

170 FRY, ROGER. Picasso. New Statesman (London) 16:503-4 Ja 29 1921

170a FURST, HERBERT. Guernica, exhibited at the New Burlington Galleries. Apollo 28:266 N 1938

170b —— Picasso; or are we all drunk? 1il Apollo 29:204-5 Ap 1939

* 170c —— Picasso s'en va-t-en guerre. Apollo 41:94-5 Ap 1945

* 171 GACETA DE ARTE (Tenerife) ns no37 1936
Special Picasso issue, with 12 illustrations and text by Picasso, Breton, Ramón Gómez de la Serna, Eluard, Guillermo de Torre, Eduardo Westerdahl, José de la Rosa, J. Moreno Villa. Bibliography by Guillermo de Torre.

* 172 GAGNON, MAURICE. Pablo Picasso—Fernand Léger. *In* Fernand Léger; la forme humaine dans l'espace. p27-35 Montréal, Éditions de l'Arbre, 1945

GAILLARD, POL. See 3

GALLATIN, A. E., COLLECTION. See 309

173 GASCH, SEBASTIÁ. Picasso. Gaceta Literaria (Madrid) 4no95:7 D 1 1930

174 —— Picasso i impressionisme. Gaseta de les Arts (Barcelona) no42:3 1926

* 175 GASSOL, VENTURA. Hallucination. Formes et Couleurs (Lausanne) 6no2:69-70 1944
A poem dedicated to Picasso.

* 176 GAUNT, WILLIAM. Picasso and the cul-de-sac of modern painting. 7il Atelier 1 (Studio 101): 408-16 Je 1931

* 177 —— Whither Picasso? 10il London Studio 17 (Studio 117):12-21 Ja 1939

178 GAUTHIER, MAXIMILIEN. Notices bio-bibliographiques des peintres figurant à l'exposition de l'Art vivant: Pablo Picasso. 4il Art Vivant (Paris) 6:410 My 15 1930

* 179 GEISER, BERNHARD. Picasso, peintre-graveur; catalogue illustré de l'oeuvre gravé et lithographié, 1899-1931. 365p 257il Berne [Author] 1933

* 180 GEORGE, WALDEMAR. Aut Caesar aut nihil—reflections on the Picasso exhibition at the Georges Petit Galleries. 12il Formes no25:268-71 1932

* 181 —— Les cinquante ans de Picasso, et la mort de la nature-morte. 3il Formes no14:56 Ap 1931

* 182 —— Fair play: the passion of Picasso. 12il Formes no4:8-9 1930

183 —— Grandeur et décadence de Pablo Picasso. 12il Art Vivant (Paris) 6:593-7 1930

184 —— Picasso. 12p 33il Rome, Valori Plastici, 1924
Text in English.

* 185 —— Picasso, dessins. 15p 64il Paris, Éditions des Quatre Chemins, 1926
The text appeared in Amour de l'Art 7:189-93 1926.

186 —— Picasso et la crise actuelle de la conscience artistique. 5il Chroniques du Jour no2:3-10 Je 1929

* 187 GEORGES-MICHEL, MICHEL. Chefs d'oeuvre de peintres contemporains. p[168-76] 5il por New York, Éditions de la Maison Française, 1945
A brief poem with text in French and English.

* 187a —— Les grandes époques de la peinture "moderne." p166-74 8il New York, Brentano's, 1945

* 188 —— Peintres et sculpteurs que j'ai connus, 1900-1942 . . . p11-31 2il New York, Brentano's, 1942

* 189 GIEDION, SIGFRIED. Space, time and architecture. passim 3il Cambridge, Harvard University Press, 1941
"Picasso's Guernica" p369-70.

* 190 GIEDION-WELCKER, CAROLA. Modern plastic art. passim 6il Zürich, Dr. H. Girsberger, 1937

* 190a —— Picasso–Poet und Revolutionär. 10il Das Werk (Winterthur) 32no4:113-23 Ap 1945

191 GILLET, LOUIS. Un peintre espagnol à Paris. Revue des Deux Mondes (Paris) ser8 40:562-84 1937

* 191a GISCHIA, LEON AND VÉDRÈS, N. La sculpture en France depuis Rodin. 182p il Paris, Éditions du Seuil, 1945
"La sculpture des peintres" p145-8 3il.

* 192 GOLDWATER, ROBERT J. Picasso, forty years of his art. Art in America 28:43-4 Ja 1940

* 193 —— Primitivism in modern painting. p118-25 10il New York, Harper, 1938

* 194 —— AND TREVES, MARCO, ed. Artists on art. p416-21 por New York, Pantheon Books, 1945
Includes statements of Picasso reprinted from 1 and 2.

195 GÓMEZ DE LA SERNA, RAMÓN. Completa y verídica historia de Picasso y el cubismo. 21il Revista de Occidente (Madrid) 25:63-102, 224-50 Jl-Ag 1929
English translation in Living Age 327:627-32 Ja 15 1930. Reprinted with slight variation in the author's Ismos. p39-107 25il Buenos Aires, Editorial Poseidón, 1943. Published, with some omissions and 51il, under the original title, by Chiantore, Turin, 1945. An Italian translation by G. M. Bertini is inserted.

—— See also 76, 171

* 196 GONZALES, XAVIER. Notes from Picasso's studio. New Masses 53no12:24-6 D 19 1944

* 197 GONZALEZ, JULIO. Picasso sculpteur; exposition de sculptures récentes de Picasso. 8il Cahiers d'Art 11no6-7: 189-91 1936

—— See also 77

* 198 GORDON, JAN. Modern French painters. passim 2il (1 col) New York, Dodd, Mead, 1923

* 199 GRAHAM, JOHN D. Primitive art and Picasso. 8il Magazine of Art 30:236-9 Ap 1937

GREENE, BALCOMB. See 364

200 GROHMANN, WILL. [Biographical sketch, with list of principal works, and bibliography] In U. Thieme and F. Becker, ed. Allgemeines Lexikon der bildenden Künstler 27:576-8 Leipzig, Seemann, 1932

—— See also 76

* 201 GROTH, JOHN. Studio: Europe. 282p il New York, Vanguard Press, 1945
"Picasso and the artists" p151-65. Portion originally published in Museum of Modern Art Bulletin (312). Another
* version entitled, Letter from Paris, in Art Digest 19no5:9 D 1 1944. Includes statements attributed to Picasso.

202 GRUYTER, W. JOS. DE. Moderne fransche schilderkunst; het cubisme en Picasso. 10il Elsevier's Geïllustreerd Maandschrift (Amsterdam) 75:314-29 1928

* 203 GUÉGUEN, PIERRE. Picasso et le métapicassisme. 2il Cahiers d'Art 6:326-9 1931

—— See also 76

GUERNICA. See 26, 54a, 78, 104, 113b, 128, 160, 169a, 170a, 187a, 188, 189, 204, 204a, 205, 206, 214, 222, 231, 243, 258, 261b, 272, 275, 276, 283, 293, 306, 320, 321, 326, 337, 396, 444, 453, 471, 482, 535

* 204 GUERNICA AND 59 STUDIES. 1il Columbus Gallery of Fine Arts Bulletin 12no2:[2] N 1941

* 204a GUERNICA AND STUDIES IN A BENEFIT EXHIBIT. 1il Art News 37no34:12 My 20 1939

* 205 GUERNICA MISSES THE MASSES, BUT WINS THE ART CRITICS. 1il Digest 13no16:11 My 15 1939

GUGGENHEIM, PEGGY. See 308

205a GUILLAUME, JULIETTE PAUL. Les papiers collés de Picasso. 1il Renaissance de l'Art Français 21:15-16 Ja 1939

* 206 H. . . . Guernica. 13il Volné Směry (Prague) 34no1-2:54-6+ 1937-38

* 207 HAESAERTS, PAUL. Picasso et le goût du paroxysme. 17p 35il Anvers, Het Kompas; Amsterdam, De Spieghel, 1938

* 207a HAM, DICK. Picasso; how an American in Paris photographed a celebrated artist. 4 por U. S. Camera 9no3:16-17 Ap 1946

* 208 HAMNETT, NINA. Laughing torso; reminiscences. 326p il London, Constable, 1932

* 209 HANNOVER. KESTNER-GESELLSCHAFT. Schlemmer und Picasso. 7p il 1932
Exhibition catalog.

HARPER'S BAZAAR. See 367a

* 210 HARRIMAN, MARIE, GALLERY, NEW YORK. Figure paintings, Picasso. folder 1939
Exhibition catalog.

* 210a HARRISON, GWEN. L'affaire Picasso. 2il por Maelström (Florida) 1no2:13-15 Summer 1945

* 211 HARTFORD, CONN. WADSWORTH ATHENEUM. Pablo Picasso. 15p 35il 1934
Exhibition catalog.

* 212 HARVARD SOCIETY FOR CONTEMPORARY ART, CAMBRIDGE, MASS. Metamorphoses of P. Ovidius Naso; drawings, copper plates, etchings, artist's proofs by Pablo Ruiz Picasso. 4p 1932
Exhibition catalog.

* 213 —— Picasso. 4p 1931
Exhibition catalog.

* 214 HARVARD VIEWS GUERNICA. Art Digest 16:10 O 15 1941

* 215 HAUSENSTEIN, WILHELM. Gespräch über Pablo Picasso. 2il Ganymed (Munich) 4:288-92 1922

216 HEILMAIER, HANS. Anmerkungen zu Pablo Picasso. 5il Deutsche Kunst und Dekoration 68:76-80 1931

217 —— Ein Meister heutigen Malerei: zur grossen Picasso-Ausstellung in Paris. 10il Deutsche Kunst und Dekoration 70:301-8 1932
Spanish translation in Revista de Arte (Santiago de Chile) 2no8:18-25 1936.

HEINE, MAURICE. See 137

218 HENNION, MARION G. There's a divinity that shapes our ends . . . [Exhibition, Museum of Modern Art] Catholic World 150:735-7 Mr 1940

HENRY, DANIEL [pseud] See KAHNWEILER, HENRY

HEUTE. See 356a

219 HILDEBRANDT, HANS. Die Frühbilder Picassos. 3il Kunst und Künstler 11:376-8 1913

* 219a —— Die Kunst des 19. und 20. Jahrhunderts. passim 4il (1 col) Wildpark-Potsdam, Athenaion, 1924

* 220 HILL, RUSSELL. Picasso paints and waits. New York Herald Tribune p10 F 24 1945

* 221 HIND, CHARLES LEWIS. Art and I. p160-6 London, J. Lane, 1921

222 HINKS, R. Guernica. Spectator (London) 161:712 O 28 1938

222a HOPPE, RAGNAR. Fransk genombrottskonst under nittonhundratalet. lil Ord och Bild (Stockholm) 40:527-43 1931

223 HORTER, EARL. Picasso, Matisse, Derain, Modigliani. 4p 38 plates Philadelphia, H. C. Perleberg, 1930

* 223a HUGNET, GEORGES. Le génie et ses loisirs. 2il Vrille (Mantes) p[20-1] Jl 1945

—— See also 76-7, 314

HUIDOBRO, VICENTE. See 76

224 HUNEKER, JAMES GIBBONS. The pathos of distance. 394p New York, Scribner's, 1913
"Matisse, Picasso, and others" p125-60.

* 224a HUYGHE, RENÉ. Histoire de l'art contemporain; la peinture. passim il Paris, Alcan, 1935

* 225 IHARA, U. Picasso. 9p 37il Tokio, Atelier-Sha, 1936
Text and index in Japanese.

* 226 ISAACS, HERMINE RICH. Picasso and the theatre. 6il Theatre Arts 23:902-8 D 1939

ISEDA, USABURO. See 366

* 227 JACOB, MAX. Souvenirs sur Picasso. 4il Cahiers d'Art 2:199-202 1927
Also published in Volné Směry (Prague) 25no6:134-8 1927.

228 JACOBSEN, GEORG. Picasso. 7il Kunst og Kultur (Oslo) 24:1-14 1938

229 JAHAN, PIERRE. Picasso. 3il por Art et Style 1:14-17 F 1945

230 JANIS, HARRIET. A clarification? 1il National Academy of Design Bulletin 2:12 Ap 1937

* 231 JANIS, SIDNEY and JANIS, HARRIET. Picasso's Guernica—a film analysis. il Pacific Art Review 1no3-4:14-23 1941.
* Reply by Frederic Taubes in same 2no1-2:4-6 1942; Rejoinder in 2no3-4:57-64 1942.

* 232 JANNEAU, GUILLAUME. L'art cubiste. 111p il Paris, C. Moreau, 1929

* 233 JEDLICKA, GOTTHARD. Begegnungen: Künstlernovellen. p181-213 por Basel, Benno Schwabe, 1933

* 234 —— Picasso. 74p Zürich, Oprecht & Helbling, 1934
 A lecture at the Zürich Kunsthaus, Oct. 1932. Reprinted in part, with 3il (1 por), in Werk (Winterthur) 32no4:125-8 Ap 1945.

* 235 JEWELL, EDWARD ALDEN. Stature of Modern Art's proteus. 4il New York Times secX:9 N 19 1939

* 236 JOHNSON, UNA E. Ambroise Vollard, editeur, 1867-1939; an appreciation and catalogue. p23-5,105-14 4il New York, Wittenborn, 1944

JOLAS, EUGÈNE. See 137

JOUHANDEAU, MARCEL. See 137

237 JUNG, CARL G. Picasso [psychoanalyzed] Neue Zürcher Zeitung N 13 1932
 Partial translation, with comment by Zervos, in Cahiers d'Art 7no8-10:352-4 1932. A Spanish version in Revista de Occidente (Madrid) 12no131:113-22 My 1934.

238 JUNOY, JOSÉ. Arte & artistas. p69-75 3il Barcelona, "L'Avenç," 1912

* 239 JUSTI, LUDWIG. Von Corinth bis Klee. p155-64 1il Berlin, Bard, 1931

* 240 [KAHNWEILER, HENRY] Der Weg zum Kubismus, von Daniel Henry [pseud] p15-46 20il München, Delphin-Verlag, 1920

KASYADE, EDOUARD. See 137

* 241 KATZ, LEO. Understanding modern art. 2:496-507 12il [Chicago] Delphian Society, 1936

* 242 KAYSER, STEPHEN S. The revolution of still life. 2il Pacific Art Review 1no2:16-28 1941

* 242a KENT, ROCKWELL. That ivory tower. New Masses 55no1:17 Ap 3 1945
 An attack on Picasso prompted by the Seckler interview (3a). Readers' reaction and discussion in same 55no3:17 Ap 17 1945; 55no7:26-8 My 15 1945.

* 243 KEPES, GYORGY. Language of vision. 228p il Chicago, Paul Theobald, 1944.
 "Guernica" p217.

* 244 KITAHARA, YOSHIO. Picasso—54 dessins. 28p 54il Tokio, Atelier-Sha, 1937
 Text in Japanese.

KLEINHOLZ, FRANK. See 273

245 KOOTZ, SAMUEL M. Picasso and others. Virginia Quarterly Review 7no3:393-9 Jl 1931

246 KRAMÁŘ, VINCENC. Jubilejní rok Pablo Picassa. 2il Volné Směry (Prague) 29no9-12:250-2 1932

247 —— Kubismus. 88p 24il Brno, Nákladem Morav.-Slezské Revue, 1921
 The entire work is devoted to Picasso.

* 248 KRÖLLER-MÜLLER, H. Die Entwicklung der modernen Malerei. passim 6il Leipzig, Verlag Klinkhardt, 1925

* 248a KÜPPERS, PAUL ERICH. Der Kubismus. passim 3il Leipzig, Klinkhardt & Biermann, 1920

* 249 KURTZ, RUDOLF. Expressionismus und film. p22,26,28,46 2il Berlin, Verlag der Lichtbild-bühne, 1926

* 250 LANE, JAMES W. Picasso, the Spanish charivari. 4il Parnassus 8:16-18 N 1936

251 LANGAARD, JOHAN H. Pablo Picasso. 9il Kunst og Kultur (Oslo) 24:45-56 1938

LARREA, JUAN. See 535

* 252 LASSAIGNE, JACQUES. Picasso. 2il Art Vivant (Paris) 230:39 Mr 1939

—— See also 330

LAZO, AGUSTÍN. See 444

LE CORBUSIER. See 334

* 252a LEE, FRANCIS. A soldier visits Picasso. 2 por View 6no2-3:16 Mr-Ap 1946

* 253 LEICESTER GALLERIES, LONDON. Catalog of an exhibition of works by Pablo Picasso. 15p il 1921
 Foreword by Clive Bell, reprinted from 42.

* 254 LEIRIS, MICHEL. L'exposition Picasso à la Galerie Louis-Carré. 1il Volontés (Paris) Je 27 1945

* 254a —— Toiles récentes de Picasso. 14il Documents (Paris) 2no2:57-71 1930

—— See also 78,137

* 255 LEMAITRE, GEORGE. From cubism to surrealism in French literature. p72-4,88-9,124-6 2il Cambridge, Harvard University Press, 1941

* 256 LEVEL, ANDRÉ. Picasso. 58p 82il Paris, Crès, 1928

Bibliography (cont'd)

* 257 LEVY, JULIEN. Surrealism. p25-7,170-3 3il New York, Black Sun Press, 1936

* 258 LEWIS, WYNDHAM. Picasso. 5il Kenyon Review 2:196-211 Spring 1940.

* 259 —— Relativism and Picasso's latest work. Blast (London) 1:139-40 Je 20 1914

* 260 LEWISOHN, SAM A. Painters and personality. p105-11 8il New York, Harper, 1937

* 260a LHOTE, ANDRÉ. Naissance du cubisme. *In* R. Huyghe, ed. Histoire de l'art contemporain; la peinture. p215-18 6il Paris, Alcan, 1935

* 261 LIFAR, SERGE. Serge Diaghilev, his life, his work, his legend. passim 2 por New York, Putnam, 1940

LIFE. See 307, 452

* 261a LIMBOUR, GEORGES. Picasso au Salon d'Automne. 3il Spectateur des Arts (Paris) no1:4-8 D 1944

* 261b LINDSTROM, CHARLES. Guernica. Art Digest 14no2:16 O 15 1939
Quotation from exhibition label prepared by Lindstrom for the San Francisco Museum of Art.

LIVING AGE. See 357

262 LLORENS I ARTIGAS, JOSEP. El grans mestres de la pintura moderna, Pau Ruiz Picasso. Gaseta de les Arts (Barcelona) 2no20:1-2 Mr 1 1925

263 —— Pablo Ruiz Picasso. La Revista (Barcelona) S 1923
* French translation in Bulletin de l'Effort Moderne no4:5-7 Ap 1924.

† 264 —— Pau R. Picasso. La Mà Trencada (Barcelona) no6 1924

† 265 —— Picasso. La Veu de Catalunya 1919

* 265a LOEB, PIERRE. Picasso, el hombre. Siempre (Havana) N 11 1944

* 266 LONDON BULLETIN. 28il no15-16:1-40 My 15 1939
Special issue on the exhibition "Picasso in English collections" at the London Gallery.

* 266a LONDON. VICTORIA AND ALBERT MUSEUM. Exhibition of paintings by Picasso and Matisse. 32p 14il (2 por) 1945
Catalog of exhibition organised by l'Association Française d'Action Artistique and the British Council. Text in French and English. Foreword by Christian Zervos. For controversy aroused by exhibition, see 110.

* 267 LOREY, EUSTACHE DE. Picasso et l'Orient musulman. 16il Gazette des Beaux-Arts ser6 2:299-314 D 1932

* 268 LUNA ARROYO, ANTONIO. A propósito de Toulouse-Lautrec y Picasso. El Universal (Mexico) Ag 6 1944

269 LURÇAT, JEAN; RÉMY; AGAMEMNON, JEAN. Picasso. 1il Étoiles du Quercy no3:52-3 Ja 1945

270 LUZZATTO, GUIDO LODOVICO. Picasso; collezione G. F. Réber. 3il Casabella (Milan) 5:53-5 Je 1932

MABILLE, PIERRE. See 78

McANDREW, JOHN. See 444

* 271 McCAUSLAND, ELIZABETH. Pablo Picasso and José Posada. American Contemporary Art 1no8:9-11 O 1944

* 272 —— Picasso. 30p 12il New York, ACA Gallery, 1944
Includes reprints of the author's articles in Springfield (Mass.) Republican, 1934-1944, as well as statements by Picasso.

* 273 —— and KLEINHOLZ, FRANK. Picasso. American Contemporary Art 1no12:9-11 F 1945
Text of a radio broadcast.

274 MacCOLL, D. S. And Picasso? Nineteenth Century (London) 89:88-9 Ja 1921

* 275 McGREEVY, THOMAS. Guernica exhibited. 3il London Studio 16 (Studio 116):310-12 D 1938

* 276 MACKENZIE, HELEN F. Understanding Picasso. 19 plates Chicago, University of Chicago Press, 1940

* 277 McMAHON, AUDREY. From the sketchbook of the artist—four caricatures. 4il Parnassus 4:9 F 1932

278 MacORLAN, PIERRE. Rencontre avec Picasso. por Annales Politiques et Littéraires (Paris) 93:79 Jl 15 1929

* 279 MAHAUT, HENRI. Picasso. 14p 32il Paris, Crès, 1930

280 MAHRT, HAAKON BUGGE. Picasso og vor tid. 3il Konstrevy (Stockholm) 5:163-6 1929

* 281 MAJOR AND MINOR PICASSO PAINTINGS AT PIERRE MATISSE. 1il Art Digest 18:10 D 15 1943

* 282 MAÑACH, JORGE. Picasso. Universidad de La Habana; publicación bimestral 34:52-64 Ja-F 1941

* 282a MANGAN, SHERRY. L'affaire Picasso. Time 44:78 O 30 1944

* 283 MARINELLO, JUAN. Picasso sin tiempo. 31p Havana, Úcar, García, 1942. (Colección Ensayos)
* English translation by Samuel Putnam in New Masses 51no11:23-8 Je 13 1944. Reprinted in part in American
* Contemporary Art 1no4:4-7 Je 1944.

* 284 MATISSE, PIERRE, GALLERY, NEW YORK. Picasso exhibition. folder 1943
Exhibition catalog.

† 285 MAROTO, GABRIEL G. Picasso y el arte de siempre. "1930" (Havana) no46 1930

MAUCLAIR, CAMILLE. See 137

* 286 MAUNY, JACQUES. Picasso the tormentor. Magazine of Art 32:365 Je 1939

MAUSS, MARCEL. See 137

* 287 MAYOR, ALPHEUS HYATT. Picasso's method. 6il Hound & Horn 3:176-88 Winter 1930

* 288 MEIER-GRAEFE, JULIUS. Entwicklungsgeschichte der modernen Kunst. [2d ed.] 3:621-36 3il München, Piper, 1915.

289 MELLQUIST, JEROME. Picasso: painter of the year. Nation 149:658,660 D 9 1939.

* 290 MELVILLE, ROBERT. The evolution of the double head in the art of Picasso. 6il Horizon (London) 6no35:343-51 N 1942

* 290a —— Picasso in the light of Chirico. 1il View 1no11-12:2 F-Mr 1942

* 291 —— Picasso, master of the phantom. 52p 12il London, Oxford University Press, 1939

* 291a —— Picasso's treatment of the head. *In* Paul Wengraf, ed. Apropos, number 3. p8-14 4il London, Lund Humphries, 1945. (A series of art books)

292 MERCANTON, JACQUES. Je ne cherche pas, je trouve. 4il por Labyrinthe (Geneva) 1no9:1-3 Je 15 1945

MERIDA, CARLOS. See 444

* 292a MERLI, JOAN. Nonell i Picasso. 2il Catalunya (Buenos Aires) 12no132:14-15,32 N 1941

* 293 —— Picasso, el artista y la obra de nuestro tiempo. 316p 210il por Buenos Aires, "El Ateneo," 1942.
Bibliography, p305-16.

* 293a MILLER, HENRY. A letter. *In* Hilaire Hiler. Why abstract? p46-8 New York, New Directions, 1945

* 294 MILLER, LEE. In Paris . . . Picasso still at work. 6il (4 por) Vogue 104no7:98-9,149-50,155 O 15 1944

* 295 MILLIER, ARTHUR. The art thrill of the week. 3il Los Angeles Times Jl 14 1940

MINOTAURE. See 353-4

MIRO, JOAN. See 77

* 296 MOHOLY-NAGY, LÁSZLÓ. The new vision. p61-4, 66-73 8il New York, Brewer, Warren & Putnam [1930]
* Third edition, revised, with 2il, published by Wittenborn, New York, 1946.

* 297 MONGAN, AGNES and SACHS, PAUL J. Drawings in the Fogg Museum of Art. 1:402-4 8il Cambridge, Harvard University Press, 1940

MONNET, GEORGES. See 137

* 297a MORENO VILLA, JOSÉ. Claridades sobre Picasso; su pintura, sus poemas, su politica. Hijo Pródigo (Mexico) 9no30:149-57 S 1945

—— See also 171, 401, 444

* 298 MORICAND, CONRAD. Portraits astrologiques . . . Picasso. p49-52 Paris, Au Sans Pareil, 1933

* 299 MORRIS, GEORGE L. K. Picasso: 4000 years of his art. Partisan Review 7no1:50-3 Ja-F 1940

300 MORTIMER, RAYMOND. Picasso's work and art. 6il Architectural Review (London) 70:21 Jl 1931

* 301 MOSCOW. MUSEUM OF MODERN WESTERN ART. First museum of modern western art. p111-36 10il 1923
Russian text by Ia. Tugendkhold.

302 MURRY, JOHN MIDDLETON. The art of Pablo Picasso. New Age (London) ns10:115 N 30 1911

303 NASH, PAUL. Picasso and painting. Week-End Review 3:959 Je 27 1931

304 NEBESKÝ, VÁCLAV. Pablo Picasso. 8il Volné Směry (Prague) 21:110-24 1921-2

NEITZEL, L. H. See 27

* 305 NEUMEYER, A. Picasso and the road to American art. Journal of Aesthetics 1no6:24-41 1942

* 306 NEW BURLINGTON GALLERIES, LONDON. Exhibition of Picasso's 'Guernica'. [4]p 2il 1938
Exhibition catalog. Exhibition held under the auspices of the National Joint Committee for Spanish Relief.

* 307 NEW FRENCH ART; PICASSO FOSTERED IT UNDER NAZIS. 4il (1 col) Life 17no20:72-5 N 13 1944

* 308 NEW YORK. ART OF THIS CENTURY. Objects, drawings, photographs, paintings, sculpture, collages, 1910 to 1942. p38-41 2il 1942
Edited by Peggy Guggenheim.

* 309 NEW YORK. MUSEUM OF LIVING ART. A. E. Gallatin collection. 46p il New York, New York University, 1940
19 illustrations of Picasso's work.

* 310 NEW YORK. MUSEUM OF MODERN ART. Art in our time [ed. by Alfred H. Barr, Jr.] no153-63, 259,304 11il 1939
Exhibition catalog.

* 311 —— Art in progress. 255p il 1944
Exhibition catalog. 6 illustrations of Picasso's work.

* 312 —— Bulletin. 9il (3 por) 12no3:1-11 Ja 1945
"Picasso 1940-1944—a digest with notes" by Alfred H. Barr, Jr., p2-9 7il (1 por). "Picasso at work, August 1944" by John Groth, p10-11 1il (por).

* 313 —— Cubism and abstract art [by Alfred H. Barr, Jr.] p29-42,78-92,96-110 26il 1936
Exhibition catalog.

* 314 —— Fantastic art, dada, surrealism; ed. by Alfred H. Barr, Jr. 248p il 1936
Exhibition catalog. 9 illustrations of Picasso's work. Second edition, 1937, includes two essays by Georges Hugnet, p15-52.

* 315 —— Modern drawings; ed. by Monroe Wheeler. 103p il 1944
Exhibition catalog. 11 illustrations of Picasso's work.

* 316 —— Modern painters and sculptors as illustrators; ed. by Monroe Wheeler. 115p il 1936
Exhibition catalog. 5 illustrations of Picasso's work.

* 317 —— Modern works of art [ed. by Alfred H. Barr, Jr.] 38p il 1935
Exhibition catalog. 8 illustrations of Picasso's work.

* 318 —— Painting and sculpture in the Museum of Modern Art; ed. by Alfred H. Barr, Jr. 84p il 1942
7 illustrations of Picasso's work. Supplement, ed. by James Johnson Sweeney, 1945, includes 1 illustration of Picasso's work.

* 319 —— Painting in Paris [ed. by Alfred H. Barr, Jr.] p36-8 5il 1930
Exhibition catalog.

* 320 —— Picasso, forty years of his art; ed. by Alfred H. Barr, Jr. 207p 214il (1 col) 2 por 1939
Exhibition catalog.

* 321 —— What is modern painting? By Alfred H. Barr, Jr. p20,26-9,36-8 3il 1943. (Introductory series to the modern arts, 2)

NEWSWEEK. See 358

* 321a NEWTON, ERIC. Picasso and Matisse; studies in contrast. 8il (2 por) Picture Post (London) 29no12:26-7, 29 Ja 5 1946

322 NEZVAL, VITĚZSLAV. Poesie 1932. 1il Volné Směry (Prague) 29no9-12:197-207 1932

* 323 NIKODEM, V. Pablo Picasso. 12p 65il Praha, S.V.U. Mánes, 1936

* 323a THE 1940-45 PICASSO IN HIS LATEST PARIS SHOW. 3il Art News 44no11:11 S 1-30 1945

NOSOTROS. See 361

NUIT ET JOUR. See 340a

* 324 OLGUÍN HERMIDA, HUMBERTO. Forma y trayectoria de Pablo Picasso. 9il Mañana (Mexico) p36-9 Jl 1 1944

* 325 OLIVIER, FERNANDE. Picasso et ses amis. 231p 15il Paris, Stock, 1933
The text is abridged from the author's articles in Mercure de France 227:549-61;228:558-88;229:352-68 My 1-Jl 15 1931. Portions were translated in London Studio 7 (Studio 107):199-203 Ap 1934.

326 OPPÉ, P. Guernica by Picasso. London Mercury 39:67 N 1938

† 327 OPPO, CIPRIANO EFISIO. Picasso. Nove Cento (Rome) no2 Winter 1926-27

328 —— Il tramonto di Pablo Picasso. Nuova Antologia (Rome) 67:324-33 O 1932

* 329　ORS, EUGENIO D'. Pablo Picasso. 62p 90il Paris, Éditions des Chroniques du Jour, 1930
*　　　Translated from the Spanish. Also an English translation, published by E. Weyhe, New York, 1930.

* 330　—— and LASSAIGNE, JACQUES. Almanach des arts. 301p il Paris, Librairie Arthème Fayard, 1937
　　　"Lettre à Pablo Picasso" by Eugenio d'Ors, p179-86 4il. "A propos de l'exposition Picasso" by Jacques Lassaigne, p187-9.

331　OSLO. KUNSTNERNES HUS. Henri-Matisse, Picasso, G. Braque, Laurens. 32p il Oslo, Reistad, 1938

* 332　OZENFANT, AMEDÉE. Art. p89-108 11il Paris, J. Budry, 1929
*　　　English translation: Foundations of modern art. p84-98 13il New York, Brewer, Warren and Putnam, 1931.

* 333　—— Picasso et la peinture d'aujourd'hui. 9il Esprit Nouveau 2no13:1489-503 [1923]
　　　Signed with the pseudonym Vauvrecy.

* 334　—— and JEANNERET, CHARLES ÉDOUARD (LE CORBUSIER). La peinture moderne. passim 19il Paris, Crès, 1925

335　PACH, WALTER. Picasso's achievement. 1il por Forum (New York) 73:769-75 Je 1925

* 336　PACHECO, CARLOS. Pablo Picasso, inquietud viviente. 5il Revista de Revistas (Mexico) Ag 13 1944

* 337　PALENCIA, CEFERINO. Picasso. 262p 41il (12 col) 5 por Mexico, Editorial Leyenda, 1945 (Coleccion "Arte")

* 338　PARROT, LOUIS. Homage to Pablo Picasso. por Tricolor (New York) 2no10:78-80 Ja 1945

* 339　PAUL, ELLIOT. The work of Pablo Picasso. 6il Transition 13:139-41 Summer 1928

* 340　PAVOLINI, CORRADO. Cubismo, futurismo, espressionismo. passim 1il Bologna, N. Zanichelli, 1926

* 340a　LE PEINTRE LE PLUS CHER DU MONDE EST COMMUNISTE. 4il por Nuit et Jour (Paris) no38:1,4 S 13 1945

PENROSE, ROLAND. See 61

PÉRET, BENJAMIN. See 77

* 341　PÉREZ ALFONSECA, R. El españolismo de Picasso. 1il Gaceta de Arte (Tenerife) 3no28:4 Jl 1934

* 342　PERLS, KÄTE, GALERIE, PARIS. Picasso 1900 à 1910. folder 1il 1937.
　　　Exhibition catalog.

* 343　PERLS GALLERIES, NEW YORK. Picasso before 1910. 4p 4il 1939
　　　Exhibition catalog.

† 344　PESTAÑA RAMOS, OSCAR. Picasso: primera época. Gaceta de Arte (Tenerife) no7 1932

* 345　PETERSON, JAY. Picasso as a Spaniard. New Masses 25no13:7 D 21 1937

* 346　PETIT, GEORGES, GALERIES, PARIS. Exposition Picasso. 77p 36il 1932
　　　Exhibition catalog. Documentation by Charles Vrancken.

347　PFISTER, KURT. Ausstellung [Picasso] in der Modernen Galerie Thannhauser—München. 7il Deutsche Kunst und Dekoration 50:248-52 1922

* 348　PHILADELPHIA MUSEUM OF ART. Bulletin. 12il 40no204:33-48 Ja 1945
　　　Bulletin titled "The Gallery collection, Picasso-Léger."

* 349　PHILLIPS, DUNCAN. El Greco, Cézanne, Picasso. 2il Art and Understanding 1no1:96-105 N 1929

* 350　PHILLIPS, VIRGINIA. Concerning Picasso's cubism. The Avenue (New York) 1:17-22,36-40 F 5-Mr 5 1934

350a　PICASSO [BIOGRAPHY] *In* Enciclopedia italiana di scienze, lettere ed arti. 27:148-9 4il Roma, 1935

350b　PICASSO [BIOGRAPHY] *In* Enciclopedia universal ilustrada. 44:516-18 3il Bilbao, Espasa-Calpe, 1921

* 351　PICASSO [BIOGRAPHY] *In* Current biography. p592-5 por New York, H. W. Wilson Co., 1943

† 352　PICASSO, PABLO. Album de reproductions. Roma, Valori Plastici, 1913

* 353　—— Une anatomie; dessins . . . 29il Minotaure no1:33-7 1933

* 354　—— Crucifixions; dessins . . . d'après la *Crucifixion* de Grünewald. 9il Minotaure no1:30-2 1933

*355　——Songe et mensonge de Franco. 32il Cahiers d'Art 12no1-3:37-50 1937
　　　Reproductions of the etchings in three states. For facsimile of manuscript, see 10.

356 —— Trente-deux reproductions des maquettes en couleurs d'après les originaux des costumes & décor pour le ballet *Le Tricorne*. 32il Paris, P. Rosenberg, 1920

* 356a PICASSO. 8il Heute (Munich) no7:16-19 Mr 1 1946
 Portrait on cover.

357 PICASSO AND HIS COURT. Living Age 320:527 Mr 15 1924

* 358 PICASSO AND THE GESTAPO. por Newsweek 24no13:98,100 S 25 1944

* 359 PICASSO AND THE RUSSIAN BALLET. Minneapolis Institute of Arts Bulletin 30no7:33-5 F 15 1941

* 360 PICASSO, DEGAS, AND ZOLA: they were all amateur photographers. 2il Vogue 93:58-9 Je 15 1939

361 PICASSO EN MÉXICO. 17il Nosotros (Mexico) Ag 5 1944

* 362 PICASSO: EPOCHS IN HIS ART. 1il Milwaukee Art Institute Bulletin 16no6:3 F 1942

* 363 PICASSO IN MEXICO. 2il por Time 44:69 Ag 7 1944

* 364 PICASSO IN RETROSPECT: THREE CRITICAL ESTIMATES. Art Front 2no11:12-15 D 1936
 Signed Joe Solman, Clarence Weinstock, Balcomb Greene.

* 365 PICASSO NATURES-MORTES—STILL-LIVES—1937-39. 8il XXe Siècle no5-6:55-64 1939

* 366 PICASSO, 1901-1925. 16p 61il [n.p.] 1938
 Japanese text by Usaburo Iseda.

* 367 PICASSO, 1918-1926, AT PAUL ROSENBERG GALLERIES. 1il Art Digest 16:19 Mr 1 1942

* 367a PICASSO, PHOTOGRAPHED BY BRASSAÏ. 6il Harper's Bazaar 80no2:132-5 F 1946

† 368 PICASSO'S DRAWINGS. Art Chronicle (London) 8:270-1 1913

* 369 PICASSO'S MODERNISM. Minneapolis Institute of Arts Bulletin 30no6:30-1 F 8 1941

* 370 PIERRE, GALERIE, PARIS. Papiers collés, 1912-1914, de Picasso. folder 1935
 Exhibition catalog. Essay by Tristan Tzara.

PIERRE-QUINT, LÉON. See 137

PINCELL [pseud] See UTRILLO, MIGUEL

* 371 PIPER, JOHN. Picasso at the Tate. Axis 1:27-8 Ja 1935

* 372 —— Picasso belongs where? 1il Axis 6:30-1 Summer 1936

† 373 PLANA, ALEJANDRO. Picasso y su significación en la pintura moderna. La Vanguardia (Barcelona) Ja 22 1936

374 POORE, CHARLES. The engaging old master of modernity. 10il New York Times Magazine p10, 11,16 N 29 1936

* 375 POUTERMAN, J. E. Books illustrated by Pablo Picasso. 6il Signature (London) 14:10-21 My 1940

* 375a POWER, J. W. Elements de la construction picturale. p50,53-4 1il Paris, Antoine Roche, 1932
 English text inserted.

* 376 PRAMPOLINI, ENRICO. Picasso, scultore. 31p 16il Rome, Fratelli Bocca, 1943. ("Anticipazioni," serie Arti 2)

—— See also 102

PRÉVERT, JACQUES. See 80, 137

* 377 PROPERT, WALTER A. The Russian ballet in western Europe, 1909-20. p54-8 10il London, Lane, 1921.

* 378 PROTEAN PABLO. 2il Time 34no22:59 N 27 1939

* 379 PUDNEY, JOHN. Picasso—a glimpse in sunlight. New Statesman and Nation (London) 28:182-3 S 16 1944
 Includes statements attributed to Picasso.

PUECH, CHARLES-HENRI. See 137

* 380 PUTNAM, SAMUEL. Picasso's politics are a puzzle to art-for-art's-sake critics. 2il The Worker (New York) p10 N 12 1944

—— See also 283

* 381 QUELQUES ARTISTES CONTEMPORAINS. no2 1930
 Special issue on the Ballets Russes. List of ballets with décors by Picasso, p32.

382 RAMIREZ, ANIBAL. Exposicion Picasso. 6il Así (Mexico) Jl 29 1944

* 383 RAPHAEL, MAX. Proudhon, Marx, Picasso; trois études sur la sociologie de l'art. p187-237 Paris, Excelsior, 1933

* 384 —— Von Monet zu Picasso. [3d ed.] p110-18 8il München, Delphin-Verlag, 1919

* 384a RAUFAST, RÉGINE. Picasso au Salon d'Automne 1944. 7il Formes et Couleurs (Lausanne) 6no5:185-7 1944

* 385 RAY, MAN. Picasso photographe. 9il Cahiers d'Art 12no6-7:168-78 1937

—— See also 77

* 386 RAYNAL, MAURICE. Anthologie de la peinture en France. p265-74 3il Paris, Éditions Montaigne, 1927
* English translation: Modern French painters. p138-45 3il New York, Brentano's, 1928.

* 387 —— Pablo Picasso. 14p 48il Paris, Éditions de l'Effort Moderne [1921]
* Also published in a de luxe portfolio edition. The text is reprinted in Bulletin de l'Effort Moderne no10:8-11; no11:5-7; no12:6-7 D 1924-F 1925.

* 388 —— Les papiers collés de Picasso. 12il Arts et Métiers Graphiques (Paris) no46:29-33 1935

* 389 —— Picasso. 8il (2 col) Art d'Aujourd'hui (Paris) no1:18-24 Spring 1924

* 390 —— Picasso. 117p 101il Paris, Crès, 1922.
German translation published by Delphin-Verlag, Munich, 1921

* 391 —— Picasso. 3il Le Point (Colmar) 2no3:126-8 1937

392 —— Picasso et l'impressionisme. 4il Amour de l'Art (Paris) 2:213-16 1921

—— See also 39

* 393 READ, HERBERT. Art now. passim 10il New York, Harcourt, Brace, 1934.

394 —— Pablo Picasso. *In* Great contemporaries. p311-20 London, Cassell, 1935
Reprinted in the author's In defense of Shelley & other essays. p207-21 London, Heinemann, 1936.

395 —— Picasso and the Marxists. London Mercury 31:95-6 N 1934

* 396 —— Picasso's Guernica. London Bulletin no6:6 O 1938

* 397 —— The triumph of Picasso. 3il The Listener (London) 15:1023-4 My 27 1936

—— See also 61, 535

398 REES, G. Picasso: the man and his work. Royal Society of Arts Journal 86:607-9 Ap 29 1938

* 399 REID, ALEX. & LEFEVRE, LTD., LONDON. Thirty years of Pablo Picasso. 26p 11il 1931
Exhibition catalog.

* 400 REINHARDT GALLERIES, NEW YORK. Picasso and Derain. [7]p 2il 1930
Exhibition catalog. Foreword by James Johnson Sweeney.

RÉMY. See 269

* 401 RENAU, JOSÉ and MORENO VILLA, JOSÉ. Pablo Picasso; dos ensayos. 6il El Nacional (Mexico) p1-7 Je 18 1944

—— See also 444

* 402 REVERDY, PIERRE. Pablo Picasso. 16p 26il Paris, Éditions de la Nouvelle Revue Française, 1924

403 REY, ROBERT. Exposition Pablo Picasso. 1il Beaux Arts (Paris) 2:125-6 Ap 1924

RIBÉMONT-DESSAIGNES, GEORGES. See 137

* 404 RICH, DANIEL CATTON. Consider Picasso. 3il Art Institute of Chicago Bulletin 25:68-71 My 1931

* 405 RICHMOND, VA. MUSEUM OF FINE ARTS. Collection of Walter P. Chrysler, Jr. 272p il 1941
Exhibition catalog. 43 illustrations of Picasso's work.

406 RILKE, RAINER MARIA. Duineser Elegien. p20-3 Leipzig, Insel-Verlag, 1923
Fifth elegy inspired by Picasso's The Family of Saltimbanques. Text in German and English. An American edition, translated by J. B. Leishman and Stephen Spender, with original German text, published by W. W. Norton, New York, 1939.

407 RING, GRETE. Die Pariser Picasso Ausstellung [bei Georges Petit] 3il Kunst und Künstler 31:286-94 1932

RIVIÈRE, GEORGES HENRI. See 137

† 407a RODRÍGUEZ CODOLÁ, MANUEL. Exposición Ruiz Picasso. La Vanguardia (Barcelona) 1897

408 ROËLL, W. F. A. Pablo Picasso. 17il Elsevier's Geïllustreerd Maandschrift (Amsterdam) 35: 304-15 1925

* 409 ROGERS, MEYRIC REYNOLD. Mother by P. Picasso acquired by St. Louis. 1il St. Louis City Art Museum Bulletin 24no2:13-15 Ap 1939

410 ROHE, M. K. Pablo Picasso. 9il Kunst für Alle (Munich) 28:377-83 1912-13

ROSA, JOSÉ DE LA. See 171

ROSENBERG, PAUL. See 491

* 411 ROSENBERG, PAUL [ART DEALER] NEW YORK. Loan exhibition of masterpieces by Picasso (from 1918 to 1926). folder 1942
Exhibition catalog.

* 412 ROSENBERG, PAUL [ART DEALER] PARIS. Exposition Picasso—oeuvres récentes. folder 1il 1939
Exhibition catalog.

413 —— Exposition de cent dessins par Picasso. 6p 1927
Exhibition catalog.

* 414 —— Exposition d'oeuvres récentes de Picasso. 12p 5il 1936
Exhibition catalog.

* 415 ROSENBERG & HELFT [ART DEALERS] LONDON. Exhibition Picasso, recent works. 4p 1il 1939
Exhibition catalog.

416 —— Exhibition, recent works of Picasso. 8p 3il 1937
Exhibition catalog.

* 417 ROTHENSTEIN, JOHN. Art in Paris now. Sunday Times (London) N 5 1944
Criticism of the paintings of Picasso and others represented at the Salon d'Automne, Paris.

418 ROTHENSTEIN, J. K. Picasso at home. por Time 45no19:63-4 My 7 1945

* 419 RUSK, WILLIAM S. Picasso and post-renaissance painting. Design 42no3:7-8 N 1940

* 420 RUTTER, FRANK. Modern masterpieces. 347p il London, Newnes [n.d.]
"Picasso and the cubists" p209-22 3il.

* 421 SABARTÉS, JAIME. Picasso, 1937. 26p por Milano, All 'Insegna del Pesce d'Oro, 1937

422 —— Picasso en su obra. 19il Cruz y Raya (Madrid) 30:61-85 S 1935

—— See also 5, 77, 88, 536

SACHS, PAUL J. See 297

* 423 SACKVILLE-WEST, EDWARD. [Influence of Picasso] New Statesman & Nation (London) 29:207 Mr 31 1945
* Discussion by Michael Ayrton and Graham Sutherland in same 29:242,274 Ap 14-28 1945.

424 SACS, JOAN. La pintura d'en Picasso. 9il Vell i Nou (Barcelona) 4:287-93,307-10 1918

* 425 SADLER, SIR MICHAEL. Pablo Picasso. 1il Art Work (London) 7:153-4 1931

426 SALMON, ANDRÉ. L'art vivant. p169-74 il Paris, Crès, 1920

427 —— [Discussion of current criticism of Picasso in Paris] 2il Apollo 11:119-20 1930

* 428 —— La jeune peinture française. passim Paris, Société des Trente, 1912.

* 429 —— La jeune sculpture française. p103 Paris, Société des Trente, 1919

* 430 —— La négresse de Sacré-Coeur. 237p Paris, Éditions de la Nouvelle Revue Française, 1920
A novel about Montmartre in 1907; Picasso appears as one of the chief characters under the name Sorgue. Translated as The Black Venus. 293p New York, Macaulay, 1929.

* 431 —— Picasso. 14il Esprit Nouveau no1:59-81 1920

—— See also 76

432 SALON D'AUTOMNE, PARIS. Catalogue des ouvrages de peinture, sculpture, dessin, gravure, architecture et art décoratif. 62p 1944
"Exposition Pablo Picasso" p61.

* 432a SAN LAZZARO, G. DI. Cinquant'anni di pittura moderna in Francia. passim 3il Roma, Danesi, 1945

* 432b SARFATTI, MARGHERITA G. Storia della pittura moderna. p32,36-9,49,51 5il Roma, Paolo Cremonese, 1930

SAVINIO, ALBERTO. See 102

SCHAEFFNER, ANDRÉ. See 137

SCHAPIRO, MEYER. See 535

SCHEIWILLER, GIOVANNI. See 76, 525

433 SCHÜRER, OSKAR. Pablo Picasso. 30p 41il Leipzig, Klinkhardt & Biermann, 1927
* The text is a revision of the author's article in Der Cicerone 18:757-72 1926.

434 —— Picasso, Laurencin, Braque. 4il Deutsche Kunst und Dekoration 55:208-16 Ja 1925

435 —— Picassos Klassizismus. 5il Kunst für Alle 41:202-7 1925-26

—— See also 76

SECKLER, JEROME. See 3a

436 SEIZE, MARC. La crise de Picasso. Arts Plastiques (Paris) no9 [1929?]

437 SELIGMANN, HERBERT J. Picasso on Fifth [Avenue] The Nation 117-714 D 19 1923

* 438 SELIGMANN, JACQUES & Co., NEW YORK. Picasso: "blue" and "rose" periods, 1901-1906. 24p 21il 1936.
 Exhibition catalog.

* 439 —— 20 years in the evolution of Picasso, 1903-1923. 10p 17il 1937
 Exhibition catalog.

* 440 SEVERINI, GINO. Arte indipendente, arte borghese, arte sociale. passim il Roma, Danesi, 1944
 "Picasso e l'arte borghese" p9-16 1il.

—— See also 102

441 SITWELL, SACHEVERELL. Pablo Picasso. 7il Drawing and Design ns1:120-5 1926.

* 442 SOBY, JAMES THRALL. After Picasso. p96-9 9il Hartford, Conn., Mitchell; New York, Dodd, Mead, 1935.

* 443 —— Picasso, a critical estimate. 6il Parnassus 11:8-12 D 1939

* 444 SOCIEDAD DE ARTE MODERNO, MEXICO. Picasso. 72p 32il 1944
 Exhibition catalog. Text by José Moreno Villa, Agustín Lazo, Carlos Merida, José Renau. Chronology by John McAndrew.

* 445 SOFFICI, ARDENGO. Cubismo e futurismo. 78p il Florence, Libreria della Voce, 1914
 "Il cubismo (Picasso e Braque)" p7-23 2il.

* 446 —— Ricordi di vita artistica e letteraria. 2d ed. 426p Firenze, Vallecchi, 1942
 "Gli studi di Picasso" p365-73.

* 447 —— Selva arte. passim Firenze, Vallecchi, 1943

—— See also 102

SOLMAN, JOE. See 364

* 448 SOLMI, SERGIO. Disegni di Picasso. 34p 4lil Milano, Ulrico Hoepli, 1945
 Bibliography by G.Scheiwiller.

† 448a —— Pablo Picasso, der Zeichner. Zürich, 1933

448b SONDAZ, M. L. Picasso expose un ensemble de toiles à la Galérie Paul Rosenberg . . . Cahiers du Sud (Marseille) 12:159-62 Ag-S 1926

† 449 SOTO, M. F. DE. Picasso y su obra. Arte y Letras (Barcelona) no31 1917

* 450 SOYER, MOSES. In the world of art [Picasso] New Masses 55no5:27 My 1 1945

451 SPAINI, ALBERTO. Picasso. 6il Brescia 4:27-30 D 1931

* 452 SPANISH PAINTER'S BIG SHOW TOURS THE NATION. 9il (7 col) por Life 8:56-9 Mr 4 1940

* 453 SPENDER, STEPHEN. Picasso's Guernica. New Statesman and Nation (London) 16:567-8 O 15 1938

* 454 STEIN, GERTRUDE. Autobiography of Alice B. Toklas. passim 3il New York, Harcourt, Brace, 1933

* 455 —— Dix portraits. p15-18 Paris, Éditions de la Montagne, 1930
 Text in French and English, 3 illustrations by Picasso.
* Published in Échanges (Paris) no1:149-52 D 1929. Re-
* printed in Omnibus (Berlin) p198-200 1931 and in 458a.

456 —— Everybody's autobiography. passim New York, Random House, 1937.

* 457 —— Pablo Picasso. 7il Camera Work special no:29-30 1912

* 458 —— Picasso. 169p 63il Paris, Floury, 1938.
 English edition: Picasso. 55p 63il New York, Scribner's;
* London, Batsford, 1939.

458a —— Portraits and prayers. p17-20 New York, Random House, 1934

459 STEIN, LEO. Pablo Picasso. New Republic 38:229-30 Ap 23 1924.

STENDAHL GALLERY, LOS ANGELES. See 482

460 STEVENS, WALLACE. The man with the blue guitar, & other poems. p3-35 New York, Knopf, 1937

STRAWINSKY, IGOR. See 76

* 461 SURVEY OF PICASSO AT BIGNOU GALLERY. 1il Art Digest 15:14 F 15 1941

SUTHERLAND, GRAHAM. See 423

* 462 SWEENEY, JAMES JOHNSON. Panorama of Picasso. New Republic 101:231-2 D 13 1939

* 463 —— Picasso and Iberian sculpture. 16il Art Bulletin 23no3:191-8 S 1941

* 464 —— Plastic redirections in 20th century painting. passim 9il Chicago, University of Chicago Press, 1934

—— See also 76, 318, 400, 535

* 465 SWEET, FREDERICK A. Picasso—forty years of his art. 3il Chicago Art Institute Bulletin 34:21-4 F 1940

* 466 —— Woman with mirror. 1il Chicago Art Institute Bulletin 35:106-7 D 1941

TAUBES, FREDERIC. See 231

* 467 TÉRIADE, E. L'avènement classique du cubisme. 10il Cahiers d'Art 4:447-53 1929

* 468 —— En causant avec Picasso; quelques pensées et réflexions du peintre et de l'homme. L'Intransigeant (Paris) Je 15 1932

TÉRY, SIMONE. See 4

469 THANNHAUSER, MODERNE GALERIE, MUNICH. Ausstellung Pablo Picasso. 36p 12il 1913
Exhibition catalog. Introduction by Justin Thannhauser.

THIEME, U. and BECKER, F. See 200

470 THREE HITHERTO UNPUBLISHED STUDIES BY PICASSO. 3il Artwork (London) 3no11:186-8 S-N 1927

TIEMPO. See 12

TIME. See 28, 363, 378

* 471 TODD, RUTHVEN. Drawings for "Guernica." London Bulletin no8-9:59 Ja-F 1939
A poem dedicated to Pablo Picasso. Reprinted in Poetry 54:91 My 1939.

* 472 TORRE, GUILLERMO DE. Picasso. 2il Forma (Buenos Aires) 5:10-11,24 Ja 1938

473 —— Picasso and the younger Spanish painters. Europa (New York) 1no2:41-7 Ag-O 1933

—— See also 15, 171

* 473a TORRES-GARCÍA, JOAQUÍN. Universalismo constructivo. passim Buenos Aires, Editorial Poseidon, 1944

* 474 TORRIENTE, LOLÓ DE LA. Picasso en México. 2il Gaceta del Caribe (Havana) 1no6:20-1 Ag 1944

† 475 TOZZI, MARIO. Disegni di Picasso. Arti Plastici (Milan) Ag 16 1927

TREVES, MARCO. See 194

TUGENDKHOLD, IA. See 301

* 476 TZARA, TRISTAN. Le papier collé; ou, Le proverbe en peinture. 12il Cahiers d'Art 6no2:61-73 1931

—— See also 370

* 477 UHDE, WILHELM. Picasso et la tradition française. passim 7il Paris, Éditions des Quatre Chemins, 1928
* English translation: Picasso and the French tradition. Paris, Éditions des Quatre Chemins; New York, Weyhe, 1929.

USABURO ISEDA. See 366

478 UTRILLO, MIGUEL. Pablo R. Picasso. 5il por Pèl & Ploma (Barcelona) 3no77:14-17 Je 1901
Signed with the pseudonym Pincell.

* 479 VALENTINE GALLERY, NEW YORK. Abstractions of Picasso. 10il 1931
Exhibition catalog.

* 480 —— Picasso. 4p 1933
Exhibition catalog. Preface by Valentine Dudensing.

* 481 —— Picasso from 1901 to 1937. folder 1937
Exhibition catalog.

* 482 —— Picasso; Guernica. 7p 3il por [1939]
Exhibition catalog. Presented by the American Artists Congress for the benefit of the Spanish Refugee Relief Campaign. Same catalog issued for the exhibition at Stendahl Gallery, Los Angeles, 1939.

* 483 —— Picasso, 21 paintings—1908 to 1934. folder 1938
Exhibition catalog.

484 —— Retrospective exhibition 1901-1934, Picasso. folder 1936

485 VANDERPYL, FRITZ R. Peintres de mon époque. p91-106 Paris, Stock, 1931

VAUVRECY [pseud] See OZENFANT, AMÉDÉE

VÉDRÈS, N. See 191a

486 VENTURI, LIONELLO. Pablo Picasso. 10il Arte (Rome) 36:120-40 1933

* 486a VERNE, HENRI. Le secret de Picasso. 1il Opéra (Paris) 3no13:4 Ag 1 1945

* 487 VERNEUIL, GRETA DE. Pablo Picasso. 5il Cultura Peruana (Lima) 1no4:[4]p S 1941

XXe SIÈCLE. See 365

VITRAC, ROGER. See 137

VOGUE. See 360

* 488 VOLLARD, AMBROISE. Recollections of a picture dealer. passim Boston, Little, Brown, 1936

VRANCKEN, CHARLES. See 346

* 489 WALLIS, ANNE ARMSTRONG. A pictorial principle of mannerism. 2il Art Bulletin 21no3:280-3 S 1939

* 490 WARNOD, ANDRÉ. Les berceaux de la jeune peinture. p92-5 Paris, Albin Michel, 1925

—— See also 4a

WARTMANN, W. See 530

* 491 WASHINGTON, D.C. PHILLIPS MEMORIAL GALLERY. Picasso. 4p 4il 1944
Exhibition catalog. Text by Paul Rosenberg.

* 492 WATSON, FORBES. Four approaches to Picasso. Magazine of Art 33:5 Ja 1940

* 493 —— A note on Picasso. 7il The Arts 4:332-8 1923

* 494 WEEKS, HENRY H. A nudist appraisal of Pablo Picasso . . . 8il Sunshine and Health (New Jersey) 9no6:11-14,23 Je 1940

495 WEILL, BERTHE. Pan! dans l'oeil! ou Trente ans dans les coulisses de la peinture contemporaine, 1900-1930. passim 2il Paris, Lipschutz, 1933

WEINSTOCK, CLARENCE. See 364

* 496 WESTERDAHL, EDUARDO. Pablo Picasso; intelectualismo, sumisión y relacion automática de la pintura. por Gaceta de Arte (Tenerife) no19:2-3 S 1933

† 497 —— Picasso: periodo monstruoso. Gaceta de Arte (Tenerife) no7 1932

—— See also 171

*498 WESTERMANN, GALLERY, NEW YORK. Picasso; etchings, lithographs, reproductions. folder 1939
Exhibition catalog.

* 499 WESTHEIM, PAUL. Helden und Abenteurer: Welt und Leben der Künstler. p218-23 1il Berlin, Reckendorf, 1931

500 —— Picasso. D'Aci i d'Allà (Barcelona) 2il (1 col) 22no179:[5,7] D 1934

—— See also 1

* 501 WHEELER, MONROE. Meeting Picasso. il University Review (Kansas City, Mo.) 3:175-9 Spring 1937

—— See also 315-16

* 502 WHITEHILL, VIRGINIA N. On public taste and Picasso. Parnassus 12:12 Ja 1940

503 WHITNEY, PETER D. Picasso is safe. San Francisco Chronicle S 3 1944

* 504 WIEGAND, CHARMION VON. Picasso's last period. 1il Direction 3no6:38-41 Summer 1940

* 505 WIGHT, FREDERICK. Picasso and the unconscious. Psychoanalytic Quarterly 13no2:208-16 Ap 1944

506 WILDENSTEIN GALLERIES, NEW YORK. Exhibition of drawings by Picasso. folder 1928
Exhibition catalog.

* 507 —— Exhibition of recent works by Picasso. folder 1923
Exhibition catalog.

* 508 WILENSKI, REGINALD HOWARD. Modern French painters. passim 22il New York, Reynal & Hitchcock [1940]
New edition published 1944.

509 —— [Review of E. d'Ors, Picasso] Apollo 13:187-90 1931

* 510 WRIGHT, WILLARD H. Modern painting. 352p il New York, Lane, 1915
"Picasso and cubism" p237-62 2il.

* 511 ZAHAR, MARCEL. Picasso; la danse dans la peinture contemporaine. Archives Internationales de la Danse 1:94-9 D 1933

* 512 ZAHN, LEOPOLD. Picasso bei Thannhauser. Der Cicerone 14no12:524-5 Je 1922

* 513 —— Picasso und der Kubismus. 13il Jahrbuch der Jungen Kunst 3:116-30 1922

* 514 —— Picasso und Kandinsky. Der Ararat (Munich) 2:171-3 1920

ZAYAS, MARIUS DE. See DE ZAYAS, MARIUS

* 515 DER ZEICHNER PABLO PICASSO. Der Cicerone 19no20:642-3 O 1927

* 516 ZERVOS, CHRISTIAN. À propos de la dernière exposition Picasso. 1il Cahiers d'Art 6:325 1931

* 517 —— De l'importance de l'objet dans la peinture d'aujourd'hui. 48il Cahiers d'Art 5no5:225-40; 5no6:281-94 1930

* 518 —— La dernière exposition de Picasso [à la galerie Paul Rosenberg] 12il Cahiers d'Art 14no1-4:81-8 1939

* 519 —— Dernières oeuvres de Picasso. 12il Cahiers d'Art 2:189-98 1927

* 520 —— Dernières oeuvres de Picasso. 26il Cahiers d'Art 4:233-50 1929

* 521 —— Histoire de l'art contemporain. p193-222 27il Paris, Éditions des Cahiers d'Art, 1938

* 522 —— Lendemain d'une exposition. 4il Cahiers d'Art 1:119-21 1926

* 523 —— Oeuvres récentes de Picasso. 8il Cahiers d'Art 1:89-93 1926

* 524 —— Pablo Picasso. 2v in 3 pts 1348il Paris, Cahiers d'Art, 1932-42
Vol. 1, also published by E. Weyhe, New York, 1932, with English text, covers works from 1895 to 1906. Vol. 2, in two parts, with French text, covers the years 1906 to 1912, and 1912 to 1917.

* 525 —— Pablo Picasso. 26p 30il Milano, Hoepli, 1932
Text in Italian. Bibliography by Giovanni Scheiwiller.

* 526 —— Picasso à Dinard, été 1928. 27il Cahiers d'Art 4:5-20 1929

* 527 —— Picasso; oeuvres 1920-1926. 19p 47il Paris, Éditions des Cahiers d'Art, 1926

* 528 —— Picasso; oeuvres inédites anciennes. 29il Cahiers d'Art 3:204-27 1928

528a ——Position de Pablo Gargallo dans la sculpture contemporaine de Paris. Sélection (Antwerp) 10:14-18 Jl 1930
Includes comments on the two Pablos, Pablo Gargallo and Pablo Picasso.

* 529 —— Projets de Picasso pour un monument. 13il Cahiers d'Art 4:342-54 1929

—— See also 2, 76-9, 88, 237, 266a, 535, 538

* 530 ZURICH. KUNSTHAUS. Picasso. 25p 32il 1932
Exhibition catalog. Foreword by W. Wartmann.

* 531 ZWEMMER GALLERY, LONDON. Chirico, Picasso. 8p 2il 1937
Exhibition catalog.

* 532 —— Fifty drawings by Pablo Picasso. folder [1937]
Exhibition catalog.

Books in preparation

533 THE DRAWINGS OF PABLO PICASSO. 72 plates New York, Curt Valentin [1946?]

534 DRAWINGS OF PABLO PICASSO. 15 plates New York, Pantheon Books [1946]

535 PABLO PICASSO; GUERNICA. il New York, Curt Valentin [1946]
Text by Georges Duthuit, Paul Eluard, Juan Larrea, Herbert Read, Meyer Schapiro, James Johnson Sweeney, Christian Zervos.

536 SABARTÉS, JAIME. Picasso, portraits et souvenirs. Paris, Éditions Louis Carré [1946?]

537 LA SCULPTURE DE PICASSO. il Paris, Éditions du Chêne [1946?]

538 ZERVOS, CHRISTIAN. Picasso year by year; trans. by Dr. and Mrs. C. A. Hackett. [London] Nicholson and Watson [1946?]

NIGHT FISHING AT ANTIBES. August, 1939. Oil, 6 feet 9 inches x 11 feet 4 inches. Private Collection. See page 223. The painting is reproduced here since no photograph was available in time for inclusion in the main body of the book.

Index

311

312

313

Eighteen thousand copies of this book have been printed in August 1946 for the Trustees of The Museum of Modern Art by the Plantin Press, New York. The color inserts were printed by William E. Rudge's Sons, New York.